THE ART OF SUBTRACTION

Digital Adaptation and the Object Image

The Art of Subtraction

Digital Adaptation and the Object Image

BRUNO LESSARD

UNIVERSITY OF TORONTO PRESS
Toronto Buffalo London

ISBN 978-1-4426-3191-5

Library and Archives Canada Cataloguing in Publication

Lessard, Bruno, 1977–, author
The art of subtraction : digital adaptation and the object image /
Bruno Lessard.

Includes bibliographical references and index.
ISBN 978-1-4426-3191-5 (cloth)

1. Literature – Adaptations – History and criticism. 2. CD-ROMs.
3. Digital media. I. Title.

PN171.A33L47 2017 809 C2017-901220-7

University of Toronto Press acknowledges the financial assistance to its
publishing program of the Canada Council for the Arts and the Ontario
Arts Council, an agency of the Government of Ontario.

À Joëlle

Contents

Acknowledgments

I have incurred a great number of professional and personal debts working on this book over the years.

At the Université de Montréal, I would like to thank Amaryll Chanady and Philippe Despoix for their suggestions in the early stages of development. Livia Monnet provided a unique model of open-mindedness, critical thinking, and erudition. I remain extremely grateful for her guidance and support and for the opportunity to present on my research at the "Gender, Embodiment, Subjectivity, and the Transformation of Cinematic Practice in Contemporary New Media Art" conference she organized at the Université de Montréal in 2004. This project also benefitted from conversations with Thomas Lamarre (McGill University), whose insightful comments led to significant revisions. I am indebted to the Fonds de recherche du Québec – Société et culture (FRQSC) for a doctoral scholarship that supported this work in its first iteration.

In Toronto, where I held a Social Sciences and Humanities Research Council (SSHRC) postdoctoral fellowship at York University, I am grateful to Janine Marchessault and Barbara Crow for providing me with research and teaching opportunities. At Ryerson University, I would like to acknowledge the support of the Faculty of Communication & Design for an aid-to-publication grant as well as the School of Image of Arts for research assistance.

At the University of Toronto Press, Siobhan McMenemy's editorial expertise and dedication were key in making the revision process a smooth one. The contribution of three anonymous reviewers proved invaluable in asking probing questions and improving the manuscript.

Finally, to Joëlle go my deepest thanks, for her love, affection, and patience throughout the writing of this book, which I dedicate to her.

THE ART OF SUBTRACTION

Digital Adaptation and the Object Image

Introduction

We live in the age of ubiquitous adaptation. From a Hollywood film based on a graphic novel to a mobile game adapting the life of a reality TV celebrity to a jazz pianist setting American poetry to music, adaptations have become an essential part of the twenty-first-century media landscape and a cornerstone of media consumption. Within the last twenty years, the field of study that has done the most to come to terms with this cultural phenomenon is adaptation studies. No longer on the margins of film studies as a result of its literary lineage, adaptation studies has come of age. More than five decades after George Bluestone's foundational study *Novels into Film*,[1] the Association for Adaptation Studies; dedicated journals such as *Literature/Film Quarterly*, *Adaptation*, and *The Journal of Adaptation in Film & Performance*; annual conferences; and countless monographs, anthologies, and edited collections published by prestigious presses have given adaptation studies an institutional legitimacy that it had lacked for decades. The field has thus evolved into an exciting gathering of scholars attuned not only to theoretical developments in post-structuralism and cultural studies, but also to sociological approaches, audience studies, and fan studies. Inspired by such research orientations, and striving to go beyond the issue of fidelity that characterized much early work in the field, scholars such as Robert Stam, Linda Hutcheon, and Thomas Leitch have explored the possibility of jettisoning the novel-to-film case study and, therefore, the film-centric focus that still defines the area of study.

Few scholars, however, have thoroughly reflected upon the possibility for adaptation studies to fully enter the digital age.[2] Indeed, those interested in the adaptation process cannot but be intrigued by the puzzling absence of *sustained* studies of digital adaptations, that is, adaptations to

websites, smartphones, ROM environments, tablets, installations, and digital games. This absence demonstrates how great a challenge digital media still present to adaptation studies, and how this branch of film studies is ill-equipped to deal with adaptation to digital platforms of all kinds. Having explored adaptations to interactive media elsewhere,[3] I show in this book that the critical tools available in adaptation studies need to be expanded to address digital adaptations productively. This will be necessary in order to go beyond merely enumerating the titles of digital adaptations, as has been the case so far, or returning to age-old issues such as the "fidelity debate."[4] *The Art of Subtraction* proposes new conceptual tools to lay the foundation for future studies of digital adaptation.

As adaptation studies moves into the digital realm, the tools of the critical trade could draw on theories introduced in other fields to truly develop the "methodological and theoretical hybridities" adaptation scholar Kamilla Elliott has discussed.[5] Critical theories associated with intermediality, transmediality, media archaeology, software studies, game studies, and the digital humanities are just a few of the more recent approaches that have problematized what fifteen years ago was called "new media studies." Such thriving fields have answered N. Katherine Hayles's call for "approaches that can locate digital work within print traditions, and print traditions within digital media, without obscuring or failing to account for the differences between them."[6] The digital adaptation of literary works functions as an ideal site where such interrelations between print culture and digital practice can be investigated. This book's emphasis on digital adaptations of literary works thus serves two main purposes: establishing a comparative framework for thinking digital adaptations with the help of novel concepts that could be appropriated by scholars interested in examining adaptations of the literary kind to other digital platforms, and inquiring into the afterlife of the literary and the transformations print culture artefacts such as novels undergo in a digital environment.

One unsuspected digital environment in which one can locate vestiges of the literary tradition is in the CD-ROM medium. Focusing on "old new media" without using a teleological lens is key to unearthing both media and practices that have gone under the radar and establishing a comparative framework for thinking through so-called "old media" and the claimed newness of "new media." In this study, I examine such an instance of "old new media," CD-ROM, which has gone under the radar of digital media studies, game studies, the digital humanities, and adaptation studies. My goal is not to offer a comprehensive history

or a media archaeology of the CD-ROM medium. Rather, this study zeroes in on the still unexplored practice of digital adaptation of literary works in order to highlight the unique contribution CD-ROM made to the adaptation of literary works at the time of its ascendency, and understand how it capitalized on the literary canon to help frame a novel type of adaptation practice. This is not to say that CD-ROM did not make other valuable contributions to artistic creation in the form of experimental work, or that there were no other sources to draw on or other creative approaches to the then unique multimedia platform, but that the literary source is the most apt to cast light on digital work drawing on the print tradition.

The Art of Subtraction thus makes an overdue contribution to adaptation studies using four adaptations of literary works to the CD-ROM environment: Jean-Louis Boissier's *Moments de Jean-Jacques Rousseau* (2000), Zoe Beloff's *Beyond* (1997), Adriene Jenik's *Mauve Desert: A CD-ROM Translation* (1997), and Chris Marker's *Immemory* (1998). With the help of these CD-ROMs, one of the objectives is to demonstrate that adaptation has entered the digital age, and that studies of adaptation practice do not have to be limited to films, TV series, or novelizations. Digital media arts have made a great contribution to adaptation practice, but that story remains to be told; *The Art of Subtraction* can thus be envisaged as one chapter of that story covering the contribution of CD-ROM. The following analyses of CD-ROMs implicitly question the widespread practice of merely mentioning titles or, at best, providing short descriptions of digital adaptations. While adaptations of literary works and films to digital games have received some attention,[7] the same cannot be said of adaptations to digital media arts, and this study seeks to remedy the situation.

As a comparative literature graduate, I have always paid special attention to the dangers and pitfalls of comparisons. In the present comparative context, a central research question is: How can the study of CD-ROM – or any digital medium for that matter – help us understand the literary work, or vice versa, in a new way? A second question relating to comparison is: Can the tools developed in adaptation studies help understand the digital adaptation of a literary work? If not, what is the conceptual and theoretical approach that could yield the best results? In this study, I introduce two notions, "subtractive adaptation" and the "object image," to lay the foundation for a theory of digital adaptation that, I hope, will be appropriated to examine adaptations to other digital environments.

This study takes inspiration from various areas in digital media studies. The strategies for analysing digital media are multifaceted, and each media object, whether it be a digital game, a blog, or a smartphone, requires its own unique approach. With regard to the type of digital adaptation studied in this book, I believe the tradition of *close reading* developed in literary studies, which has been productively used for digital literature, can demonstrate the fruitfulness of the concepts introduced and the richness of digital works that have not received much attention. Therefore, I agree with Hayles when she argues that "recognizing the specificity of new media without abandoning the rich resources of traditional modes of understanding language, signification, and embodied interactions with texts"[8] developed in literary studies over decades is one of the most appropriate strategies for making sense of adaptations to CD-ROM.

Hayles's influential call for "media-specific analysis" in a now well-known article goes hand in hand with the close reading strategy adopted in her writings on electronic literature, and, I should add, in this study of digital adaptation. Hayles writes: "Media-specific analysis (MSA) attends both to the specificity of the form … and to citations and imitations of one medium in another."[9] More than a decade ago, Hayles argued for "media-specific analysis" and the need to pay close attention to the media materiality of digital objects. This concern has become paramount to the type of analysis Hayles and others in the fields of platform studies, forensic media studies, media archaeology, and the digital humanities have promoted over the last decade. In other words, attending to the "body" or media materiality of digital media (in our case CD-ROM) is crucial to understanding the affordances of the medium before any analysis can take place. Such emphasis on media materiality was necessary in order to avoid treating digital objects as if they were texts on a printed page without attending to the materiality of computer-generated objects. In this context, Hayles aptly explains the relationship between materiality and close reading: "The crucial move is to reconceptualize materiality as *the interplay between a text's physical characteristics and its signifying strategies*. The definition opens the possibility of considering texts as embodied entities while still maintaining a central focus on interpretation."[10] As Hayles makes clear, the focus on media materiality and interpretation is not meant as a return to formalist critique or media determinism. Rather, the goal is to reimbue media with a sense for materiality, which is to say understanding the "body" of the digital medium that is located between representation and simulation as a processual object.

Moreover, as a result of the assemblage of textual matters *and* moving images in CD-ROM adaptations, this study builds on the close reading strategies developed in both literary and film studies over the last decades without resorting to traditional formal analysis. Acknowledging that the close reading approach is not the only valuable one today, it remains the case that it is one of the most adequate to show the complexity of a given work in the absence of previous sustained studies. This is necessary when dealing with works that have not drawn much attention. What Hayles outlined several years ago with regard to electronic literature still applies to CD-ROM-based work: "electronic literature has already produced many works of high literary merit that deserve and demand the close attention and rigorous scrutiny critics have long practiced with print literature."[11] A recent publication such as Jessica Pressman, Mark C. Marino, and Jeremy Douglass's *Reading Project: A Collaborative Analysis of William Poundstone's* Project for Tachistoscope {Bottomless Pit}[12] offers a book-length study of one single work of digital literature, which shows how digital works can be objects of extensive analysis just like novels or films and similarly deserve close study. The close reading practices advocated by these scholars find an echo in the reading strategies deployed in the core chapters of this study, as each core chapter provides a close analysis of a single adaptation to CD-ROM.

Jessica Pressman's *Digital Modernism: Making It New in New Media* (2014), which addresses the adaptation of modernist tropes and motifs in digital literature, serves as a precursor to the approach presented in the following chapters. In her study of several digital adaptations, she emphasizes how they allow a reconsideration of specific techniques and cultural issues found in the adapted texts: "These works adapt seminal texts from the modernist canon (e.g., Pound's *Cantos*, Joyce's *Ulysses*), remediate specific formal techniques (e.g., stream of consciousness, super-position), and engage with cornerstone cultural issues (e.g., the relationship between poetics, translation, and global politics). They employ a strategy of renovation that purchases cultural capital from the literary canon in order to validate their newness and demand critical attention in the form of close reading."[13] Similarly, what the following chapters demonstrate is not only the possibility of rethinking adaptation studies in the digital age, but also of rethinking the social, cultural, philosophical, and technological issues at the heart of Jean-Jacques Rousseau's *Confessions*, Villiers de l'Isle-Adam's *Tomorrow's Eve*, Raymond Roussel's *Locus Solus*, Nicole Brossard's *Mauve Desert*, and Marcel Proust's *In Search of Lost Time* from the point of view of the digital.

As adaptation studies has mostly been concerned with anglophone literature, this study also expands the purview of adaptation studies into the realm of francophone studies, and it shows how media artists relied on the cultural capital of literary works written in French as a backdrop to their exploration of the then new CD-ROM medium.

Subtractive Adaptation

What is the place of the digital within adaptation studies? What digital objects would generate fruitful analyses, and which theories would be more conducive to producing such results? Given the radical departure from film adaptation and the traditional concerns of adaptation studies that digital media imply, it is no wonder one critic has suggested that "we rethink adaptation in light of new media."[14] Two contributions stand out in this respect: Thomas Leitch's work on "postliterary adaptations," and Costas Constandinides's analyses of "post-celluloid adaptations." Both critics' efforts in this regard could be said to have expanded on Robert Stam's brief but suggestive mention of "post-celluloid adaptations" in light of the computerization of all media.[15]

Leitch's notion of "postliterary adaptation," that is, adaptations that are not based on a literary source like a novel, refers to films drawing on board games, video games, and theme-park attractions. The bulk of Leitch's work on "post-literary adaptations" focuses on video games made into critically unsuccessful films such as *Super Mario Bros.* (1993), *Double Dragon* (1994), *Street Fighter* (1994), and *Doom* (2005). His reflections pay close attention to "the requirements of linear narrative"[16] that constrain these game-to-film adaptations. Arguing that reviewers and critics have not yet found a way to discuss such films, Leitch notes that "The problem is especially acute in the case of movies whose sources are not only nonliterary but nonnarrative."[17] I would add that "nonnarrative" works have not received sustained attention precisely because they do not tell "stories" in the conventional sense of the word, and that this has prevented digital adaptations based on print sources or films from being taken seriously by critics, as we will see in chapter 1.

Constandinides's work differs from Leitch's, as the former does engage new media theory and concepts to an unprecedented degree in adaptation studies. While Constandinides is not interested in media arts or digital games per se, he devotes an entire study to the impact of the digital on fiction films based on traditional print sources and graphic novels. He analyses instances of "post-celluloid adaptations"

in the form of CGI-driven productions based on graphic novels and digital monsters in films such as *Van Helsing* (2004) and *King Kong* (2005). Constandinides ultimately argues that "it is important to study systematically the signification of the digital image within the context of film studies / film adaptation studies and in relation to the logic of incompleteness and interactivity."[18] Expanding on Constandinides's insight, I would argue that digital platforms of all sorts, when speaking of adaptation practice, need to be examined in the context of film adaptation studies, but the field should also strive to integrate digital media studies in its various contemporary declensions, as it can provide the tools for understanding "incompleteness and interactivity," which is a hallmark of all digital environments, from the web to social media. If adaptation studies is to enter the digital age, it cannot be limited to film-related issues and terminology and the film medium itself, as has been the case with "post-cinematic adaptations."[19]

Answering Leitch's and Constantinides's calls for adaptation studies to enter the digital realm, this study of CD-ROM adaptation makes a timely contribution to media philosophy by focusing on the notion of artistic subtraction from the point of view of the digital. Indeed, the CD-ROM medium provides a unique opportunity to delve into the rarely examined notion of subtraction in art to define the potentialities and limitations of a digital platform. A key point of interest is the revamped function of narrative within a digital environment, which is to say how CD-ROM played the linearity of traditional storytelling against the contingent aspects of digital storytelling predicated upon user input. Combined with insights found in literary studies, software studies, and critical theory, this contribution to media philosophy builds upon Gilles Deleuze's film philosophy and Michel Foucault's philosophy of space in his reflections on heterotopias to offer a first foray into what a philosophy of adaptation for the digital age could be.

Drawing on neglected moments in the writings of Deleuze and Foucault, *The Art of Subtraction* shows that CD-ROM adaptation challenged the reign of narrative once interactivity, programmability, and contingency had taken over in media environments. As I will go on to argue, storytelling is not the most important facet of digital adaptation, at least in its 1990s iterations such as CD-ROM adaptations. Anyone with hands-on experience of interactive media will corroborate that the narratives contained therein often failed to conform to traditional storytelling, which is an aspect that should be borne in mind when feeling the impulse to reduce digital adaptation to story or narrative.

It turns out that CD-ROM adaptation was far more interesting in terms of the problems and issues it raised than the original narratives it failed to adapt. In short, subtractive adaptations functioned as singular reflections on language, communication, perception, and media and thus offered an innovative type of media philosophy. It is therefore the interplay between the literary text and the digital adaptation in terms of problem or issue that one should try to understand. This perspective on adaptation actually signals the democratization of the interpretation process in not favouring the literary text or the CD-ROM. The emphasis is then put on the central term that both works share and the reasons why it is subtracted from the original.

A first step is to recognize that the transformative experiences literary texts underwent in the subtractive adaptation process were very different from those of the film adaptation process. Indeed, hypermediality presented a challenge to the categories of original text and adaptation. In the theory of subtractive adaptation put forward in this book, the literary text is no more or no less important than the CD-ROM adaptation. They are equally crucial insofar as they both shed light on a philosophical, artistic, or media problem to which writers implicitly, and CD-ROM artists explicitly, tried to find an answer. The subtractive procedure reflected the wish to zero in on the problem or issue at the heart of the literary work; it was not the original plot itself that mattered. The literary work was the first to address the problem or issue, but this fact does not imply that it found the best solution. In the realm of subtractive adaptation, seniority was no argument.

There are two other salient differences between film adaptation and subtractive adaptation to which we should turn our attention, and these will surface in the discussions of specific CD-ROMs. First, subtractive adaptation used a very subtle modality of transformation pertaining to a philosophical, linguistic, perceptual, or artistic issue or problem that few film adaptations addressed; however, it did not presuppose any knowledge of the literary work on the part of the interactor to tackle this problem. Second, subtractive adaptation did not linearize the experience of the literary materials, as early film adaptations did and contemporary adaptations still do for the most part. Rather, their being made using hypermedia potentialities opened up a spatial experience that was not meant to offer only a linear recreation of the original text. It was the negotiation of such creative spaces that CD-ROM artists faced when adapting not only an already available diegesis but also an issue or problem found in the literary texts. This situation reflected the

practice I call "subtractive adaptation," which is one line of creative experimentation that could be found in the art of CD-ROM.

Two main sources of inspiration have shaped my understanding of "subtractive adaptation." First, the distinction between *full* and *limited* animation has influenced the concept of subtractive adaptation proposed to qualify CD-ROM adaptations. Full animation refers to the number of drawings used to animate a sequence. In the case of film, there are twenty-four frames per second that pass in the projector. In the case of animation, if you wanted to reproduce the film effect, you would need to draw twenty-four frames per second of footage. This would turn out to be very time-consuming and expensive, so strategies were implemented to cut down on production costs in a way that would still allow for the creation of quality products. Well-known animated series such as *The Flintstones*, whose repetitive background movement is an example of limited animation, demonstrate how perception is actually challenged when background layers rather than characters move in a given sequence. However, certain animation artists claim that the only legitimate form of animation is full animation because it is about movement rather than stillness, as is supposedly the case with limited animation.

Thomas Lamarre's work on Japanese animation has greatly helped to rehabilitate the notion of limited animation for what it truly is, that is, a legitimate type of animation that cannot be exclusively linked to financial constraints.[20] Lamarre has thus re-examined the notion of limited animation by avoiding the pitfalls associated with the traditional opposition between full and limited animation. Drawing on the work of Japanese critic Mori Takuya, Lamarre does away with the opposition and, inspired by Gilles Deleuze's distinction between the movement- and the time-image in his two-volume study of cinema,[21] argues for a similar approach to the problem of distinguishing between full and limited animation without endowing one term with more positive attributes than the other. Similar to the way in which Deleuze does not claim that the time-image is more sophisticated than the movement-image, Lamarre argues that limited animation adopts a different approach to creating movement and reality effects. This form of animation thus engages an altogether different artistic "problem" or "issue" from that of full animation and should not be considered a lesser form of artistic expression.

Second, "subtractive adaptation" also draws on a recent discussion of contemporary cinema. Indeed, French film scholar Antony Fiant has

proposed to use the notion of "subtractive cinema" [*cinéma soustractif*] to discuss a particular type of contemporary production that has been quite successful on the film festival circuit in recent years. Fiant argues that filmmakers such as Béla Tarr, Wang Bing, Pedro Costa, and Tsai Ming-liang have promoted a singular aesthetics de-emphasizing action-driven scenes and fast-paced montage in order to create a "reduction of the world"[22] using various subtractive strategies such as decreasing the importance of the plot; emphasizing contemplation, slowness, indecision, and elliptical scenes relying on long takes; rarifying speech and privileging muteness; blurring the boundary between fiction and reality; and minimizing the role of narrative. Characters in such films are "given to the contingency of the world";[23] their actions are no longer motivated by their thoughts as much as by the exterior forces that force them to move, think, and feel.

Subtractive cinema has two major impacts on spectators. First, Fiant notes that spectators are somewhat "abandoned" while watching subtractive films; they have to actively reorganize the filmic world that was once explicitly organized in coherent sequences supporting a linear plot development, thereby requiring a higher level of spectatorial engagement. Second, spectatorial identification makes way for contemplative observation in subtractive cinema in a way that shows a certain disregard for the viewing pleasures associated with traditional Hollywoodian spectacle. Subtractive cinema thus reduces every element – including human life – to its bare minimum in its quest to find a certain essence of narrative time, contingency, and necessity and confronts the expectations of viewers in a unique way.

When I compare film adaptation to digital adaptation, I am drawn to adopt a similar critical frame of mind in order to avoid the claim that CD-ROM adaptation was less sophisticated than film adaptation because it was bound to the digital artefact's limited memory (Read-Only Memory [ROM]), or that one could not adapt the complete storylines of Rousseau or Proust due to the interactive medium's inability to tell a coherent story. On the contrary, precisely because it did not wish to tell a story the way a film adaptation did, subtractive adaptation relied on other strategies to offer a compelling experience. One of its strategies was to de-emphasize the importance of characters and cause-and-effect narrative to create interactive *digital heterotopias* (a concept introduced in chapter 2) in which the innovative amalgam of Macromedia Director, the virtual page, the QuickTime screen, and the interactor's input took precedence over the original narrative. Another key strategy in

subtractive adaptation practices was to focus on a problem or issue at the heart of the literary work and elevate it to the rank of prime mover. Subtractive adaptation then became a problem-solving machine that was interested in tackling issues that film adaptation would normally neglect due to the fact that it is invariably caught up in reproducing a story, adapting settings, and emphasizing character development. Therefore, adaptation to CD-ROM tended to limit itself to the number of problems it wished to confront. Interestingly, in the case of the subtractive adaptations under study, such problems pertained to language, communication, perception, and media, namely, problems that were directly related to the fate of the very interactive medium in which they were set.

Similar to Deleuze's, Lamarre's, and Fiant's views on the time-image, limited animation, and subtractive cinema, I do not see film adaptation as the quintessential form of adaptation, but only as the most commercially successful one due to cinema's primordial place in the twentieth century. Subtractive adaptation served a different purpose at the end of the last century: it confronted a problem or issue related to language, communication, media, or culture – such as gender, translation, or memory at the heart of the literary work – and recast it into the singular media environment of CD-ROM by relying on its hypermedia potentialities. Considering that language, communication, technology, and media are full of indeterminate moments, it is fascinating that such a transitory digital medium seized upon these spheres of human creativity to examine them anew. Think of subtractive adaptation as another way of discussing the digital iteration of literary works; as reframing Michel Foucault's notion of heterotopia in the context of digital media relying on the Macromedia Director and QuickTime software; and as being the first type of adaptation requiring user input. In the 1990s, subtractive adaptation practice proposed new artistic and conceptual frameworks for thinking through literary problems and for prolonging the practice of adaptation into the realm of digital media with the help of a new type of image: the object image.

The Object Image

What happens when an image becomes an object to be manipulated? How can an image that merges the temporal unfolding characteristic of cinema and spatial exploration be described? What signals the transition from representing the event to staging the eventual, and, therefore, how

can we account for the gradual shift from representation to simulation in image-making practices? A useful way to answer these questions and set up the analysis of the object images deployed in subtractive adaptations is to turn to Gilles Deleuze's brief musings on the then emerging "electronic image" in the conclusion to *Cinema 2: The Time-Image*.[24] Deleuze's reflections on the passage from the time-image to the electronic image reveal how space, malleability, and programmability, which are key elements in the appreciation of CD-ROM adaptation, had already become important concerns in the mid-1980s. The difference with Deleuze's electronic images is that contemporary object images do not point to the future of cinema – which belongs to the realm of computer-generated imagery (CGI) and 3D – but to the programmed actions found in interactive media arts and digital games. In other words, after the transition from the time-image to the electronic image, it is the transition from the electronic image to the object image that is crucial to retrace, especially the way in which the latter entailed new practices in terms of image making and spectatorship.

The concluding chapter in Deleuze's *Cinema 2* not only sums up the arguments put forth in more than five hundred pages of image typology, but it also engages the future of cinema given the increasing pressure of "electronic images" on fiction filmmaking in the early 1980s. In his reflections, the philosopher hints at a tentative yet highly prescient image type that could be called a "space-image." Deleuze reveals not only a type of image that departs from the time-images he deftly discusses, but also one that creates a rift whereby time ceases to be the crucial concept to make sense of cinema, the quintessential temporal art form. As we will see, just a small step is necessary to go from Deleuze's space-image to the object images found in CD-ROM adaptations.

According to Deleuze, the electronic image would be heir to the time-image, and it is the third type of image on which Deleuze elaborates, albeit very briefly, in the conclusion to *Cinema 2*. What was at stake for Deleuze in the early 1980s was not only the future of the image, but also of cinema itself in an epic battle between the time-image and the electronic image: "It is the time-image which calls on an original regime of images and signs, before electronics spoils it or, in contrast, relaunches it."[25] This confrontation characterizes a state of affairs in which, Deleuze argues, "The life or the afterlife of cinema depends on its internal struggle with informatics."[26] Similar to the way in which Deleuze found in the time-image the seeds for the electronic image and the challenges "informatics" presented, I cannot help but feel that it is in the electronic

image that we can find the seeds for both object images themselves and interactors' ways of manipulating object images in interactive media environments such as CD-ROM.

What is particularly surprising in Deleuze's reflections is the introduction of the long-awaited notion of *space* in his philosophy of cinema.[27] Indeed, discussing the legacy of the time-image, Deleuze's descriptions of the electronic image open the door to new visual configurations that foreground the notion of space. For example, it is the fate of spatial perspective in electronic images to which Deleuze alludes in the following passage: "The organization of space here loses its privileged directions, and first of all the privilege of the vertical which the position of the screen still displays, in favour of an omni-directional space which constantly varies its angles and co-ordinates, to exchange the vertical and the horizontal."[28] His descriptions of the new electronic images denote the manipulation of electronic images, the potential reappropriation, and, ultimately, the becoming-object of images in the hands of programmers and interactors. What emerges from these reflections is the type of image that would have followed the time-image, in what we can imagine as *Cinema 3*, which would have merged temporal unfolding and the interactor's spatial exploration of the image in order to provide the basis for theorizations of the programmable and interactive object image.

Deleuze's emphasis on space is a crucial factor in the transition from the electronic image and the programmable object image because the latter functions as an independent interface to be scanned, touched, and interacted with. Such actions bring to light the spatialization of the image when time becomes subordinated to space in a way that recalls how time subordinated movement in the transition from the movement-image to the time-image in post-World War II cinema, as Deleuze explains in *Cinema 1*. Finally, the last point to make is that this spatialized image, which is called *object image* in this study, would build on movement that is *exterior* to the image itself, that is, it is the interactor who would generate the movement with her actions according to the image's programmed potentialities.

The object image, as implemented in subtractive adaptation practices, was a programmed entity that presented new challenges in the early 1990s. As the latest stage in image-making practices, the object image was part object and part image; it could not be conceived of without assessing its noematic (or phenomenological) aspect, just as it could not be appreciated if it were not linked to the notion of human

action. The object image was a programmed image that the interactor manipulated physically, haptically, and imaginatively in subtractive adaptations. Such manipulations made the object and the image coexist simultaneously in contingent configurations that were predicated on the actions of the interactor who activated the image. The original "will to art" on which Deleuze touches in his reflections on the electronic image was to be found in the object images of media arts that were open to such exterior actions. Envisaged from such a media historical perspective, designing object images amounted to more than creating a programmed entity that would serve as an interface to the textual and audiovisual elements embedded in a given interactive adaptation. The interactor became in charge of the montage of images in a programmed simulation that blurred the boundary between production and reception.

The combined originality of subtractive adaptation practices and the object image's will to art were the result of nothing less than six intertwined elements – data, process, surface, interaction, author, and audience[29] – to which I will constantly return in the following chapters. That is to say, depending on the CD-ROM adaptation under study, I will turn to the data underlying the coded image and what it allowed the interactor to do or not do; the surface of the object image that was explored haptically or not and its representational contents that referred to the literary source; the actions of the interactor who activated the hidden potential of the object image; the artists responsible for the design of such object images and their adaptation strategies in the context of interactive media; and the imagined audience for such adaptations that radically challenged the conventions of film adaptation. These six elements all come into play when assessing the type of object image that resulted from the visual projection of virtual objects in subtractive adaptations.

The notions of subtractive adaptation and object image thus build on CD-ROM's singular artistic, conceptual, and computational frameworks that made it stand apart from analogue media's emphasis on representation. For example, as an interactive medium, CD-ROM presented the interactor with a unique configurative system featuring instances of procedural expressivity that privileged discrete and disconnected data and actions over deterministic representational systems such as narrative arcs. Rather, subtractive adaptation employed strategies of configuration that relied on procedure, simulation, computational processes, and operational logics. In fact, one of the main characteristics of

subtractive adaptation was to be a singular form of simulation located in the gap between the programmed nature of its object images and the interactor's subjective understanding of the issues and problems raised in the adaptation. CD-ROM adaptation, as such a form of interstitial and procedural expression, required that the interactor participate in the design of the adaptation; actually, subtractive adaptation was inconceivable without the input of the person sitting at the computer. It is she who negotiated the design in terms of both the data and embedded processes involved and their potential interplay or conflictual assemblage.

Overview

Chapter 1 travels back in time and offers a retrospective glance at the rise of CD-ROM. Focusing on media materiality and introducing the technical aspects of CD-ROM – its "body" if you will – in the first part of the chapter, I then turn to the challenges CD-ROM faced in the marketplace and the need for truly innovative experiences that soon arose. To contextualize subtractive adaptation in the media arts scene of the 1990s, I provide a rich overview of ROM artworks, electronic literature, installation pieces, and web-based works that were both individually and collaboratively designed. I also discuss the various ROM exhibitions that featured such work at the time. A study of the rhetoric that was used during the period of CD-ROM's ascendency, which was predicated upon "promise," follows the survey and demonstrates the teleological inclinations of many new media critics.

Chapter 2 builds on the historical, technological, and conceptual background provided in the previous chapter and highlights the creative space of CD-ROM. This chapter thus focuses on the spatial environment in which CD-ROM designers and artists created. Digital media were often praised for their open-endedness, multimediality, and hypermediality, and how these functioned as their main assets as media. In order to better understand the interrelations between such attributes, the chapter presents a conceptual and artistic space that I call "digital heterotopia." Drawing on Michel Foucault's brief notes on heterotopias, I adapt the notion in order to make sense of the multiple spaces within the body of CD-ROM: the creative framework that Macromedia Director provided; the book and its interface, the page, in the form of virtual "pages" that could accommodate both text and screen; and the QuickTime software that offered virtual reality (VR) panoramas, sound, and cinema in smaller form and with which were associated the notions of

"database cinema" and "spatio-temporal montage." It is in this media space that CD-ROM's digital heterotopias were to be found, and it is in this type of space that subtractive adaptations unfolded.

In chapters 3 to 6, I close read four artistic CD-ROMs based on literary works, and I underscore how they all implicitly foregrounded a novel type of adaptation practice drawing on a technological, linguistic, or sociocultural issue pertaining to communication, language, perception, performance, translation, or memory. In chapter 3, Jean-Louis Boissier's *Moments de Jean-Jacques Rousseau* sets the stage for a timely re-examination of the logic of the gaze by way of interactive chronophotography, haptic vision, and relation-images in his adaptation of Rousseau's memorable "moments" in the *Confessions*. Chapter 4 engages Zoe Beloff's *Beyond* and its emphasis on the female voice and body in performance. In this chapter, two novels, Villiers de l'Isle-Adam's *Tomorrow's Eve* and Raymond Roussel's *Locus Solus*, create a phantasmatic matrix in which woman as technological medium performs in uncanny scenarios on which Beloff elaborates in her own performances as medium and lecturer. Chapter 5 addresses Adriene Jenik's *Mauve Desert: A CD-ROM Translation* and discusses issues of lesbian desire, performance, and translation in the context of Nicole Brossard's celebrated novel, *Mauve Desert*. A dual-voiced concept of translation as movement between both languages and spaces is key for understanding the work as a form of interactive travel "writing" containing autobiographical and performative self-translations. The final chapter negotiates the encyclopedic spaces of Chris Marker's memory in *Immemory*. Elaborating on Marcel Proust's reflections on photography in *In Search of Lost Time*, Marker's CD-ROM accentuates the importance of space, geography, and "juxtaposing superpositions" in the negotiation of both photographic memories and the configuration of a digitally enhanced *punctum* offering new insights into photographic contingency, digital photography theory, and subtractive adaptation.

Back to the Future: The Rise of CD-ROM

Because of its reliance on popular products such as games, encyclope-
dias, movies, and databases, the emergence of CD-ROM in the 1980s
signalled the arrival of a new digital medium whose commercial poten-
tialities made publishers expect unheard-of profits. In the 1990s, a num-
ber of artists appropriated the very same medium and perceived its
potential for offering interactive experiences that preceding media had
not been able to generate. A plethora of unprecedented opportunities,
both commercial and artistic, were at arm's length, and the multimedia
platform par excellence was full of promise. Two decades later, with
the benefit of hindsight, critical observers are in an excellent position
to examine the sociocultural, commercial, and artistic history of this
digital object.

As mentioned in the Introduction, this book draws inspiration from
a number of critical efforts that have inquired into digital media from
a perspective different from that accompanying the rise of digital mul-
timedia in the 1990s. Recent scholarly work on electronic literature,
digital games, and media arts has revealed compelling facets of digi-
tal media in terms of hardware, software, and artistic practices, and it
has made the case for not only the study of "old new media" but also
for a timely revalorization of historicity.[1] In the case of CD-ROM, the
study of this medium can deliver insights into not only the fate of digi-
tal media in late capitalist societies but also into how preceding sources
and media adapt to and survive in a digital environment. Because crit-
ics have not seriously engaged in detailed studies of CD-ROM art and
technology, they have misconstrued the medium to the point of trans-
forming it into a simple media commodity, thereby tapping into the
market logic of all things digital, which is predicated upon the planned

obsolescence of products in light of the continuous introduction of new digital commodities featuring incremental changes or minor updates. Therefore, it is crucial to consider CD-ROM as a multimedia object, an artistic medium, and a potential source of scholarly debate in a retrospective look at its rise in the 1980s and early 1990s in order to better understand the medium itself and, eventually, its appropriation by artists working with literary materials.

Approaching Digital Multimedia

"Digital multimedia": the very expression used to evoke a number of scenarios. One person would envision the presence of several media on one digital platform, for example, while the next would imagine the new reception strategies that would reunite the traditionally isolated tasks of reading, viewing, and listening. Others would recall Richard Wagner's notion of *Gesamtkunstwerk*, the total work of art that combined text, music, and performance, but this time updated for the digital age and its main form of address, the graphical user interface. Despite these fascinating scenarios and historical vistas, what most observers would probably agree on is that something went wrong with digital multimedia to the point that it has been relegated to the margins of media history, even though it played a crucial role in disseminating the very notion of "multimedia" in the 1990s. What could possibly explain the lack of critical and theoretical interest for the multimedia experience that promised so much and with which we are all familiar?

A preliminary answer could lie in the fact that digital multimedia rose to prominence in so-called "postmodern culture." Reflecting a socio-historical period characterized by the loss of credulity towards metanarratives, as Jean-François Lyotard famously put it at the end of the 1970s, digital multimedia could indeed be conceptualized as the postmodern media par excellence: they are fragmentary due to their hypermedia qualities; they do not generate the deep attention characteristic of print culture and revel in surface attention; and they exemplify the fate of media commodities that are constantly being displaced in a seemingly unending cycle of innovation and obsolescence.

What I would like to propose is that we evade such facile descriptions to explain digital multimedia and, rather, ask what type of socio-historical and art historical account we could offer using digital multimedia as the stepping stone for understanding a key moment in late twentieth-century media arts, technology, and adaptation practice. Therefore, instead of

starting from assumptions about digital multimedia in terms of postmodern ethos, let us try to see what digital media propose as media entities rather than as mere market commodities. CD-ROM functions as an exemplary case of such new media entities, and, because it once embodied the notion of "digital multimedia," it is even more important to turn to it to draw lessons from media history before we set out to examine its pioneering role in digital adaptations.

A first step in approaching CD-ROM's peculiar journey could be to consider its ontological status as a medium, which is a way of raising the ghost of medium specificity in the context of digital media. For example, Lev Manovich has discussed digital multimedia from the point of view of someone interested in establishing qualitative differences between media. With regard to multimedia, he makes the case for distinguishing between a metamedium and multimediality.[2] Whereas the computer would be the first metamedium in media history because it could integrate and simulate all preceding media in a quasi-seamless fashion, multimediality would refer to a preceding media epoch in which separate media coexisted together in one medium, say, CD-ROM, but did not become a hybrid entity because they maintained their singular differences and languages. Multimediality would therefore point to the juxtaposition of different media in one space, but it would not reflect the current-day media ecology in which media tend to combine their languages at the level of materiality to offer a more hybrid product.

A second approach is that of Geoffrey Rockwell and Andrew Mactavish, who provide a different take on digital multimedia by turning to one of its most debated aspects: "A multimedia work is a computer-based rhetorical artifact in which multiple media are integrated into an *interactive* whole."[3] Rockwell and Mactavish do touch on a characteristic that is absent from Manovich's ontology of multimediality: the interactive nature of digital multimedia. Indeed, there is no doubt that any definition of digital multimedia must address a series of characteristics: it has to incorporate the idea that there are at least two media involved; these media must be hyperlinked to other visual, audio, or textual data; and the activities performed are often related to human action, hence the introduction of the controversial notion of "interactivity."

A third approach is the one associated with "media archaeology," which has offered finer-grained histories of forgotten and obsolete media and counter chronological, teleological, and deterministic accounts of media history. By showing the various ruptures, absences, and discontinuities

in our multimedia landscape, the media archaeological work of key figures such as Siegfried Zielinski, Wolfgang Ernst, Erkki Huhtamo, and Jussi Parikka, as well as that of revisionist practitioners such as Lisa Gitelman, has paved the way for a profound rethinking of traditional media studies using Michel Foucault's "archaeology of knowledge"[4] as its starting point.

Gitelman's work is noteworthy in its wish to evade some of the limitations of media archaeology and its overemphasis on informatics, hardware, and storage media. Treating media as "historical subjects," Gitelman's work on early recorded sound, the web, and documents has positioned "new media" as a fruitful object of study beyond the misguided association with all things digital. The premise of Gitelman's work is the fact that all media were once "new," and she derives far-reaching implications from this apparent truism. On the subject of new media ontology, Gitelman notes: "new media are less points of epistemic rupture than they are socially embedded sites for the ongoing negotiation of meaning as such. Comparing and contrasting new media thus stand to offer a view of negotiability in itself – a view, that is, of the contested relations of force that determine the pathways by which new media may eventually become old hat."[5] Gitelman suggests that in her case studies media function as objects of contestation and negotiation, which is to say as both actors and instruments in the yet unwritten history of negotiations between human agents, social sites, and the technology and media embedded in such sites and which make these sites function the way they do in the first place. Reviving actors and forms that had been forgotten, she makes the case for the "unsung and offbeat heroes"[6] in history, which media studies often fails to appreciate.

Though no media archaeological analysis of CD-ROM exists to my knowledge, one could certainly derive certain principles from Gitelman's insights into media in order to shed light on this multimedia entity. While the following pages do not offer a media archaeology of CD-ROM or multimedia in general, Gitelman's emphasis on media as sites of contestation and negotiation, and the reasons explaining why a new medium may become obsolete, are briefly touched upon below. As the Introduction and the first chapter will intimate, certain media archaeological principles, along with recent developments in software studies, platform studies, and media ecology, would make for a rich history of CD-ROM or digital multimedia in general, although this story is not the one this book wishes to tell.

Of course, any study of digital multimedia will have to address the various aspects that Manovich, Rockwell and Mactavish, and Gitelman mention. However, in the following chapters I will emphasize the *artistic* use of digital multimedia in order to show how inquiring into CD-ROM art can open up the types of questions that often remain in the dark in the case of more commercial offerings. Rather than be mired in debates over what constitutes multimediality or not, the levels of human action that constitute true interactivity, or typologies of multimedia forms,[7] my goal is to examine CD-ROM by way of new conceptual tools developed for this unique artistic medium and for digital adaptation practices in particular. I prefer to take advantage of the fact that CD-ROM, as a form of multi- and hypermedia, has gone under the radar in terms of generating debates over the fate of multimedia, and ask what types of theoretical questions this largely unexamined digital artefact can pose. As Rockwell and Mactavish rightly put it: "The study of multimedia as a form of expression has yet to develop a theoretical tradition of its own."[8] In which case, therefore, we should take advantage of its unexamined status to ask new questions. Of course, falling back on ready-made theories to shed light on CD-ROM would be a critical faux pas, and Rockwell and Mactavish deplore the fact that critical theories from other disciplines – literary and film studies being the usual suspects – have been borrowed to make sense of multimedia in a way that does not do justice to its singularities. Rather, I prefer to put the emphasis on how a theory of digital multimedia can vie with other influential theories, and how the digital artefact itself commands its own theoretical, conceptual, and historiographical paradigms.

As we shall see below, most 1990s observers of CD-ROM premised their accounts of the newly arisen digital medium on hypothetical scenarios – what I call "CD-ROM as promise" – and simply ignored what CD-ROMs were actually about in their then current state. This in turn may have led commentators to ignore the practice of subtractive adaptation. Concluding their introduction to multimedia, Randall Packer and Ken Jordan make an interesting remark: "Just as movies have been based on novels since the silent era, we are seeing multimedia adaptations of classic works, some of which may one day become classics themselves."[9] Again, trying to evade hypothetical scenarios, what these critics point to is the notion of canonization and, in fact, the recanonization of certain literary works in the hands of media artists who used digital multimedia to offer a type of adaptation that was different from film adaptation.

Media Materiality and Market Economy

This study's approach to digital multimedia differs from those adopted in a series of representative publications on CD-ROM drawing on the reflections found in the business press, game studies, and digital museum studies. Such publications embraced a number of positions to frame the multimedia problem in its first years, and they can be categorized as follows. The first position, premised on hope, advanced that CD-ROM held great promise for the future, but somewhat failed to deliver the goods in the present. As Gillian Newson and Eric Brown put it in the late 1990s: "For most of us, CD-ROM publishing failed to live up to its promise, and now the cracks are beginning to show in the online industry."[10] A second position, more critical in nature, decried the claims to interactivity and multimedia as a new type of experience. In other words, this approach denied digital multimedia's claim to radical innovation. A third approach deplored the lack of compatibility between old CD-ROMs and newer operating systems and media, and it suggested that the Internet had solved all compatibility problems, thereby relegating CD-ROM to a simple footnote in media history. A fourth position claimed that digital multimedia qua interactive device signified a regression of thought to a mechanistic and instrumental understanding of human cognition. Finally, some argued that CD-ROMs failed to activate their true built-in multi- and hypermedia potential, merely duplicating the book's or film's way of presenting narrative and characters. Simply put, this argument centred on multimedia designers' lack of understanding of their medium's true potential. With the rise of the Internet, smartphones, and social media, the democratizing potential of such media has been noted by many scholars such as Caroline Bassett, who has reflected on the limitations of the one-way interaction characteristic of the CD-ROM experience that have become even more apparent than they were when critics first reflected on the medium in the 1990s.[11] I will time and again attend to such criticisms, but only insofar as they can set the stage for a different understanding of CD-ROM and digital adaptation.

Let us begin with a simple question: what was CD-ROM? What could we possibly learn from a study of CD-ROM that would not be imbued with nostalgia for old media, or that would revel in deterministic claims to the effect that DVDs and the Internet have displaced CD-ROM and that, therefore, we should have moved on? Terry Harpold makes a memorable remark on the subject of old new media and their potential

relevance today: "Nostalgic and counter-nostalgic responses to 1990s literary hypertexts alike stress their historical importance, but without accounting fully for their critical-theoretical *persistence*. The most obvious risk in this is that these texts will thus appear to be of interest only to the literary historian, or, worse, relics of the digiterati's *Wunderkammer*, belonging there with other *disjecta membra* of an era before Flash and the iPhone set us free."[12] Bearing Harpold's comment in mind, at this stage it is useful to retrace CD-ROM's journey in the 1980s and early 1990s and place its rise and fall within their proper material and commercial contexts.

Before being seized upon by media artists, the disc format was associated with the music industry (the audio disc) and the film industry (films and operas on videodisc). While the audio disc still generates a fair share of the music industry's revenues (although many claim its days are numbered), the videodisc is now a thing of the past that collectors still want to acquire but whose present commercial share is close to none. Even though it is not my intention to delve extensively into the history and marketing strategies of the disc platforms, it is nevertheless important to stress that CD-ROM stemmed from both the analogue videodisc and the digital compact disc, thereby marking its kinship as technologically dual. Indeed, the first thing that someone with absolutely no knowledge of CD-ROM would notice is that it was identical in appearance to the ubiquitous audio CD.[13]

CD-ROM was one of the descendants of the compact disc that Phillips invented in 1978. In more technical terms, CD-ROM was a plastically coated twelve-centimeter diameter digital artefact possessing four layers. It could store information files (texts, documents, catalogues), visual data (still or moving images), and audio information (soundtracks). It was a compact disc that contained a "Read-Only Memory (ROM)"; that is, the computer could read the information inscribed on the disc, but data could not be inscribed, erased, or edited.[14] As opposed to "Random Access Memory (RAM)," which can be rewritten, CD-ROM's constituents were static. CD-ROM used the same laser scanning technology and replication and mastering procedures as the audio compact disc. Upon activation, a red laser beam would read the data contained on the compact disc, and the pits etched on this disc that could contain approximately 650 megabytes of data gave indications that the computer translated into binary code. This information was moulded onto one surface in spiral tracks that would be read by the laser beam once it had been inserted in the computer's ROM drive. CD-ROM's successor,

DVD-ROM (Digital Versatile Disc-Read-Only Memory), used the same reading technology and was equally closed to new information or updates. The major difference, however, was DVD-ROM's enhanced capabilities as a storage medium. Compared to CD-ROM's 650 megabytes of data, the single-sided and layered DVD-ROM's 4.7 gigabytes were a welcome improvement in 1996, and they provided new opportunities for designers and artists, the most appreciated being the possibility of including larger visual files.[15]

Philips and Sony set the data format standard for CD-ROM in the 1983 Yellow Book. Four years later, twelve of the biggest computer companies adopted the ISO 9660 (High Sierra) standard, which concerned common internal file structures. This standard would allow cross-platform compatibility between PC, Macintosh, and Unix users. Other standards such as the Hierarchal File System (Macintosh) and Hybrid HFS-ISO would also be used to define directory and file structures. In the early 1990s, an agreement between some of the world's leading computer companies (including Microsoft and Philips) set the stage for the Multimedia PC standard in October 1991, which was designed for an Intel 286 processor. The format had a huge impact: "The standard gave software developers clarity about the kind of hardware they could expect on CD-equipped home PCs and, in turn, gave hardware manufacturers the confidence to mass produce equipment such as CD-ROM drives in volumes large enough to bring down the cost significantly."[16]

The research and development activities of Philips and Sony, combined with the Microsoft-sponsored conference dedicated to CD-ROM and its proceedings, *CD-ROM: The New Papyrus*, paved the way for the emergence of a new medium that would redefine the way information would be stored and delivered. Unlike the audio disc, however, hardware moguls initially destined CD-ROM to hit the computer user market. In comparison to the music market, CD-ROM demanded more media-literate buyers; the personal computer had just made its entrance, and CD-ROMs required loading expertise that few home computer users had in the mid-1980s. Added to the prohibitive cost of a personal computer, CD-ROMs would have to wait a few years before becoming pervasive. Of course, where computer implementation was already thriving and users were already familiar with computer technology, CD-ROMs fared better: "This translate[d] into professional information users – predominantly public and corporate librarians, academics and, slowly at first but gathering pace, managers in corporations with direct access to PCs."[17]

The main problem for CD-ROM designers was to reach the home computer market. Facing few potential buyers who had access to the then expensive CD-ROM drives, the industry butted against the perspective of developing, marketing, and distributing a product that would remain on the shelves. At the same time, desktop computer users were reluctant to purchase an expensive CD-ROM drive whose future use would be limited to the few CD-ROMs already published. The first CD-ROMs were high-priced objects that appealed to academics, librarians, and researchers whose institutional funding allowed the purchase of such products. Often coming in the form of databases or updated versions of pre-existing databases, early CD-ROMs reflected the image of a stillborn business.

In hindsight, the major obstacle was to solve the conundrum of the missing buyers of missing products. If personal access to cheap hardware was preventing the rise of the CD-ROM home market, why not focus on the initial problem of access to CD-ROM drives and then develop CD-ROM titles that would appeal to desktop computer users? Once the home computer, equipped with a CD-ROM drive, had become a pervasive home device, it was thought that the CD-ROM market would finally become lucrative. In the end, what is important to remember regarding CD-ROM's commercial journey is that, as Tony Feldman has noted, "an entertainment product [the audio disc] was evolved into a professional product [the database] which in turn was to be evolved into an entertainment product [the CD-ROM] again."[18]

This new entertainment product faced another problem: how would readers, viewers, and gamers react when presented with a device that promised unheard of interactive experiences that the new medium failed to deliver at reasonable speed? In other words, how did the issue of speed affect the rise of CD-ROM as a new technological domain to be appropriated by media-literate individuals? Because it did come down to a hardware problem: how could the laser beam increase its speed in locating data on a CD-ROM? Even though certain CD-ROMs such as the virtual museum tour required a lesser degree of responsiveness than others such as the CD-ROM game, the interactive experience clearly faced the problem of shortening the interval that was created between inactivity, activation, and onscreen response. Insofar as multimedia's and interactivity's raisons d'être lay in fostering a responsive environment that combined more than one medium, designers could not rest content with the various temporal gaps that invariably characterized the CD-ROM experience. Therefore, I would disagree with Feldman

when he points out that "the commercial success of the consumer CD-ROM market rest[ed] on how well the video [wa]s synthetised along with all the other elements of multimedia content to produce a product that satisfie[d] its market."[19] On the contrary, the problem did not concern synthesis or immediacy; the problem lay in content delivery and responsiveness. Here the CD-ROM experience revealed one of the major problems with emerging digital media and their modes of delivery: the manner in which intensity and affect have trouble migrating from medium to medium and, especially in the context of consumers bred on a multitude of media that had no difficulty delivering the goods, the unavoidable comparisons stemming from unrewarding experiences that mostly resulted from market-driven approaches to technological design rather than creatively conceived journeys in a new medium. If CD-ROM were to succeed, it would have to find a different path.

The road to commercial success is a winding one though. The home computer market did find a way to capitalize on the increasing number of the then recent de facto CD-ROM drives in personal computers. As American and European figures demonstrate, between 1993 and 1995, a commercial growth of close to 800% marked the rise of CD-ROM in the household.[20] CD-ROM seemed to have made it. However, as commentators noted at the time, the ubiquitous presence of CD-ROM drives in computers did not directly imply that consumers would go out and buy CD-ROM titles. It was certainly an incentive to include the hardware, but it did not necessarily result in a significant sales increase.

ROM Art and Beyond

The preceding paragraphs about CD-ROM's rise and fall drastically depart from the unbridled enthusiasm of the mid-1980s that led some observers to claim that "CD ROM [sic] is a revolutionary information storage medium, much as was papyrus when it replaced stone, clay, and wood as surfaces on which early Egyptians recorded significant events in their lives."[21] What such a diagnosis failed to grasp, despite its revolutionary flair, is that a closer examination of what certain CD-ROMs actually did that was not found in other media environments should have been the key item on the agenda. This scrutiny would not have had to refer to a commercially driven goal. In fact, it could have revealed a previously unnoticed player whose resources would help to reconsider how the history of digital multimedia could be envisaged. Enter the artistic CD-ROM.

It is noteworthy that commentators who predicted the death of the CD-ROM industry all claimed, sooner or later, that artists should have been involved in CD-ROM design in order to save the market, or at least to create more compelling experiences than the ones already available in commercial offerings. Echoing this concern back in 1996, new media artist Simon Biggs made the provocative comment that "CD-ROM and the Internet are relatively new, at least for artists, and it is clear that there is conspicuous lack of 'artware.'"[22] This diagnosis pointed to two interrelated issues at the heart of the present study: first, the then current state of technology did not allow for the development of a creative practice that would be deemed "art" and with which a community of creators would be associated, and second, the provocative claim that artists would have to appropriate the medium if it were to become successful. As the following chapters will show, the most interesting response came from a community of media artists who appropriated CD-ROM to develop a new form of creative practice.

Numerous artistic CD-ROMs appeared in the wake of Biggs's comment.[23] Designed by computer scientists, filmmakers, musicians, designers, or graduate students, these artistic CD-ROMs could be divided into four types: the collected works of an artist; an original creation specifically made for the CD-ROM platform; a work designed for a group exhibition showcasing several pieces; and the adaptation of a previously created piece for another media environment (e.g., an installation piece adapted to CD-ROM).[24] Funding for such artistic CD-ROMs came from two sources. The first source was money available through institutional grants, while the second source was an artist's personal funds. There was cross-pollination between these two sources, of course, as artists may have held a grant from an institutional body, invested personal funds, and had recourse to the programming and designing skills of others.

A number of institutional initiatives allowed the creation of CD-ROMs whose primary destination was neither the retail store nor the museum shop. Less well known than the ones in the more commercial categories, the artistic CD-ROM could be likened to the artist's book in that it was a personal work destined for few "readers." Moreover, as Erkki Huhtamo describes it, the artistic CD-ROM was a distinct digital artefact that could be identified using at least three criteria: "they [CD-ROM artworks] stand out from the mainstream, explore the potential of the medium, [and] don't serve a practical (sales) function, at least as their primary concern."[25] Writing in the late 1990s, Sean Cubitt further

elaborated on the singularities of CD-ROM art by comparing it to net art to emphasize the superiority of the former: "CD-ROM artists can engage a far subtler interface than much of the transient work on the net, which is dependent on time-consuming and unpredictable downloads. CD-ROM allows the bandwidth and the leisure to develop far more complex and occasionally more traditional works."[26]

Patrick Pognant and Claire Scholl's discussion of a subfield of CD-ROM publishing concerned with "cultural CD-ROMs," that is, "titles that address the artistic, economic, scientific, tourist, sociological, and media aspects of our civilization,"[27] is indicative of the role media artists would come to play in the development of CD-ROM art. What "cultural CD-ROMs" failed to achieve, according to the authors, was their "own mode of expression."[28] The last affirmation begs the following questions: What could possibly be CD-ROM's idiosyncratic mode of expression? Was it to be found in the remediation of the book's page, in the recreation of cinema's screen, or in some other weird undefined hypermedia assemblage? The authors tentatively answered these questions, referring to a "new writing to be invented," and cited as an example of creative CD-ROM design Laurie Anderson's *Puppet Motel* (1995) and praised its "delirious interactive narration."[29] Mentioning Anderson's landmark CD-ROM supports the claim that artists did need to get involved in order for CD-ROM to reach the next stage as a creative medium.

In the 1980s and 1990s, the New York-based Voyager Company, the first commercial publisher of CD-ROMs, greatly contributed to the dissemination of the digital medium and paved the way for the "new writing" Pognant and Scholl envisioned.[30] Voyager CD-ROMs were packaged in a colourful box and designed to deliver the multimedia experience one expected of such cutting-edge products. Voyager was responsible for publishing one of the first artistic CD-ROMs: Mexican American photographer Pedro Meyer's *I Photograph to Remember / Fotografío para recordar* (1991). Capitalizing on bestselling titles such as The Beatles' *A Hard Day's Night* on CD-ROM, the company was headed for great success in the early 1990s. A very successful offering was *Poetry in Motion* (1992), which expanded on the Ron Mann documentary of the same name and showcased the capabilities of the database for random access. Initially destined to publish movies on laserdiscs, Voyager soon turned to digital books. Voyager's "Expanded Books" series included Michael Crichton's *Jurassic Park*, for example, or stand-alone titles such as *Macbeth* (1994), Art Spiegelman's *The Complete Maus* (1994), *Kon-Tiki*

Interactive: The Life & Work of Explorer Thor Heyerdahl (1996), and *Sacred and Secular: The Aerial Photography of Marilyn Bridges* (1996). The aforementioned titles are just a few CD-ROMs the Voyager Company published during these busy years before going out of business.

With regard to publishing houses and museums, the multimedia potential of CD-ROM was recognized at an early stage by the Zentrum für Kunstmedien (ZKM) in Karlsruhe, Germany, which published the "Digital Arts Edition" series in the 1990s. This series featured titles such as Tamás Waliczky's *Focusing*, Dennis Del Favero's *Cross Currents*, and Masaki Fujihata's *Small Fish: Kammermusik mit Bildern für Computer und Spieler*. While the first two titles offered CD-ROM versions of preexisting installations, Fujihata's work was specifically created for the CD-ROM environment. ZKM also published pioneering titles such as *William Forsythe: Improvisation Technologies* (2003), a dance tutorial that is still used by dance companies worldwide, and the compilation of five CD-ROMs onto one DVD-ROM, *The Complete artintact*, vols.1–5, 1994–1999. This retrospective featured the work of well-known media artists such as Bill Seaman, Luc Courchesne, Ken Feingold, George Legrady, and Agnes Hegedüs and constituted a virtual museum of media arts projects.

A number of other institutions and publishers contributed to the dissemination of CD-ROMs exploring the potential of the medium for artistic purposes. In 1997, Marsha Kinder founded The Labyrinth Project, a research initiative on database narrative located in the University of Southern California's Annenberg Center for Communication, which produced a series of database documentaries, CD-ROMs, DVD-ROMs, museum installations, and websites.[31] An initiative under the sign of collaboration between academics, media artists, designers, and filmmakers, the list of Labyrinth ROM works includes Nina Menkes's *The Crazy Bloody Female Center* (2000); *Mysteries and Desire: Searching the Worlds of John Rechy* (2000), a closer look at the life and work of fiction writer John Rechy; Yuri Tsivian's (in collaboration with Barry Schneider) *Immaterial Bodies: Cultural Anatomy of Early Russian Films* (2000), which won the 2001 award for best interactive learning project from the British Academy of Film and Television Arts; and Norman Klein's *Bleeding Through: Layers of Los Angeles, 1920–1986* (2003), a richly layered work itself loosely drawing on Klein's book *The History of Forgetting: Los Angeles and the Erasure of Memory* and made in collaboration with ZKM in tandem with interface designers and programmers Rosemary Comella and Andreas Kratky, among other pioneering achievements.

Various publishing initiatives in France also left their mark. Publishing houses Gallimard, Seuil, Hachette, and Flammarion had divisions that specifically focused on CD-ROM art, and they published Laurie Anderson's *Puppet Motel* (1995), Serge Bilous, Fabien Lagny, and Bruno Piacenza's *18:39* (1997), Defoe's *Robinson Crusoë* (1997), Jostein Gaarder's *Le monde de Sophie* (1997), Jules Verne's *Les voyages extraordinaires* (1998), and Jean-Louis Boissier's *Moments de Jean-Jacques Rousseau* (2000). Another significant project is French critic Anne-Marie Duguet's "ANARCHIVE: Digital Archives on Contemporary Art," which is a series of five ROM works published with the collaboration of various North American and European cultural institutions. These digital oeuvres archive both selected works by the artists and new pieces specifically designed for the Anarchive project. As of this writing, the series features the work of media artists Antoni Muntadas, Michael Snow, Thierry Kuntzel, Jean Otth, Fujiko Nakaya, and Masaki Fujihata.[32]

While the preceding titles were produced under institutional supervision, there are several artistic CD-ROMs that functioned as individual efforts at singling out the creative potential of the medium. Music legend Peter Gabriel's *Xplora 1* (1994), George Legrady and Rosemary Comella's *An Anecdoted Archive from the Cold War* (1994), Miroslaw Rogala's *Lovers Leap* (1995), Perry Hoberman's *The Sub-Division of the Electric Light* (1996), Graham Harwood's *Rehearsal of Memory* (1997), Reginald Woolery's *world wide web/million man march world wide web (www/mmm)* (1997), Norie Neumark's *A Shock in the Ear* (1998), Suzanne Treister's *… No Other Symptoms: Time Travelling with Rosalind Brodsky* (1999), Simon Biggs's *The Great Wall of China* (1999), Keith Piper's *Relocating the Remains* (1999), Tony Oursler's *Fantastic Prayers* (2000), and Tom Drahos's ROM adaptations of literary works by Gogol, Chateaubriand, Baudelaire, Rimbaud, Kafka, and Defoe, among others, are just a few digital multimedia artworks that are considered landmarks in the field.[33]

During the same time as Voyager was publishing its CD-ROMs, Eastgate Systems' proprietary Storyspace authoring program supported the creation of hypermedia fictions such as Michael Joyce's *afternoon, a story* (1987/1990), Stuart Multhrop's *Victory Garden* (1995), and Shelley Jackson's *Patchwork Girl* (1995), which were developed in parallel to the nascent CD-ROM experience in the early to mid-1990s. These foundational works in the field of hypertext fiction and electronic literature were distributed as diskettes, discs, and CDs for Macintosh and PC. In hindsight, what characterizes such interactive fictions, beyond the pioneering hypermedia experiences they offered, is the fact that they have

been the objects of sustained studies, as opposed to art CD-ROMs.[34] Around 1995, the development of the Internet and web browsers signalled a shift from the link-based lexia fictions mentioned above to the more multimedia interfaces that would come to characterize the Internet and on which media artists would capitalize. The move away from these early hypertext practices could be seen in Michael Joyce's *Twelve Blue* (2000), Talan Memmott's *Lexia to Perplexia* (2000), and Judd Morrissey and Lori Talley's *The Jew's Daughter* (2000). Needless to say, this growing body of electronic literature using networked and programmable media did away with the limitations of ROM art.

At the same time as Voyager and Eastgate were capitalizing on the hypermedia functions of the new CD-ROM platform, video games entered the digital age with the release of *Myst* (Brøderbund, 1993), the first CD-ROM game for PC.[35] Profoundly indebted to print culture and its main interfaces, the book and the page, the contemplative experience *Myst* offered was unique at a time when console gaming was mostly predicated on the fast-paced excitement of the Sega Genesis and *Sonic the Hedgehog* (Sega, 1993). Another CD-ROM-based game such as Trilobyte's *The 7th Guest* (1993) would capitalize on the new digital medium, but would ultimately fail to offer a convincing gameplay experience, in part because of its overreliance on film conventions.

Aside from the subtractive adaptations analysed in the following chapters, there are several noteworthy online adaptations that should be mentioned to complete this overview of the media arts scene. Websites such as Mouchette.org, which is based on the Robert Bresson 1967 film of the same name; Andrea Zapp's *Last Entry, 1st of July*, which adapts Virginia Woolf's *Orlando*; John Cayley's numerous subtractive adaptations: the navigable text movie *riverIsland* (based on several of Wang Wei's "Wang River" poems), *noth'rs*, a series of nodal texts and transliteral morphs (based on texts by Proust, Genet, Woolf, and Li Ruzhen), and *Where the Sea Stands Still*, a performance hypertext based on the Yang Lian poem of the same name; Dariusz Nova-Nowak's web-based *Dante Project*; the Internet digital travelogue *H/u/m/b/o/t* (based on Humboldt's *Personal Narrative of a Journey to the Equinoctial Regions of the New Continent* [1799–1804]); and Shmuel ben Yitzhak's digital paintings, which adapt some of Paul Celan's poems, are only a few of examples of subtractive adaptation practice that could be found on the Internet.

Various interactive installations were also based on print sources and films. One of the earliest pieces was Grahame Weinbren and Roberta Friedman's *The Erl King* (1983–86), which was based on Goethe's

"Erlkönig" poem and the "Burning Child" dream analysed in Freud's *The Interpretation of Dreams*. Weinbren continued to explore the potential of interactive cinema with *Sonata* (1991/1993), which used Beethoven's Violin Sonata No.9, Op. 47 "Kreutzer," the biblical tale of Judith, and Tolstoy's *Kreutzer Sonata* novella. Drawing on Franz Kafka and Jean-Jacques Rousseau, there were Simon Biggs's *The Castle* (1995) installation, based on Kafka's novel of the same name, and Jean-Louis Boissier's installations based Rousseau's writings: *Flora Petrinsularis* (1993), *La Deuxième promenade* (1998), and *La Morale sensitive* (1999–2001). Finally, Luc Courchesne's *The Visitor: Living by Numbers,* which adapted Pier Paolo Pasolini's 1968 film *Teorema*, provided a stunning example of what could be achieved in terms of panoramic installations.

The preceding overview of the ROM art scene and subtractive adaptations may have given the impression that I have overlooked the collaborative nature of the medium and, therefore, blindly support an elitist *politics of the auteur* for the digital age.[36] The aforementioned works made with institutional support were collaborative in nature, and it is clear that such collaboration enabled forms of creation and experimentation that are quite valuable. For example, the "production value" and the overall polished "feel" of the ROM works made under the aegis of the Labyrinth Project or ANARCHIVE do not find their equivalent in individual creations. More importantly, collaboration between writers, designers, and media artists allowed for the production of experimental work that greatly benefited from the various fields of expertise of each contributor. Such productions invariably showed the way to go beyond the more commercial offerings that were not meant to explore the artistic potential of the medium. Such works have thus presented other valuable aspects pertaining to creation, experimentation, and education in the form of, say, the desire to prolong the tradition of expanded cinema in a different setting – one that privileged the personal computer.

CD-ROM as Promise

It will come as no surprise that, in light of such diverse and challenging CD-ROMs as the ones mentioned above, astute observers of the digital arts scene soon perceived CD-ROM's unprecedented potential as an artistic medium and wished to share their enthusiasm for this multimedia platform. Indeed, over a period of six years, five important exhibitions about the ROM medium gave it more enlightened exposure than it had ever received. In 1996, the exhibition "Burning the

Interface: International Artists' CD-ROM," curated by Mike Leggett at the Museum of Contemporary Art in Sydney, Australia, featured more than one hundred artistic CD-ROMs.[37] Supported by the catalogue essays' introductory comments, the exhibition drew the attention of the art world to this unexplored area in media arts. Two years later, in 1998, the École des beaux-arts in Rennes, France held "<Compacts>," a CD-ROM art exhibition featuring the work of artists such as Zoe Beloff, Graham Harwood, Chris Marker, and Perry Hoberman. In 1999, Timothy Murray curated "Contact Zones: The Art of CD-ROM" at Cornell University in Ithaca, New York. This exhibition covered the vast panorama of CD-ROM art and bridged the gap between the critical attention given to this art form compared to other off- and online media arts. It featured over eighty CD-ROMs from twenty countries.[38] Also in 1999, Marsha Kinder and Holly Willis curated the "Interactive Frictions" exhibition, sponsored by The Labyrinth Project and held at USC's Fisher Gallery, which featured ROM works by a selection of prominent practitioners.[39] Finally, in 2002, ZKM's wide-ranging exhibition, "Future Cinema: The Cinematic Imaginary after Film," curated by Jeffrey Shaw and Peter Weibel, provided a broad media history for its forward-looking projects.[40] It goes without saying that the artists, curators, and scholars involved in these five exhibitions cast favourable light on the practice of ROM art. Their curatorial statements and essays did a pioneering job of introducing, contextualizing, and disseminating a then nascent art form that had not received sustained critical attention.

Beyond such curatorial voices, what merits closer attention is the more scholarly discourse that framed ROM art, as it adopted an ambiguous rhetoric that did not eschew prophetic and teleological claims. As I will go on to show, teleological remarks and utopian perspectives characterized the late 1990s scholarly discourse and accompanied the pessimistic commercial scenarios discussed above. It is worth dwelling on these efforts to further contextualize the failed reception of CD-ROM art and technology in the 1990s and set the stage for the new approach to CD-ROM introduced in this study.

The initial response to CD-ROM came in the form of promise. Apparently, CD-ROM's existence in the present was justified only insofar as it had a future to rely on. As Douglas Kahn put it, the artist designing a CD-ROM was forced to enter "into a world of promise."[41] Even though Kahn did celebrate the bravura and passion of the artists working with the CD-ROM platform, he nevertheless used a rhetoric of impending

breakthrough that did not disclose how CD-ROM art was an important media venture in the present: "Indeed, it looks like some future will happen. But the future of art within this scheme of things is open to question, especially the way the future feeds into now."[42] A key concern is to understand why it was practically impossible to discuss CD-ROM without having recourse to hypothetical scenarios that constantly denied this art form's singularities in the 1990s. For instance, the fact that CD-ROM's alleged slowness (again, compared to cinema, television, or digital games) seemed to be a problem for some commentators did not mean that it was a problem in and of itself. After all, few would complain of a sculpture or a painting not delivering its "contents" fast enough. Some might counterargue that sculpture and painting are not time-based art forms; they do not have to take us on a narrative ride, so to speak. But then again neither did CD-ROM.

The preceding answer to such a counterargument directly plays into what I will attempt to show in the following chapters: CD-ROM's "slowness" and "deficient interactive process" signalled the hybrid nature of this medium that built on the book and the film to experiment with various reception strategies that were rarely combined, thereby creating the impression that it was a flawed medium. This would partly explain a comment such as Kahn's to the effect that CD-ROMs "have the promise for an elaborate coordination of disparate elements that would outstrip present-day pastiche because they can cull from a wider array of technical possibilities. More importantly, speed is only an emblematic demonstration of the complexity with which the coordination may occur."[43] On the one hand, speed was not to be praised because it did not explain or justify CD-ROM's complex operations. On the other hand, this issue was relevant only insofar as CD-ROM held the promise for coordinating disparate media elements. The problem with such an account is that it rejected CD-ROM art in its then actual form to praise a hypothetical transition. As Kahn summed up the situation: "The rest lies in the promise of CD-ROMs as a *transitional* medium."[44] The problem did not lie with transition per se, but with the notion of promise itself and the critical inability to appreciate present achievements. Even though the critic claimed that "the transitional [did not have to] necessarily transport us to a predetermined locale,"[45] the problem with this formulation was the imposition of transition as *unavoidable evolution* to make CD-ROM art worthwhile.

Furthermore, media transitions not only concerned technology itself but also the activities and practices of interactors themselves. Indeed, CD-ROM technology was often praised for its potential achievements,

as seen above, and it was also celebrated for its ability to connect technology and subjectivity in a different way. In the field of new media studies, this translated into more sustained research in the late 1990s when critics thought they were approaching CD-ROM productions for what they really were, thereby rejecting claims to the effect that CD-ROM was in its infancy. For example, Greg Smith, in his introduction to a path-breaking collection on CD-ROM published in 1999, rightly stated that "multimedia and CD-ROMs are *actual* media and are no longer merely *potential* media. We need no longer spend the bulk of our time speculating on what forms these media will take, since interesting examples now exist. We should recognize that there are complex CD-ROMs out there that are just as worthy of analysis as films or literary texts."[46] I certainly concur with Smith's assertion, and this book testifies to the existence of challenging CD-ROM artworks. Moreover, as Smith mentioned on numerous occasions, a sense of the rewards of CD-ROM art could be had only by grounding critical assessments in actual works instead of in future, hypothetical achievements.

Yet, while I find Smith's wish to go beyond teleological designs praiseworthy, I cannot help but wonder why the notion of promise nevertheless returned in his account. After all, the very title of the collection draws our attention to "the promises of a new technology," and on several occasions in his introduction Smith justified spending time on CD-ROMs as a way of relating the unsatisfying present to the more rewarding future: "I argue that close attention to encounters with such early texts [i.e., CD-ROMs] can yield invaluable hints of what is to come. Since the future is an outgrowth of the present, particular attention to present multimedia can give much more insight into the future than broad prognostications about the medium's potential. My hope is that by engaging in criticism of current multimedia texts, media scholars can help define the future of these new media."[47] The problem with this line of reasoning, and it does recall Kahn's line of thinking, is that the study of CD-ROM necessarily had to be tied to future progress that concerned either upcoming technological improvements or future critical treatments. CD-ROMs were not worthy of critical attention in the present; only their impending obsolescence justified paying attention to them in the 1990s.

An alternative to such a critical view was found in Timothy Murray's curatorial statement for "Contact Zones: The Art of CD-ROM," the exhibition he curated at Cornell in 1999. Murray astutely put the emphasis on what artistic CD-ROMs allowed to rediscover in some sort of media archaeology *avant la lettre*, pointing to forgotten technologies

and socio-historical tensions that had often been erased. His curatorial justifications echoed the theoretical orientation adopted in the following chapters: "And rather than position themselves as privileged prophets of the future, the avant-garde, many artists working within the new media confront the reality that what once was thought to be the electronic future is the enigmatic NOW."[48] Discarding the possibility that CD-ROM and digital media in general would point to some sort of vague future in which technological and social tensions would be resolved, Murray pointed to CD-ROM artists' turn to the past to unearth and reconceptualize what had been forgotten in our collective obsession with the future and technological progress: "One result is a refined relation to both the past as something not simply understood and regressive, to be cut off or cast aside for the sake of avant-garde progress, but rather something wonderfully cryptic, if not also deeply troubling and traumatic, to be brought into dialogue with the present for the sake of shaping personal, political, and social paradigms that might help form the rapid extensions of the technofuture."[49]

Finally, the crux is to understand how the hybrid nature of digital multimedia, allowing various forms of montage, appropriation, assemblage, interaction, and juxtaposition that can coexist on one platform, could offer a different artistic experience in what Murray appropriately called "the interactive deterritorialization of narrative form and readerly confidence."[50] As the titles of some of the Cornell exhibition's fourteen conceptual pods indicated, narrative did not have to be primordial. Theoretical and conceptual markers such as "Archive Fever," "Baroque Interface," "Bodies without Organs," "Cinematic Specters," "Hypertextures," "Memory Errors," and "Virtual Metropolis" invariably pointed to an undeniable indebtedness to critical theory and continental philosophy, but, more importantly, they showed how narrative often played a small role in terms of media materiality and design. In fact, they were more in line with what Michael Nitsche, in his study of video game spaces and tridimensional worlds, has called "suggestive markings" and "evocative narrative elements"[51] rather than fully-fledged narratives that call back to mind the narratives found in novels or films. In other words, for CD-ROM and digital adaptation in general, what indeed counted was the "deterritorialization of narrative" in favouring subtractive strategies such as reference, suggestion, evocation, and allusion rather than complete narrative arcs. Let us turn to the type of space that welcomed such practices and define its properties.

In the Realm of Digital Heterotopias: Exploring CD-ROM Space

In this chapter, I am interested in further qualifying CD-ROM space, which is to say that I wish to shed light on CD-ROM and its memory space beyond the claims to narrative integration and media obsolescence that accompanied its rise. Drawing on Michel Foucault's wide-ranging reflections on "different spaces," I examine how his concept of heterotopia could be adopted in adaptation studies to shed light on a medium such as CD-ROM. Of course, the need to inflect the concept of heterotopia will soon become apparent to make sense of computer-related objects, and I will do so by temporarily shifting the emphasis from a human-centred approach to digital media based on interactivity to an object-based understanding of the digital artefact under study. Zeroing in on the notion of space in assessing CD-ROM will be important in order to go beyond time-based understandings of this medium relying on the promises of narrative integration. Understanding the internal creative architecture of CD-ROM must precede the analysis of users' actions because said actions are predicated on both the software and virtual space that enfold them. In the case of CD-ROM, Macromedia Director and QuickTime will be the software studied in this chapter.

In digital culture, the notion of heterotopia points to both the plethora of spaces that can be found in a single digital object in terms of ontological differences and the object's ambiguous nature, which stems from the confrontation between temporal and spatial elements in a medium such as CD-ROM. The proposed concept of "digital heterotopia" will help to make sense of these different creative spaces CD-ROM offered artists. There are three defining aspects to CD-ROM space that are worth examining: the constraints provided by the authoring system, Macromedia Director, which was the most popular CD-ROM authoring

software used in the 1990s; the impact of the book medium in the form of both the artist's book and the book's interface, the page; and, finally, the legacy of cinema in Apple's QuickTime to assess how CD-ROM space was pressured by the presence of film, a time-based art, in miniaturized form in the very process of creating a spatially oriented new visual experience, that is, database cinema. These three crucial players, Macromedia Director, the book medium, and QuickTime, defined CD-ROM art and the digital heterotopias that artists offered via their object images and subtractive adaptations. I am therefore interested in exploring the potential afterlife of Foucault's concept in adaptation studies and software studies and proposing a very malleable conceptual tool with which to accommodate the great variety of design strategies and experiences that CD-ROM and digital adaptation practices offered in the 1990s.

Digital Heterotopias

In a 1967 lecture published posthumously in 1984, Michel Foucault addresses peculiar spaces called "heterotopias." The combination of the Greek words *"hetero"* (different) and *"topia"* (space or place) already indicates the hybrid nature of this linguistic entity. These different spaces, Foucault argues, would bear witness to the transition from the nineteenth century's emphasis on time-based models of historiography and human evolution to the twentieth century's modern deployment of spatial metaphors in various forms of artistic and technological endeavours, from surrealist montage to architectural design.

Key to Foucault's thesis is the notion of "emplacement," which he defines as "the relations of proximity between points or elements."[1] Therefore, for Foucault, emplacement does not function as any "spatial entity"; on the contrary, this space's raison d'être is primarily to relate series and elements. As such, it reflects the modern problem of space as a problem of relationality instead of ontology: the goal is no longer to describe objects in space but to put the emphasis on the relations between objects, and how these relations can make experience more meaningful. This greatly differs from the Renaissance understanding of expandable space, and the notion of network will be of primordial importance to make sense of the radical changes brought about by relational spaces. As Foucault astutely remarks: "We are in an age when space is presented to us in the form of relations of emplacement,"[2] and the "spatial turn" in various academic disciplines testifies to Foucault's

prescience and emphasis on spatial relations rather than the phenom-enological study of objects in space.

Defining relations of emplacement is Foucault's next task. He posits two types of emplacement: utopias and heterotopias. As emplacements that have no real space, utopias relate to society based on patterns of inversion and perfection; they create an improved version of society in which social malaises have vanished. As real emplacements, heteroto-pias "are designed into the very institution of society, which are sorts of actually realized utopias in which the real emplacements, all the other real emplacements that can be found within the culture are, at the same time, represented, contested, and reversed, sorts of places that are out-side all places, although they are actually localizable."[3] Contrary to uto-pias, heterotopias establish relations of connection; they are moulded so that they operate to meet concrete objectives in a given society.

The science Foucault has in mind to describe heterotopias would be a "heterotopology" whose object of study can be circumscribed using six key principles. Its first principle is that "there is probably not a single culture in the world that does not establish heterotopias: that is a con-stant of every human group."[4] Acknowledging that heterotopias will differ from culture to culture, Foucault claims that there is no form of heterotopia that can be said to be universal in design. Nevertheless, he goes on to classify heterotopias according to five other principles that they would all share in different ways. The second principle refers to the mutable operative nature of heterotopias: "in the course of its his-tory, a society can make a heterotopia that exists and has not ceased to exist operate in a very different way."[5] The third principle points to how the notion of juxtaposition comes to function as an important fac-tor to relate diverging emplacements in a given heterotopia. Foucault gives the example of the theatre and cinema: "The heterotopia has the ability to juxtapose in a single real place several emplacements that are incompatible in themselves. Thus the theater brings onto the rectan-gle of the stage a whole succession of places that are unrelated to one another; in the same way, the cinema is a very curious rectangular hall at the back of which one sees a three-dimensional space projected onto a two-dimensional screen."[6] It soon dawns on the reader that Foucault is not describing heterotopias per se, but, more importantly, how differ-ent spaces relate to one another in a given heterotopia. Of course, this echoes Foucault's aforementioned remark to the effect that heteroto-pias present space in the form of relations of emplacement rather than as places where objects are stored.

The fourth principle pertains to the role of time in heterotopias and its undeniable pressure on space: "More often than not, heterotopias are connected with temporal discontinuities; that is, they open onto what might be called, for the sake of symmetry, heterochronias. The heterotopia begins to function fully when men are in a kind of absolute break with their traditional time."[7] Elaborating on the criteria that define heterotopias and heterochronias, Foucault turns to the library, the museum, and the impact of time. Heterotopias such as the library and the museum – as spaces that collect and preserve artefacts against the passage of time – establish various configurations of accumulation that differ from the seventeenth-century individual collecting of masterpieces and exotic artefacts in *Kunst-* and *Wunderkammern*. Time becomes grafted onto heterotopias in temporal disjunctions called heterochronias. The modern understanding of the pressures of time on space translates into the "idea of constituting a sort of general archive,"[8] Foucault asserts, that reflects the "desire to contain all times, all ages, all forms, all tastes in one place, the idea of constituting a place of all times that is itself outside time and protected from its erosion."[9] As opposed to such heterotopias that accumulate time indefinitely, there are heterotopias "that are linked, rather, to time in its most futile, most transitory and precarious aspect, and in the form of the festival."[10]

The last two principles refer to access and the way in which heterotopias create spaces that are either illusory or compensatory. The fifth principle refers to the interplay between the open and closed nature of heterotopias: "Heterotopias always presuppose a system of opening and closing that isolates them and makes them penetrable at the same time."[11] The final principle is that heterotopias "have a function in relation to the remaining space. This function is spread between two extreme poles. Either the heterotopias have the role of creating a space of illusion that denounces all real space, all real emplacements within which human life is partitioned off, as being even more illusory ... Or, on the contrary, creating a different space, a different real space as perfect, as meticulous, as well-arranged as ours is disorganized, badly arranged, and muddled. This would be the heterotopia not of illusion but of compensation."[12]

The various desires and hopes Foucault describes in characterizing heterotopias according to six principles not only concern the nineteenth and early twentieth century but also our own digital age. The difference, I argue, is that heterotopias, and their relations of emplacement, are simulated, programmed, networked, and highly commodified in

the twenty-first century. In other words, the multifaceted nature of contemporary heterotopias demands that we update Foucault's principles in a way that will take into account the digital technologies and social media he could not have imagined when he lectured on heterotopias in the late 1960s.

While it is not the goal of this chapter to show how digital heterotopias in general conform to Foucault's six principles, it is crucial to examine how CD-ROM functioned as a digital heterotopia more concretely in terms of media materiality. Similar to Foucault, I do not wish to claim that all digital heterotopias are the same: after all, a CD-ROM is very different from an immersive installation, just as a digital game differs from a website in terms of design. However, given their shared attributes as *interactive media*, such digital artefacts do share one fundamental characteristic that qualifies them as digital heterotopias that analogue media do not: they are *programmable entities*. In the case of CD-ROM, the combination of audio, textual, and visual data that is programmed and meant to be interacted with via object images calls for a re-examination of this digital platform in a way that will accentuate its heterotopic design. Moreover, as we shall see in the following pages, the study of CD-ROM's hardware (Read-Only Memory) and software architecture, which allowed the creation of virtual pages, screens, and VR panoramas, concerns different media components, thereby making CD-ROM a complex hypermedia entity that can help to reframe Foucault's discussion of heterotopias in the digital age and rethink his "philosophy of space."[13]

With regard to the second principle, which refers to the mutable nature of heterotopias over time, CD-ROM built on the older disc platform that contained audio tracks. CD-ROM still accommodated audio files, but it added textual and visual files that could be programmed to trigger other data and respond in real time. As for the third principle, which pertains to the key role juxtaposition plays in combining various elements in a given heterotopia, CD-ROM did allow for previously distinct media spaces to live under one roof, so to speak, bearing in mind the plurality of media (the book, the page, and the screen) that it could accommodate.

As mentioned above, the fourth feature describes the temporal discontinuities emerging from the pressure of time on heterotopias. In time-driven heterotopias (called "heterochronias") such as museums, archives, and libraries, multiple temporalities coexist to create discontinuous experiences merging past, present, and future. In the case of

CD-ROM, the impact of time manifested itself in the form of the wish to tell a story that would be linear and nonlinear at the same time, and QuickTime's smaller cinema screen put pressure on CD-ROM artists to tell stories and to conform to cinema's temporal flow in the context of a new medium predicated upon interactivity rather than temporal unfolding. Furthermore, Foucault's differentiation between heterotopias of accumulation, as opposed to heterotopias characterized by fragmentation, futility, and precariousness, complicates any clear-cut analysis of the fourth principle. Interestingly, CD-ROM embodied both types of heterotopias: its storage space functioned as a pocket-sized library, archive, or museum that accumulated whatever the designer or artist wanted to include within it in terms of audiovisual and textual information. However, due to its limited storage space and its transitory nature as a digital artefact, it also signalled its precarious status as a medium that did not offer traditional narrative arcs.

The fifth principle defining heterotopias signals their ambivalence between being open or closed systems. The nature of ROM made it a closed medium for most users in terms of media materiality, as few individuals could rewrite or modify a ROM environment. However, its openness as a medium resided in its being adaptable to all purposes, be they artistic, commercial, or professional. The most successful software used to make CD-ROMs, Macromedia Director, greatly contributed to making it an accessible and user-friendly medium, and the interactive qualities of the hypermedia platform fostered a sense of responsiveness on the part of a medium open to the actions of the interactor. Therefore, it is CD-ROM's open *and* closed nature that marked its arrival as a medium full of promise.

The final principle points to CD-ROM's function in relation to the space outside of the heterotopia. Foucault mentions that heterotopias create a space of illusion that denounces real space as being more illusory. With regard to CD-ROM, one could argue that the media spaces of the book, cinema, and television were shown to be falsely pure in the ROM environment, and they gave the impression that narrative was a human universal that should imbue all artistic creations. According to Foucault, heterotopias are also said to create a different real space: a heterotopia of compensation. Here it is the dream of CD-ROM as the quintessential multimedia space: reuniting all media in one work that would finally unify the arts. As we can see, Foucault's six principles for defining heterotopias can be reframed to discuss programmable media such as CD-ROM.

Interestingly, it is little known that Foucault had already touched on heterotopias before giving his lecture on the subject in Tunisia in 1967. In the preface to *The Order of Things*, Foucault mentions the notion of *literary heterotopia* and contrasts it with utopia. He notes that "[h]eterotopias are disturbing, probably because they undermine language, because they make it impossible to name this and that, because they shatter or tangle common names, because they destroy 'syntax' in advance, and not only the syntax with which we construct sentences but also the less apparent syntax which causes words and things (next to and also opposite one another) to 'hold together' ... heterotopias ... desiccate speech, stop words in their tracks, contest the very possibility of grammar at its source; they dissolve our myths and sterilize the lyricism of our sentences."[14] Two years before giving his lecture on heterotopias, Foucault thus offered a description of the notion that critics have unfortunately confined to language and literature alone. Having in mind the prose of writers such as Jorge Luis Borges, whose famous description of a Chinese encyclopedia opens Foucault's 1965 publication, or Raymond Roussel, to whom he devoted a book-length study in 1963, the initial description of heterotopia could give the impression that it is predicated only on textual and narrative matters and the way in which a literary heterotopia disrupts linguistic conventions or accepted syntactical coherence.

With the help of a programmable medium such as CD-ROM, I wish to emphasize that Foucault actually proposes a double-voiced definition of heterotopia elaborated over several years rather than two distinct versions of the term. The two descriptions are, therefore, complementary rather than contradictory. Especially in the context of digital media that have functioned as both disruptive entities in terms of traditional storytelling and objects enfolding a multiplicity of media spaces, one could use Foucault's double-sided description of heterotopia to shed light on the work of CD-ROM and other digital media that join together different spaces in often discontinuous assemblages. This course of action would thereby address two aspects that Foucault describes: the disruption of narrative and syntax and the coming together of different spaces in one media environment. The second factor to be taken into account is that, with the rise of the computer, digital technologies, and social media, heterotopias now include virtual spaces of exploration that Foucault could not have foreseen in the late 1960s, ranging from virtual museums to online multiplayer games. Digital heterotopias are the most significant heterotopias in terms of cultural capital, and one

could surmise that Foucault would have considered expanding his initial list of heterotopias given the great variety of "different spaces" that digital media have proposed lately.

It is precisely such novel relations between spaces of artistic and technological production that this study of CD-ROM, object images, and digital adaptation wishes to better understand in introducing the concept of digital heterotopia. Even though they relate to Foucault's original definition of the concept, digital heterotopias, as late twentieth-century and early twenty-first-century examples of artistic innovation, have to be conceptualized anew in order to properly demonstrate their indeterminate relations between textual and audiovisual media and the complex web of relations of emplacement they present. As James Faubion rightfully notes, "Heterotopias are concrete technologies,"[15] and examining them entails attending to the media indeterminacy found in all mnemotechnologies such as CD-ROM.

The shift from art object to relational aesthetics and process in contemporary art and digital media implies rethinking how users negotiate media spaces and how critics should assess these indeterminate spaces. In the case of CD-ROM's heterotopic design, a closer examination of digital multimedia space entails attending to three interrelated components: the multimedia authoring software, Macromedia Director, that was used in the 1990s; the legacy of the book form and the layout of the virtual page; and Apple's QuickTime software and the related notion of database cinema. CD-ROM's very existence as a digital heterotopia resulted from the combination of these three elements that made it a unique medium.

Macromedia Director as Creative Space

Jay Fenton, Mark Pierce, and Marc Canter founded MacroMind in 1984, a company whose first software were MusicWorks and VideoWorks. MacroMind became MacroMedia in 1988, and, under the aegis of his software company, Canter went on to design an application that would radically transform authoring applications when Macintosh was actively disseminating its graphical user interface. Macromedia released the now well-known Director software in 1988, which relied on the object-oriented programming language Lingo, and the rest is media history given both the importance Director has had since the late 1980s and its alliance with another successful framework, Apple's QuickTime.[16] The major impact of Canter's new application was to

make software available that would be compatible with the emerging market of personal computers and that would launch the multimedia frenzy of the 1990s. Designers and artists were just one step away from appropriating the authoring system and creating their own CD-ROMs at home. Canter's authoring system would allow artists and designers to integrate text, audio, and video in one given project, and the outcome of this software tool would lead to the "multimedia" and "hypermedia" projects associated with CD-ROM. At the turn of the new millennium, a series of updates and improvements would culminate in Macromedia Director 8. Macromedia Director became Macromedia MX in 2002, and the name was changed to Adobe Director when Adobe Systems acquired it in 2008.[17]

It is worth dwelling on Canter's rationale for proposing new authoring software, for it sheds light on how Macromedia Director can help to further inflect the notion of heterotopia in the digital era. In a piece written in 1986, "The New Workstation: CD ROM Authoring Systems," Canter foresaw "the need for development tools that will help programmers and artists to create CD applications fast and efficiently."[18] Wishing to go beyond text-based CD applications, Canter worked on an application that would allow users to create interactive experiences: "The hardware makes it possible to convert information into a machine-readable format; the software makes it possible for nonprogrammers (which will often be artists and musicians) to create complex programs by defining decision points, branches, and subroutines."[19] Canter's new authoring tool thus answered two demands: the first one was about the need to democratize programming for, say, artists with no computer programming experience, and the second was to model an application before it got committed to the closed format of compact disc. Needless to say, said commitment to CD also entailed limitations in terms of memory and retrieval time. He was aware of these factors: "Memory limitations and access times are some of the typical problems encountered when developing applications with authoring systems. Once a writer releases the tremendous potential of the system, he usually goes overboard and asks the system to do too much."[20] Canter points out that there were other urgent problems with the development of authoring software such as shortening "the feedback loop between the computer and the user – between the idea itself and its actualization."[21] According to him, the goal was to reach "a more direct connection to creativity for the user and a higher level of productivity."[22]

Once combined with CD-ROM, Canter's piece of software would allow nonprogrammers easy access to the creation of commercial offerings and artistic CD-ROMs. As we can see, the creation of an authoring tool that would help to bridge the gap between CD-ROM as a commercial medium and media arts as an artistic practice was predicated on the desire for both efficiency and faster programming, which is to say that the notion of speed was of the essence in Canter's description of his new software application. Aside from the reference to the memory limitations of CD-ROM, the descriptions of his authoring tool put the emphasis on the efficiency and rapidity of the new process. As digital heterotopias, CD-ROMs stemmed from this desire for designing pieces in a timely fashion.

Moreover, while Director was inseparable from Canter's emphasis on speed, user-friendliness and the democratization of programming were also fundamental. As a mid-1980s digital heterotopia, CD-ROM combined speed and democratization, thereby emphasizing the need for faster applications and more user-friendly programming tools. It is equally important to underscore that the notions of speed and democratization would become tied to a different approach to time itself in the creation of actual works. This authoring software allowed the creation of hypermedia pieces that challenged the experience of reading a book or watching a film by allowing for the presence of hot spots and alternative paths to explore. This is related to the type of image Director would allow someone to create, the object image, and the looming presence of time and time-based media in the CD-ROM heterotopia.

CD-ROM featured a plethora of object images that deserve closer attention in the context of what Director allowed one to imagine with its interface. What is particularly interesting to examine are the theatrical and filmic metaphors that characterized Director. Canter himself is responsible for creating an interface that would rely heavily on *performance*; in fact, the description of his new authoring tool states its indebtedness to performance. Using keywords such as "score," "cast," and "stage" to describe the main "actors" in Director, Canter elaborates on the architectural design of his multimedia system: "Integral to these [authoring] systems will be a powerful, easy-to-use notational system that will unify entire multimedia systems on one score, just as an orchestra is unified by the symphonic score used by its conductor. These scores will be capable of representing any sort of data, including the 'action codes' necessary for interactive programming (or authoring)."[23] Needless to say, the metaphor of the theatre stage or performance was

integral to the rhetoric that accompanied the rise of Director to the sta-
tus of main protagonist in multimedia authoring systems.

That said, it is crucial to shed light not only on the interface and the
reliance on performance-related terminology to describe Director but
also on the type of image that would be created using it. In one of the
rare critical assessments of Director, which draws on Gilles Deleuze's
typology of cinematic images to make sense of Canter's software,
David Goldberg reflects on the authoring software as "a philosoph-
ical framework and not just a production tool."[24] In order to do so,
Goldberg shifts the emphasis from the theatre to the movie theatre and
underlines that Director is based on the moviemaking metaphor. This
rhetorical move is made to discuss Director differently: "To re-think
and remember Director now that the Web is the new CD-ROM is to
apprehend a tool that has quietly integrated itself into the fabrics of
networked media and data processing that surround us."[25] Goldberg
wishes to adopt a nonteleological approach to software that ultimately
opens the door to a more sustained critical treatment than that pro-
vided in the business press, thereby showing how "Director offers the
opportunity to create alternative and critical responses to this experi-
ence on its own terms."[26]

Goldberg's stated intention being to discuss Director on its own
terms, he sets out to rethink the way in which Canter's system "thinks"
rather than merely presents visual data. One of his challenges is to go
beyond the fact that Director was built on the moviemaking metaphor;
after all, the frame, the cast, the [sound] stage, the [film] score are associ-
ated with filmmaking. So how does one discuss authoring software on
its own terms when said terms are overdetermined by film terminol-
ogy and practices? In a paradoxical move, Goldberg thinks Director
images by resorting to Deleuze's well-known distinction between the
movement- and the time-image in cinema: "Director's stage, as con-
ceptually open as unexposed film, becomes the site for creating what
Deleuze calls 'movement-images': cinematic representations of cause
and effect, predictable sequences of images, and their rational connec-
tion; and 'time-images': cinematic images that do not describe or rep-
resent time through motion, but *present* time in the space between two
disconnected audio/visual images."[27] What is particularly intriguing
in Goldberg's appropriation of Deleuze's typology of film images is the
doomed attempt to apply concepts derived from film analysis to drasti-
cally different images and their programmable nature. In other words,
what are the limits of the analogy between Director images and the film

images described by Deleuze, and how does this strategy invalidate the desire to examine Director on its own terms?

Goldberg claims that interactive media provide the equivalent of the Deleuzian movement-image. One can turn to the point-and-click activities involving buttons and scroll bars to see how the link between cause and effect would be respected, as in the case of the movement-image. Of course, this completely bypasses the fact that object images were programmable images meant to be interacted with and that could trigger other textual or audiovisual formations. Then perhaps we could ask what counts as Director time-images if, as Goldberg points out, interactive media "is comprised *almost exclusively* of movement-images."[28] He locates time-images in the multifaceted problems, glitches, and errors one could encounter when trying to access a file that would not open: "the interactive time-image arises from system errors. Malfunctioning windows, empty dialog boxes, spastic cursors and sudden video memory purges are all time-images that disrupt our previously rational linkages between one interface event and the next."[29]

A series of objections could be raised at this point. First, in terms of production, a potential problem is to claim that unexpected errors and glitches in the computer world were analogous to carefully crafted Deleuzian time-images in cinema. Second, in terms of reception, the time-images of celebrated filmmakers such as Andrei Tarkovsky, Theo Angelopoulos, Hou Hsiao-hsien, or Béla Tarr demand to be contemplated over several minutes to be fully appreciated. In the case of an "error message" qua time-image, there is no need to contemplate the screen in order to access some kind of metaphysical insight into human existence that the aforementioned filmmakers wish the spectators to gain. Finally, perhaps the strongest objection to Goldberg's way of thinking is the inherent failure in projecting film image types onto computer object images when the goal is to think Director's images on their "own terms." If indeed the goal is to consider such images differently, then one should use Deleuze's two types of filmic images as a source of inspiration for conceptualizing novel image types rather than seize upon already available types, which is what is argued for in the introduction to this book, where the object image is introduced as the heir to Deleuze's "electronic image."[30]

The notion of "object image" is a far more productive concept to develop in the context of images that were programmed, interactive, and capable of generating or giving access to other images via their hypermedia potential. Appropriating Deleuzian types of cinematic

images can only take us so far in describing object images. In order to further describe Director's object images, which relied on the notions of speed and democratization, we must examine another key factor making up CD-ROM as digital heterotopia – the influence of the book medium in the form of the artist's book and the page. Their virtual deployments thus function together as the second element that comes into play in defining CD-ROM as digital heterotopia.

The Legacy of the Book

As is well known, one of digital media's most praised achievements is the recreation of old media in new environments, thereby suggesting, in a heterotopic environment like that of CD-ROM, novel strategies for repeating previous media configurations and accessing information. Repetition in digital media, as far as CD-ROM art and technology are concerned, took the form of a marked reliance on the book form. Largely based on the tradition of illustrated and artists' books, CD-ROM borrowed from the book form its interfacing traditions (e.g., title pages, tables of contents, and indexes), which have been privileged spaces for transmitting information between reader and work. The book form thus reappeared in a digitized afterlife that cannot but remind us that digital media uncannily repeat preceding media.

The issue of repetition, as it pertains to the construction of a ROM body, poses intriguing questions as to the actual formation and recuperation of forms in a digital heterotopia. Indeed, one may wonder how ROM art actually created its body. Did it borrow its body from the book? Did it fuse its interface with print culture's perennial practices? Or did it produce an infected body, a body that could not reconcile older forms or embrace the creative practices of older media? The latter question allows us to elaborate on the claim that ROM's body, due to its overall reliance on the book form and its page layout, was actively engaged in the merging of often diversified modes of transmission in the book form. For example, the CD-ROM format's difficulties in integrating several modes of expression such as narrating, characterizing, pacing, visualizing, and structuring revealed how this medium's body struggled with earlier media's defining characteristics. This newly formed conceptual body thus created a relation to media history that was based on wishful repetition when it tried to join these older bodies and their intrinsic forms of information access. And yet this digital body seemingly sent the message that it could not entirely reconcile them on one

platform; in fact, it is the impression of differential movement between media forms that CD-ROM gave with its heterotopic design.

As stated above, the impression of differential movement relates to the capacity of digital heterotopias to make coexist or establish relations among different media forms in a new environment. Yet some observers want to give the impression that heterotopic productions are seamless. For example, Tony Feldman has described digital multimedia as "the seamless integration of data, text, sound, and images of all kinds within a single, digital information environment."[31] To anyone familiar with the CD-ROM experience, "seamless" would not be the first qualifier that comes to mind to describe the visual design or modalities of interaction of what was described as a "primitive" medium. Feldman thus refines his definition: "By 'seamless' integration we mean so close an interweaving that the discrete character of the different types of individual media is submerged in the experience of the multimedia application."[32] In other words, seamless multimedia integration would make other media disappear or at least fade into the background in order for the CD-ROM experience to be memorable; immediacy would thus function as the quintessential mode of address.

This desire for immediacy and symbiotic engagement contrasts with hypermediacy, that is, the inventive and often playful foregrounding of hybrid sources and the juxtaposing of visual and textual contents. ROM's body, far from being fatefully infected by the cohabitation of differing media organs, privileged friction and the variable positions that the copresence and juxtaposition of the book form and its page layout imposed. It is in the creation of these apparently weird and ambiguous media spaces that the most rewarding instances of CD-ROM heterotopia took place.

In order to refine our understanding of the legacy of the book and the page on CD-ROM qua heterotopia, it is worth examining a particular type of book. Among the preceding print artefacts to which the artistic CD-ROM was particularly indebted is the artist's book.[33] As the cultural medium par excellence, the book has successfully mutated into a variety of shapes and sizes that testify to its qualities as a durable interface between reader and information, fostering an undeniable sense of immediacy and intimacy. It is less well known that print culture's central medium has generated a type of book that is commercially less viable than others, namely, the artist's book, whose objective is to explore the potential of the medium for artistic purposes. In the hands of visionaries such as William Blake and Stéphane Mallarmé, the book

form became more than a medium: the artist's book transforms into a heterotopic tool that would eventually open onto new patterns of material creation. Alongside the experimental and avant-garde practices that single out the artist's book as a milestone in the history of the book, it is the conceptual and material interrogation of the medium to which one should turn in examining this art form and assessing its legacy in the CD-ROM heterotopia.

Johanna Drucker is correct when she concludes her study of artists' books by claiming that "the potential of the book as a creative form will remain available for exploration"[34] – and the multiple artistic CD-ROMs made in the 1990s testified to the creativity with which artists rejuvenated the book form. Yet it is not so easy to pinpoint what actually demarcates the book from the digitally expanded book. It is in the indeterminacy of its reworking of the book's structure using other media that the artistic CD-ROM surfaced as an unprecedented medium. Discussing the book form, Drucker locates such indeterminate intervals in what she calls "tensions": "One of these is the tension between the fixed sequence of the codex form in a material sense and the expansive, non-linear, spatialized effect of reading and viewing. In other words, the tension between its physically finite and determined order and the linearity of the material form is continually counteracted by the experience of associations produced in the work's structure."[35] Drucker's description of the book form's indeterminacy aptly encapsulates and actually challenges new media enthusiasts' depictions of the book as a linear and closed form that has become passé.

Even though Drucker, who is one of the artist's book most astute commentators, has called it "the quintessential 20th-century artform,"[36] this disputable claim should not blind us to one of the artist's book's more obvious characteristics: its versatility as a medium that can be touched, looked at, and smelled. The medium's versatility has become even more evident since the rise of digital technologies and the ensuing transformations the book and bookmaking have undergone. As Drucker has pointed out: "The book as an electronic form – whether in hypertext, CD-ROM, or as an infinite and continually mutating archive of collective memory and space – is already functioning as an extension of the artist's book form."[37]

In sum, one of CD-ROM's central achievements was its building upon both the book form's and the page layout's characteristics – sequencing, ordering, continuity, and flow – and the artist's book's emphasis on conceptual and material innovation within the confines of a

bounded medium and its unified presentation. Artistic CD-ROMs not only elaborated on but also reconceptualized information access using hypermedia potentialities. One of the central additions was sound, and, coupled with object images, the person holding an artistic CD-ROM in her hands could not be said to be holding a "book." CD-ROMs were not illustrated books; combining sound, image, and textual files, the value of such works would lie in their actual merging of three modalities of reception (reading, watching, and listening) and the possibility of revisiting information at one's own pace in a one-of-a-kind heterotopic design.

There is no denying that the book and its general interfacing tradition occupied a central place in the mind of the first CD-ROM designers. After all, bookmaking precedes the invention of printing, and centuries of bookmaking practices, combined with book reading, were bound to leave indelible traces. These preceding traditions did not function as threatening agents in the CD-ROM heterotopia; they worked as supplements that allowed a medium to increase its potentialities and reveal unforeseen assemblages. Moreover, as Jacques Derrida mentions, critical discourse has to adapt to these changes and reconfigure its task: "we should analyze the retention of the model of the book, the liber – of the unit and the distribution of discourse, even its pagination on the screen, even the body, the hands and eyes that it continues to orient."[38]

A first step in the case of CD-ROM is to understand how the page became a screen to be activated, thus transforming the book's page into a virtual page incorporating a screen that could accommodate object images and be responsive to the actions of the interactor. As N. Katherine Hayles puts it apropos of the virtual page: "the 'page' is transformed into a complex topology that rapidly transforms from a stable surface into a 'playable' space in which she [the reader] is an active participant."[39] This is related to a potential pitfall Hayles highlights when she notes the pervading influence of print culture on media critics insofar as "the temptation of reading the screen as a page is especially seductive."[40] Similarly, in the case of CD-ROM art, the scrolling and unfolding movements demanded hand-eye coordination that recalled the movements of one's eyes over the page and the holding of the book in one's hands. However, their coeval deployment in the case of a virtual page on the computer screen certainly called for a renewed discourse on "reading" when miniature screens and object images were added to the picture.

In our case, what happened when the book, once digitized in the form of a CD-ROM heterotopia, could trigger film sequences via object images and play audio files? Did the digital book's body make more sense when it could feel virtual pressure and give the impression of being "touched"? If this was so, how come, as the editors of a collection on the future of the page ask, "our understanding of what constitutes a text remains rooted in the traditions of the medieval page"?[41] Was it a lack of imagination on the part of designers that can explain why most early web pages were not that innovative? The page as a 3D space to be explored certainly offers another way of envisaging what took place in ROM art. The goal of interface and web designers certainly was to create a type of page, or rectangular space, that would be more flexible and capable of generating heterogeneous information configurations in a way that would point to the page in the expanded field.

This discussion of CD-ROM in the context of digital heterotopia is meant to unearth the radical potential and inherent dynamism of the book and the page as a combined virtual milieu. The fact that they have stood the test of time certainly demonstrates not only their endurance but also their flexibility and versatility. However, being linked to linearity and sequencing, the page has been attached to a concept of the book that privileges narrative development. Certain novelists have offered works that challenge sequencing, but these efforts remain marginal in the history of the novel from Petronius to Mo Yan. From page to computer screen, text is forced to open up its horizons to test the limits that book practices have imposed for centuries. Hypertext certainly provoked a number of reconsiderations, but its ultimate challenge lay in the way in which it forced narrative to revisit its purpose. As Joseph Tabbi puts it: "Narrative is again imagined as a journey, but a journey whose meaning does not await us in some future fulfillment at a determined endpoint; rather, once enough materials have been assembled on the screen or within the writing space and a direction through them or set of relations among them has been established, meaning can then be reconstructed along multiple pathways by which readers may return."[42] Elaborating on Tabbi's insight, we could ask the following question: how did the hypermediated page function not only as a screen but also as an entire cinema of one's own in the CD-ROM heterotopia? It would be the task of Apple's QuickTime software to answer this question, and this provides us with the last major component characterizing CD-ROM space.

QuickTime: Database Cinema and
Spatio-Temporal Montage

Similar to the manner in which the CD-ROM medium drew on the book and the page to propose new assemblages and variations, the use of the QuickTime software rejuvenated the form of experimental filmmaking in the CD-ROM environment and on the Internet. As opposed to tele-visual media, QuickTime is heir to the strong tradition of avant-garde and experimental productions in various cinematic media, having gener-ated countless miniature movies and being associated with the notion of "database cinema." Drawing on a vast archive of visual experimentation, artists and designers used the QuickTime architecture to create panora-mas and movies that ambiguously repeat cinema on a smaller scale, a cinema that is more intimate, personal, and given to all sorts of perfor-mances in the multifaceted heterotopic designs found on CD-ROM.

The place of QuickTime in critical discussions has fostered the sense that this playback software is imbued with indeterminacy. On the one hand, its relatively well-known remediation of the cinema screen once pointed to the future of film viewing in the space of the computer screen. On the other hand, its jerky rendition of what "cinema" is, albeit on a smaller scale, could not but remind the computer user that this form of cinematic experience did not really point to the future of cinema. This indeterminate position signalled how digital media could propose new forms of visual experiences, while paradoxically giving the impression that they had not yet achieved a stage whereby compelling experiences would be the norm.

The initial release of Apple's QuickTime took place in 1991. It is a versatile software tool that enabled Macintosh and PC computers to deliver multi- and hypermedia content. QuickTime could handle a variety of formats including video, music, immersive panoramas, and animation. The QuickTime application allowed the encoding and decoding from one file format to another, and it also served as a play-back device featuring the now familiar rewind, fast forward, pause, play, and stop control buttons; an audio level slider; and a rectangular, window-like screen. The QuickTime file functioned as a container file that could accommodate a variety of audio, video, and text tracks. Each track possessed either an encoded stream or a reference to locate data in another file. QuickTime allowed one to play movies, render still images, play music tracks, and create immersive VR panoramas that could con-tain hot spots on which the interactor could click to trigger additional

information. These possibilities made QuickTime one of the most flexible software on the market in terms of appropriating and coordinating various media formats. In short, QuickTime was a powerful architecture to coordinate several types of files in a way that went beyond the mere playback capacity with which we often associate it.

For our purposes, let us focus on the type of QuickTime experiences that could be had on 1990s artistic CD-ROMs before turning to QuickTime and its relationship to cinema. CD-ROMs offered two kinds of QuickTime experiences. The first experience is still the most well known in which a miniature film embedded in a window on the computer can be played. The second type is the one that featured a VR component that allowed the spectator to explore the screen space with the help of an interactive panorama, trigger other files, or be redirected. What the QuickTime VR panorama gave the spectator is a different type of moving-image experience, an experience that would de-emphasize the temporal aspect of cinema and replace it with the spatial exploration of the frame. As one enthusiastic observer once put it: "And if you are interested in going beyond the limits of mere linear video and audio and want to explore Virtual Reality (VR), interactivity, custom media skins, seamless integration with Macromedia Flash, and other applications, QuickTime is hands-down your best choice."[43]

Immersive imaging could take unexpected forms in the hands of creative artists. Apple introduced QuickTime virtual reality (QTVR), which was to be used on the Macintosh OS, in 1995, and playback function on both Macintosh OS and Windows platforms. This particular type of VR allowed interactors to pan around a given point or to perform travelling shots. The user engaged the panorama or movie by pressing or dragging the mouse left, right, up, or down. Upon encountering a hot spot in version 2.1 of QTVR, the cursor would change shape and it became possible to zoom in and out. That is to say, there were two ways of presenting QuickTime experiences: movies that were not hyperlinked to other data and, therefore, were self-enclosed entities, and panoramas containing hot spots on which the user could click to be redirected or to trigger other data. It is no wonder that QTVR was described as "another example of nonlinear media. In QuickTime VR, you can change what angle you view a scene, so when you play the media, you can look in a different direction each time. Both of these examples not only are nonlinear but also are interactive. Both the video game and the VR scene let the user have some impact on what happens."[44] Susan Kitchens turns to another crucial aspect, the artistic potential of QTVR, and remarks that

"QTVR as art is the creation of an immersive experience and is usually an outgrowth of exploration of the medium."[45] The exploration of the medium, as Kitchens put it in the heyday of CD-ROM art, meant testing the capacities of ROM in order to see what it could offer with the help of QTVR that other media could not.

However, the preceding technical account of QuickTime far from tells the whole story of this software architecture. Indeed, there are two aspects to QuickTime that merit further attention in the context of the CD-ROM heterotopia: its ambiguous relationship to film narrative and its overlooked refashioning of traditional montage. Indeed, Quick-Time's small size, pixilated resolution, and jerkiness cannot be blamed because they failed to approximate the full narrative integration of the cinematic experience, as this was not its primary goal. Similarly, focusing on the QuickTime movie itself and its montage of images rather than the entire screen, which could feature text and other elements such as hot spots, forces users to reconsider "montage" as also happening outside the QuickTime frame. Ultimately, in both cases, there is the danger of using cinema as the yardstick against which QuickTime would have had to measure up. It is the same type of danger we encountered in the Introduction when discussing the hegemony of narrative in early assessments of CD-ROM.

With regard to QuickTime and its indebtedness to cinema, Vivian Sobchack's groundbreaking analysis of QuickTime movies rightfully seeks to evaluate QuickTime on its own terms, and it discusses the unique uncanny performance of narrative and memory staged by this software framework. Briefly comparing the QuickTime movie to the conventional narrative film, she argues that miniature movies presented "discrete, enclosed and nested poetic worlds: worlds re-collected and remembered."[46] The QuickTime movie thus reflected upon the fate of memory in the digital era in its desire to recollect and remember, that is to say, putting back together different media components and activities in one cohesive environment as opposed to being bent on reproducing cinema itself.

The QuickTime movie thus offered an aesthetics of its own that complicated the very task of smoothly unifying a vast array of media and actions; Sobchack describing such movies as being both "oneiric and uncanny."[47] Her mentioning that QuickTime's aesthetics was that of dreams and the uncanny reminds us of Freudian symptoms. After all, weren't QuickTime movies full of stops and repetitions, gaps in filmic narration, and memory lapses – namely, elements that recall the

psychoanalytic subject's retelling? QuickTime movies would not only exemplify Freudian symptoms but they also faced the difficult task of combining memory, space, and time. Actually, QuickTime movies' aesthetics was spectral: such minimovies brought to mind early shorts, and they functioned as a kind of double of early shorts that came back from the dead to tell of the fate of cinema. Sobchack aptly calls the aesthetics of the QuickTime movie a "mnemonic aesthetic"[48] that would be based on such ghostly repetition and disjointed rhythm.[49] As a matter of fact, she notes that "they [QuickTime movies] poetically dramatize and philosophically interrogate the nature of memory and temporality, the values of scale, and what we mean by animation."[50] It is the copresence of these issues that singles out the quasi-impossible task of the QuickTime architecture in terms of generating animated and interactive scenarios in one environment.

Moreover, if QuickTime movies cited and repeated previous media objects belonging to our collective cultural memory, then they force us to think of QuickTime as a citational and relational environment. When Sobchack points out that in QuickTime "boxes" "both artist and viewer imaginatively prospect and inhabit the empty rooms, filling them with their own missing presence in fragments of autobiography, dream, memory, confession,"[51] she tells of both the artist's and the viewer's imaginary projections and the constant citation of nostalgic feelings that they performed when watching a QuickTime movie.

A further qualification is in order here. If we were to speak of nostalgia in the case of QuickTime, as Sobchack does, shouldn't we speak of a certain "imagined nostalgia" to describe both the QuickTime software's and computer users' longing for something that cinema may have never been?[52] Indeed, QuickTime was riddled with the individual and collective projections that cinema has allowed over its century of existence, and the fact that this piece of software reproduced these desires, aspirations, and longings does point to a space of imaginary scenarios that digital media would repeat. Therefore, it is not cinema itself that was to be repeated in the QuickTime environment but the imagined nostalgia for a supposedly complete and deeply fulfilling storytelling medium. These wishes display not so much technological nostalgia as the impossibility of expanding cinema in the tradition of narrative cinema. QuickTime thus belonged to a series of database cinema applications that have come to supplement the very idea of cinema in the digital age, and they have changed how we think of both narrative cinema and expanded forms of moving images.

The notion of "database cinema" could be qualified as the most significant form of expanded cinema in the digital age. Building on pioneering explorations in interactive cinema in the installation work of media artists such as Jeffrey Shaw (*The Legible City* [1989] and *Place: A User's Manual* [1995]) and Grahame Weinbren (with Roberta Friedman), who relied on laserdisc technology to create an alternative form of cinema in *The Erl King* (1983–6) and *Sonata* (1991/1993), database cinema, also known as desktop cinema, is heir to the interactive cinema practices introduced in art galleries and museums in the 1980s and early 1990s. It is worth examining the notion of database cinema, and how QuickTime and the amalgam of database, narrative, and cinema generated an alternative to traditional cinema in the ROM environment. Juxtaposing these accounts of QuickTime and database cinema will allow us to further define the CD-ROM heterotopia.

Media theorist Lev Manovich has offered one of the most provoking formulations of database cinema and, in collaboration with interface designer Andreas Kratky, has experimented with the database cinema form in the DVD-ROM project titled *Soft Cinema: Navigating the Database* (2005). In a well-known passage of *The Language of New Media*, Manovich juxtaposes database and narrative as polar opposites that new media productions would have exacerbated to the point of crisis. Elaborating on the differences between database and narrative, Manovich notes: "As a cultural form, the database represents the world as a list of items, and it refuses to order this list. In contrast, a narrative creates a cause-and-effect trajectory of seemingly unordered items (events). Therefore, database and narrative are natural enemies."[53] While one can rest assured that Manovich uses this dichotomy to illustrate the radical difference between database and narrative at a time, the early 2000s, when few readers were familiar with the issue, there remains the need to better explain the co-presence of (narrative) time and (database) space in digital works. Returning to a few of Foucault's principles to explain heterotopias will be helpful to put Manovich's hyperbolic claim in perspective and to assess the impact of QuickTime and its reconfigured practice of montage.

As the reader will recall, Foucault notes that one of the characteristics of heterotopias is to lay the emphasis on the notion of juxtaposition to relate various emplacements. In the context of database cinema, QuickTime, and CD-ROM, the images shown in this singular type of cinema thrived on the juxtaposition of narrative time and the great number of clips stored in the database that could be played. While the movie the

interactor watched was linear in nature, it came from the great space of clips included in the database or found on a given CD-ROM. Another form of juxtaposition took place on screen when the QuickTime software played a short movie. In such a moment, the screen may have featured textual information about the clip, or vice versa, and this type of juxtaposition underscores how the entire space of the computer screen had to be considered while a QuickTime short was playing.

Juxtaposing textual and audiovisual data this way to relate text and image alludes to the fourth principle defining heterotopia: the often-overlooked role of time in heterotopic designs. On the one hand, the QuickTime movie occupied a liminal space in which the film tradition was revived in smaller form, thus tapping into cinema's resources in terms of montage, mise en scène, performance, and so on. What should be borne in mind is that film's temporal nature was in no way altered if one focused only on the succession of images in the QuickTime frame – it was a movie in smaller form, but it was nevertheless a movie. On the other hand, the way in which this form of cinema was accessed and made available was unique at the time. Drawing on a database of QuickTime shorts, the interactor could call up a clip and it would start playing. It is in this sense that we need to modify Manovich's notion of "spatial montage" in order to describe QuickTime and desktop cinema. Indeed, rather than being about space only, montage in desktop cinema included the notion of time as well, as the QuickTime movie functioned as any other movie in terms of unfolding images one after another. Integrating time into the equation in a way that would accommodate its undeniable function in the unfolding of images, one should speak of the "spatio-temporal montage" performed by both the interactor and the QuickTime software in the CD-ROM heterotopia.

Furthermore, the notion of spatio-temporal montage implicitly addresses the fifth principle characterizing heterotopias: their simultaneously open and closed nature and the interplay between opening and closing. Indeed, QuickTime, as a paradoxically nostalgic form of cinema bent on producing its own innovative version of cinema, resulted from the interactor's open access to a plethora of clips that could be accessed in no particular order, while it simultaneously restricted the viewing experience to the linearity of the traditional viewing experience as images unfolded in the miniature frame of QuickTime. It is the interplay between offering a closed narrative and apparatus characteristic of the film tradition and an open database of clips that could be accessed in no prescribed order that further characterized the presence

of QuickTime in the CD-ROM heterotopia. Far from being the simple tale of database against narrative, QuickTime was part of and further complemented CD-ROM's heterotopic design in a way that accentuated the interplay between space and time in a form of spatio-temporal montage that was performed at the level of both the interactor and the software architecture.

Founding director of the Labyrinth Project, which is devoted to the exploration of the potential of database narratives and documentaries and the production of ROM works, Marsha Kinder has usefully discussed this type of "cinema" in the context of digital multimedia design. Central to Kinder's account is Manovich's aforementioned claim to the effect that narrative and database are incompatible. On the contrary, Kinder sees "database and narrative as two compatible structures whose combination is crucial to the creative expansion of new media."[54] Arguing that narrative and database are based on the same principle, that is, selection, Kinder unpacks the claim according to which narrative would not derive from a process of selection and arrangement, and that database would not rely on some sort of narrative quest once particular items have been selected. The tension that Kinder seeks to resolve is meant to show how "selection and combination [...] lie at the heart of all stories and are crucial to language."[55]

In her reflections on digital literature and technogenesis, N. Katherine Hayles also addresses the limitations of Manovich's dichotomous framing of the narrative and database issue. Echoing Kinder's take on the issues, Hayles conceives of narrative and database as relational entities and therefore complementary ones. She writes: "Because database can construct relational juxtapositions but is helpless to interpret or explain them, it needs narrative to make its results meaningful. Narrative, for its part, needs database in the computationally intensive culture of the new millennium to enhance its cultural authority and test the generality of its insights."[56] With hindsight, there was no need to posit narrative and database as dichotomies like Manovich did in the heyday of new media studies. What I would further qualify, in the case of CD-ROM and digital adaptation, is the fact that narrative does seem to figure less prominently in the works to be examined in the following chapters. This does not mean that narrative is unimportant or nowhere to be found in other digital productions, but that Boissier, Beloff, Jenik, and Marker seized upon CD-ROM as a small-scale database to be experimented with rather than a storytelling machine predicated on print culture's narrative impulse. In this sense, I agree with Hayles when she

argues that we are not witnessing the disappearance of narrative in the twenty-first century, but the ongoing transformation of "the position narrative occupies in our culture."[57]

Kinder and Hayles having debunked the database-narrative split in Manovich's theory of new media, I wish to end this chapter with one of Manovich's remarks that has attracted little attention. While the stark contrast between database and narrative could lead one to think that Manovich is unwilling to bridge the gap between the two cultural forms, the fact is that he does come to the realization that the very notion of narrative may be more ambiguous than meets the eye in the context of hypermediated works: "However, in the world of new media, the word narrative is often used as an all-inclusive term, to cover up the fact that we have not yet developed a language to describe these new strange objects."[58] As I have been arguing, Manovich's crucial comment suggests that we have to turn to other concepts to make sense of object images and digital heterotopias in order to confront their novelty beyond claims to narrative integration or lack thereof. Manovich's rhetorical move reminds us that there is nothing intrinsic to narrative within digital media; it is only one among many possibilities.

Contrary to Manovich's privileging of Vertovian cinema to retrace the genealogy of "new media," I wish to emphasize that any account of QuickTime cannot exclusively rely on the tradition of film to explain what took place on screen when a QuickTime movie was played in the CD-ROM environment. The predominance of cinema as the quintessential art form of the twentieth century seems to have prevented critics from discussing both the entire screen space and the fact that QuickTime movies were stored in ROM. Just as QuickTime could neither be said to introduce spatial montage, nor could it be said to be the exact repetition of cinema in smaller form. The more accurate term "spatio-temporal montage" offers a better understanding of the interplay between time and space in QuickTime and the movies it offered in the CD-ROM heterotopia. Finally, such a form of "cinema" allows us to rethink the role of narrative in digital heterotopias. Far from signalling the disappearance of narrative, it is its embeddedness in digital heteterotopias of all kinds that deserve further attention.

QuickTime should have generated a discussion about the nature of montage beyond what was inside the frame and between the images in order to consider the entire computer screen and the spatio-temporal montage of textual and audiovisual data. The heterotopic principle of juxtaposition found in QuickTime offered a novel form of montage

that was about the simultaneous coexistence of various media forms on screen. In fact, it was QuickTime's indebtedness to and departure from cinema that was intriguing. In its wish to simultaneously move away from cinema while drawing on it extensively, the QuickTime movie could be said to have offered a different type of cinematic experience that did not entirely break with tradition, thereby juxtaposing its indebtedness to linear media while reconsidering the role and behaviour of cinema in the realm of the computer. One of the lessons of studying QuickTime is that vague claims on the end of narrative in digital media, or the radical split between narrative and database, were exaggerated and in fact inaccurate when examined in light of the actual digitally enhanced experience of using QuickTime in CD-ROM space.

This chapter's emphasis on heterotopia has qualified the type of cultural and technological space one negotiated in CD-ROM art and technology by expanding on Foucault's notion of heterotopia, which allows for a better account of digital technology that does not rest content with either hyperbolic claims or the rhetoric of obsolescence. On the contrary, the examination of CD-ROM in terms of digital heterotopia has brought to the fore the need for a different critical framework for understanding the three elements that define the exploration of CD-ROM space as an artistic medium: the role of Macromedia Director in offering a different type of creative space predicated on speed and democratization; the legacy of the book medium and the page in the artist's book; and the function of QuickTime, database cinema, and spatio-temporal montage. Focusing on these constitutive elements has shown the larger artistic and technological implications that the chronological examination of software development fails to deliver. Having examined how CD-ROM qualifies as a digital heterotopia in which a multiplicity of media coexisted in the combined software architectures of Director and QuickTime, we are in a better position to examine subtractive adaptations.

A Sensuous Gaze: Interactive Chronophotography and Relation-Images

Jean-Louis Boissier has been making videodiscs, CD-ROMs, and interactive installations since the early 1980s. Among his most celebrated works one finds *C'est elle! C'est bien elle!* (2011), *Les perspecteurs* (2004), *Modus Operandi* (2003), *La morale sensitive* (2001), *Deuxième promenade* (1998), *Mutatis mutandis* (1995), *Flora petrinsularis* (1993), *Globus oculi* (1992), *Album sans fin* (1989), *Pékin pour mémoire* (1986), and *Le bus* (1985). He has also exhibited internationally and has curated several exhibitions. In 1983, Boissier assisted Frank Popper on the exhibition "Electra, l'électricité et l'électronique dans l'art au XXe siècle," at the Musée d'Art Moderne, Paris. In 1984–5, he participated in the preparation of the path-breaking exhibition "Les Immatériaux" under Jean-François Lyotard. More recently, the artist has been involved in curating "Artifices," the digital arts biennal in Saint-Denis (1990–96), the "Revue Virtuelle" at the Centre Georges Pompidou (1992–96), "Jouable" (2002–04) in Geneva, Kyoto, and Paris, and "Mobilisable-Masaki Fujihata" (2008) at the École Nationale Supérieure des Arts Décoratifs, Paris.

Published by Gallimard in collaboration with the Centre pour l'Image Contemporaine (Saint-Gervais Genève) in 2000, *Moments de Jean-Jacques Rousseau* is indebted to two of Boissier's earlier installations, *Flora petrinsularis* and *Deuxième promenade*, which also focus on Rousseau.[1] Using Rousseau's autobiographical and theoretical writings as an inspirational database of key memories, Boissier has designed a digital heterotopia that recreates several crucial events or, as they are called on the CD-ROM, "moments" in Rousseau's life. Drawing on two central texts, the *Confessions* (1782–89) and the *Reveries of the Solitary Walker* (1782), the artist's CD-ROM does not require

scholarly knowledge of Rousseau's works. On the contrary, on the CD-ROM the interactor will find the complete texts of the *Confessions* and the *Reveries* to which she will be able to refer to read *in extenso* the literary passage evoked in a given visual sequence. The CD-ROM offers these two complete texts in the prestigious Pléiade edition of Rousseau's literary works and several passages in nonfictional writings.

The CD-ROM adaptation, as its name suggests, is devoted to illustrating important *moments* in the Rousseau corpus. Boissier selected several important episodes in Rousseau's writings prior to going on location between 1997 and 2000. In order to recreate Rousseau's experiences and feelings, the artist visited small towns in France and Switzerland where he restaged the "*moments*" that occurred more than two hundred years ago, events that are depicted in the writer's works. With the help of young actors and actresses in modern dress who play the roles of Mme Lambercier, Marion, Mme Basile, Sophie d'Houdetot, Mme de Warens, and Zulietta, among many other characters, Boissier has successfully recreated Rousseau's "moments" without trivializing them. Indeed, the adaptation wishes to reproduce Rousseau's misadventures in all their complex psychological intensity. Retaining the indexical nature of cinema while tapping into the potential of hypermedia, Boissier's heterotopia is a challenging instance of subtractive adaptation that demonstrates the potentialities of interactive media to accentuate the posthumous relevance of Rousseau's writings for anyone interested in intermedia issues. In fact, as Boissier underscores: "Rousseau was chosen because of his appropriateness for experimenting with a new medium or art form that belongs to both cinema and the book, the spectacle and reading, or, alternatively, the gap between the album and the book."[2] Thus conceived, subtractive adaptation becomes an artistic problem that concerns experimenting with and between media first and foremost.

There are two reading / viewing paths from which to choose on Boissier's CD-ROM. First, with the help of eighty-four "shifters" [*embrayeurs*][3] – namely, words that are found in certain of Rousseau's texts that are hyperlinked to filmic sequences that allow the visualization of the scene described by the writer – Boissier has created a digital reverie that uses Rousseau's words and their recurrent appearances in his corpus.[4] For instance, the word "*monde*" [world] occurs on several occasions in Rousseau's texts. Boissier's strategy has been to shoot a short sequence for a particular occurrence, say,

in the *Confessions*, and link this occurrence to another instance of the word in the *Reveries*. The interactor goes from sequence to sequence according to the words she selects. The second possibility is to read the complete text of the *Confessions* or the *Reveries* and to click on a passage that is hyperlinked to a visual sequence. For example, the interactor decides to read Book II of the *Confessions*. On page eighty-six of the Pléiade edition, where the Marion episode is described, the interactor clicks on the highlighted passage and is able to see the sequence shot to adapt it. What the CD-ROM emphasizes implicitly, however, is the combinatory function of source text and hyperlinked object image, and it is on this design aspect that I shall focus in describing Boissier's work.

In the first part of this chapter, Rousseau's reflections on the illustrated book are compared with Boissier's own perspective on digital image making as interactive chronophotography in order to set the stage for the analysis of the CD-ROM. The first step will be to present some of the characteristics that inform Rousseau's eighteenth-century visual culture in order to facilitate the understanding of Boissier's subtractive adaptation. The emphasis will be put on Rousseau's desire for an ambiguous form of "moving still" in which performative moments will be able to emerge. Even though Rousseau's notion of the performance-image does not refer to "technology" per se, it is crucial to look at the writer's meditations on illustration and image making in order to better understand Boissier's artistic achievements in *Moments*. Building on Rousseau's desire for a "performance-image" that would adequately illustrate his prose, Boissier revives chronophotography in the form of "relation-images" [*images-relation*] that function as hyperlinked interactive chronophotographic sequences.

In the second part, I inquire into the interrelations between sight and touch in Rousseau's writings and Boissier's subtractive adaptation of three principal moments in Rousseau's *Confessions*. Echoing Rousseau's theory of perception, Boissier's work addresses the viewer's senses in his theoretical writings and the CD-ROM via his conception of the interactor's body as the site of multifunctional sensory activities. In fact, in the artist's work Rousseau's writings become object images that wish to enhance embodied sensations. Challenging the Lacanian notion of the gaze, Boissier's interactive chronophotography calls for a more sensuous gaze and mobilizes haptic vision in order to evoke a sense of materiality and embodiment in the making and reception of relation-images.

Rousseau's Performance-Images

Among the writers discussed in this book, Rousseau is the only one not to have seen technologically reproducible images such as those of photography or cinema. This is not to say, however, that he did not meditate on perception and the function of still images in eighteenth-century visual culture. In fact, in both his (auto)fictional and political writings, Rousseau constructs an elaborate theoretical position that addresses contemporary perspectives on image making and perceptual states. Furthermore, Rousseau's fictional, autobiographical, and theoretical writings abound in allusions to and uses of visual technologies and devices. From the mirror to the camera obscura to the telescope, visual technologies are evoked so often that the writer cannot but be perceived as an important witness to the changes in the various modes of production and reception of still images. As we shall see, Rousseau's desire for transparency, immediacy, and inner truth is related to his interest in image making, perception, and visual devices of all sorts.

Describing the visual culture and theories of perception of both Rousseau and the *Siècle des Lumières* in general would demand a closer look at the philosophers who rejected Descartes's dualistic perspective.[5] Their differences notwithstanding, the works of key thinkers such as Voltaire, Bacon, Locke, and Newton deeply engaged in a re-evaluation of Descartes's intellectual legacy. Known as the "Sensationalists," they argued that ideas are the reflection of sensuous perceptions rather than innate intuitions.[6] Rousseau was very much interested in these philosophical reconsiderations with regard to perception and the changing perceptual states brought about by the latest technological devices in a way that inspired both his fictional and theoretical writings. The study of Rousseau's relation to image making, the visual arts, and the act of seeing or gazing is a fruitful way to cast light on the manner in which such issues are re-envisaged in his autobiographical writings such as the *Confessions* and the *Reveries*.

In his study of Rousseau and perception, John O'Neal has noted that the writer introduced "'seeing' into the literature of his times."[7] This is not to say, however, that contemporary writers such as Diderot or Duclos were not interested in the visual potentialities of literature. O'Neal elaborates on his claim, writing that "Rousseau clearly establishes, through his fictional works, seeing as the ideal means to a higher understanding."[8] We could add two remarks to O'Neal's claim. First, Rousseau addresses sight not only in his fictional writings, but also in

his pedagogical and political works. In fact, in his nonfictional writings, he is at pains to show how sight is not an individualized faculty; if it can function at all, it must be supplemented by touch. Second, the looseness of the vocabulary to describe Rousseau's apparent innovation is unhelpful. Indeed, did Rousseau introduce "seeing" or "gazing" into the literature of his day, which, as Jacques Lacan explained at some length, are radically different types of "perception"? I will argue that the gaze is what matters for Rousseau in his fictional works. However, the gaze cannot be considered only in terms of the failure to see in Boissier's subtractive adaptation; as will be made clear, it is complemented by haptics.

In hindsight, Rousseau's writings offer salient examples of looking, seeing, beholding, and gazing that can fuel any meditation on sight and haptics. One way to begin such an inquiry would be to compare and contrast Rousseau's theory of the senses to Boissier's conceptualization of vision and touch. What it amounts to for Boissier in his heterotopia is not so much Rousseau's characters and plotlines as the theoretical justification regarding image making and visual devices in Rousseau's theorization of sight, which he recycles to contextualize his work. In other words, Boissier's subtractive adaptation of Rousseau concerns the retelling of the history of visual media via changing perceptual states rather than the actual characters or plots found in the writings. Rousseau's reflections on the potential illustration of his epistolary novel, *La Nouvelle Héloïse* (1761), is a case in point and allows a rare glimpse at the author's conception of visual adaptation.

Rousseau's recommendations to illustrate his novel in "Sujets d'estampes" open with an interesting comment that pertains to the paradoxical representation of movement in still images. Rousseau suggests the following: "Similarly, in figures in movement, one must see what precedes, and what follows, and give the time of the action a certain latitude, without which we will never grasp the unity of the moment to express adequately."[9] Rousseau's wish for temporally flexible prints also points to the artist's ability to show what eludes the look: "The Artist's ability lies in making the Spectator imagine a great number of things that are not on the drawing board, and this depends on a judicious choice of scenes, among which those that he renders suggest those that he does not."[10] Boissier will take up this still image containing a past, present, and future in his interactive chronophotographic sequences that play with Rousseau's triple temporal regime and the artist's capacity to show and suggest the unseen.

In the same text, Rousseau elaborates on the wish to capture time and movement in images: "One must notice in all the characters a vivid action, and well depicted in the unity of the moment."[11] As Philip Robinson remarks on Rousseau's recommendation: "Lack of life, lack of movement, are the inescapable weakness of visual art. Rousseau does not dream that one day, in the movie film, such a capturing of each 'instant of life' will be possible. It is a matter of speculation whether he would have approved of the invention."[12] One cannot deny that Rousseau's description of the aforementioned scene certainly confirms his interest in the representation of moving images and the visual inscription of performance. This concern will surface when we look at Boissier's presentation of Rousseau's important "moments" and the combined efforts of the reader turned spectator.

The transition from reader (of the novel) to spectator (of the print) implies that Boissier's CD-ROM is a picture book, and, as such, it calls for multiple reception strategies. One must add that in the context of Rousseau's claims, reading prints or "reading pictures" is not so much about "reading" as it is about reading the text and establishing visual correspondences between the text and its virtual, potential illustration. As Catherine Ramond has noted: "The text of the novel [*La Nouvelle Héloïse*] will be objectified in the print and its description, offered to the gaze of the spectator that is no longer that of one of the characters in the novel."[13] Moreover, prints call for a gifted artist who will be able to show what cannot be shown in Rousseau's text itself, an opportunity given by the transition from a textual to a visual environment.

The shift from readership to spectatorship should give us pause, for it implies the assessment of a new function in the visual economy of Rousseau's media environment. Wishing to go beyond the intrinsic limitations of the still image (i.e., painting for Rousseau), the writer's predilection for the print stems from a certain imaginary (inter)activity: "Even if I don't like paintings that much, I adore prints; they give my imagination something to do."[14] According to Rousseau, the print allows a preliminary identification with the image, and it forces him to supplement the image by whatever his imagination may desire: "the print permits the two-way traffic of identification and illusion."[15] Rousseau's main concern thus is that the spectator be allowed to contribute something to the visual representation. The type of print Rousseau has in mind describes the illustrated *La Nouvelle Héloïse*, and it is noteworthy that his indications perform the task of making visible what Rousseau himself seems incapable of rendering on paper.

Moreover, it is not simply the representation of movement and imaginary (inter)activity that concerns Rousseau, but the insertion of performance in the still image. In fact, it is performance itself that is at the centre of Rousseau's recommendations for printmaking: "Indeed, it seems that to the pictorial code induced by the print one must add, even substitute, the presence of a really present dramatic code that could enter in conflict with the code of the image. The passages in his novel [*La Nouvelle Héloïse*] that Rousseau chooses to illustrate already are, for the most part, deeply laden scenes with dramatic intensity to which the accompanying image and text add a representational space and numerous theatrical effects."[16] On this account, prints would become pocket-size visual sites of performance the reader would combine with Rousseau's idiosyncratic writing style in order to have a complete overview of the text's signification. The legibility of his novel would not only concern Rousseau's power as gifted author, but also the reader's ability "to read" the images and "see" the unfolding plot. It is the combination of both activities that will make the prospective illustrations for the novel successful, and performance thus is crucial in Rousseau's choice of moments to illustrate.

Boissier's Relation-Images

Rousseau's notes on the illustration of *La Nouvelle Héloïse* in "Sujets d'estampes" cannot be taken lightly. This piece of writing functions as the rare occasion on which Rousseau allows the reader access to his theoretical positions on the role of the artist, the combined input of the reader turned spectator, the crucial function of performance, and the difficulty of representing movement and time in the still image. Moreover, in the context of this chapter, they direct our attention to Boissier's own meditations on the function of the reader, spectator, and interactor in the digital age, and orient the analysis of the artist's achievement in his reconsideration of cinematic time, as relates to Rousseau's dream of a "fluid and still" image. Having mentioned Boissier's production of interactive photograms, it is important to further elaborate on this in the context of Etienne-Jules Marey's early experiments in image making. Using Rousseau's reflections on prints and desire for "moving still images," Boissier actually *performs* Rousseau's dream of a book of images in his own object images. Wanting to express "this powerful desire for images that pervades Rousseau's writing,"[17] and benefiting from the potentialities of the computer to generate different

artistic experiences, Boissier is able to produce Rousseau's "still performance-images" that contain a plurality of intertwined temporalities and demand the involvement of the interactor in order to unfold. Considering Boissier expressed his artistic practice's indebtedness to indexicality and chronophotography, it is not farfetched to claim that the artist is one of Marey's heirs.

Discussing Boissier's archaeological perspective on cinema and his interest in reviving chronophotography, Raymond Bellour makes an interesting observation: "We know too that, having been overtaken by the 'new images' of video and computer graphics, cinema today tends all the more to return to its origins and its archaeology, in order to affirm its singularity within a larger history throughout which images have been assembled and displayed by means of less developed and historically less successful 'programming' [logiciels] – Marey's chronophotography, for example, to which Boissier claims allegiance."[18] The media archaeology within which Bellour places Boissier's work is deeply engaging on many levels. First, Bellour calls attention to the revisionist nature of some contemporary filmmakers' desire to return to film history's earliest techniques and revive them using digital technology. Second, in a way that recalls Lev Manovich's proposal to reread visual culture's key moments according to a terminology that relates to digital media, exemplified in his reconceptualization of Dziga Vertov's 1929 *Man with a Movie Camera* as proto-database, it performs this apparently anachronistic gesture by describing cinema's coming of age as the development of different software. Ultimately, Bellour points out how Boissier's work can be associated with the revival of Marey's techniques in the digital age, to which several other contemporary filmmakers and experimental artists have contributed.[19]

One of the French physiologist's most important concerns was the wish to depart from the arbitrariness of painting and preserve the indexical link between the photographed animal or person and the visual, end product.[20] Boissier takes up Marey's ideal because, as he points out himself, his method consists in "removing signs from places and collecting these places themselves and inscribing the narrative of our own investigation … This project would lead us everywhere we know Rousseau had been."[21] In more technical terms, Boissier's adaptation of Rousseau's texts calls for a shooting procedure "in which the image retains its indexical nature as a reference to an external reality."[22] Boissier elaborates on the distinction between the digital and the analogical image in terms of documentation and indexicality: "In

our project, the digital realm was never intended to erase the analog power of the optical recording or its capacity to designate an exterior reality."[23] As is made clear, one of the artist's major preoccupations is that the analogical and indexical recordings of the settings and the characters be kept intact in his adaptation.

Drawing on a vast array of technological innovations, Boissier's heterotopia uses a number of design strategies having at their core the notion of "interactivity." Boissier will call his ambiguous form of cinematic time, inspired by the work of one of the forefathers of cinema, the "interactive assembling of still images."[24] In Boissier's writings, the assemblage of photograms bears several names: interactive cinema, interactive moment, and interactive print. What these names have in common is the *relational* quality of the "moments" they propose and the rather intriguing association between digital cinema, interactivity, and chronophotography: "The interactive-video substance of which our moments are made is rendered by a montage closest to the photograms, discrete and constitutive elements of cinema or chronophotography, of which it could be a new genealogical branch."[25] Moreover, Boissier demands that we stop and look back at projection shows and early cinema to put in perspective the digital productions that captivate us today: "And we could as a consequence take the time to observe those apparatus [sic] which, along with new media, ground newer genealogical branches of the cinema 'species,' often appropriating those traits abandoned: stereoscopes, panorama, moving projectors, variations in the placement of the spectator, and so on."[26] What Boissier has called the *relation-image* is the embodiment of both this interactive mode of visual presentation and counterhistorical view of the development of image production.

In his extensive theoretical reflections on digital technologies and interactive art, Boissier has developed the notion of the relation-image, which, as a case of the object image, both designates "an image that, by way of its internal interactions, opens up onto external actions"[27] and sums up both his artistic practice in general and the programmatic intention that undergirds his Rousseau projects. Boissier's wish is to revive the Rousseauian performance-image that would explore the "variation of temporal regimes"[28] that digital media afford. Inspired by Gilles Deleuze's two main categories of cinematic images, the movement-image and the time-image, Boissier has sought to define the type of image that would appropriately correspond to interactive cinema.[29] By proposing "relation-image," the artist alludes to the necessary

human intervention that must accompany the coproduction of his object images. His "images" tend to function as associations between the computer program and the interactor in a way that makes "relation" an intermediary between form and transformation. Indeed, the purpose of the relation-image is to think change and transformative processes in the context of image-making strategies that do not rest solely on form. Whereas Erwin Panofsky's notion of "perspective as symbolic form" did not allow the possibility for change, becoming, or transformation, Boissier's notions of "relational perspective"[30] and "image as relational form" move beyond issues of symbolism or representation in order to foster a sense of transformative agency within the confines of both Rousseau's thoughts on image making and illustration and Marey's chronophotographic experiments. In Boissier's heterotopia, the debated issue of "interactivity" in media arts and new media studies suggests more than the interaction between computer program and interactor. The problem becomes one of relating or making various media interact in order to show how human and media memories can be rearticulated using digital technologies.

The relation-image, as the "direct presentation of an interaction,"[31] could be depicted as a rather simple addition to Deleuze's taxonomy, were it not for the fact that it mobilizes a vast array of discourses, apparatuses, texts, and technologies. Thus envisaged, Boissier's relation-images tap into debates over adaptation in visual media less because they address issues of fidelity or repetition than because they tend to maximize and concretize desires embedded in Rousseau's and Marey's projects. The problem of adapting then becomes the problem of realizing; it builds on new technologies not to represent but to perform embedded scenarios, thus asking new questions of old media: What potentialities do they offer contemporary media spheres, and how can older media provoke new relations now that digital technologies have the capacities to simulate older media environments?

Boissier's experimental interpretation of Rousseau and implementation of relation-images have been described by the artist himself as the result of "a strategy of research into interactive cinema."[32] Experimenting with chronophotography, Boissier uses frames to construct another form of cinematic time that progressively unfolds onscreen camera movements. These "moments" are not put together as a linear montage though. On the contrary, Boissier likens his "moments" to "a passage through associations of ideas, a daydream or *reverie*."[33] These relation-images do not begin or end; even though there are entry

points, as Boissier has pointed out, they use the loop as a temporal figure of repetition: "the image carries on in infinite loops, oscillating or circular, which invert, bifurcate, flowing into other loops, all according to the common actions of the *mise en scène* and the current, actual reading."[34]

It is with these thoughts in mind that Boissier endeavours to adapt Rousseau's autobiographical writings. Adding to Rousseau's remarks on how to illustrate *La Nouvelle Héloïse*, Boissier wishes to depict a multitemporal print in which the spectator becomes involved in the image, and Rousseau's wish for a print that would display performances is activated in Boissier's dramaturgy of interactivity. Indeed, it is not enough to confer movement upon the print; Boissier wants the interactor to activate the images of Rousseau's "moments." From Rousseau's conceptualization of the print as potential performance, Boissier has retained the writer's wish for a fluid print that would capture performances. Marey's achievements will be kept in such prints – preserving their indexical link to a given geographical setting where actors performed before the camera.

Needless to say, Boissier's original perspective on moving-image production entails a renewed look at how performance and the senses are deployed in such a heterotopic environment. Bearing in mind that one of this chapter's main arguments is that Boissier adapts Rousseau's *ideals* rather than his fictional works, it is noteworthy that the artist himself has described how his work is indebted to performance insofar as his relation-images "recorded *interactive performances*."[35] As is the case with the other CD-ROMs examined in this study, such interactive performances owe their afterlife to the combination of the eye and the hand. In fact, one of the most interesting contributions Boissier has made in his re-evaluation of moving-image production is its association with haptics. Discussing one of St-Preux's letters to Julie in *La Nouvelle Héloïse*, in which the former comments on the combinatorial functioning of the eye and the hand, Boissier notes: "When the eye supplants in this way the hand, we are speaking of the haptic powers of the image. Our shots and their digital treatment, which reinforces the contrast and detail, contribute to this effect."[36] Even though I would not go so far as Boissier and claim that on his CD-ROM "interactivity supplants gesture,"[37] I would nevertheless pause longer than the artist does on what it actually means for the interactor's "haptic powers" to be called upon. When Bellour maintains that "Thus, everywhere one is surprised with interactions, with the strong feeling that it is the hand

allied with the eye that produces them, whatever has been predetermined by the programme,"[38] the critic may be on to something that merits closer attention.

The combination of the eye and the hand, in the form of "haptic vision," is an engaging philosophical issue. In the context of Rousseau and the Enlightenment, it becomes an even more pertinent topic because it was at the heart of the eighteenth-century zeitgeist. Having examined Rousseau's and Boissier's reflections on image making and perception, it is necessary to have a look at both artists' wish for perception to move beyond the predominance of sight. The following section introduces Rousseau's thoughts on the eye and the hand, and analyzes three of Boissier's adaptations concerning famous episodes in the *Confessions* that mobilize the gaze and haptic vision. In Boissier's relation-images and interactive chronophotography, Rousseau's theoretical comments on the eye and the hand are reactivated in a different historical context and medium in order to show how the gaze can be combined with touch to create a type of spectatorial engagement long neglected in psychoanalytic film theory.[39]

"A Mirror up to Nature": Rousseau's Touch and Boissier's Vision

In Book II of the *Emile*, Rousseau confronts a contemporary philosophical problem known as "Molyneux's question."[40] This "question" refers to several eighteenth-century *philosophes* such as Berkeley, Locke, Leibniz, Condillac, Diderot, and Voltaire who reflected on the hypothetical case of a blind person's ability to recognize objects after sight had been restored. Rousseau's discussion of two senses, sight and touch, partakes in this debate over innate cognition. Indeed, it is in the *Emile* that Rousseau theorizes sight, touch, and haptic vision, and this discussion is crucially important to understand how Boissier's object images appeal to the interactor's senses.

In the *Emile*, Rousseau claims that sight has to be constructed or at least "educated"; it is not an innate faculty, and the Rousseauian subject will have to practice "seeing" according to specific recommendations. In Rousseau's pedagogical work, sight becomes a sensuous instrument that possesses its own historical development. First, the eye is not a given anymore: "The eye no longer is the instrument or the symbol of evidence: it has a history that is for anthropology to tell from a narrative viewpoint."[41] Second, for Rousseau, sight cannot be effective if it is not

combined with touch in a reciprocal association: "Thus, just as learning to touch implies that one exercises the hand with the help of the eye, optics implies that the eye be taken by the hand."[42] As mentioned in Rousseau's privileging of prints over paintings to illustrate his epistolary novel, touch is fundamental in his theory of the senses because it provides sight with an apparent proximity or immediacy.

At the beginning of the third of his *Lettres morales*, Rousseau makes a comment that characterizes his general perspective on vision. Rousseau gives Sophie a rather negative view of humanity: "we are a band of blind men, cast at random in this vast universe. Not perceiving any object, each of us makes for himself a fantastic image of everything that he afterward takes for the rule of the true … We are blind men at every point, but born blind men who do not imagine what sight is."[43] In Rousseau's radical claim that human beings are born blind, what should be underscored is the implicit proposition that sight is just one of the senses that are "the instruments of all our knowledge."[44] This explains Rousseau's emphasis on the interrelation between sight and touch. It is the higher function of these two senses that the writer wishes to underline: "Sight and Touch are the two senses that serve us the most in the investigation of the truth because they offer us the objects more entirely and in a state of persistence more fit for observation than the one in which these same objects lay themselves open to the three other senses."[45]

In the *Emile*, Rousseau turns to sight and touch and gives them a pedagogical emphasis that is meant to show how the senses are constructed rather than given. First, Rousseau will claim sight's unreliability: "Thus sight is the least reliable of our senses, just because it has the widest range; it functions long before our other senses, and its work is too hasty and on too large a scale to be corrected by the rest."[46] Rousseau will go on to suggest that sight be combined with touch to remedy its internal defects: "Of all the senses, sight is that which we can least distinguish from the judgments of the mind; so it takes a long time to learn to see. It takes a long time to compare sight and touch, and to train the former sense to give a true report of shape and distance. Without touch, without progressive motion, the sharpest eyes in the world could give us no idea of space."[47] Rousseau's apparent denigration of sight is not what should primarily concern us; it is the manner in which he describes the eye as being supplemented by the hand in one effective synesthetic combination that should attract our attention. Rousseau adds: "Instead of simplifying the sensation, always reinforce it and verify it by means

of another sense. Subject the eye to the hand, and, so to speak, restrain the precipitation of the former sense by the slower and more reasoned pace of the latter."[48]

As discussed above, Rousseau's meditations on the visual arts can be analysed according to his understanding of the print, but one should also show how his thoughts on the subject actually corroborate his claims on sight and touch. Having to choose between the print and the painting to illustrate *La Nouvelle Héloïse*, Rousseau favoured the print because it establishes a closer relation between the eye and the hand: "The print too can be held in the hand close to the eye; it can 'belong" in that intimate sense to the person who contemplates it ... The inevitable exteriority and 'otherness' of the visual medium [i.e., painting] is to some degree reduced."[49] The closeness of the visual object, associated with the visible texture of the image, establishes a quasi-synesthetic environment in which the print embodies the ultimate relation between the eye and the hand. For Rousseau, the haptic combination of the eye and the hand makes the print a perfect site of immediacy and transparency. Appealing to the reader's senses the way it does, the print would be a more truthful medium to illustrate the novel because it conforms to Rousseau's theory of haptic perception.

Having discussed Rousseau's reflections on the performance-image and his theory of haptic perception, let us examine Boissier's subtractive adaptation of these issues focusing on the notion of the gaze in *Moments*. Examining three of Boissier's most complex interactive chronophotographic sequences will show how the artist has produced embodied moments of contemplation with the combination of relation-images and haptic vision. Examining the photograms featuring Mme Basile, I shall underline the visual construction of the digital prints and discuss the work of the interactor who has to relive Rousseau's often-traumatic experiences. In order to do so, it is important to show how such photograms function; how they are staged to appeal to the interactor; how Boissier's digital chronophotography privileges spectatorial identification; and how the senses (especially sight and touch) perform together in order to reconfigure Rousseau's important "moments" in memorable relation-images. Ultimately, these photograms reveal how to reconcile spectatorial identification with haptic vision in a renewed understanding of the gaze. The first case in point will be the photogram devoted to the event that Rousseau describes in Book II of the *Confessions*, where he retells the story of his visual encounter with Mme

Basile. Staged as a confrontation between self, other, and mirror, the event articulates a different understanding of the dialectic of the gaze.

Mentioning the several opportunities he has had to glance unsuspectingly at Mme Basile, Rousseau begins the lengthy description of what took place that day. Entering the room in which Mme Basile sits embroidering, Rousseau describes the scene:

> One day she went up to her room, bored with the stupid conversation of the clerk, leaving me in the back of the shop, where I did my work. When my small job was finished I followed her and, finding her door ajar, slipped in unperceived. She was beside the window at her embroidery, and facing that part of the room opposite the door. She could not see me come in nor, on account of the noise of carts in the street, could she hear me … She was in a charming attitude, with her head slightly lowered to reveal the whiteness of her neck, and she had flowers in her beautifully brushed hair. Her whole form displayed a charm which I had ample time to dwell on and which deprived me of my senses. I threw myself on my knees just inside the door and held out my arms to her in an access of passion, quite certain that she could not hear me, and imagining that she could not see me. But over the chimney-piece was a mirror, which betrayed me. I do not know what effect this scene had upon her. She did not look at me or speak to me. But, half turning her head, she pointed with a simple movement of her finger to [the lock of hair on] the mat at her feet. I trembled, cried out, and threw myself down where she had pointed, all in a single second.[50]

What first strikes the reader in this passage is the manner in which Mme Basile's look never crosses Rousseau's. It is in the mirror hanging on the chimney that Mme Basile actually sees Rousseau's impromptu and unrestrained emotional display. The exchange of looks occurs in the mirror, and the desiring subjects do not seem able to reach their objects unmediated. It is the paradoxical failure and success of the gaze that this scene dramatizes, a gaze that is as invisible for the subjects as its mediated nature is.

In *The Four Fundamental Concepts of Psychoanalysis*, Lacan refines the function of the gaze he first elaborated in his well-known article on the "mirror stage." Departing from the existentialist understanding of vision – best exemplified in Jean-Paul Sartre's unbearable *regard d'autrui* in *Being and Nothingness* – Lacan questions the very terms that have been used to conceptualize perception, asking: "In other words, must we not distinguish the function of the eye and that of the gaze [*regard*]?"[51] The

eye and the gaze implying two very different visual economies, the psychoanalyst maintains that the gaze is a much more evanescent entity than the look: "Furthermore, of all the objects in which the subject may recognize his dependence in the register of desire, the gaze is specified as unapprenhensible."[52] For Lacan, the viewing subject does not stand in the middle of various gazers; rather, the subject is an *effect of the gaze*. The visual signifiers would capture the subject's look without pointing to a specific signified. As Joan Copjec explains: "This point at which something appears to be invisible, this point at which something appears to be missing from representation, some meaning left unrevealed, is the point of the Lacanian gaze."[53] Consequently, the gaze stands outside the field of perception and is the object-cause of desire. A Lacanian interpretation of the episode between the young Rousseau and Mme Basile would thus emphasize the former's subjectivity as an effect of the gaze.

Were it only for such a failed visual encounter, the incident would be quite banal. However, when depicted in the context of the failure of the gaze to answer the subject, the incident seems to motivate another reading. Rousseau gives his own interpretation of the scene: "Disturbed by my state, disconcerted at having provoked it, and beginning to realize the consequences of a gesture no doubt made without reflection, she neither drew me to her nor repulsed me. Indeed, she did not take her eyes from her work, and tried to behave as if she could not see me at her feet. But despite my stupidity I could not fail to realize that she shared my embarrassment and perhaps my desires, and was restrained by a bashfulness equal to my own. This, however, did not give me the strength to conquer my fears."[54]

Rousseau's description of this "vivid and mute scene" leaves a great deal to be deciphered. Literally captivated by the sight of Mme Basile not seeing him, Rousseau endeavours to explain this event using words such as "embarrassment" and "shame." However, Copjec's understanding of the gaze may reveal more about Rousseau than the writer himself would allow: "The subject, in short, cannot be located or locate itself at the point of the gaze, since this point marks, on the contrary, its very annihilation. At the moment the gaze is discerned, the image, the entire visual field, takes on a terrifying alterity."[55] As far as Rousseau is concerned, his description of the missed visual encounter reveals the obliteration of the young man's place in intersubjective desire.

In Boissier's adaptation of the scene, what the interactor first notices is that the event occurs in Paris in 1998, and that Mme Basile's appearance

seems to match Rousseau's description. Wearing a dress with pink roses, Mme Basile is seen sewing. This is what takes place in the photogram on the left-hand side of the screen. Once the interactor uses the mouse to move the photogram from left to right, Mme Basile sits back, and the mirror is revealed hanging on a white wall. This photogram stays with Mme Basile visible in the mirror; she carries on the same activity as in the first photogram.

The interactor soon realizes that Rousseau is nowhere to be seen in this scene or on the CD-ROM altogether. Boissier's scenic strategy is more interesting. Describing the installation *Flora petrinsularis*, which also presents the Mme Basile episode, he reflects on his mise en scène: "Whereas it is he [the interactor] who designates the signs, the images simultaneously address him, his subjectivity [...] The reader is forced to share with Rousseau the place that is assigned to him *a priori*. He should feel, whether it be consciously or not, both pleasure and shame."[56] In a recurrent process of imaginary identification with Rousseau, the interactor literally becomes the writer as she adopts Rousseau's point of view and relives his past experience with Mme Basile. In this object image, when Mme Basile looks into the mirror, she does not see Rousseau; rather, she perceives the interactor glancing at her. Looking directly at the interactor, Mme Basile continues to embroider until the interactor decides to go on to another photogram or to return to the photogram on the left, in which case Mme Basile will look into the mirror. In other words, whether you go from the first photogram to the second or the second to the first, Mme Basile will look at the interactor in the mirror. This moment echoes what Boissier has said of the becoming of cinema in the sense that "Considering the becoming-interactive of cinema means focusing on what, in the image itself, inscribes relations really involving the gazers."[57]

What draws attention in the photogram featuring Mme Basile and the interactor standing in as Rousseau is the reconfiguration of the gaze in these object images. First, one must acknowledge that Rousseau not only seems to have introduced seeing into literature of his day, as O'Neal has argued, but, more importantly I believe, he touches on the difference between the look and the gaze two hundred years before Lacan. As several scholars have noted, Rousseau offers a convincing differentiation between the eye and the gaze: "The distinction Rousseau makes between *sight* and the *gaze* proves that he is aware of the perceptual process, *seeing* or *glancing* being reserved for the passive reception of images, whereas *gazing* conveys a voluntary act that allows one to

distinguish and compare. Therefore, the act of gazing attaches itself to the pulsations of desire."[58] In Lacan's thought the gaze is an *objet a*. It is a fragmented object that causes desire that can never be pinned down for sure.[59] It functions elusively, and its evanescence is its essence. A Lacanian analysis of the scene featuring Mme Basile would examine Rousseau's staging of his desire as the desire of the other (Mme Basile) in the rapid exchanges of looks that paradoxically liberate him from and enchain him to Mme Basile. Such an account, however, would bypass the workings of the gaze in Rousseau's retelling, which the subject is unaware of and which Lacan's magisterial analysis has helped to enlighten.

The mirror that features so prominently in the episode is the object that engages Rousseau on the path to intersubjective desire. His solitary visual pleasure being taken away as Mme Basile looks back at him in the mediatized environment of the mirror, Rousseau loses his privilege as bearer of the look to become the object-effect of the gaze. This reciprocal exchange is completed when the voyeur becomes the exhibitionist and when the roles are exchanged again. What characterizes Mme Basile's subtlety is that she does not look at Rousseau directly; instead, she furtively glances at him in the mirror and points to a lock of hair on the floor, which is supposed to be the sign of a mutual understanding. The female intruder sustains desire as much as she blocks it, and Rousseau's fantasies are subjected to intersubjective recognition. Mme Basile's visual tact demonstrates her unwillingness to become the object of the gaze, because she does not look back at Rousseau. The question to be answered is: does Boissier's subtractive adaptation reproduce Rousseau's depiction of the scene, or does it add something to the Lacanian logic of the gaze so useful to analyse Rousseau's description?

In his analysis of Boissier's photogram, Bellour rightly notes that Boissier did not include the description of the scene itself as quoted above. Rather, it is Rousseau's interpretation that accompanies the photogram. But what the photograms depict is the incident itself; in this case, the scene involves Mme Basile and the interactor as the sixteen-year-old Rousseau. However, one would think that the analysis of the photogram would demand more than the description of the setting. Based on an episode largely concerned with imaginary identification, intersubjective desire, and the mediated gaze, it may be more appropriate to ask how Boissier's object images actually reinterpret this scenario of fantasy with the help of digital tools.

Focusing on the aesthetics of the loop in Boissier's work, Bellour mentions the type of shots used and describes the setting, and he makes an astute remark on the process of identification in the heterotopia that ties in with haptic vision: "It is clear that I operate the mouse and watch the image transform, this confessional text calls upon me to take Rousseau's place as much as that of reader and judge, as he wished."[60] Such a suggestive comment requires elaboration in order to better assess the combination of senses, fantasies, and intersubjective demands the adaptation features. Boissier adds to Rousseau's depiction of the gaze and our understanding when he states that "to conceive of an entity such as the body, an imaginary body provided by the film as the medium of the gazer's performative and perceptive intentionality, could be another way of keeping identification at bay in the relational act."[61]

The process of imaginary identification that Bellour and Boissier emphasize is related to a specular effect the mirror (for both Rousseau and Boissier) allows. The CD-ROM adaptation permits not only the reproduction of this moment in Rousseau's life but also a subtler process of identification between Rousseau and the interactor. In other words, the *Confessions* presents an autobiographical subject before the mirror, and the CD-ROM offers the interactor a screen through which he sees a mirror. What, then, does it mean to become Rousseau in this doubled "screen" (computer screen and mirror), and how is it possible to make the transition from written subject to embodied interactor?

Reminding her readers how feminist film theory misappropriated Lacan's logic of the gaze in conceiving the screen as mirror, Copjec argues that such a viewpoint omits "Lacan's more radical insight, whereby the mirror is conceived as screen."[62] Indeed, one need return to Lacan's eleventh seminar in order to find out how the desiring subject uses the screen: "Man, in effect, knows how to play with the mask as that beyond which there is the gaze. The screen is here the locus of mediation."[63] For Lacan, the screen is not a mirror; it is the mirror that functions as a screen mediating between the subject's demands and the gaze. In the case of Boissier's recreation of Rousseau's mirrored looks, the gaze eludes both Rousseau and Mme Basile, but it seems to occupy a space outside the screen. Indeed, the computer screen mediates between the interactor and the mirror, but the former knows that there is a gaze structuring this episode. This peculiar appropriation of the gaze is linked to the performative capacities of the subtractive adaptation.

Activated by the eye and the hand of the interactor, the scene manifests the desire to render what Rousseau must have felt at the moment when Mme Basile refused to look back. However, and this is what needs to be underlined, Boissier departs from the written text of the *Confessions* and has Mme Basile look straight at the interactor. What are the consequences of such a choice? Does it affect the logic of the gaze prefigured by Rousseau and theorized by Lacan?

Jean Starobinski has formulated the manner in which the gaze, when deprived of sight, can be supplemented by other senses. In the relational concept of the eye that he develops in his reading of French writers, Starobinski proposes a haptic aesthetics, and his account of the gaze uses an embodied basis that could explain the workings of the sensuous gaze in Boissier's relation-images, as in the case of Rousseau's visual encounter with Mme Basile.[64] This analysis helps to make sense of the function of the mirror as a specular supplement that doubles the material process of the image with the imaginary process of identification and their embodied basis in the senses.

It is not so much shame that transpires from Rousseau's account as the manner in which the gaze is not only relational, as Starobinski contends, but also an object that always fails to be the representation of a mutual desire. The visibility of desire – in the mirror – takes the object of desire for the emptied signifier it is. In *Moments*, the relational and sensuous concept of the gaze playfully turns from Rousseau's text and transforms the imaginary identification into a form of spectatorial identification that nevertheless uses the mirror as a prop to reorient and mediatize desire. This desire, literally made visible, embodies the other (Rousseau) as a transferable being whose desire remains unfulfilled. The desire of the other, on the CD-ROM, becomes for a moment the desire of the interactor. However, contrary to what happens in Book II of the *Confessions*, Mme Basile does look back at the interactor. The eyes cross, the interactor's desire is thwarted, and the specular identification so much prised by Rousseau is evacuated as a result of the fundamental change in the scenario and the exclusion of the Rousseau character. What Boissier's relation-images propose, however, is the adaptation of the logic of the gaze in both Rousseau and Lacan in order to reinvest the realm of the senses with digitally enhanced embodied vision.

The second filmed "moment" concerns an early episode in the *Confessions*, which is Rousseau's description of Mlle Lambercier's potential spanking. Rousseau's affection for his surrogate mother derives from a peculiar understanding of discipline and punishment. Indeed, on the

one hand, the young Rousseau seems to fear Mlle Lambercier's author-
ity when it takes the form of corporeal punishment; on the other hand,
he takes an undeniable pleasure in being spanked and, mostly, in wait-
ing to be spanked. Here is the excerpt Boissier has included on his CD-
ROM to accompany the adaptation of Rousseau's description:

> For a long while she confined herself to threats, and the threat of a punish-
> ment entirely unknown to me frightened me sufficiently. But when in the
> end I was beaten I found the experience less dreadful in fact than in antici-
> pation; and the very strange thing was that this punishment increased my
> affection for the inflicter. It required all the strength of my devotion and all
> my natural gentleness to prevent my deliberately earning another beating;
> I had discovered in the shame and pain of the punishment an admixture of
> sensuality which had left me rather eager than otherwise for a repetition
> by the same hand.[65]

Rousseau's enigmatic *jouissance* seems to stem from Mlle Lambercier's
deferred treatment. The very possibility of being spanked becomes
a source of pleasurable sensation, which Rousseau tries to convey in
a way that combines shame and revelation. Moreover, the fact that
Rousseau longs for his surrogate mother's punishment is problematic
in itself. However, this detail will not guide my analysis of Boissier's
adaptation of the scene.

As stated earlier in the interpretation of the Mme Basile photogram,
the Rousseau persona is not to be seen in Boissier's adaptation. It is the
interactor, in a process of identification via subjective camera shots, who
becomes Rousseau. In most of Boissier's photograms, the actor breaks
the fourth wall that is supposed to make a clear distinction between fic-
tion and reality, actor and spectator.[66] Here, in the case of Mlle Lamber-
cier, she is represented in medium close-up, her hand threatening the
young Rousseau. Staring at the interactor, Mlle Lambercier, in the first
photogram, reminds the interactor that she may administer a beating.
When the interactor decides to touch the screen via the mouse and go
from left to right, the panning shot reveals a man, Mlle Lambercier's
brother, his back turned to the camera. A few seconds later, without
the interactor having to touch the object image, the man turns around
and glances threateningly at the interactor. Mlle Lambercier's brother,
whose punishment Rousseau claims would not have been as "enjoy-
able" as that of his sister, appears to be more of a castrative agent than
the bearer of pleasurable sensations for the precocious Rousseau.

The most interesting effects this photogram has on the interactor is in its spectatorial and embodied address. Indeed, it is the touching of the mouse or keyboard that allows the interactor either to escape Mlle Lambercier's menacing hand and move to the even more threatening sight of her brother or to come back to Mlle Lambercier, as Rousseau may have done himself had he been in the position of the interactor. What Boissier stages in this photogram is the inescapable presence of the deferred punishment the interactor as Rousseau would have "to suffer." While the interactor performs back-and-forth movements, there arises the augmentation of the precise pleasure the initial waiting was meant to generate. The interactor, in the imaginary position of Rousseau, is compelled to repeat the writer's own ambiguous obsession with Mlle Lambercier's hand. It is on such occasions that the radical nature of Boissier's mise en scène emerges: the performative nature of the digital heterotopia rehearses the masochistic tendencies and perverse desire of Rousseau not before the screen for the spectator, as a conventional film adaptation would have it, but in the transference of affect from Rousseau to interactor via the object images' emphasis on haptics.

Such a subtle manoeuvre is repeated in a third "moment," and it concerns the famous scene in Book II of the *Confessions* where Rousseau unjustly accuses a young woman, Marion, of stealing a ribbon he has himself stolen. Putting the blame on the young woman, Rousseau will forever suffer from guilt, he claims, because of his devious accusation. In an interesting moment of self-analysis, which reappears in the textual excerpt Boissier has placed above the photogram, Rousseau comments on the reasons why he has wrongfully accused Marion: "I accused her of having done what [that is, stealing the ribbon] I intended to do myself. I said that she had given the ribbon to me because I meant to give it to her."[67] Here again, the excerpt does not exactly correspond to the photogram the interactor is invited to explore. Whereas Rousseau's words point to the psychological explanation of his behaviour, the first photogram features Marion in close-up, her eyes looking downward. Once the interactor has moved to the right, Marion looks up and addresses the interactor in passing. The main photogram on the right offers a closer look at Marion's sad demeanour. Staring into the eyes of the interactor, Marion conveys the impression of a helpless woman waiting for justice to be served. Returning to the left-hand side of the photogram, the interactor finds a new shot of Marion, the actress wiping her eyes with her sleeve.

At first glance, there seems to be a discrepancy between what the photograms show and the accompanying textual excerpt. Indeed, the focus of the object images is on what Rousseau must have felt faced with Marion's inquiring eyes, whereas the excerpt explains the reason motivating Rousseau's accusation. One element that strikes the reader in Rousseau's retelling is the manner in which the writer does not seem so much repentant as actually haunted by the memory of an incident that keeps returning in his adult mind. As Rousseau explains: "I saw nothing but the horror of being found out, of being publicly proclaimed, to my face, as a thief, a liar, and a slanderer."[68]

Furthermore, the photograms revive the scene in order to make the interactor experience Rousseau's guilt before the falsely accused Marion. The performative quality of the photograms, as shown above, stems from the direct address on the part of the actresses who willingly integrate the interactor in the adaptation. Rousseau's physical description of Marion ("Marion was not only pretty. She had that fresh complexion that one never finds except in the mountains, and such a sweet and modest air that one had only to see her to love her"[69]) can be corroborated, but what evades the interactor's look is Rousseau's descriptions of Marion's pleas of innocence because they do not appear in the photograms. Indeed, Boissier did not preserve the elliptical, dramatic, and montage effects of Rousseau's description: "When she came she was shown the ribbon. I boldly accused her. She was confused, did not utter a word, and threw me a glance that would have disarmed the devil, but my cruel heart resisted. In the end she firmly denied the theft. But she did not get indignant. She merely turned to me, and begged me to remember myself and not disgrace an innocent girl who had never done me any harm."[70] The only words Marion will be allowed to speak are those that are supposed to bring Rousseau to his senses: "The poor girl started to cry, but all she said to me was, 'Oh, Rousseau, I thought you were a good fellow. You make me very sad, but I should not like to be in your place.'"[71] Alluding to the guilt that will stem from Rousseau's false accusation, Marion claims that this will be his eternal punishment.

In the final analysis, Boissier's adaptation strategy is simple and effective: to go on location, in Haute Maurienne in 1998, to film a young actress whose candour and fair features will recall those of Rousseau's Marion; to downplay any dramatic speeches or scenes; and to focus on Marion's facial address. The interactor should experience what Rousseau experienced before the accused Marion. Her face becomes a space in which the interactor is able "to read" a plethora of signs that demand

recognition and action. As Daniel Bougnoux has said of the face in a way that uncannily relates to Boissier's relation-images: "Not only is the face, etymologically speaking, the object of sight – the other's body part that has a predilection to draw attention – but it also responds to the gazes directed towards it by observing the way in which it is gazed at. Object and subject of the gaze, the face weaves a relational intrigue."[72] Moreover, the manipulation of the photogram, via the mouse or keyboard, should help the interactor experience a moment she has never lived. In fact, performing Marion is not enough; the interactor must "perform Rousseau" if the virtual encounter is to take place. In the three photograms analysed above, performing Rousseau refers not so much to the autobiographical Rousseau's theatrical stagings or expressions as to the interactor taking Rousseau's place before Mme Basile's mirror, Mlle Lambercier's threatening hand, and Marion's sad complexion in Boissier's object images that rely on the computer screen, the mouse, and a renewed conception of the gaze to offer a novel type of adaptation.

A Different Look

Boissier's subtractive adaptation of "moments" in Rousseau's *Confessions* brings us back to the "original," that is, the written descriptions of the original incidents, but, more importantly, they question their logic of the gaze. Suggesting that sight is not the only sense involved in the gaze, Boissier's CD-ROM allows us to reconsider Rousseau's *Confessions* to look for the work of the other senses in the unfolding of the piece. In fact, the specular identification characteristic of screen-based environments like cinema – considered to be the obverse side of haptic vision that allows the metonymical contact or caress of the screen, subjects, or objects it presents in a quasi-symbiotic fashion – becomes problematized as the terms of this visual dichotomy seem to function simultaneously in Boissier's adaptation.

The reconsideration of the gaze in Boissier's interactive chronophotography depends on the function of the interactor in the object images Boissier has created. The digital dispositif itself contributes to restaging the encounter between subject and visual stimuli. It is in the reconfiguration of the gaze that Boissier's achievement would lie. Departing from Rousseau's early staging of the look in action, Boissier envisages it as something that can be seen to re-emerge in the digital environment in an embodied way. In Boissier's heterotopic design, the

interactor does not vanish, but testifies to Rousseau's metaphoric disappearance. The gaze is not seizable in the CD-ROM adaptation; it is "pictured" within the confines of the screen that shapes the encounter for the interactor. Wouldn't it be truer to claim that for Boissier the photograms and the computer screen do not only concern images, looks, or gazes, but also embodied actions, corporeal demands, and intersubjective desires that place the interactor in an unprecedented "viewing" position? Because the gaze is supposed to "photo-graph" the subject, according to Lacan, it would be appropriate to argue that it is the computer screen that gazes at the interactor and projects her image onto Boissier's relation-images.

The performance of the sensuous gaze, augmented by touch and hearing, makes Boissier's subtractive adaptation the site of an important reconfiguration of the gaze as that which is unsatisfied and always already consumed visually. However, it can be redeemed by the other senses that are not affected in the exchange between the interactor (who is in Rousseau's position) and the female characters and actresses. The relation-images that stage these visual encounters could not function without the collaboration of the hand with the eyes that could open onto other forms of the object image such as what Boissier has termed the "playable image."[73] In such a revisionist account of what cinema could be and what digital adaptation is, the gaze would detach itself from the realm of the visual and would concern the performative, the kinetic, the proprioceptic, and the synesthetic. Boissier's CD-ROM forces a reconsideration of the logic of the gaze that would not be centrally concerned with sight but with the interrelations that the other senses, in conjunction with the eyes, would produce. The visual residue of desire, as patent as it may seem in Rousseau's account, is displaced by Boissier in the material appropriation of the gaze in embodied, mnemonic traces of the senses, which the interactor performs in a way that reconfigures Rousseau's suggestive thoughts on illustration and perception.

A Cinema of One's Own: The Mediumistic Performance of the Female Body

Zoe Beloff works with a variety of moving-image forms and technologies, including film, stereoscopic projection, and interactive media. The artist likes to think of herself as an heir to the nineteenth-century mediums whose materialization seances conjured up unconscious desires in theatrical fashion. In installations such as *A World Redrawn: Eisenstein and Brecht in Hollywood* (2015), the collectively produced *The Days of the Commune* (2012), *Dreamland: The Coney Island Amateur Psychoanalytic Society and Their Circle 1926–1972* (2009), *The Somnambulists* (2007), *The Ideoplastic Materializations of Eva C.* (2004), and *The Influencing Machine of Miss Natalija A.* (2001),[1] Beloff explores the vast phantasmagorias we have engaged in ever since the rise of visual media, including discourses on hysteria and psychoanalysis, spirit photography, the paranormal, the vicissitudes of male desire, female mediumship, and mechanisms of mental projection, among many others. Beloff has made several analogue and 3D movies that explore themes similar to the ones examined in her installations, which include *Two Marxists in Hollywood* (2015), *Charming Augustine* (2005), *Claire and Don in Slumberland* (2002), *Shadow Land or Light from the Other Side* (2000), *A Mechanical Medium, Lost* (1999), *A Trip to the Island of Knowledge* (1994), *Life Underwater* (1994), and *Wonderland USA* (1989).

Beloff has designed two fascinating artistic CD-ROMs: *Beyond* (1997) and *Where Where There There Where* (1998).[2] A collaboration between the artist and the New York Wooster Group Theater Company, the latter work is inspired by Gertrude Stein's 1938 play *Doctor Faustus Lights the Lights*, and it stages playful investigations of the relationship between electricity, logic, and language games. *Beyond*, the subtractive adaptation under study in this chapter, is one of the most challenging CD-ROMs

produced in the last twenty years. Intermingling several philosophical, cultural, technological, and artistic traditions, Beloff's heterotopia proposes a complex interpretation of French writers Villiers de l'Isle-Adam and Raymond Roussel in the context of Walter Benjamin's philosophy of history, the almost simultaneous birth of cinema and psychoanalysis, and, finally, the role of women in the great phantasmagoria that put their bodies at the centre of what Beloff has called the "dream life of technology."

Moreover, being reminiscent of the manner in which Perry Hoberman's *The Sub-Division of the Electric Light* (1996) revives ancient film and slide projectors, *Beyond* combines the panorama and cinema and allows them to function as digital artificial entities in which past dramas and experiences are replayed and relived in an ambiguous form of visual nostalgia and mourning. *Beyond* thus explores the paradoxes of desire and the paranormal provoked by technologies of mechanical reproduction such as the panorama, photography, magic lantern shows, and cinema, as Beloff inserts her digital practice in a revival of sound technology that is predicated on the female body in performance to be effective.

This chapter addresses Beloff's digital heterotopia and focuses on the two main literary sources that *Beyond* adapts: Villiers de l'Isle-Adam's *Tomorrow's Eve* [*L'Eve future*] (1886) and Raymond Roussel's *Locus Solus* (1914). First, a discussion of the novels using the critical insights of recent cultural histories of sound technologies, inscription, and reproduction sets the stage for contemplating the issues at the heart of the CD-ROM: the fate of the body in the mechanical reproduction of the voice, the physical and visual manipulation of the female body by scientific authorities in cases of hysteria, and the staging of performances starring unwilling women. Villiers's and Roussel's novels present some of the cultural and philosophical discourses associated with fin-de-siècle media such as photography, phonography, and early cinema in their treatment of women, representations on which Beloff builds with regard to material and symbolic inscriptions of the female voice and the mediumistic body. What characterizes Beloff's adaptation is this rich sociocultural background that greatly complements her rendering of Villiers's and Roussel's novels. In fact, it is not farfetched to say that the setting for Beloff's adaptation is early cinema culture itself.

In the vast space of technological and cultural sources that *Beyond* revisits, two intertwined aspects concerning early cinema culture will deserve closer attention. In her QuickTime movies and panoramas, the

artist alternates between attraction (or spectacle) and narration, thereby recreating early cinema's tension between showing and telling[3] and resolving this tension by performing as both medium and film lecturer. *Beyond* thus revives early cinema culture's film lecturer in the digital era and shows how such an embodied performer is the key agent who acts as a "quilting point" that sutures the object images' indeterminate stance between showing and telling.

Introducing *Beyond*

First launched as a web serial in 1995, *Beyond* features performances that were uploaded weekly and collected in the CD-ROM environment two years later. To revisit the daunting array of sources included in *Beyond*, Beloff uses QuickTime movies and virtual panoramas in which she inserts her own obsessions and performances. In Beloff's heterotopia, virtual panoramas are used to lead the interactor from one mental space to another, a space she calls "mental geography." Once inside this space, the virtual panorama becomes "sensitive": one can click on certain images inside the panoramas to view a specific QuickTime movie that is hyperlinked to the image. Beloff thus joins the panorama with the very personal cinema that the viewing of QuickTime movies on the computer implies.[4]

Beloff's CD-ROM is a singular artefact that positions the interactor between two visual worlds. On the one hand, there is the heterotopia in which text, image, and sound are combined on a digital multimedia platform and with which the viewer is encouraged to interact. On the other hand, there is the more conventional filmic world with which we associate the usual silent viewing position. While it is true that this viewing regime relates to cinema, it would be inaccurate to say that it confines itself to it. Indeed, as Beloff has mentioned, traversing the virtual spaces of her work is a highly individualistic experience that has nothing to do with watching a film in a movie theatre.

The singularity of Beloff's work stems from the use of QuickTime movies and panoramas that enhances a visual experience bordering on technological indeterminacy. Indeed, while the aesthetics of the QuickTime movie both recalls cinema's early days and is emblematic of the digital age, the virtual panoramas make us time travel to the period when artists and inventors tried to reproduce the illusion of movement with paintings and still images. The actualization of the panorama and early cinema in the software architecture of QuickTime points to a

critical perspective that does not support the discourse of technological progress. While it is obvious that Beloff uses digital tools to create her CD-ROMs, she nevertheless focuses her attention on past moments in the history of women and technology that reveal her interpretation of memory as a discontinuous space of narratives and repressed moments in which technologies often work to destabilize our collective understanding of tradition and gender relations.

It is not a simple remediation of cinema that takes place in *Beyond*. As I will argue, Beloff's object images aim to reach beyond not only cinema's becoming-narrative but also the supposed stability of memory itself.[5] As Walter Benjamin's philosophy of history tried to do away with a certain historical memory made of facts and figures, winners and losers, Beloff's concept of memory does not function as a self-regulating and stable repository of past experiences and images either.[6] Her CD-ROM foregrounds memory and the numerous histories that memory is made of in a way that privileges recycling and remediation in all their virtual potentialities. The artist's use of ruins throughout her work points to the way in which discarded objects and debris possess a virtual future of their own that can be activated by anyone who sees in them their potential for renewal.

Beloff's CD-ROMs are particularly stimulating examples of a digital practice that accentuates differential discursive spaces and fuses various media without trying to hide their multifaceted origins. A work such as *Beyond* re-examines the collective fantasies and phantasmagorias underlying nineteenth-century audiovisual technologies and the social discourses that clothed the rise of female subjectivity and agency in various fin-de-siècle "scientific" experiments qua spectacles. Beloff reanimates modernity's combined excitement and anxiety facing the sociocultural and media transformations best captured by Baudelaire and Benjamin. Addressing the legacy of cinema and, most importantly, its multiple origins in various moving-image technologies and performances, the artist practices a very idiosyncratic media archaeology that merges the artistic archive, the visual appeal of cinema, and the artist's persona as performer.

One of Beloff's challenges is to find a way to address the plethora of audiovisual and textual sources in her work by making an engaging space of interaction. As Jeffrey Skoller has noted apropos of *Beyond*: "The problem returns once again to the earlier tensions within historical construction between the need to shape materials from the past into narrative forms that create meaningful relationships between past and

present and an open field that allows for unpredictable connections."[7] In fact, *Beyond*'s hypermedia design questions both Skoller's emphasis on "narrative forms" and the idea that CD-ROM art must rely on narrative integration to be interesting, and positions interactive media materiality as being always engaged in the blurring of boundaries between narrative and performance. The combination of CD-ROM technology and the resurgence of early cinema's lecturer via the female body in performance will cast light on Beloff's digital adaptation practice, which underscores the multifaceted tensions between digital mediumship, database cinema, and novelistic sources that do create "unpredictable connections" in the diverse object images her work offers.

Using Villiers de l'Isle-Adam's *Tomorrow's Eve* and Raymond Roussel's *Locus Solus* to conceptualize her work, Beloff takes inspiration from the particular treatment of technology, women, reproduction, voice, and performance in these source texts. The fact that women and technology intermingled in the minds of nineteenth-century scientists is intriguing, and Beloff has tried to unravel the manner in which women were deprived of agency while machines were granted autonomy in late nineteenth- and early twentieth-century writings. In works such as Villiers's and Roussel's novels, the new "woman" did not use technology, but she actually became part of various technological assemblages that put her body to the test.

Producing the Mechanical Woman: Villiers and Roussel

The American inventor and legendary figure, Thomas A. Edison, has come to stand for the creator par excellence, the man whose powerful intellect allowed him to invent the incandescent light bulb, the kinetoscope, and the phonograph, among many other inventions.[8] The fact that Villiers's *Tomorrow's Eve* features a character named Edison and that Roussel's *Locus Solus* refers to the legendary figure and, most importantly, his invention – the phonograph – points to the centrality of the mythical inventor and his inscription device that captured sound on a cylinder of tinfoil and celluloid. That the novels offer a distinct treatment of the female voice and body is noteworthy, but they both address the same fundamental issues of aurality and reproduction. The role of the phonograph and film in the authors' multifaceted manipulation of the female body and voice is of particular interest, and it is the manner in which Villiers's and Roussel's novels articulate this issue that I wish to underline prior to looking at Beloff's CD-ROM.

The tentative title for Villiers's novel was "Edison's Paradoxical Android." However, the focus soon shifted from the figure of the inventor to the curious function of the mechanical woman for the future of humanity, hence the title we know: *Tomorrow's Eve*. The narrative is fairly straightforward. Lord Ewald – having saved Thomas Edison's life in the past – demands that Edison grant him a favour in return and create a "perfect" woman based on his rather intellectually "imperfect" girlfriend, Alicia. Accepting the challenge, Edison will keep Alicia's physical appearance and produce an android that will fulfil Lord Ewald's desires. This perfect woman will be called Hadaly.[9]

Edison's powers do not lie solely in his ability to record sound. Indeed, he uses different visual technologies such as photosculpture to project Alicia's physical appearance onto the android's body, and this hybrid art that combines sculpture with the latest technological finding, photography, will allow for what he calls "transubstantiation." In Book 4 of the novel Edison shows Lord Ewald a sound film that features the performance of dancer Evelyn Habal. The narrator describes the scene: "The transparent vision, miraculously caught in color photography, wore a spangled costume as she danced a popular Mexican dance. Her movements were as lively as those of life itself, thanks to the procedures of successive photography, which can record on its microscopic glasses ten minutes of action to be projected on the screen by a powerful lampascope, using no more than a few feet of film."[10] What is quite interesting for the reader in this passage is to come across the description of an invention that resembles cinema, but ten years before the Lumière brothers brought it to public attention. A contemporary of Etienne-Jules Marey and Eadweard Muybridge, Villiers had heard of the former's work on chronophotography and of the latter's experiments in zoopraxography. Somewhat reminiscent of Marey's and Muybridge's experiments, Villiers's description of Edison's apparatus points to the manner in which the *performing body* was at the centre of the experiments in movement photography that eventually led to the combination of the phonograph and recording technologies. As Marie Lathers points: "During his recuperation of the past, Edison stresses, however, that the two recording technologies, the phonograph and the camera, must be used in conjunction."[11] Finally, one should bear in mind that it is a woman (via her voice and body) who is the favourite "site" for this technological performance and conjunction of media. Edison's visual apparatus thus echoes the thesis about the complementary role of the phonograph, the camera,

and performance in the novel, a central media assemblage on which Beloff will base her subtractive adaptation.

Addressing some of the crucial themes in the novel, Felicia Miller Frank has said of this assemblage that "the striking predominance of the voice in the text and the accompanying foregrounding of the phono-graph"[12] are the most important issues in Villiers's work. In her analysis, Miller Frank wishes to revise Raymond Bellour's and Annette Michel-son's thesis that it is the representation of a proto-cinematic experience that characterizes the novel by emphasizing the phonograph and its aural space.[13] Similarly, Alain Boillat has suggested that Villiers's novel "merits greater attention from the point of view of the voice and the implications of phonographic technology"[14] in a way that cannot but remind us how aurality is tied to visual technologies. In the final analy-sis, it is the assemblage of visual technology, aurality, *and* the perfor-mance of "hysteric" women that needs to be addressed in both Villiers's novel and Beloff's work, as we shall see.

Ten years before the publication of Sigmund Freud and Joseph Breuer's *Studies on Hysteria* (1896), *Tomorrow's Eve* also marks a turn-ing point in the literary representation of women. Whereas Freud and Breuer would depart from Jean-Martin Charcot's physiological account of female hysteria to argue for a psychological treatment of it, Villiers's novel displaces the problem of man's misunderstanding of female desires onto the potential role technology could play in order for him to overcome the dissatisfaction with his female partner. Indeed, it seems that Villiers did not want to use psychological means to "cure" women; in fact, his utopian and often misogynist treatment of women implies that they have to be "emptied" of their original psy-chological "content" in order to fulfil man's desires. Woman seems to function as a technology gone awry: she has to be "reprogrammed" by male scientists in order to function properly. While Méliès was presenting a cinematic spectacle in which some performances made women appear and disappear, another "magician," Charcot, used photography to capture the women who performed in his staged rep-resentations of the spectacle called "hysteria." In a manner recalling Charcot's female "protégées," Edison's android becomes malleable and can be "re-programmed" to conform to man's idea of woman-hood and femininity. Edison's and Charcot's scientific projects do look alike upon closer inspection. What they stage is *woman as per-forming medium*, and Beloff will restage this obsession in her object images.

This mediumistic performance would concern both the representation and the erasure of the female body. In fact, Villiers's novel emphasizes the effacement of the female body in performance. While the representation of the female body was necessary for both the creation of Hadaly and the invention of cinema, it seems that female embodiment had to be excluded in order for those creations to take place. In other words, the female body in performance had to disappear in order for its phonographic and cinematic representation to be created. In the description of the movie projection quoted earlier, Edison not only discusses Evelyn's dance performance, but he also marvels at the recreation of live movement itself. Edison's own performance as creator would overshadow that of Evelyn as female performer. The spectacle of mechanical reproduction takes precedence over the performance of the body that fuels the image Edison contemplates with admiration. The materiality of the dancing female body seems to demand too much from the male inventor, and he wants to deal with it in a manner that will erase its embodied presence. Therefore, there is a double performance taking place in *Tomorrow's Eve*: one involves the erasure of the female body in performance, and that is coupled with the performance that the newest technology offers as spectacle.

Turning to Roussel's novel, which is a great stage of hallucinating machines, *Locus Solus* is also concerned with the themes of repetition, revival, reproducibility, inscription, and aurality that pertain to the manipulation of the female body in performance. However, it adds another issue that was not discussed in the analysis of Villiers's work: the desire *to raise the dead* as part of the desire to create an invention that would reproduce life mechanically. The third-person narrator of Roussel's novel is part of a group of friends who take a tour of Locus Solus, the name of Canterel's mansion. The main character, Canterel, is based on Thomas Edison, the central character in Villiers's *Tomorrow's Eve*. While Roussel's narrator describes Canterel's numerous inventions, we soon realize that the most impressive and uncanny inventions are the ones that allow the dead to come back to life and indulge in various performances and repetitions. Two scenes of reanimation are noteworthy: the first concerns Faustine, a reborn dancer, and the second features Lucius's desire to reproduce his dead daughter's voice. Whereas a woman performer, Faustine, is brought back from the dead to dance for the male viewing pleasure, the character of Lucius wishes to revive his dead daughter's voice with the help of the phonograph, Edison's own invention. At the heart of Roussel's novel thus lies the wish to reanimate

that is translated into the posthumous performance of the female voice and body.

Roussel and *Locus Solus* have had famous interpreters in the past. One need only mention the names of Michel Leiris, Michel Foucault, Alain Robbe-Grillet, and Pierre Janet in order to show that this marginal voice of modern French literature has attracted the attention of important thinkers and artists.[15] However, in the writings of such illustrious commentators, it seems that too much emphasis has been put on Roussel's art of composition to the detriment of other significant issues. As revealed in his posthumous book entitled *Comment j'ai écrit certains de mes livres*,[16] Roussel explains how he developed his famous writing style, which is characterized by the extreme attention paid to minute details, long factual descriptions, and contingent wordplays. Yet Roussel's project, as Douglas Kahn has astutely argued, seems to be more about the interrelations between visuality and aurality than about stylistic exercises: "It is also obvious how sound, working inward and outward from the surfaces of his [Roussel's] texts, operates to supply an environmental and corporeal volume that vivifies and gives dimension to his scenes. It becomes difficult, in fact, when confronted with these sonic achievements of Roussel, to place him so confidently behind the eye alone; instead, one must acknowledge a tenaciously persistent aurality in an otherwise visualist universe."[17] Pursuing Kahn's hypothesis, I will not dwell on Roussel's writing style but, rather, on the cultural, multimedia, and multisensory climate in which the revival of the dead, the emphasis on repetition, and various scientific discoveries evolved in an uncanny world of aurality and visual performance.

In his cultural genealogy of sound reproduction, Jonathan Sterne argues that the reproduction of sound is linked to embalming and disembodiment. He writes: "In contrast, the voices of the dead no longer emanate from bodies that serve as containers for self-awareness. The recording is, therefore, a resonant tomb, offering the exteriority of the voice with none of its interior self-awareness."[18] Thought provoking as it is, Sterne's suggestion points to the manner in which both photography *and* phonography were inscription practices linked to the struggle against death. Similarly, the desire to hear the voice of the dead being central in Lucius's wish to reproduce his dead daughter's voice, it seems crucial to look at how this wish does away with the body that relishes in the quasi-presence of the voice, and how, ultimately, the body paradoxically re-enters the picture in such desires to perform without the body of the speaker. Preserving the voice of the dead reflected the desire for

ongoing disembodied oral performances beyond life, embalming the voice for a future playing. Roussel's novel exemplifies such a cultural practice.

The reader of Roussel's novel soon notices the manner in which the author places the human voice at the centre of his plot. The narrator, who is one among other friends of Canterel's to take a tour of his villa, controls the voice of the inventor. Indeed, this inventor is never allowed to speak directly: the narrator speaks his words and sums up what Canterel said the day he visited the mansion. The use of indirect speech is strange considering how Canterel is modelled after Villiers's Edison, a character that indulges in hearing his own voice and recording other people's voices. At the beginning of the first chapter, the narrator comments on Canterel's voice and talents as orator: "A warm, persuasive voice lent great charm to his engaging delivery, whose seductiveness and precision made him a master of the spoken word."[19] As the reader will come to realize, technologies of inscription of the voice are more important to Roussel than what is said and by whom.

Canterel's villa is a place where the inventor can devote his life to scientific research. Among the experiments Canterel conducts in his laboratories, the reader notices a certain predilection for reviving the dead and making them perform. Beloff has described Roussel's mise en scène: "Within each little stage, an actor performs the same melodramatic set piece over and over again with uncanny exactitude. These scenes become truly strange when we discover that all the so-called 'actors' are dead."[20] Indeed, and it is the aspect in Roussel's novel that Beloff will use at greater length in her heterotopia, Canterel is the host of many "characters" that come back to life to perform in quasi-machinic fashion.

As in Villiers's *Tomorrow's Eve*, the notions of repetition and performance are linked to a peculiar treatment of the female body. In Roussel's novel, Faustine, a dancer, is capable of breathing and performing underwater with the help of Canterel's invention, *aqua-micans*. For the visual pleasure of his visitors, Canterel uses this particular type of water in which a special oxygenation is renewed periodically, allowing any animal or human being to breathe normally when immersed. When Faustine's hair moves in the *aqua-micans*, a beautiful music is heard to enhance the visitors' pleasure. This is the reason why Faustine is known as "the woman with the musical hair."[21] As we can see, Faustine's is a case of supernatural and uncanny performance: she can dance underwater, and her hair plays music when in contact with *aqua-micans*. She

defies the limits of human life, and this is only one instance of the type of strategy that Canterel uses to play God and give the reader a taste of artificial life. He uses Faustine's body in order to offer his visitors a visual spectacle in a way that is reminiscent of Charcot's own staging of female bodies.

The central chapter of the novel discloses Canterel's greatest inventions, *vitalium* and *résurrectine*. It is here that Roussel's interest in repetition and Canterel's own indulgence in raising the dead come to life, so to speak. When in contact inside the brain dead, *vitalium* and *résurrectine* generate an electric shock that "overcame its [the brain's] cadaveric rigidity, endowing the subject with an impressive artificial life."[22] However, Canterel's invention remains incomplete if mention is not made of the way in which the ghostlike figure re-enacts a crucial moment of its past life repeatedly. Canterel stages the uncanny spectacle of a dead person performing through constant repetition a particular dramatic event or trauma: "As a consequence of a curious awakening of memory, the latter would at once reproduce, with strict exactitude, every slightest action performed by him during certain outstanding minutes of his life; then, without any break, he would indefinitely repeat the same unvarying series of deeds and gestures which he had chosen once and for all."[23] The narrator concludes: "The illusion of life was absolute: mobility of expression, the continual working of the lungs, speech, various actions, walking – nothing was missing."[24]

At Locus Solus, Canterel builds a human stage in order for the resurrected individuals to perform not only for his visitors but also for a close relative. The latter was "employed in identifying, from his words and gestures, the scene reproduced – which might consist of a cluster of several distinct episodes."[25] The scene is comprised of two people, the resurrected and the relative, and the ultimate moment occurs when the viewer recalls the given scene that is constantly repeated. Therefore, aural performance is linked to testifying, to recognizing a voice and claiming its identity. As we will see, Beloff's own artistic project can be examined from the perspective of an address to the interactor to testify to the ambiguous role women played in performances and accounts of hysteria, mediumship, spirit photography, and to come to terms with the strategies, both discursive and visual, that imprisoned them.

In Roussel's novel the emphasis on the voice also concerns the character of Lucius Egroizard, a man who lost his sanity "when he saw his one-year-old daughter [Gillette] being odiously trampled to death by a band of brigands dancing the jig."[26] Egroizard's case links a deadly

dance "performance" to the recreation of his daughter's voice using the phonograph. A great admirer of Leonardo da Vinci, Egroizard is an inventor himself who is obsessed with one idea: to hear his dead daughter's voice again. One of his inventions in order to fulfil his wish is a rudimentary phonograph: "A very simple apparatus consisting of a short gold needle fitted to a round membrane provided with a horn."[27] Kahn goes so far as to suggest that "her [Gillette's] voice would infer her body, her presence, her very being."[28] If the reproduced sound of Gillette's voice comes to stand for embodied agency and corporeality, then Egroizard's desire to revive his daughter is another instance of a male fantasy that indulges in bringing back to life a female voice that serves as the simulacrum of complete bodily presence. Interestingly, Roussel inscribes obsession and madness in the character that is consumed with inventing, inscribing, and hearing.

Of course, it is not so much Egroizard who must be blamed for his morbid obsessions as Canterel for his selfish reproduction of the man's pathetic wishes. Far from being a purely formal endeavour, as Alain Robbe-Grillet has argued,[29] Roussel's (and Beloff's) emphasis on the centrality of the voice and its embodied inscription bears witness to the fact that they symbolize how fin-de-siècle technology meddled in human existence and, most importantly, in women's lives. Villiers and Roussel question the idea that human life can be discussed without recourse to devices for inscribing the female voice and body, that is, technologies that have to be sustained by a dream life of technology mixing aurality, death, and rebirth, as Beloff has emphasized.

Furthermore, the inscription of the voice is staged as a performance in both Villiers's and Roussel's novels. The voice is never staged without an obvious reference to the female body on display or in performance. What is primordial is that they be staged as visual spectacle, but this cannot be done without expressing a certain tension at the heart of the two novels. Indeed, the recording of a female voice signifies getting rid of the body, but the desire to display this very same body on film or in performance re-establishes the role corporeality plays in technologies of inscription. Both writers seem to try to evade materiality with references to a dematerialized voice, but this voice has to be inscribed somewhere and returns to haunt them.

The most important element to which Beloff constantly returns in her subtractive adaptation is the resurrection of voices that she finds in Villiers's and Roussel's novels. In fact, it is the *performative aural aspect* of the novels that seems to fascinate her. In both novels performance

is subsumed into repetitive moments of fright, magic, and impossibility. Beloff pushes further the possibility of representing these moments with the help of object images that join text, sound, film, and the input of the interactor. Her performances focus on the female voice and body, and the QuickTime software generates the virtual environment in which these performances take place. Beloff's best performances are invisible: she uses her voice as a performative tool to stage the reproduction of female mediums' voices.

Mediumistic Bodies in the QuickTime Environment

In Beloff's heterotopia there are approximately eighty QuickTime movies and more than twenty virtual panoramas. The interactor can play these object images by crossing the virtual panoramas and clicking on the hotspots of her choice. Once a hotspot has been activated, the interactor is able to watch the movie through QuickTime's miniature screen. Of course, I cannot describe all the panoramas and their related movies here, but one example will suffice to give the reader an idea of the virtual environment the interactor navigates prior to watching the movies.

Beyond's virtual panoramas concern different case histories (in the form of QuickTime movies) entitled "Faustine," "Florine," "Gillette," "Irène," "Marceline," and "Simone." These names relate to several print sources: Pierre Janet's writings and case studies, Alan Gauld's *A History of Hypnotism*, and Roussel's novel. The virtual panoramas are constructed to resemble an insane asylum in which female patients are separated from one another. The names of the patients are written on a fake wall, and the interactor clicks on a name to watch the corresponding short.

In her work Beloff takes up the role of medium in the digital age and gives it an uncanny twist. Indeed, she is willing to serve as a medium, but only as one who will not be as passive or unconscious as her historical predecessors. Beloff explains how she combines the roles of medium and interface: "They [the viewers] find themselves travelling through time and space, encountering my virtual alter ego, which, as a medium that interfaces between the living and the dead, leads the viewer on a journey that is as mysterious, as it is unpredictable."[30] Her mediumistic role as interface between two worlds takes two important forms: first, she uses her body to perform before the camera, and, second, her voice-over commentaries put the action on screen in perspective. Either way, Beloff reinscribes herself in the fairly long genealogy of female

mediums that takes us back to Charcot's hysterics.[31] Noteworthy is the performance of the female body in two emblematic QuickTime movies, which concern the revival of the hysterical and mediumistic female body. This revival clearly points to nineteenth-century phantasmagorias such as hysteria, spirit photography, and female mediumship, that is, fantasy scenarios in which women rehearsed men's desires of control and subordination.

The QuickTime movies to which we will turn contain performances by Beloff in which she revisits various instances of medical treatment of women similar to the type Charcot practiced. In such movies the artist might touch the screen, her body, or play with objects. On some occasions, a woman who plays a medium in trance will give a performance. Whether it be in film footage of hysterics, in her own performances, or in seances, the artistic practice that Beloff has developed accentuates the manipulation and inscription of the female body in performance, and staging the female body is at the heart of the counter-history she wants to tell. Moreover, the crucial role of Beloff's voice-over in her heterotopia reveals the power of the voice to both augment the uncanny effect of the performances the object images convey and linearize the spatial aspect of performance.

The short "Material Ideoplasticity" refers to spirit photography – that is, a type of photography in which one can make out an uncanny shape in the form of a ghost that haunts the photo shoot – to show that this peculiar photographic practice would not have had such impact were it not for the presence of spiritualist mediums. Linked to the various scientific discoveries of the time such as electricity and the telephone, spiritualists "saw their revelation as fundamentally modern, casting out the outmoded Calvinist beliefs in original sin and hellfire damnation, they welcomed evidence that their new revelation of the afterlife could be established 'scientifically.'"[32] Spirit photographers claimed that they did not know how the ghostly figures made their way into the images.

Moreover, "Material Ideoplasticity" foreshadows Beloff's interest in the case of female medium Eva C., her 2004 installation *The Ideoplastic Materializations of Eva C.* being based on Baron von Schrenck-Notzing's long case study of Eva.[33] Eva C. was a French medium who became famous because she could make ghosts materialize, and her case is well known due to Eva's capacity to produce a whitish substance called "ectoplasm" that would pour out of her orifices. Beloff's QuickTime "case study" of Eva is a personal reconstruction because, as the artist herself states, in the absence of male authorities on the subject she is

"forced" to rely on her memory to recreate the materializations of Marthe Béraud (aka Eva C.). Interestingly, the voice-over points out that they will be played by *actress* Eva C.; the artist thus foregrounds the elusive nature and subjective quality of the reconstruction of historical evidence and the performative elements in this reconstruction.

Watching this short, the interactor first sees the word "Kabinett," the location referring to the space of investigation designed by von Schrenck-Notzing to inquire into the matter of female mediumship. Noteworthy is the presence of Beloff's hands that show cut-out figures of various famous characters before the images – images supposedly proving Eva's power to conjure up ghosts and spirits. The performance of the hands in front of the film projection is meant to add a layer of signification to the one already present in both the medical subtext (i.e., Eva's case study as reported by von Schrenck-Notzing) and the film subtext (sequences from early pornographic films known as "stag films"). Here again, Beloff's input concerns the addition of performative moments. In Beloff's short, the performances at seances dialogue with the performances in stag films. Moreover, the performance of the interactor who navigates between these object images and deciphers the various layers of textual and visual meaning must not be underestimated. It is she who must reflect on the use of various performances and who has to assess Beloff's achievement, for the focus on performance implies various discourses on the female body and its physical and visual mistreatment that cannot go unquestioned. The performer indicates that the materializations were perceived as supernatural events no one seemed to question at the time, and Beloff certainly puts the interactor in the position of someone who has to pass judgment on the general theatricality, artificiality, and overall staginess of the whole affair.

In the QuickTime movie the voice-over proceeds to describe the seances in which Eva C. took part. She was undressed and examined by the Baron. She was then led into a room where another woman and Beloff's persona were waiting for her in "the so-called Kabinett." The woman put her into a trance, and what followed were bellowing, moaning, and various other noises. The "mediumistic labour of pains," as Beloff's voice-over describes them, led to a materialization that took the form of ectoplasm, an uncanny substance that oozed from Eva's orifices. Photographs were then taken to archive such "materializations." The high point of these experiments is reached 23 February 1919, when a photograph of a ghost surrounded by naked mediums is taken. In

subsequent seances, phantom faces resembling the pictures of various celebrities were explained as "ideoplastic reproductions." Eva became associated with an "uncanny photo matte," which "divested images from her orifices."

In "Material Ideoplasticity," Beloff's voice-over commentary truly is delightful.[34] She opens her description of what is about to occur and "deplores" the absence of Baron von Schrenck-Notzing and Dr. Charles Richet in helping her retell the case study of Eva. The interactor soon realizes that what is taking place is no regular medical check-up. Eva is to be undressed and examined, and Beloff's words try to convey the feeling that what is taking place is absolutely normal – that is, for the "scientific authorities" present at the time. Beloff's persona tells the interactor that she was with the Baron and Madame Bisson at the time, and, therefore, it is as a witness, which is to say as an interface between the living and the dead, and as a time traveller that the artist acts. Finally, Beloff plays the world of aurality against mockumentary and fictional footage in order to recreate the artificial and unscientific environment in which such meetings took place.

Let us look at a short that may be seen as the culmination of Beloff's subtractive adaptation practice in terms of revisiting the discourses on hysteria and female mediumship. "Magnetic Passion" is one of the most complex QuickTime movies in Beloff's heterotopia; its combination of textual and audiovisual references makes extreme demands on the interactor. The short offers a double visual diegesis and three soundtracks. The first film narrative concerns an early short entitled *The Somnambulist*, and the other shows the superimposed images of Beloff pointing to certain moments or characters in said short. In the first soundtrack Beloff reads a passage describing Janet's methods, and in the second the aural component is from Claude Debussy's opera, *Pelléas et Mélisande*. The third soundtrack is the dialogue that takes place between Golaud and Mélisande in the first act of the opera. Let us see how these five audiovisual layers function together in the movie.

In "Magnetic Passion" Beloff appropriates an early short that dramatically rehearses the issues she wants to address in her adaptation, and *The Somnambulist* emphasizes Beloff's interest in female mediumship. This early movie raises the question of female agency and autonomy, an issue at the heart of Beloff's rereading of the history of medicine in terms of hysteria and female mediumship. In the short she appropriates, a medium-long shot shows a woman dressed in white going into a room. Carrying a taper, the woman is seen in medium shot crossing to

the other side of this room, which turns out to lead to the higher portion of a wall. Being in a somnambulist state, the woman does not realize that she might fall off the wall. The tragic fall does occur, and two men, a police officer and an unidentified gentleman, arrive at the scene to eventually carry the body offscreen. The image then cuts to the woman lying on a bed. Soon the blurry image of a soul with angel wings can be glimpsed leaving the body.

The musical subtext to this work deserves more attention. Beloff recycles the Mélisande character from Debussy's opera that embodies an archetypal woman under the burden of patriarchy, and this points to other women and mediums who felt threatened by the presence and actions of unknown men. Mélisande fears the touch of men and enacts a docile female subject reminiscent of Charcot's hysterics and Janet's case studies. The artist uses Mélisande's fear of one man to express the distress of other women (mediums) who were not able to speak in the past.[35] Beloff's performance in the movie thus enters in dialogue with the music, which is taken from Debussy's opera and whose libretto is based on the Maurice Maeterlink play of the same name. Actually, in "Magnetic Passion" Beloff's voice-over commentary is difficult to hear due to the use of Debussy's work in the soundtrack. Nevertheless, the interactor can hear the description of the manner in which a woman can be put to sleep. She reminds the interactor of Janet's techniques and soon lets the opera supplant her voice-over narration.

In this movie Beloff's performance is one of the most interesting in *Beyond*. The artist opens with the circular manipulation of a transparent ribbon on which the interactor can read "'*Le magnétiseur amoureux*' or '*Attitudes passionnelles*.'" The ribbon turns around a plate on which a lit candle is seen in close-up. As we know, the carrying of the candle is a reference to the actress in the early movie, *The Somnambulist*. Reacting to Mélisande's admonition "*Ne me touchez pas!*" [Don't touch me!], Beloff's persona does touch the image of the somnambulist woman in the early short (in the movie the interactor does not see the artist's body but only her hand and forearm). Beloff's hand manipulates something that resembles a paintbrush or a stick. She touches the female body with it, but the woman's response indicates that she does not want to be touched. In short, Beloff repeats a familiar scenario in which a male medical authority would touch, manipulate, and force a woman into a somnambulist state or trance via various acts of touching and feeling. As women may not have wanted to express their disgust at such procedures, Beloff gives them a voice via Mélisande's.

The use of *The Somnambulist* and Debussy's character Mélisande is particularly apt to convey the psychological fear and profound disgust women experienced at the time. The forced manipulation and touching of the women whom Beloff revives attest to her interest in confronting the history of medicine and psychoanalysis and the actions of scientific authorities. At the centre of this rewriting of history via digital means lies the reintegration of women's bodies into the image to reappropriate the narratives and techniques used by men, showing how they were based on fantasies, fake settings and procedures, and falsified evidence. This critical take on history could be seen as a dream state in which the interactor is allowed to relive the desires that animated a certain quest for knowledge and participate in this counter-hegemonic rewriting of history. The uncanny mixture of female agency, technology, and revival – that is, woman and machine, woman as machine, at least in the work of Edison, Charcot, Freud, Janet, Villiers, and Roussel – certainly points to the way in which various discourses contribute to shape Beloff's shorts as philosophical toys, instruments that are haunted by hysteria, spirit photography, female mediumship, and performance.

An art practice such as Beloff's thus archives the past via various potential connections and redistributions by way of often forgotten media and historical figures in order to question both official retellings of the past and the supposed "ordinariness" of what took place in the past. As Hal Foster has written on the "archival impulse" in contemporary art, a subtractive adaptation such as Beloff's does not express "a will to totalize so much as a will to relate – to probe a misplaced past, to collate its different signs (sometimes pragmatically, sometimes parodistically), to ascertain what might remain for the present."[36] Foster identifies a certain tendency in contemporary art that privileges the relational and decentered link between artist, archive, and public over the actual content (or representation) of the work. In the context of interactive media arts, which arguably depend even more on the interactor's actions to come alive, the emphasis on relationality would seem most appropriate.

The digital archiving of memory as history, media, and body that the ROM environment allows would in fact cultivate not only relationality but also what Nicolas Bourriaud has called the "postproduction" impulse in contemporary art.[37] The combination of relationality and postproduction would most appropriately describe a digital work such as *Beyond*. In the tradition of films based on found footage, the artist redirects home movies, literary and philosophical writings, and

various media artefacts in order to create new performances. Such performances maximize the potential of hypermedia to delve into issues of material and corporeal indeterminacy and actively foreground the reinterpretation of the past and the critical processing of this reactivated information. It is precisely the problem of addressing their combination in a heterotopia that singles out the radical novelty of a digital piece such as *Beyond*, and the way in which it has redefined what it is to simultaneously create and archive in the digital age.

As is the case with Beloff's object images, such citational practices are meant not only to replay but also to restage, rethink, rearchive, and repossess memories that are based on unquestioned premises and desires. Regarding *Beyond*, the technological form dovetails with the content it features: the uncanny work of memory and temporality in both the QuickTime environment and the accounts of forgotten events concerns visual and discursive constructions called "hysteria," "spirit photography," and "female mediumship" that can take place only in the deployment of female performers' bodies. In the final analysis, as Beloff points out, the performance of symptoms had to be supported by *technology as performance* first and foremost: "I'm interested in how these women's performances inspired technology in a certain way. There's a back and forth. The doctors had a desire for hysterics to perform, and then they had to find a way to capture these performances ... hysteria exists only in the moment of its performance, like cinema."[38]

Performing Women's Voices: The Lecturer as "Quilting Point"

The revival of voices enacted in Roussel's novel is one of the central *topoi* that Beloff uses in her adaptation of mediumistic performances. A feminist appraisal of the voice-over in *Beyond* cannot bypass Beloff's use of her voice to comment on, narrate, and critique the manipulation of the female body in seances revisited for the interactor. Even though Janet Beizer has suggested that female bodies were for Charcot the equivalent of dummies through which ventriloquists talk, and that representations of hysteria could be likened to moments in which female bodies were taken over by voices that did not belong to their own bodies,[39] what seems to be lacking in such feminist accounts of the female voice in the history of psychoanalysis is the *performative dimension* of the voice, a dimension that is at the heart of Beloff's achievement. In Beloff's heterotopia, the artist's voice functions as a critical tool to reembody women's experiences. The macabre spectacle of voices that

come back from the dead to haunt our collective account of hysteria and mediumship is both adapted and questioned by Beloff, and her playful approach to media arts satirizes male obsessions, acts, and endeavours. Key to this approach is the use of her voice in memorable performances that cannot but remind one of how her practice echoes the role of early film lecturers, a role that has come to light only recently in film studies.[40]

The transition between an early film industry intent on emphasizing the attractiveness of its new technology and the expansion of its commercial base via adaptations has generated a lot of discussion. The tension between the spectacle the new technology had to offer and the potential stories it could tell has sparked a lot of interest in early cinema studies. What took place between 1904 and 1908, according to Tom Gunning, is the gradual shift from a moving-picture show based on excitements, illusions, and shocks to a cinematic experience that relied on linear storytelling and more complex characterization. To use a well-known phrase, the "cinema of attractions" was about "showing rather than telling."[41] The institutionalization of so-called "classical Hollywood cinema" would be characterized by a singular movement towards the construction of linear narratives, thereby moving away from the spectacles and cheap thrills of the cinema of attractions in order to privilege narrative integration.

Of course, one of the major pitfalls of such an opposition between showing and telling, or attraction and narration for that matter, is that it fails to account for the fascinating, albeit transitory, period during which early moving-image culture embarked on the quest to integrate narration while retaining the astounding events of the cinema of attractions. This brief, heterogeneous, and historical moment that was to determine the cinematic experience for decades is, as Gunning has pointed out in a revisionist manner, "best characterized by the interrelation between narrative and attractions, rather than the exclusion of one or the other."[42] Even though the film historian still maintains that attractions dominated, he nevertheless makes the claim that "the most useful approach is to observe their interaction."[43] Such interaction between attraction and narration was depicted in the highly popular and extensively studied genre of the chase film.

But even in such films, in which thrills and narration interact, there remained the need to privilege extended narrative constructions and, therefore, linearize the motion pictures in order to make them more intelligible to new audiences. Interestingly, the initial solution for achieving greater linearization would be found offscreen in the person

of the performer known as the lecturer. Striving to give the film experience an allegedly narrative voice that would suture the movement of images and spectators' expectations, "The lecturer was needed to solve the crisis in narrative form as filmmakers were caught between new ambitions and older forms."[44] The recently revived performer of early moving-image culture, the film lecturer, would comment on the images, translate intertitles, and add whimsical remarks to an often disquieting visual experience. His contribution served the *embourgeoisement* of the cinema show via "a supplement of 'directorial necessity' or 'concatenatory momentum'"[45] that was akin to, for example, the narrative voice found in Dickens's novels.

We could borrow a Lacanian concept, namely, the "quilting point" [*point de capiton*] and detour it towards film studies in order to shed light on the apparent incompatibility between the discourses surrounding attraction, narration, and the film lecturer's performance. On this revised account, the lecturer's performance would serve as the "quilting point" between a cinema show based on attraction and a later one relying on more linear narratives. If the interaction between attraction and narration is to be privileged, as Gunning suggests, it is at the precise point the lecturer's performance *sutures* both modalities of experience. Moreover, as Lacan points out in his commentary on fear in Racine's *Athalie*: "It [the quilting point] is the point of convergence that allows to situate *retroactively* and *prospectively* all that goes on in this discourse."[46] The lecturer's performance would thus organize both the experience of viewers in demand of narrative coherence and early film scholars' desire to locate the moments of interaction between attraction and narration. The quilting point, as performative assemblage, would *retroactively* organize the experience of early moviegoers and *prospectively* orient the discourse of new media studies on attractions and narrative integration.

Furthermore, Beloff's performance as digital lecturer challenges what Slavoj Žižek has mentioned on the subject of the quilting point. He writes: "The 'quilting' performs the totalization by means of which this free floating of ideological elements is halted, fixed – that is to say, by means of which they become parts of the structured network of meaning."[47] Here one might ask: does the digital lecturer's performance as quilting point halt or fix the interaction between attraction and narration, or, as I maintain with respect to Beloff's *Beyond*, does it open wide the field of the moving image to unexplored potentialities between attraction, narration, and performance, which, in the digital

age, seems even more probable? In other words, Beloff's persona as lecturer, effectively deriving from early cinema's tensions between attraction and narration, would reboot the Lacanian concept of the quilting point and its emphasis on unity and identity[48] in order to emphasize its relational and pivotal nature rather than its supposed stabilizing function. If there is a lack or void at the heart of early cinema studies that cannot be denied, it is in the repression of the lecturer's performance as that which already demonstrated the interaction with both image and audience, a failure that points to the "constitutive narrative lack of the cinematograph"[49] itself. What the lecturer's role would embody is the difficulty in sustaining a sense of stability between attraction, narration, and interaction. On the one hand, he allowed narration to enter film space, but, on the other hand, he disrupted the flow of images once spectators had become accustomed to storytelling and jeopardized "the screen as the site of a coherent imaginary world in which narrative action took place."[50] Far from being a history of technological development and narrative integration, the moving-image experience reflects the repression of performance as its constituting absent centre or void. Beloff revives the role of the lecturer as such a "quilting point."

The resurgence of the lecturer in the digital age taps into the debate over performance in early cinema. Indeed, as digital media is often said to repeat the history of cinema and its eclectic birth, Beloff's piece not only accentuates the multimedia sources at the heart of early cinema but it also revisits the debates over attraction, narration, and performance in the role of the lecturer. In the case of the CD-ROM adaptation, digital performance embodies a vessel in which the artist simultaneously revives and revisits what she considers to be a moving-image culture based on the repression of performance: "I can't imagine why performance wouldn't be possible with film. First of all, early films were performed. There was a projectionist who cranked the projector, and how he cranked the projector performed the film in different ways. Music was played with the film or someone was telling the story. The film itself was just one element of a little vaudeville performance."[51] Beloff taking up the function of performer in her heterotopia, her mediumistic role as lecturer and interface takes two main forms: she uses her body to perform before the camera, and her voice-over commentaries put into perspective the sources she uses and the action on screen. Either way, she reinscribes herself in the fairly long genealogy of women mediums, which takes us back to Charcot's hysterics, and, by the same token, she rearchives the silenced history of the lecturer. In the two shorts analysed

above, Beloff's role as commentator actualizes the film lecturer's performance that would comment on the images and allow the spectator a better comprehension of what took place on screen.

Bearing in mind film historian Germain Lacasse's account of the lecturer's role, we should emphasize an aspect that previous examinations of this crucial figure have passed over in silence: the lecturer's work is based in performance. Indeed, Lacasse has analysed worldwide instances of *boniment* as performances and has argued that, more than a simple voice adding to the visual spectacle, the lecturer addressed the tension between attraction and narration in a performative mode that combined multimediality and orality. He argues that the lecturer's performance would serve as what I call a "quilting point" in that it "could have integrated the attraction in a narrative practice, thus organizing the passage from one medium to another, and assuring the transition from oral performance to audiovisual performance."[52]

That said, Beloff's role as lecturer departs in one respect from that of her male counterparts in early film showings. In the artist's subtractive adaptation, the collective aural world characteristic of early cinema becomes a localized and specialized form of commentary in which medical knowledge is supplemented by subjective and playful remarks performed in isolation. As the artist describes her work method: "These QuickTime movies are really records of performances I did in my apartment, projecting film, putting myself into the image using rear projection, playing records, narrating, all live."[53] Beloff's public being a differed audience of one in most cases, she could not react to the spectators' applauds and laughs, and she had to create a convivial interface that would supplement the lack of collective space and interaction.

Beloff's adaptation thus archives her performances that replay for us, via the QuickTime software, the fundamental tension between attraction and narrative integration that characterizes the birth of moving-image culture and its growing reliance on storytelling. As I have suggested in this section, the lecturer, as both a reassuring and disturbing agent in the development of linear narration, functioned as a peculiar form of performative mediation, or "quilting point," that underscored the muted role technological and corporeal performance played in the fashioning of the moving-image industry and its mediated origins. Lacasse has most aptly described the lecturer's fate as being intimately linked to mediation: "the lecturer's history is the history of this mediation, or of the emergence of cinema that gradually becomes 'auto-mediated': the lecturer first presents the invention and attraction; he then uses the

views as attractions in his magic lantern animated show; finally, he is 'thrown' out by the movie he 'swallowed.'"[54] What Lacasse's description and Beloff's artistic practice depict is the lecturer's participation in the mediation of attraction and narration as *performative incorporation*. A CD-ROM such as *Beyond* replays this film, but it systematically tends to portray repetition as a performative incorporation of media, body, and voice.

Beyond would in fact address a double repetition: the repetition of the archive in the newly constituted digital archive of Beloff's object images and the repetition of film history in the form of the lecturer's performance as that which tentatively sutures attraction and narration. Beloff's art qua repetition recalls what Thomas Lamarre has described as "another kind of repetition, based not on repeating the systematizing tendency implicit in forms but rather the potentializing tendency complicit with forms."[55] The mnemonic worlds of QuickTime technology and the lecturer's performance as quilting point open a window onto not what digital media or cinema could be in the future, but what they could have been in the various scenarios that involved silenced subjects and forgotten technologies.

It is as a *spectral medium* that Beloff revisits various media, origins, and materialities in object images that combine the archive and early cinema, thus becoming another medium in the long tradition going back to Villiers's Hadaly. The material and technological ghosts that Beloff conjures up haunt our collective interpretation of nineteenth-century phantasmagorias and the problematic role that women played in their development. Jeffrey Skoller has described how such an artistic digital archive mediates and repeats the past for future generations: "The actualization of a random-access digital archive reconnects the postcinema present most powerfully with the phantasmagoria of its past technologies, always with the hope that the present is capable of actualizing the unrealized dreams of the past."[56] Recalling filmmaker Raúl Ruiz's plea for a shamanic [*chamánico*] cinema,[57] Beloff's performance as lecturer is a mediumistic instance of a (self-) archiving practice caught between past and future media – a practice that mediates between the living and the dead in order to conjure up the ghosts of the deceased in various technological forms supporting a singular form of adaptation and spectral inventiveness.[58]

Spaces of Desire: Mapping and Translating Lesbian Reality

Published by Shifting Horizons Productions in Los Angeles in 1997, *Mauve Desert: A CD-ROM Translation* was Adriene Jenik's MFA project in electronic arts at Rensselaer Polytechnic Institute.[1] Initially conceived as a film project, the CD-ROM is the adaptation of Québécoise author Nicole Brossard's celebrated novel, *Le Désert mauve* (1987). Unable to get funding for a film adaptation of the novel, Jenik resorted to producing a hypermedia adaptation of the literary work that had made such a strong impression on her. Jenik's choice of Brossard's novel is not fortuitous, for Brossard's work addresses issues of gendered desire, identity, activism, ecology, and performance that would pervade Jenik's artistic practice. Indeed, one could see in Jenik's CD-ROM the catalyst for works that would emphasize collective performance and networked collaboration, issues that the media artist would further integrate in works posterior to *Mauve Desert: A CD-ROM Translation.* However, the CD-ROM adaptation is singular in her body of work in that it is an offline environment addressing a single viewer, and it inquires into the potential of digital adaptation. Jenik is responsible for writing, directing, designing, producing, and programming the entire CD-ROM, and the work is considered a landmark piece of "interactive" storytelling and one of the earliest instances of CD-ROM adaptation.

Jenik is a media artist who has been working as an engineer, teacher, and activist for three decades. Her art practice engages both artists and the public in collaborative projects and performances that blend social and personal communication.[2] Her participation in collective projects includes *Paper Tiger TV* (1981–present) and *Deep Dish TV* (1985–present), performances with the band Snakes & Ladders, and publications with the 'zine collective SCREAMBOX (with Pam Gregg and Bryn Austin,

1991–3). Among her televisual and video productions one finds the internationally exhibited video short, *What's the Difference Between a Yam & a Sweet Potato?* (with J. Evan Dunlap, 1991), and the award-winning live satellite TV broadcast, *El Naftazteca: Cyber-Aztec TV for 2000 A.D.* (with Guillermo Gómez-Peña and Roberto Sifuentes, 1994–5).

Jenik's work has reinserted live performance into the digital media environment. This type of "networked theatrical improvisation" includes the development of large-scale community-based events over wireless networks. For example, *Desktop Theater* (1997–2002) is a series of live theatrical interventions and activities in public chat rooms developed in collaboration with Lisa Brenneis.[3] Inaugurated with *waitingforgodot.com* in 1997, *Desktop Theater* combined weekly experiments and "doubly-live" presentations. More recent projects such as *SPECFLIC* (2003–present),[4] *OPEN_Borders Lounge* (co-creator, Charley Ten, 2007–present), and *3 Days of Counting (7 Years of War)* (2010), all collaborative in nature, rely on telematics, networking, and mobile forms of communication and interaction to explore the porous boundaries of the notion of "performance."

In this chapter's first section, the main issues in Brossard's novel are introduced with particular emphasis being put on the concept of "reality," and the way in which this notion is inflected by a specific understanding of lesbian desire whereby both performance and translation shape "reality" in Brossard's conception of lesbianism. These two key notions will serve as the guiding thread to explore Jenik's heterotopia. Furthermore, at the heart of cinematography lies the writing of movement. Jenik is determined to revisit this graphocentric representation of movement and mobility. Indeed, in her subtractive adaptation the writing of movement becomes more than its visual representation; Jenik's understanding of movement produces potentialities that are hinted at rather than inscribed, virtualized rather than represented. In Jenik's object images the writing of space and movement is present, as in any film adaptation, but it is virtualized in what the maps and potential journeys present. The spaces of desire that the main map of the CD-ROM displays are not traditional "places"; they are virtual maps of combinatory desires and associative gendered thinking. Considering that Brossard's novel foregrounds such spaces of interaction and potential translations *au féminin*, it is puzzling that critics have overlooked feminist translation theory to analyse Jenik's adaptation.[5] A dual-voiced concept of translation, as a movement between both languages and spaces, will help to shed light on Jenik's CD-ROM as a form of digital

travel "writing." Finally, the artist's singular form of travel "writing" will be considered as a novel type of autobiography in which performative self-translations are offered in the form of object images.

Gendering and Performing Reality:
Nicole Brossard's *Mauve Desert*

Nicole Brossard's *Le Désert mauve* (1987) is a triptych often considered emblematic of postmodern literature possessing cult status in feminist and lesbian circles. The first narrative in the novel (forty-one pages in the French original) concerns the coming-of-age story of Mélanie, a fifteen-year-old teenager who lives in the Arizona desert with her mother, Kathy Kerouac, and her lover, Lorna. This first story, written by Laure Angstelle, is entitled "Mauve Desert." The second narrative, entitled "A Book to Translate," is the account of Maude Laures's struggle with the translation of the first story involving Mélanie. This narrative occupies the central section of the novel and discloses Maude Laures's thoughts on the various characters in Laure Angstelle's short story. The third narrative is the somewhat puzzling French-into-French translation of Laure Angstelle's "Mauve Desert" by Maude Laures, her translation being entitled "Mauve, the Horizon." In this translation qua repetition the reader notices subtle modifications between the original French version and its "translation" into French.[6]

Critics have commented on the opening sentence of Brossard's novel, "The desert is indescribable,"[7] remarking on the manner in which the author foregrounds the setting of her novel as something that words fail to convey. The narrator and potential translator would face a difficult task: how does one represent the enigmatic absence and stillness characteristic of the desert in a medium – the written word – that will not succeed ultimately?

As we shall see, Jenik's CD-ROM takes issue with Brossard's statement that the desert cannot be described. However, it is not the written word that may be the most adequate medium to represent it. Instead of focusing on the opening sentence, as most critics have done, one should turn to the second and third sentences to highlight the way in which the narrator unwittingly implies that the visual realm might be key to an authentic translation of the desert. In fact, the narrator underlines how visual supplements are essential to circumscribe the desert: "Reality rushes into it, rapid light. The gaze melts."[8] Apparently, the gaze's fragile nature would be threatened by a written representation. Juxtaposing the impossible

written description of the desert with a "rapid light" that flashes before one's eyes, causing the gaze to melt, the narrator thus associates the representation of the desert with an impossible written treatment that is best expressed by a visual metaphor: the reality of the desert is a rapid light that can hardly be seen. Its implacable reality provokes a collapse of vision that results in the loss for words expressed in the first sentence.

The opening sentences of the novel articulate what is at the heart of Brossard's novel and Jenik's digital adaptation: a reconfiguration of "reality" in terms of virtuality, gendered viewing positions, and visual translation. Indeed, Mélanie's quest in the novel translates into her coming to terms with reality in a way that marks the construction of lesbian desire via virtual spaces of exploration, gendered spectatorship, and multifaceted translations and adaptations. Brossard herself has commented on lesbian and female reality in a manner that echoes such issues and, in fact, refers to adaptation: "caught between the sense we give to reality and the non-sense patriarchal reality constitutes for us, we are most often forced to adapt our lives to simultaneous translation of the foreign tongue."[9] Brossard's description implies a constant translation in which desires have to accommodate patriarchal language, and the body becomes the site of a reconfiguration of female and lesbian desires in terms of adaptation, for "reality has been for most women a fiction, that is, the fruit of an imagination which is not their own and to which they do not *actually* succeed in adapting."[10]

A feature of Brossard's description of female desire and reality that seems to have escaped several critics and that justifies a visual adaptation of her novel is the manner in which Mélanie's language contains a great number of graphic elements. For example, Mélanie reminisces on her adolescent ways of perceiving reality and desire: "I was fifteen and I was watching reality encroach on beings like a tragic distortion of beauty. Humanity's trembling aura hovered in the harsh light."[11] Mélanie's words point to reality as that which both veils perception and carries a tragic feeling that obscures inner beauty. Mélanie uses a visual element, the aura, to describe the evanescent and shifting nature of humanity that is lost in another visual element, a "harsh light," reminiscent of the "rapid light" described earlier in the novel. In fact, according to Mélanie, reality *is* an image: "Then reality became an IMAGE. I fell asleep at dawn, strapped in my sheets, *object* of the image."[12] The young woman's thoughts actually reformulate the misappropriated account of the Lacanian gaze in feminist film studies according to which a male subject gazes at a female "object" in fantasmatic scenarios of possession

and empowerment.[13] Mélanie's description captures the complex situation of the object that gazes back at the subject who is somewhat willing to be enfolded in the image.

Mélanie elaborates on this irresistible light that attracts desire and gives reality its deformed shape. She says: "I was nothing but a desiring shape in the contour of the aura surrounding humanity. Reality is a becoming spaced throughout memory."[14] With this fascinating description of human desire on the brink of an aura is juxtaposed the description of reality as "a becoming spaced throughout memory." Clearly, Brossard's character distinguishes between a temporal understanding of reality and memory and a spatial description of it. Whereas the temporal understanding is a linear treatment that focuses on succession and evolution, a spatial understanding of memory, which is the one that concerns a medium such as CD-ROM, conceives of memory as a space in which elements can be retrieved with the help of associations and juxtapositions.

Furthermore, when reality is described metaphorically as a "becoming spaced throughout memory," the characteristics of said reality are in a continuous process of construction in a given space. In Brossard's novel, the construction of reality through the spaces of memory is associated with an embodied understanding of the adolescent body that is itself in the making. Mélanie is aware of this double construction of reality and body: "A body was required to face the unthinkable and this body, I would produce it … This body would be a life equation tapping impossible reality."[15] Mélanie's conception of the body as that which is constructed willfully could give us the impression that she believes in the possibility of *ex nihilo* body creation. Yet Mélanie knows that construction is the keyword: her body is not a given but a production tapping the resources of female reality. Even though she may desire to construct it by herself, this desire points to an illusionary ideal that tells us more about the *nature* of her desire rather than her general understanding of body image fashioning in terms of production and performance.

In this discussion of reality, production, and performance in Brossard's novel, it will be useful to turn to the work of Judith Butler on performativity, for the notion has found itself at the centre of debates over Brossard's novel.[16] For instance, Alice Parker has claimed that "Rather than identity, which requires border guards, her [Brossard's] writing incites performativity (J. Butler et al.) and the play of possibility,"[17] and, adding to Parker's insight, I would emphasize how performance

cannot be separated from performativity. Given the somewhat blurry distinction between performance and performativity in Butler's work of the early 1990s, queer theory scholars have tried to untangle the knots between the two notions, claiming that, on the one hand, performativity is an unconscious and often forced reiteration of norms and behaviours that an individual replays in order to be a heterosexual or homosexual subject. On the other hand, a performance would be linked to the conscious behaviour and adoption of a set of norms or practices in order for one to be a lesbian, for example. In this analysis of Brossard's novel and Jenik's heterotopia, I will adopt the notion of performance as the most useful critical concept, for Mélanie and Jenik both seem aware of the performances in which they engage to inflect reality and question their (lesbian) desires.

The conception of gender as something that one *performs* rather than *is* departs from the definition of identity and sexual identification understood as the revelation of a given subject's inner truth or essence. Butler has shown how the ontological basis of gender identity amounts to the performance of gendered roles and performative repetitions. However, in Butler's thought performativity is subsumed under the temporal historicity of a subject's gender identifications. What seems to be lacking is the work of performance in space. As Moya Lloyd aptly puts it: "What is occluded, as a consequence, is the space within which performance occurs, the others involved in or implicated by the production, and how they receive and interpret what they see."[18] In other words, a consideration of the public for whom a performance is put on should be envisaged. Performance and performativity do not only occur in time but also in space. In Jenik's adaptation the intermedia passage from novelistic linearity to the multilayered spaces of CD-ROM accentuates the spatial element in performance.

Furthermore, added to the notion of space in Brossard's novel is the fleeting nature of reality that is linked to its linguistic performance rather than the expression of its essence. Brossard and Mélanie constantly highlight this feature. Echoing in their words is the desire to recode the female body in lesbian language. Lesbian corporeality becomes a matter of performance, invention, and characterization. Brossard stages as theatre the invention of reality that Mélanie proposes via autobiographical insights into her desire. Mélanie remarks on her teenage years: "I entered the life of my fifteen years like a character. Unexpectedly, unsuspecting."[19] The young woman's conception of identity as characterization and spontaneous improvisations points

to a form of self-fashioning in which performance shapes reality rather than reality shaping the various performances in which she engages. Interestingly, in Maude Laures's translation of Laure Angstelle's story, the translator emphasizes even more the theatricality at the heart of the teenager's desire: "Here I am in my life of 15 years having become a character, pure adventure in theatrical time."[20] The theatricality and the performances that coming to terms with reality implies are not lost on the translator either. In Maude Laures's remarks on the character of Mélanie, the translator analyzes Mélanie's facial expressions: "Though young it is a lived-in, multiplied face, not common but bearing the mark of what amply fills the senses and thereby renews their theatricality: the multiple of dying, the multiple of passion."[21] Interestingly, the translator compares her facial theatricality to a mask that we can all wear "when the taste for living exceeds in us good measure."[22]

The performances in which Mélanie is seen addressing her nascent lesbian desire are the result of her following the performances of lesbian behaviour her mother, Kathy, and lover, Lorna, offer. Moreover, Mélanie's growing interest in Angela Parker, the surveyor whom Longman kills in the final moments of the novel, and the expression of this desire to get to know Angela have to be related to the model of lesbian love that she follows. The manner in which Mélanie's mother and her lover discuss matters of the heart points to theatricality in a way that Mélanie has incorporated, as seen in her descriptions of reality and desire.

In a conversation between Kathy and Lorna, Mélanie is allowed a glimpse at lesbian desire and its embodied expression and performance. In this dialogue Mélanie's mother and Lorna discuss the possibility of desiring without the body being involved. Intriguingly, Kathy implies that desire is an immaterial and intellectual feeling, whereas Lorna cannot conceive of it. Lorna asks Kathy: "Do you think it possible to love around the body? To love without smells, without taste, without tongues seeking their salt on the beloved's skin, without the rustling of hands on thighs, without needing to refine our senses?"[23] Facing Kathy's refusal to consider the materiality of the body in the workings of desire, Lorna adds: "I find it unbearable, even for a second, to think of loving without bodies coming in to free or to sustain desire."[24] Clearly, Kathy and Lorna perform two different versions of lesbian love: one places the senses and desire at its centre while the other privileges a heightened form of love that rests on "a specific emotion which creates presence way beyond the real body."[25]

However, as the discussion comes to an end, Kathy concludes that it is impossible to describe or account for love. Ironically, she tells Lorna that she could satisfy her and turns to commonplaces of the lover's discourse in which a prepared set of words and expressions could replace her philosophical meditations on love. Kathy remarks: "Well then I guess there's no explanation and that it's pointless to seek a reason for the love I feel for you. Perhaps it's easier to choose from among the suite of mirrors, costumes, and roles, words that are simpler, softer, less crude, ordinary."[26] Kathy's failure to express a form of love that would go beyond the mere repetition of set patterns of desire and the libidinal exigencies of the body are characteristic of the Platonic conception of love and desire as dematerialized feelings. Ultimately, Kathy expresses her dissatisfaction with Lorna's incapability of understanding her, and she tells her lover that she could use what passes as love, that is, a series of duplicitous mirrors, performances, and fake feelings trying to portray insincere sentiments that are clearly repetitions of things heard or seen before. Even though Kathy seems unwilling to admit it, the expression of love and desire is the performance of the body implied in Lorna's words. Actually, both women's words point to the performances seen on the "stage" called love.

Mélanie's conception of love and desire follows Lorna's. In her climactic meeting with Angela on the dance floor of the Mauve Hotel, Mélanie describes the manner in which time becomes subjected to and actually enters the space of the body: "There is no more time. Time has entered us in minute detail like a scalpel, time compels us to reality. Time has slipped between our legs. Every muscle, every nerve, every cell is as music in our bodies, absolutely."[27] At the end of Mélanie's coming-of-age story lesbian feelings are linked to a musical performance trying to be in sync with the body that feels desires emerging. This embodied internalization or spacing of time, that is, its corporeal becoming, forces the women to experience reality in the corporeal space of the body, as the dance performances are described as the more authentic and genuine experiences. The spatial nature of performance relying on bodily movements in a given space, Mélanie's desire for Angela is expressed in an embodied understanding of sexuality that privileges space over time. In other words, the spatial performances and the bodily expressions of the dancers are more important to Mélanie than the temporal accompaniment, music.

The wish to abandon time for space in such performances of desire is also found in the novel's most important trope, translation. Actually, in

the novel spaces of desire are subsumed under translation. The spaces in which the articulation and construction of gendered identity take place are sites of struggle, and the escape from reality is a task that translation (across languages and spaces) can accomplish only with the help of the body. The translator, Maude Laures, mentions: "'Some day I will exit reality,' find a lode, a *vein*, the little opening in which I will be *forced to slow down*, to reduce intensity, the speed of the image. Redo everything, body, weight and volume, the length of winter, nature and representation, framework of the spirit."[28] The escape that the translator proposes includes a form of hyperreality in which identification with the image is made possible through a vector that would reconfigure time and space in terms of the body. If Sue-Ellen Case is right when she argues that "Nicole Brossard provides a poetic meditation on the lesbian body that creates something like a 'field theory' of lesbian as space,"[29] then Jenik, on her part, takes up the translator's challenge and offers her own hyperreal venture into lesbian space and desire. As we shall see, Jenik escapes Case's critique of Brossard's writing and the absence of "the materialist concerns constitutive of any full consideration of cyber or lesbian-screened space."[30]

The Double Translation: Languages of Corporeality and Travelling Desires

As discussed in the preceding section, performance comes to be subsumed under the great number of translations, both linguistic and spatial, that characters perform in the novel, and focusing on the linguistic and spatial translations that captivate Mélanie, Maude Laures, and Jenik is the next step. The first type of translation to be explored is the well-known passage of an original text into another language. The second meaning of translation relates to geometry and designates the movement of a given shape in space. Mélanie's road trips and the interactor's map reading justify the understanding of translation as a spatial activity as much as a linguistic one. Both Mélanie's and Jenik's practices and performances call for this double understanding of translation as a movement between languages and spaces.

Susan Holbrook has rightfully claimed that "In the world of *Mauve Desert* [...] translation is the dominant figure of interpretation."[31] Elaborating on Holbrook's insight, I would add that feminist translation theory is the best conceptual tool to approach the linguistic translations explored in Brossard's novel and Jenik's adaptation. Moreover,

considering feminist translation cannot be separated from its perfor-
mative incidences on the female translator, the manner in which femi-
nist translators have accentuated the embodied interaction between the
translating body and the translated text is fundamental. The translated
text that a female translator "performs" would become a site of deter-
ritorialization and reterritorialization in which a given language loses
most of its patriarchal inflexions and gains a sense of corporeal dyna-
mism and fluidity. Feminist translation theory proposes an embodied
theory of translation that thus departs from the more detached concep-
tion of the translator's task, as presented in the work of key male think-
ers on translation.[32]

The English translator of Brossard's *Le Désert mauve*, Susanne de
Lotbinière-Harwood, has stressed the way in which the female body
is linked to translation via an interlinguistic *jouissance*, and she has
described the arousal experienced in translating Brossard's work as a
"lesbian feminist literary utopia"[33] that appeals as much to the senses
as to the intellect. The translator has pointed out how Brossard's chal-
lenge to rethink translation in the "feminine" as a creative rather than
derivative activity relates to gender. Indeed, as Jenik's Maude Laures
mentions on the CD-ROM: "To wholly inscribe her body, Brossard's
translator has invented ways of gender-marking the English text."[34] The
reformulation of linguistic "reality" that feminist translators wish to
achieve via a subversive grammatical refashioning of English is linked
to rewriting and rereading activities that involve the body: "For, re-
reading her body-text into our own we are, in all senses, re-writing it
through our bodies. And such intimacy, in a literary relationship as in
real life ones, produces anxiety. The task then becomes to risk the dan-
ger to experience the pleasure."[35] Jenik's translation of languages on her
CD-ROM addresses such a view of the female body in translation. The
female translations desired by Brossard and de Lotbinière-Harwood
would relate to embodiment via the feminist translator's body when
orality is considered in light of the translating body. Orality would
reveal the performative dimension in which the female translator or
adapter revisits a given territory in the aural spaces of Jenik's hetero-
topia, hearing being a sense that is often neglected in analyses of new
media arts.[36]

In Brossard's novel, the translator's efforts to circumscribe the novel's
propositions are taken up on Jenik's CD-ROM by the artist herself. In
her heterotopia she is the hypertranslator who is obsessed by her desire
to transform Brossard's novel. From linguistic to visual adaptation, the

translation process occupies a central portion of the CD-ROM. As far as Maude Laures is concerned, this "drive to translate" is best represented in a section of the CD-ROM that the interactor can access after clicking on "Yucca Mountain." The following page offers the choice of clicking on a glove compartment or radio. Upon clicking on the glove compartment, other possibilities are offered: an unnamed map, a map of Montréal, a gun, a notepad, and the maker's map. Clicking on the map of Montréal leads to a screen where, once the notepad with "Maude" inscribed on it has been activated, the interactor can reach the section called "A book to translate," which is named after the second part of Brossard's novel.

At the top of the screen there are four squares on which the interactor can click. At the bottom of the screen there is another series of four squares of similar size, the whole screen containing eight squares from which to choose. The central space between the two rows of squares is the filmic space that displays the still or moving images that can be viewed upon selecting a square. Here the interactor can listen to the soundtrack of her choice. The videos and excerpts from the novel can be heard in French or English when the bottom right square is activated.

One of the hallmarks of postmodern literature being the disclosure of the writing process in the published text itself, Jenik similarly undermines in many ways the traditional and seamless task of the translator. For example, she reveals the various books used in the making of her CD-ROM. The first square positions Jenik as professional translator, and the still image displays a series of library stacks on which books are shelved. The interactor can click on several of those books to see either their titles or in some cases to glimpse at their contents. Some of the books that Jenik consulted show her interest in feminist and ecological concerns. In fact, one of the squares features an interview in which Maudes Laures reminds the interactor that translation theory has always been conceived in sexist terms and arbitrary choices. Maude Laures's thoughts call to mind feminist translation theory whose main goal has been to revisit the history and practice of translation from the point of view of women and in terms of female desire and corporeality, thereby emphasizing how female readers and translators would differ from their male counterparts.

On the CD-ROM, Maude Laures mentions how she likes to mouth the words in translation and hear herself speak the words aloud, the repetition of Brossard's words in translation thus evoking the corporeal pleasure of reading aloud. The second square on the upper row

translates into practice what Maude reveals in the bottom right square, that is, reading and mouthing the words when she is at work translating. This method reveals the medium and the body involved in the process of translation. In fact, Maude Laures herself thinks of translation and words as relating to materiality and the body: "Words were in the mouth like little pits ... a presence, a solid body needing to be expelled after a while by bringing the tongue forward as if preparing to grimace, then in one breath, projecting in front of oneself the indivisible part. Between the teeth then remained only flesh and taste, edible part, a good daily portion."[37] Jenik uses the very same passage as soundtrack, and de Lotbinière-Harwood evokes it in her meditations on translation: "As a translator, I have grown accustomed to reading the original text aloud to grasp its *souffle* (the pulse of life!), and then to reading out loud my translation-in-progress ... I would even say that rhythm – how the body-woman [*corps-femme*] moves in the text to be translated – is a criterion of beautiful translations *au féminin*."[38]

On the CD-ROM orality thus becomes intertwined with the written word in the act of translation. Jenik's Maude Laures accentuates the necessary oral activity of the translator who has to hear and mouth the words in order to know if they are appropriate. The oral dimension of Brossard's poetic output is underlined, and the sentences from the novel are activated in another medium, the human voice, while the printed word on the page is left aside. Moreover, the usual silent reading practices give way to the body of the translator in the reading and reciting of the words. Maude Laures's practice as a translator joins a feminist conception of language and a fascination with the actual sounds of the words that remain mute on the page. As mentioned earlier, the soundtrack heard on top of Maude Laures's voice during the interview describes the corporeal pleasures derived from speaking the words on the page. Finally, the close-up on the woman's lips is not unintentional on a CD-ROM so much concerned with desire and corporeality, the translator's lips arousing desire and performing what Maude Laures and de Lotbinière-Harwood describe. The fact that the woman's face cannot be seen except for her mouth is suggestive. Jenik's use of sound and moving images takes the interactor away from the world of print and reading and opens a window onto the performance of orality in translation. In short, Brossard's *Mauve Desert* offers a definition of translation pertaining to the linguistic movement across languages, and Jenik expands on the metaphor of translation in order to show how desire surfaces across languages in aural spaces.

The second definition of translation with which both the novel and the CD-ROM are concerned refers to geometry and involves the spatial movement of a shape from one position to another. One could argue that the spatial definition of translation is even more important than the linguistic one in the context of a novel so much concerned with open spaces and travelling. The exploration of spaces is made explicit in Mélanie's keenness on driving and going on road trips. Brossard exploits the double meaning of translation, and this strategy is made even more explicit in Jenik's subtractive adaptation. The writing of movement in space being at the heart of both travel writing and cinema, an examination of the role space has occupied in the development of travel writing and cinematography is important to put into perspective how Jenik uses spatial translations in object images that combine both reading and viewing spaces reminiscent of print and film cultures.

At the heart of two important works of criticism that conceive of the book as an atlas lies the wish to link both geography and travel to literature and cinema.[39] Indeed, Franco Moretti's analysis of the relation between topography, geography, and the European novel is very suggestive because it emphasizes the significance of maps. As Moretti writes: "First, [maps] demonstrate the *ortgebunden*, tied-to-a-place nature of literature; as we will see, each form with its geometry, its confines, its spatial taboos and fluxes of movement. Then, maps shed light on the internal logic of the narrative: the plot's semiotic space around which it organizes itself."[40] Moretti's study thus shows the impact of maps on the development of narrative, and how geographical and spatial representations leave a great deal of signs to be deciphered in the reconsideration of literature as a "literary geography" [*geografia letteraria*].[41] The critic forces us to rethink literature in terms of the various mappings that have been represented since the Renaissance explorations of unknown spaces.

Giuliana Bruno's study of geography and film can be seen as a companion piece to Moretti's study of maps, geography, and the novel. The geographical understanding of artworks reminds us that the European novel emerged at the height of European travelling ventures, and Bruno reminds us that one of early cinema's most popular genres was the travel film. Her description of the effects of the travel film cannot but evoke Jenik's heterotopia: "The travel-film genre inscribed motion into the language of cinema, transporting the spectator into space and creating a multiform travel effect that resonated with the architectonics of the railroad movie theater that housed it."[42] Travelling being at the

heart of early cinema, one cannot ignore its influence on previous media as they are revived in the digital age. Moreover, the desire to visit and actually conquer foreign territories in both literature and early cinema is suggestive, and it recalls a hybrid form of narration, which is travel writing.[43]

Bruno notes that travel writing and diaries have had important impact on film. She writes: "As narrative trips, travel writing and travel diaries ... formed an important part of the spatiovisual architectonics that led to the cinema and its narrative flow."[44] Topography and space were important factors in the development of cinema, but narratives of technical evolution often diminish their impact. Emphasizing space would accentuate overlooked associations and departures. Interestingly, Bruno puts the emphasis on the visual nature of female travel writing that "was often so descriptively graphic, in fact, that it approached filmic observation. Its language was a form of (pre)cinematic site-seeing."[45]

In works as diverse as Jack Kerouac's *On the Road* (1957) and Ridley Scott's *Thelma and Louise* (1991), twentieth-century novelists and filmmakers have drawn similar parallels between movement in open space and liberated subjectivity.[46] Indeed, what is found in Moretti's study of the novel and geography, and in Bruno's work on emotion, corporeality, and travel, is the will to connect art and movement in spatial translations that defy the limits of subjectivity. Evoking travel writing and early travel films reminds us that the analysis of films, interactive media arts, web-based environments, and digital games cannot overlook the reevaluation of space.

CD-ROM adaptation cannot escape this reconsideration either. Jenik's work shows how *kinema* is revived in another media environment that also stresses geographical movement and spatial translations. In Brossard's novel Mélanie's trips are discovered from a linear perspective, that is, as the reader turns the pages. In Jenik's work, Mélanie's journey is transferred onto a map of the Nevada desert; her travels and encounters are depicted in spatial terms both for her and the interactor. Jenik maps out the spaces of desire that inhabit Mélanie, as she proposes an itinerary of those spaces in object images. In short, the journey that the interactor envisages for herself does not have to follow the one found in Brossard's novel.

The virtual road map with which the interactor is provided on the first screen is clearly aimed at an identification process that Jenik wishes to include in the virtual road trip. "Mélanie's map" features several known spaces of confrontation and identification such as the Mauve

Motel that Mélanie visits in the novel. Probably the most interesting space of travel, the "Maker map" takes the interactor on a journey at the heart of Jenik's artistic procedures. The "Maker map" has a strange and significant visual design. Three-quarters of the screen are occupied by Jenik's bespectacled face. Surrounding Jenik's face are criss-crossing roads with several two-dimensional road signs on which the interactor can click. It is worth analysing some of the visual and textual contents of those road signs to shed light on Jenik's politics of travel, which displays her wish to circumscribe what moves her to adapt Brossard's novel to CD-ROM.

Probably the most significant aspect of the "Maker map" is the disclosure of the correspondence between Jenik and Brossard at the time of conception, production, and financing of the adaptation. Initially conceived of as a film adaptation, *Mauve Desert*, due to lack of funding, ended up being a CD-ROM. However, as work progressed, Jenik realized how the hypermedia platform enabled a type of creativity and "interaction" that conventional cinema would not have been able to produce. Even though Brossard showed reluctance towards the digital adaptation of her novel, Jenik convinced the author that CD-ROM "can arouse passion, identification, and beauty."[47]

The road signs composing the "Maker map" disclose several key moments in the making of the work. Jenik's aim in offering a maker map is to do away with the illusion of the seamless work, and she reveals the drawbacks faced in the process of creating her work. Interestingly, these object images are presented as a spatial journey, and Mélanie's road trips are doubled by Jenik's own road to success as she comments on the numerous spaces and places she visited during production. Incidentally, two road signs offer short video sequences of the desert. Knowing that most interactors will not have set foot in the Nevada desert, Jenik documents her heterotopia with images recalling the places that Mélanie and the artist visited during the course of the novel and its adaptation.

Jenik's subtractive adaptation could be seen as a hybrid form of digital travel "writing."[48] This type of travel "writing" would offer something different because the ontological status of the "writing" does not relate to actual but *virtual* past experiences. Moreover, digital travel writing, due to its screen-based setting, provides the artist with a plethora of audiovisual possibilities. An expanding literary genre combining autobiography, documentary, and playful invention using hypermedia potentialities, travel accounts cannot be considered a form

of "writing" anymore. Travellers have at their disposal a vast array of audiovisual, networking, and social media strategies to use that greatly enhance what travel "writing" can offer. As far as Jenik's CD-ROM is concerned, her adaptation can be seen as the retelling of Brossard's retelling of Mélanie's journey. Jenik's treatment of Mélanie's autobiographical impressions in the first part of *Mauve Desert* can be envisaged as a *belated form* of travel "writing" that implies recreating memories in the hypermedia environment of CD-ROM.

From printed account to hypermedia adaptation, differences in treatment and effect arise. As Sidonie Smith has shown: "Vehicles of motion are vehicles of perception and meaning, precisely because they affect the temporal, spatial, and interrelational dynamics of travel,"[49] and, one might add, the "movement" or translation from novel to CD-ROM implies different reception strategies in the appropriation of this new form of "travel writing." Whereas the silent reading of the novel implies a cartography of the mind, CD-ROM actualizes the spatial data in the novel and makes it accessible in real time via clicking activities. The interactor can choose from several locations on the virtual map that Jenik uses, each area offering landscapes and soundscapes that make Mélanie's journey more concrete. The representation of the map produces a feeling of immediacy, and the same map gives us the illusion that Mélanie's road trip is unfolding before our very eyes.

The interactor can select various locations on the CD-ROM, and she may be redirected to other places afterwards. If a road trip demands driving from point A to point B, Mélanie's journey becomes deprived of sequential logic for the interactor who does not have to follow the itinerary found in the novel; actually, the interactor's journey does not have to follow any route. It can start with Mélanie's last stop; it can focus on Mélanie's interaction with Angela Parkins; or it can gaze at lesbian desire through the words and actions of Kathy and Lorna. The imaginary map of the book gives way to the map on screen; the imaginary car confronts the read-only memory of the medium and its hazardous "speed." The difference in means of "transportation" allows for such a distinction. The physicality of the car and the godlike gaze of the interactor overseeing the space of the desert while sitting at the computer imply different viewing positions. As Smith has noted: "More broadly, modes of motion organize the entire spectrum sensorium differently and thus affect the conditions, the focalizing range, and the position of the perceiving subject, differentially connecting and disconnecting her to and from the terrain of travel, differentially organizing her ways of

negotiating unfamiliar territory, and differentially affecting systems of behaviour."[50] The car's rapidity of movement, compared to the repetitive actions and slow progression on the CD-ROM, would imply a fast-paced gaze characteristic of automobility. Jenik's CD-ROM, however, favours reading activities that are slow and often tedious due to poor lighting or small characters.

Moreover, one must underline that the CD-ROM adaptation somewhat de-emphasizes the radical nature of a teenager going on a road trip, which impacts on the reception of the work. Indeed, while the novel represents a critique of femininity in terms of gendered and performative "translations," the CD-ROM suffers from Mélanie's occasional absence given that she is not *constantly present* and seems to have saved the driver's seat for an unidentified interactor who may be, as is the case with this author, a man. Having been associated with masculinity and speed for decades, the car in which the interactor sits may lead him to forget that the actual driver is a young woman who questions "reality" and its gendered biases due to the absence of a pervading visual representation of Mélanie. The driver's performance, as exemplified by a young woman such as Melanie, would imply the erasure of normative behaviour as far as "car culture" is concerned. If women appropriated the car to challenge sedentary femininity and reshape discourses around gender, then the questioning and performing of gender, in both the novel and on the CD-ROM, represent in diverse ways this potential subversion.

Even though I would not, as Smith does, conflate all digital media in one inclusive virtual reality, there remains distinctions to be made between travel "writing" in interactive installations, on the Internet, and on CD-ROM. Being concerned with the reconceptualization of travel writing in Brossard's novel, Jenik's work does not erase the body in motion, as Smith implies in her account of gender camouflage online. In travel narratives, the eyes and the mind of the reader follow the events. Viewing and reading the events on a CD-ROM, the interactor cannot fashion an identity characteristic of online chat rooms due to the fact that she is not responding to another person's comments but to the point-and-click demands of a computer program. Therefore, if "women become resistors along the circuits"[51] of virtual reality, as Smith argues, they would need a much more enhanced environment than the one with which the CD-ROM could provide them. Witnessing another woman's performance of gender does not necessarily result in a performance of gender on the interactor's part. However, one could claim that recent

travel "writing," be it digital or televisual, offers "translation sites" that place performance at the heart of travelling.

Autobiography as Performative Self-Translation

The dual-voiced concept of translation, once associated with performance, gives us a more concrete idea of the linguistic and spatial issues involved in gender identification, desire, and their performative becoming, and it ultimately forces a reconsideration of the notion of performance as relates to both language and space. Critics such as Susan Holbrook and Barbara Godard have actually favoured the neologism "transformance" to account for the type of performance in which lesbian and feminist translators engage.[52]

To my knowledge, Carol Maier is the first critic to have associated translation with performance. In fact, Maier combines the task of the translator with orality and space. She writes: "The image of the translator as actor appealed to me because it called to mind movement and sound."[53] She adds that we could associate translations with different musical interpretations of a given work, the translator becoming an interpreter in such an understanding of translation. De Lotbinière-Harwood expands on Maier's formulations in her book on the task of the female translator. The translator of Brossard's *Mauve Desert* links translation to performance and theatricality: "Being at the same time a body-reading, body-listening, and body-rewriting, it [the body-translating] moves incessantly inside the words of the text to be translated; it searches dictionaries and the intertext, rummages through its own imagination, questions the author, leans towards the female readers ... In constant motion, the body-translating performs the passage between the original meaning to decode and the final meaning to encode, always taking into account the rapport, the relation to the other, as on a stage."[54] The theatrical aspects of feminist translation that de Lotbinière-Harwood underscores not only concern the corporeal pleasures involved in translation but also the subject's identity formation in and as translation. The space in which the body-translation is articulated by desire and identification would result from a performative translation. Such a challenging reassessment of translation as performative reorientation suggests how feminist translation theory can account for gender identification across languages, races, and geographical spaces differently.

Jenik's adaptation shows how the translational movement from the media space of the book to that of CD-ROM, from French into English,

and from white to interracial love is itself a process of continuous performative translation. Moreover, Jenik has linked identity to performative moments in which she must translate herself between media, from script writing and filming to CD-ROM, "and in the process ask myself so many questions."[55] The (inter)media dimension in self-fashioning adds an important element to the notion of performative translation and the nature of contemporary self-writing or *hypomnemata*.[56] Working on the project, Jenik defines her desire as a continuous dialogic process between not only languages and gender identifications but also between the various media that shape contemporary lesbian subjectivity. Writing and translating would signify performing digital in a visual world of continuous media transformations. The writing space characteristic of the author / translator is itself translated into digital spaces of reconfiguration in which everything becomes possible in terms of media representation as a result of the computer's ability to simulate and perform all media.

The performative aspects of the computer – via writing, reading, viewing, and translating – are combined for and by the interactor in Jenik's autobiographical self-translations. A recent approach to autobiographical writing concerning performativity that evades the problematic disclosure of inner truths seems attractive for both heterosexual and lesbian women. In Sidonie Smith's view, there is no self that is unified or coherent before the actual writing of the self. The supposed interiority of both male and female subjects would be the result of the performance in which they inscribe their life stories. This is the critical view that Smith favours when she adopts Butler's description of performativity as an iterative process: "The history of an autobiographical subject is the history of recitations of the self. But if the self does not exist prior to its recitations then autobiographical storytelling is a recitation of a recitation."[57] It is precisely those moments of performance, heterogeneity, and interaction that we find in Jenik's autobiographical self-translations.

In the notion of autobiography as performative self-translation one must emphasize the moments of reiteration. Indeed, Butler has emphasized that gender identification possesses performative, citational, imitative, and repetitive aspects that need to be accounted for. In other words, there is always repetition and imitation in gender construction. As Jan Campbell and Janet Harbord have written: "What is most challenging about Butler's account is that the theatricality of the performative process applies not only to the scenarios of drag … but the theatrical

acts of mimesis circle back to the centre, to insist that all gender identifi-cation is constituted through the imitative process."[58]

Repetition is not only an important term in Butler's thought, but also in feminist translation theory in general. For example, Miléna Santoro's account of feminist translation practice places repetition at the heart of both women's linguistic endeavours and Brossard's novel. She writes: "While her [Maude Laures's] translation may in some ways attempt to repeat what Laures has created, this repetition is recognized as neces-sarily entailing a displacement, a replacement."[59] Santoro's concept of translation shows that there is always repetition but with a difference: difference in space, time, media, and desire. Similarly, the construction of desire and space in Brossard and Jenik is linked to linguistic and spatial translations that rest on repetition. In Brossard's novel, it is the translation into French of a text originally written in French, and in Jen-ik's heterotopia it is the hypermedia translation of the novel itself that functions as a double translation: the retranslation of Maude Laures's translation that occupies the third portion of the novel and the hyper-media translation of Brossard's work.

In the novel Maude Laures's translation into French of a short story written in French is an ambiguous repetition of the "original." Jenik's CD-ROM could be described as the fourth chapter in Brossard's novel. This fourth translation, however, is a digital translation that adds aural-ity and object images to the written word. The repetition involved in gender making is present in the process of intermedia translation, and it is doubled in the performative conception of gender that Butler pro-poses. Ultimately, the multitude of self-translations and repetitions the CD-ROM offers points to a complex understanding of becom-ing in which repetition occupies a central place in the reevaluation of autobiography in the context of digital media. Actually, the spatial and reiterative aspects of autobiography demand to be reconsidered. Rather than conceive of lesbian identity and desire as evolving only in time, Mélanie and Jenik offer a different conception of emotions that is worth examining in terms of space, repetition, and performative self-translation.[60] Similarly, on the CD-ROM Mélanie's and Jenik's bodies are understood as nomadic entities in which desire and identification always amount to a sense of space that is to be defined and overcome constantly in the object images that constitute Melanie's and Jenik's "visual autobiographies."

Most feminist scholars who have worked on visual autobiographies would not support the claim that self-representation functions as a

mirror revealing an individual's inner self or essence. Moreover, they would reject the hypothesis, as Julia Watson and Sidonie Smith do, that the female autobiographical subject only displays "narcissistic self-absorption,"[61] autobiographies being mistakenly depicted as mirrors that reflect the "real" life of a narcissistic subject. In fact, what "auto-biographies" in the form of self-portraits, photographs, installations, cartoons, performances, and websites display is a visual address in the mode of "enacted life narrations."[62] Such visual narratives function as what Watson and Smith call the "performative interfaces,"[63] which most characteristically allow access to the past. The depicted self in such per-formative interfaces is the result of addresses that go beyond the textual inscriptions of print culture and its reassuring self-presence.

Jenik's adaptation is certainly one form of autobiographical self-translation that detours us from textual inscriptions of the self. Adapt-ing Brossard's novel to the hypermedia environment of CD-ROM, Jenik wants us to reconsider the inherited discourses on the Western autobio-graphical subject in the context of an interactive media environment that challenges "the narrative elasticities and subversive possibilities of the genre."[64] Moreover, adapting a feminist novel, Jenik inserts her practice in various discourses on gender that we find her questioning or simply reinforcing. This aspect of Jenik's practice recalls Smith's comments on Mikhail Bakhtin's notion of "heteroglossia" that are useful to under-stand autobiography and self-translation from the margins, because these cultural discourses "affect various technologies of subjectivity by means of which autobiographical subjects secure themselves, dislodge themselves, or refashion themselves."[65] How does Jenik articulate her position as a desiring lesbian subject and maker of object images in acts of performative self-translation?

One of the most predominant modes of address on the CD-ROM is Jenik's voice-over. In her work the artist asks that the interactor ques-tion her own desire to understand and explore the digital heteroto-pia. This demand may distract us, however, from the autobiographical moments in which Jenik performs her desires before the very eyes of the interactor. Indeed, as Jenik conceptualizes the performances in which the actors must enact their lives and desires, the artist, in the "Maker map" section, is caught in autobiographical revelations that Brossard could not have foreseen, but that her novel certainly encour-ages. In fact, one could argue that Jenik's autobiographical revelations on the CD-ROM are even more fascinating than the actual representa-tion of Brossard's fictional characters. The voyeuristic impulses that

Jenik triggers in the interactor cannot go unmentioned, and her performance via self-writing can be analysed using the double metaphor of translation. Indeed, the technical and procedural challenges that she faces upon producing the adaptation have to be related to the performance of lesbian desire and identification found in the transition from the space of the novel to digital platform, from written language to programmable audiovisual media.

In the section titled "Maker map," the interactor who clicks on a road sign sees various sentences in the form of questions that appear at the top of the screen. Jenik asks herself: "How can I create an erotic of lesbian desire when I don't even understand my own desire?" The interactor thus becomes enmeshed in autobiographical revelations that she did not expect to come across and that certainly do not appear in the other digital heterotopias examined in this book. Jenik's questioning is legitimate though; it reveals how the adaptation process is not only a matter of media transformation, but also of inner motivation and self-translation that pertains to desire. The translation of the novel into virtual spaces of desire is the ultimate conclusion both Brossard and Jenik expect. But how can Jenik fulfil her intermedia mission if she cannot locate her spaces of desire and the performative moments they provoke?

Jenik actually questions the performance of desire when she asks herself this question: "Why do I romantize [sic] Melanie?" This question, however, points to two Mélanies: the one Jenik imagines in reading Brossard's novel, and the one she creates in her CD-ROM translation. The actual mental and emotional conception of Mélanie in terms of romanticism certainly points more to Jenik's desires than to the actual Mélanie who is to be found in the novel. Even though Mélanie is a free-spirited young woman who can arouse feelings of envy and jealousy, there is little romanticism in her words and actions. Her questioning of reality and apprehension of life as performance would contradict this claim.

Jenik asks herself another question that is directly related to her understanding of Brossard's depiction of Mélanie: "Why do I romanticize the time in my life when I was 'bad'? Is this an American trait?" Jenik identifies herself and compares her past behaviour with Mélanie's, Brossard's novel allowing her to put in perspective an actual account of her past. Indeed, why does she feel the need to romanticize her past actions in terms of badness or nationality? Is it because, as Smith argues, the autobiographical subject "comes to an awareness of the relationship of

her specific body to the cultural 'body' and to the body politic,"[66] or does she need to accentuate her past behaviour in terms of badness to display the attitude that she would like to project onto that behaviour? Is Jenik replaying and repeating Mélanie's behaviour in the novel when she questions reality and comes to the conclusion that she entered life as a character on the stage of her life? Mélanie's faith in performance rather than representation seems to be transferred onto Jenik's autobiographical self-translations.

The autobiographical traits of Jenik's journey are quite important and are somewhat rapidly passed over in most studies of her adaptation, as if critics had not found it important to turn the tables on Jenik's initial demand to question inner motivations and desires. This drive to understand, after all, concerns Jenik herself. Indeed, one could try to locate the personal obsessions that force a filmmaker or new media artist to adapt a particular work at a particular point in time. As Sue-Ellen Case points out about Jenik's *Mauve Desert*: "The CD-ROM version performs an obsession with the text and with Brossard more than any simple replication of the text itself could."[67] Case's mentioning of Jenik's CD-ROM as a performative site of obsession is suggestive, for it implies that the CD-ROM would reveal more than a film adaptation. Due to the great number of repetitive actions that the medium allows, the digital platform would permit a more obsessive and repetitious involvement with the work's spaces of desire than film could. The repetitive clicking and navigating activities in Jenik's heterotopia would provoke such behaviour in the interactor.

The plurality of clicking and navigating activities involved should not distract us from the way that they actually serve the confessional mode. At the heart of Jenik's object images lies the possibility that she might tell too much or reveal personal details. The artist asks: "Do I want anyone to know me?" Indeed, Jenik's CD-ROM is a very personal project that she shares with anyone who is willing to buy her adaptation. In other words, is Jenik selling a part of her desire and entering public space via consumerism? Of course, Jenik is perfectly aware that this digital exercise and the fear of sharing it with the world disclose something about her deepest feelings. She asks: "What am I hiding from?" She may have answered the last question herself: "This is indeed a fantasy. Am I too old to live it out?" Facing the difficult conceptual and financial steps involved in the adaptation of a literary work, Jenik questions her very motivations and attributes them to a fantasy that she wants to live out. However, the question is whether or not she wants to go all the way and

traverse the spaces of her desire completely. It is somewhat ironic that at the beginning of the CD-ROM, when Jenik's voice-over addresses us, the artist demands that we, interactors, question the motivating force underlying our desire to understand her work. Is Jenik trying to distract us from one of the central aspects of her work, its autobiographical component? In the final analysis, Jenik's performative self-translations are as important in their autobiographical revelations as they are in the overall design of the adaptation of Brossard's novel.

The autobiographical self-translations moving from the space of the book to the simulative environment of the computer and its interface, one may ask how a screen-based medium reconfigures desire. The critic writing on Jenik's CD-ROM cannot but smile at one of Brossard's remarks in the early discussions of the project, for her question seems to contradict the very premises of Brossard's novel itself. Indeed, in a 1995 fax found on the CD-ROM, Brossard asks Jenik: "Can the symbolic exist on a computer screen? [Can] a dimension behind the surface be gotten to?" How surprising it is to read Brossard's questions when Mélanie's own words would have given the author the best answer. All symbolic dimensions of desire are the expression of what lies on the surface of desire, not its actual depth, which cannot be attained anyway. This reminds us of the autobiographical self's desire to disclose the essence of its very being. Brossard's belief in a dimension behind the surface of the screen recalls the quixotic search for the core of the autobiographical self and somewhat contradicts the performative construction of desire in her novel. The screen does not obscure but filters the performance of desire, and it suggests viewing positions that the novel cannot accommodate.

Benefitting from the potentialities of computational media, Jenik asks herself, pertinently one might add: "How should it end? Am I bound to Brossard's ending?" This question actually becomes superfluous in the context of multilinear media such as CD-ROM. Indeed, even though there is a final section that leads to the credits sequence, the interactor is not forced to end her journey with it. Jenik's work can be explored using any given path and conclude on any given road stretch. For the interactor who decides to view the official "ending," "End of the road" plays a variation on the trilingual opening sequence discussed above. The ending features a similar trilingual soundtrack in French, English, and Spanish. However, what the narrators read is one of the last paragraphs in the novel. Fittingly, the last paragraph takes the theme of reality and replays it in the key of desire. A still image of Mélanie driving in the

setting sun while the reflection of her eyes is moving in the rear-view mirror is only one way to end the journey.

Jenik's CD-ROM is a fascinating adaptation of a very famous Québécois literary work. The artist's choice of Brossard's *Mauve Desert* is a judicious one, for the triptych itself translates quite easily into a multilinear combination of reading possibilities and exploratory activities. Furthermore, Jenik's approach to Mélanie's understanding of reality and desire articulates what is crucial in the novel: the linguistic and spatial translations inherent in both the task of the translator and the predilection for road trips. The construction and performance of gender, from its novelistic embodiment to its heterotopic setting, reveals the feminist agenda of the media artist in a way that highlights the performative nature of identity as a never-ending self-translation. Jenik's subtractive adaptation takes the interactor on a multifaceted journey that makes her question the very motives underlying desires via the artist's own motivation to hypertranslate Brossard's novel.

In Search of Lost Space: Photographic Memories and the Digital *Punctum*

Chris Marker's *Immemory* (1998) is the most well-known and commented upon artistic CD-ROM discussed in this study.[1] The work builds on digital multimedia's potentialities to significantly expand on the French artist's celebrated achievements such as *La Jetée* (1962), *Sans Soleil* (1982), and *Level Five* (1997) in the realm of the film essay. *Immemory* is indebted to two of Marker's multiscreen installations: *Zapping Zone* (1990), which was designed for the landmark "Passages de l'image" exhibition held at the Centre Georges Pompidou in Paris, and *Silent Movie* (1995), made to commemorate the centennial of cinema and to pay homage to silent film.[2] *Silent Movie*, a five-screen installation piece, elaborates on Marker's obsession with memory and features some of the films he watched as a child. Marker has continued to explore the world of interactive installation art with *The Hollow Men* (2005), the title referring to T.S. Eliot's poem of the same name.[3] Noteworthy is Marker's last exhibition, "A Farewell to Movies / Abschied vom Kino," which featured works such as *Silent Movie*, *Immemory*, and *The Hollow Men*, and computers to see the exhibition in the virtual space of Second Life.

Developed in collaboration with the Centre Georges Pompidou and first exhibited there under the title *Immemory One* in 1997,[4] *Immemory* occupies a crucial place in Marker's oeuvre for at least two interrelated reasons. First, the CD-ROM pursues the artist's interest in the potential of the computer and the digital image to delve into questions of time, memory, and recollection, issues that were first explored in *Level Five*. Second, and more importantly, with *Immemory* Marker takes a step further in continuing to move away from the cinematic apparatus. Starting with *Zapping Zone*, a work that has been described as "something like a first outline of *Immemory*,"[5] Marker increasingly left behind the

cinema screen and its projection space to inquire into a different form of artistic experience that would be more conducive to the presentation of his memories. As a subtractive adaptation, *Immemory* foregrounds the issue of memory and its relation to technology and media. If indeed "The problem of the medium is at the centre of the *Recherche*,"[6] then Marker's challenge is to find the appropriate artistic medium to convey the virtual life of past images and memories, a problem Proust implicitly places at the centre of his art, and that *Immemory* radically reconsiders in its object images.

Offering a vast heterotopia comprised of eight "zones," namely, "Cinema," "War," "Travel," "Poetry," "Photography," "Museum," "Memory," and "X-Plugs," which are playful digital collages and photomontages, *Immemory* proposes navigable spaces that the interactor can explore in nonlinear fashion. These zones present the interactor with Marker's memories in a global multimedia collection to be contemplated differently from his film essays, photographs, writings, or documentaries. Indeed, Marker uses the CD-ROM medium to offer object images that contain the combined desires of the filmmaker, photographer, documentarian, traveller, and writer, and they force a singular rearticulation of his memories and souvenirs on the interactor in one interactive space joining together everything he deems "immemorial" in his life experiences and documented travels around the world. Marker's digital heterotopia presents QuickTime clips, digitized photographs, postcards, notes, collages, and poems, among other artefacts, in an imaginary museum of sorts. More than a digital album of photographs or collection of hyperlinked images, *Immemory* belongs to the long history of artworks such as Aby Warburg's *Mnemosyne-Atlas*, August Sander's *Menschen des 20. Jahrhunderts*, Albert Kahn's *Archives de la planète*, or Jean-Luc Godard's *Histoire(s) du cinéma* collecting the sociocultural and artistic memories of an era. The CD-ROM functions as a sustained meditation on the state of memory in the digital age, and the fact that the work is based on two canonical sources only makes things more interesting for the critic interested in digital adaptation.

Immemory draws on two thematically related artistic monuments: Marcel Proust's *A la recherche du temps perdu* (1913–27) and Alfred Hitchcock's *Vertigo* (1958).[7] Freely combining the novel's and the film's main characters' obsession with time travelling, memory, and self transformation, the CD-ROM builds on Marker's own inclination to relive past experiences and moments, and, most importantly, make them available in a dedicated space where the process of exploring the artist's digitally

enhanced life stories and collected images is key. Explicitly stating his thematic indebtedness to Proust, Marker unwittingly inscribes his CD-ROM in the genealogy of film adaptations that have tried to recreate the Proustian quest for lost time and memory. Indeed, as a work relying largely on images to elaborate on Proust's novel, *Immemory* has to be considered in light of the numerous difficulties that beset any adaptation of the *Recherche*. As is the case with the other CD-ROM adaptations in this study, Marker is successful in his attempt to adapt Proust where most filmmakers have failed precisely because his adaptation is limited to a set of central issues rather than the entirety of Proust's novelistic cycle.

In this final chapter, I wish to circumscribe the nature of Marker's practice as an adapter, and how he manages to adapt Proust in a multilinear media environment featuring a particular type of object image. I am particularly interested in showing how Marker's object images play variations on controversial issues in Proust studies such as the underestimated role of space in the *Recherche* and Proust's ambiguous interest in photography. In the process of digitally enhancing his photographic memories, one of the challenges that Marker faces as an adapter is to create the transitions between zones and his coded photographic images; that is, finding space for movement and animation in a responsive, programmed environment based on "juxtaposing superpositions" that blur the boundary between both the photograph and the photographic process in multilinear assemblages. Marker's heterotopia being based on a literary work that is overly time-driven due to its joint emphasis on narrative and time regained, *Immemory* abandons temporal montage and privileges a spatial assemblage of photographic memories in a novel type of "art of memory" that challenges digital photography's preoccupations with the fate of indexicality. Marker's subtractive adaptation thus reconsiders Roland Barthes's notion of the *punctum* in light of the artist's use of photographs and photomontages that play with photographic contingency by coding it to answer the actions of the interactor.

This chapter thus offers a twofold contribution. First, as far as studies of Marker's CD-ROM go, issues such as the neglected notion of space in Proust, the ambiguous use of photography in the *Recherche*, and the existence of the "digital *punctum*" have not been discussed so far. Focusing on these neglected issues contributes to aligning Marker's and Proust's work in terms of shared concerns and in actually expanding them beyond the disciplinary concerns of literature and digital media

via photography. Second, the combination of these neglected aspects in the reception of *Immemory* also expands the notion of subtractive adaptation put forward in this study, as it opens up a potential way of working with the notion that is unexplored in previous chapters. Indeed, while Marker's approach to adaptation could be said to be "looser" than that of Boissier, Beloff, or Jenik, one could equally argue that this looseness as *radical subtraction* reveals the limitations of film adaptations of Proust at the conceptual level precisely because they have not *subtracted* enough from Proust, which is one of the lessons Marker's *Immemory* teaches any artist who would like to adapt the *Recherche* in future.

"Time Spatialized, Juxtaposed": Marker's Geography and Proust's Space

Marker's liner notes to *Immemory* reveal how much the work is indebted to a great number of unlikely sources such as St. Augustine, Sei Shonagon, Robert Hooke, and Nicolas Bouvier. Though less significant in impact than the overarching presence of Proust's *Recherche*, these sources help Marker to contextualize the design of his work and the particular issue of space that could be considered antithetical to Proust's intentions in his novel. It is worth delving into these apparently counterintuitive reflections, for, as is often the case in subtractive adaptation practices, it is not so much what is said to account for a source of inspiration that matters but what actually serves the artistic design and its deployment.

In his introductory notes to *Immemory*, Marker makes a very suggestive proposition that intends to reconceptualize the way in which we understand the key issue of memory. Indeed, rather than conceive of memory as "a kind of history book," Marker suggests that "fragments of memory" be considered "in terms of geography."[8] He remarks on the type of geography he has in mind: "in every life, we would find continents, islands, deserts, swamps, overpopulated territories and *terrae incognitae*," further adding that "We could draw the map of such a memory and extract images from it with greater ease (and truthfulness) than from tales and legends." He goes on to conclude that if the memories under study are that of a photographer or filmmaker, it does not signify that said memories will be more interesting, but simply that there are "traces with which one can work, contours to draw up his maps." Interestingly, it is such a "prodigious rhizomatic map"[9] that the

reader is called upon to imagine in Proust's novel, and the interactor is invited to draw it up by navigating *Immemory*. Marker's stated desire, it turns out, is for *Immemory* to serve as a catalyst for the interactor who "could imperceptibly come to replace my images with his, my memories with his, and that my Immemory should serve as a springboard for his own pilgrimage in Time Regained."

Marker's reflections should give us pause, for they allude to a number of issues at the centre of this chapter. A central issue on which Marker does not dwell in his proposal to reconsider memory in terms of geography is the tension between history, or historical retelling, and geography, or encounters in space. Though Marker implicitly points to the notion of time that is at the heart of Proust's novel, he radically proposes to do away with historical retelling or narrative when comes the time to call upon memories. What he envisages is a large space or vast collection of images and documents that would not need to be aligned with either a narrative retelling of past experiences or a chronological unfolding of events. On the contrary, Marker indicates that a "visual geography" could translate into a series of images that one could easily extract from the database of memories embedded in all of us in a way that cannot be replicated in the case of more traditional narrative retellings. As Marker notes on his design strategy: "My idea was to immerse myself in the maelstrom of images to establish its Geography."

This is not to say that *Immemory* lacks structure. As mentioned above, the interactor is invited to explore eight clearly defined zones. At given moments in a particular zone, the interactor is able to crossover to another zone by clicking on particular images that actually belong to two or more zones. However, such moments of transversal free play are the exception rather than the rule in the exploration of the CD-ROM's zones. In terms of *Immemory*'s geography, one notices that the CD-ROM possesses an implicit structural design on which Marker himself sheds light, commenting that "any memory, once it's fairly long, is more structured than it seems. That after a certain quantity, photos apparently taken by chance, postcards chosen according to a passing mood, begin to trace an itinerary, to map the imaginary country that stretches before us." There is a sense of mystery, the type of impression one gets from exploring an uncharted territory in other words, when navigating such a memorial space. Marker in fact adds that such a space would conceal "a chart, as in the tales of pirates." This unidentified map to the hidden treasures of Marker's memory would be *Immemory* itself, which would function as a "'guided tour' of a memory, while at the same

time offering the visitor a chance for haphazard navigation." Marker's introductory reflections thus disclose a palpable tension between structure and open-endedness, on one hand, and hiding and disclosing in terms of what is going to be accessible in his heterotopic design, on the other. The filmmaker's reflections refer to the potentiality of CD-ROM to offer a different artistic experience in a way that combines space and playfulness. As Marker notes on the use of this digital medium: "With the CD-rom, it's not so much the technology that's important as the architecture, the tree-like branching, the play."[10]

Marker's reflections on the design of *Immemory* cast new light on how one can adapt a literary work that has been considered impossible to adapt. Indeed, his desire to transfer memories into geographical rather than historical zones could be said to sharply contrast with the more conventional understanding of both narrative and time with regard to recollecting past memories and structuring them in linear fashion. By challenging the configuration of memory, time, and narrative characteristic of Proust, Marker goes beyond certain *idées reçues* found in the scholarship on the literary work at the heart of *Immemory*, Proust's *Recherche*. Similarly, a small number of influential literary critics and philosophers have commented on the *Recherche* in a way that echoes Marker's privileging of space and geography rather than time and history. The provocative reflections of Georges Poulet, Gilles Deleuze, and Félix Guattari on Proust can serve as further clarifications on Marker's ingenious design, and they actually point to numerous aspects on which I will elaborate in this chapter.

Proust's *Recherche* is generally associated with the themes of time, memory, and recollection. After all, the very title of the work signals the crucial importance of time and the quest for regaining lost time. It is therefore not surprising that, in the first three decades following the publication of the last volume, *Time Regained*, several critics spent a great deal of time and energy exploring, for example, the interrelations between the *Recherche* and Henri Bergson's concept of duration. Neither is it fortuitous that most adaptations of the *Recherche* have been in a time-based medium such as film. Therefore, it is with a great deal of scepticism that, in the early 1960s, readers were confronted with Poulet's and Deleuze's path-breaking reflections on Proust, which should have had greater impact on how the *Recherche*'s emphasis on time and memory is considered.

Poulet's study of Proust, entitled *L'Espace proustien* (1963), makes a bold move that is given away in its very title. Contrary to what

everybody thought, the essence of Proust's novel would lie in space rather than time. Examining various passages in the novel in which he uncovers the crucial import of space on descriptions that were apparently about time, Poulet elaborates on his provocative thesis that Proust is at home with the transformation of time into space, which, in fact, the writer would embrace to make it "one of the principles of his art."[11] In search of lost space, Proust's novel would inquire into the past insofar as it belongs to a given space, that is, past experiences are always remembered in a given space, and, one might add, in a given body. As the critic puts it: "Now, in the same way that the mind localizes a remembered image in duration, it localizes it in space."[12] Poulet thus puts the emphasis on "localization," thereby pointing to the understated role of space in the *Recherche*.

Similar to the importance of time, another key *topos* in Proust studies is the fragmentary nature of memory and the way in which the *Recherche* would offer the reader a fragmented "reading space" that, in fact, performs the discontinuous and fragmentary nature of both time and memory. Poulet further qualifies his reconsideration of Proust's magnum opus by pointing out that the discontinuous nature of time is "itself preceded, indeed even commanded, by a discontinuity still more radical, that of space."[13] Time and space would thus be enmeshed to the point that it is impossible to discuss the problem of time without addressing how it is always perceived, felt, and experienced in a given space or body in the novel. Citing the "madeleine episode" as an example, Poulet argues that it cannot be considered only in terms of regaining lost time: "Creation or re-creation of space, the phenomenon of the madeleine has thus for its consummation the integral reconstitution of place."[14] In other words, Poulet's emphasis on space has the merit of reminding the reader that time is always predicated on space in Proust's work.

Whoever is inclined to describe the passing of time in a given space, as is the case with Proust, must address the difficult problem of conveying movement in space. While there are various strategies for showing movement in a given space, one of them being Proust's emphasis on Marcel's various journeys, it still is difficult to give the reader a clear visual appreciation of movement in real space. As Poulet notes, Proust's way of solving this problem is to find another way of addressing movement in space by *juxtaposing* information. Movement therefore takes on a different form because it is assigned to the reader's own mental navigation of juxtaposed data, so to speak. One way of solving the problem

of representing movement on the page is by creating juxtaposed images in the reader's mind.

At this point in his argumentation, Poulet raises an interesting problem: the distinction between juxtaposition and superposition, a central contrast in Marker's approach to CD-ROM adaptation. Poulet notes that the difference between juxtaposing and superposing information would lie in the former placing one thing *next* to another, as opposed to the latter, which puts one thing *after* another. While juxtaposition would point to "the simultaneity of the two conjoined realities," superposition "requires the disappearance of the one so that the appearance of the other may take place."[15] What would be at stake for Proust, according to a reading that privileges time over space, is the depiction of life passing by, each new sensation and experience covering up the preceding one, that is, expressing the "essentially temporal character of existence."[16] Therefore, superposition could be seen as the privileged modality of movement for Proust. Poulet would go on to complicate things by arguing that, although time is of crucial importance in the novel, it is nevertheless subordinated to space in a way that would contradict the association of Proust's narrative strategies with superposition exclusively. On the contrary, Poulet would make the case for the prevalence of both juxtaposed images in Proust and, in fact, an ambiguous type of superposition predicated on juxtaposition. We must therefore further qualify Proust's use of superposition given its complex implementation in the novel.

The crucial role of the "magic lantern episode" in the opening pages of the *Recherche* has been overshadowed by the canonical "madeleine episode." The magic lantern episode constructs a more nuanced understanding of superposition, and the resurgence of the past in the present first gives us an indication that Proust's notion of superposition does not entail the complete disappearance of one element so that another may appear. His strategy in the novel is subtler; it foregrounds the cohabitation of past and present in a way that flirts with juxtaposition, precisely because there is a semblance of simultaneity of movement. Drawing on film terminology, one could say that Proust uses dissolves rather than cuts in order to show the presence of the past in the present. Poulet remarks that Proust uses the magic lantern episode to exemplify a *"juxtaposing superposition"* [*superposition juxtaposante*]: "In projecting an image on a wall, the lantern covers the wall but does not disguise it; so well that the image and the wall appear simultaneously, the one under the other."[17] The critic concludes: "the theme of the magic lantern,

placed by Proust at the beginning of his work ... has, it seems, a definite mission, that of expressing a paradox on which the Proustian novel will rest: the simultaneity of the successive, the presence, in the present, of *another* present: the past."[18]

We can derive from Poulet's reflections the importance of conceiving of Proustian time as more complex than it appears because it is irrevocably predicated on space, and the notion of superposition has to be refined and further qualified to accommodate the copresence of juxtaposed past images in the present. This, in turn, should allow us to reconsider the above definition of juxtaposition, precisely because the *Recherche* is intent on blurring the boundary between time and space, past and present. Poulet argues that juxtaposition "is the contrary of motion," for it is "an assemblage of objects that remain in their place, in fixed premises, while the movement just mentioned is a displacement that transfers an image of the past into the present."[19] In fact, Poulet speaks of tableaux and paintings to exemplify what he means by Proust's spatial design, but far from being just a collection of images, thoughts, and tableaux, the Proustian juxtaposition would be a "multiplicity unified"[20] that the reader has to assemble to avoid potential discontinuity. Movement would therefore lie in the reader's mind rather than on the page to create an *"illustrated space,"*[21] Poulet aptly concluding that Proustian time is "time spatialized, juxtaposed."[22]

While Poulet's comments on the *Recherche* allow us to better understand the intertwinement of time and space, superposition and juxtaposition, Gilles Deleuze's equally revisionist comments open onto a complex theory of reception that relates to Poulet's emphasis on space. Published only one year after Poulet's pioneering study of Proust, Deleuze's 1964 book *Proust et les signes* also destabilizes the reader by turning on their heads leading principles in Proust studies. Deleuze seizes upon two received ideas – the *Recherche*'s emphasis on the past and involuntary memory – to argue that Proust's work reflects the writer's interest in the future rather than the past, and that the notion of apprenticeship through large-scale decipherments of signs is more important than the process of involuntary memory. Proust's work would be turned towards the future, because it is "based not on the exposition of memory, but on the apprenticeship to signs."[23] Learning something new would concern the various signs to which the narrator, Marcel, is exposed: "To learn is first of all consider a substance, an object, a being as if it emitted signs to be deciphered, interpreted."[24] Deleuze considers the entire *Recherche* as three "worlds of signs"

belonging to worldliness [*mondanité*], love, and sensuous impressions or qualities, which function as the objects of Marcel's inquiring mind and his gradual transformation into a writer.

Deleuze's remarks on Proust end up offering a refracted notion of memory, which Marker would unwittingly echo to create his own in *Immemory*'s zones. Indeed, Deleuze's insightful reflections show how Proust's work would not be concerned with "the past and the discoveries of memory," but with the "future and the progress of an apprenticeship"[25] associated with learning how to decipher signs in a number of worlds. This approach to Proust in turn translates into a method to decipher not only signs, but also the work of memory itself when it is confronted by a plethora of signs that result from a shock to thought. Thought and memory thus function as relational entities that are nothing if they are not conjoined or forced into coexistence by a shocking revelation, reflection, or sight. This leads Deleuze to conclude that the leitmotiv in Proust's work is "force," that is, "impressions that force us to look, encounters that force us to interpret, expressions that force us to think."[26] What forces one to think is the thought-provoking sign, and it is, Deleuze maintains, the result of a contingent event that testifies to its necessity in the world.

Echoing both Poulet and Deleuze, Félix Guattari's reflections on Proust emphasize the importance of space, the future-oriented nature of Proust's narrative, and, more importantly, the open-endedness of its literary architecture. Guattari writes that "the structure of the *Recherche*, [due] to its nature as a palimpsest and rhizome, which results in constant juxtapositions and overdeterminations among characters, actions, places, etc.,"[27] forces a reconsideration of space in terms similar to Poulet's. Joining Deleuze, Guattari notes that "the *Recherche* is not directed towards this type of past, but towards a construction of things to come, towards a proliferation of the future in the act of creation."[28] Combining the emphasis on space with the one on the future, Guattari adds his personal touch by pointing to the proto-multilinear framework Proust offers: "The processes leading to the implementation of a literary creation machine ... are not linear at all. Throughout the *Recherche* it is developed via approximations, advances, and retreats ... In my view, the origin of these zigzags, these solutions of continuity, resides in a problem that never stops haunting the *Recherche*: that of the promotion of a new type of assemblage of enunciation."[29] These reflections lead him to conclude that "The *Recherche* can and must be read in all directions: from the end towards

the beginning, but as well as diagonally by traversing spaces, times, faces, characters, intrigues."[30]

Rethinking the way in which we should conceive of Proust's legacy, Poulet's, Deleuze's, and Guattari's revisionist reflections should give us pause, for they entail a radical reconsideration of what it means to address the *Recherche* in the context of time, memory, and digital adaptation. On the one hand, Poulet, Deleuze, and Guattari stress that Proust was interested in space, juxtaposition, and the future, and the way in which it is not possible to conceive of time, memory, and the past without addressing the opposite of each of these fundamental terms. On the other hand, their remarks tap into Marker's own reflections on geography, the object image, and his desire to rehabilitate space to show how memory can be envisaged without being exclusively predicated on historical retellings in a linear media environment.

The rehabilitating observations examined above can help us better understand Marker's achievement in *Immemory*. Marker posits that Marcel's madeleine must be translated into our own obsessions with the image and image making.[31] The image acts as Marker's madeleine, and he rehabilitates the power of the image to generate "involuntary associations" rather than Proust's "involuntary memories" in a media environment *forcing* the nonlinear *decipherment* of photographic *signs*, to use Deleuze's terms. If what Marker's CD-ROM proposes is "the geography of his own memory, to be traced via the accumulated signs and mementos of a lifetime,"[32] then reflections on space and the decipherment of multifaceted signs in the form of object images will help us to circumscribe Marker's desire to transform the suggestive powers of Proust's madeleine into an equally suggestive image. Precisely because we can inflect the notion of object image using Poulet's emphasis on space and Deleuze's emphasis on the decipherment of signs, we can assume that Marker's ontology of the object image will be more spatial than temporal in nature, and it will open onto the decipherment of a number of digital worlds and visual signs, as Deleuze would have put it, in the "global memory" Marker has created "out of the signs of his own life."[33]

After having established how space, the decipherment of signs, and the multilinear assemblage should occupy a more central position in inquiries into both the *Recherche* and *Immemory*, it is important to reconsider how the notion of *image*, as a technologically reproducible entity, figures in Proust's work and how it both inflects and is inflected by the notions of space, decipherable signs, and multilinearity. It is

intriguing that the ambiguous status of space in Proust extends to the photographic image, for the writer felt the indeterminate power of the photographic image and its potential influence on the *Recherche*. At first, the power of the image was deemed ambiguous precisely because the analogue image Proust had in mind was associated with a naturalist representation of phenomena à la Emile Zola that his *ars poetica* strongly rejected.[34] As we will see, the irrepressible influence of the photographic image would come to haunt Proust's famous descriptions. This guiding principle, combined with the rehabilitation of space, the decipherment of signs, and the multilinear assemblage, will function as our second interpretative key to make sense of *Immemory*'s photographic memories more meaningfully than has been the case so far.

Photography: A Proustian Technology?

In his poetic meditation on Proust and photography, well-known photographer Brassaï notes that "Photographic art is at the heart of Proustian creation: the author takes his inspiration from the techniques of photography for the description of his characters, the composition of his narrative, and utilizes an infinite variety of photographic metaphors in order to elucidate the very process of this creation."[35] Then it will come as a surprise that Proust is said to have shown abjection and disappointment in the technological innovations of his day. Recalling Kafka's ambiguity in this respect, Proust's interest in audiovisual technologies nevertheless found its way into the *Recherche*, in which the telephone, optical instruments and toys of all sorts, photography, and the cinematograph play a significant role.[36] In fact, several observers have turned the tables on Proust, and they have thoroughly examined the function of various visual media in his work, one critic qualifying his aesthetic approach as "intermedia in essence."[37] The magic lantern episode is emblematic of such a moment in which media and the senses would call for an "intermedia aesthetics" predicated on space. Eduardo Cadava underlines the power of the image and the role of visual media in the magic lantern episode discussed above: "Awakening in his dark room, Marcel finds himself in a photographic space. What whirls before him in this dark space is not only the changing, unseen walls, the doors, the furniture, but also the things, places, and years that remain written within his memory. Like a spectator in the dark projection hall of a cinema, he encounters a succession of images moving before him with a rapidity that, in bringing together the past and the present, prevents

him from orienting himself in relation to either the image, the past, or the present."[38] Emphasizing space allows a reconsideration of the madeleine episode as happening in an intermedia space and revealing the complex world of multimediality via a series of images in the "photographic space" of Marcel's "dark room." Thus envisaged, Proust's achievement would lie well beyond his presentation of involuntary memory to inquire into multimediality and the various processes of mediatization it implies.

In his reflections on media and memories in the liner notes to *Immemory*, Marker addresses the impact of the technological image on art, memory, and the public by reconfiguring Proust's madeleine. Marker's artistic creed is quite telling in this respect: "I claim for the image the humility and powers of a madeleine." In fact, it recalls Walter Benjamin's well-known comment on the actual nature of Proustian memories: "To be sure, most memories that we search for come to us as visual images. Even the free-floating form of the *mémoire involontaire* are still in large part isolated, though enigmatically present, visual images."[39] Taking photography as a case in point, Marker notes that "today, could it paradoxically be the vulgarization, the democratization of the image that allows it to attain the less ambitious status of a memory-bearing sensation, a visible variety of smell and taste?" Positing the image as the quintessential mode of recollection, as opposed to Proust's pastry calling back to mind lost sensations and memories famously associated with "involuntary memory," Marker goes on to argue that we would feel more drawn to "an amateur photograph linked to our own life history than before the work of a Great Photographer," because the former directly relates to our "personal history" rather than the impersonal realm of art. The democratization of the image and the free play between images and open-ended design are central to Marker's CD-ROM, and the artist's notes indicate how he wishes to rehabilitate space, geography, and the photographic image to distance himself from Proust's strategy in searching for the most appropriate medium for memory.

Upon reading Proust, one cannot but notice that photography is often depicted as leaving a great deal to be desired in terms of expressivity and vividness. For instance, Marcel comments on his memories of Venice: "I tried next to draw from my memory other 'snapshots,' those in particular which it had taken in Venice, but the mere word 'snapshot' made Venice seem to me as boring as an exhibition of photographs."[40] Critics have long noted that Proust associates photography with voluntary memory in direct reference to the medium, which, in his case,

equals a rather instrumental view of photography as a medium that can call back to mind only dead images. The problem with photography, as Marcel notes in the famous description of the photograph of his grandmother, is that it fails to do justice to the fullness of a human being's life, relegating every facet of it to surface impressions:

> A few days later I was able to look with pleasure at the photograph that Saint-Loup had taken of her [Marcel's grandmother]; it did not revive the memory of what Françoise had told me, because that memory had never left me and I was growing used to it … my grandmother had an air of being under sentence of death, an air involuntarily sombre, unconsciously tragic, which escaped me but prevented Mamma from ever looking at that photograph, that photograph which seemed to her a photograph not so much of her mother as of her mother's disease, of an insult inflicted by that disease on my grandmother's brutally buffeted face.[41]

As opposed to imagination, sensation, and perception, which Proust associates with involuntary memory, photography would not reveal the truth of the past or the essence of things but only surface matters in the form of a realist, two-dimensional copy. Similarly, Susan Sontag remarks on the use of photography in the *Recherche* that "Whenever Proust mentions photographs, he does so disparagingly: as a synonym for a shallow, too exclusively visual, merely voluntary relation to the past, whose yield is insignificant compared with the deep discoveries to be made by responding to cues given by all the senses – the technique he called 'involuntary memory.'"[42] As Charlus puts it very succinctly in *Within a Budding Grove*, photography's realist bias is its major flaw as an artistic medium: "A photograph acquires something of the dignity which it ordinarily lacks when it ceases to be a reproduction of reality and shows us things that no longer exist."[43]

In his account of photography, the notion of "reality" is key to Proust in the sense that it is intimately related to photography's seemingly inseverable ties to indexicality. At stake for Proust in photography's realist bias is the fact that it would misconstrue human perception in promoting matter-of-factness in the form of indexical truthfulness. As Marcel explains: "Our mistake lies in supposing that things present themselves as they really are, names as they are written, people as photography and psychology give an unalterable [*immobile*] notion of them. But in reality this is not at all how what we ordinarily perceive. We see, we hear, we conceive the world in a lopsided fashion."[44] Mistaking a

rich inner life for a mere pictorial representation of it, photographers would perpetuate a false understanding of "reality" and the way in which it can be grasped artistically.

Furthermore, such an emphasis on snapshots of reality would not properly render how "real time" flows in the sense that it is not made of a series of discontinuous images but of what Henri Bergson called "duration" [durée]: "For I possessed in my memory only a series of Albertines, separate from one another, incomplete, a collection of profiles or snapshots, and so my jealousy was restricted to a discontinuous expression, at once fugitive and fixed, and to the people who had caused that expression to appear upon Albertine's face."[45] Equating photography with such a view of life as a series of discontinuous impressions, Marcel cannot remember Albertine's face beyond what photography, as a medium equivalent to voluntary memory, can bring back to mind in its discontinuous and fixed images lacking movement and fluidity.

Based on such negative views on photography exposed in the *Recherche*, it might come as a surprise that certain critics have examined Proust's novel in terms of what Mieke Bal calls "visualization"[46] and the understated role "photographic and cinematic writing" occupies in the *Recherche*, revealing how Proust was interested in conveying striking visual images beyond the ones the reader could imagine as a result of the writer's unique mastery of the French language. According to such views, it would be shortsighted to claim that Proust thoroughly rejected photography altogether. Addressing the photographic medium, Bal notes that "photography's presence in Proust's work goes well beyond its explicit or thematic evocation. The photographic mechanism can be seen at work in the cutting-out of details, in the conflictual dialectic between the near and the far, and in certain 'zoom' effects. It can also be seen in the effects of contrast, which prevent or enable the under- or overexposed image to be seen."[47] Indeed, on numerous occasions in his novel, Proust uses photographic similes and metaphors to convey the inner life of individuals and to access lost memories: "Pleasure in this respect is like photography. What we take, in the presence of the beloved object, is merely a negative, which we develop later, when we are back at home, and have once again found at our disposal that inner darkroom the entrance to which is barred to us so long as we are with other people."[48] Here human perception and memories, in all their fleetingness, are likened to a mere "negative" that the individual will have to develop once she has gained access to the "inner darkroom" where a given memory will emerge from the flow of chaotic images registered

daily. Similarly, in the following passage, Marcel has recourse to photography and uses a simile to explain, paradoxically one might add, how literature is the superior form of life and artistic endeavour: "Real life, life at last laid bare and illuminated – the only life in consequence which can be said to be really lived – is literature ... But most men do not see it because they do not seek to shed light upon it. And therefore their past is like a photographic dark-room encumbered with innumerable negatives which remain useless because the intellect has not developed them."[49]

Bearing in mind the preceding passages from the *Recherche*, there would be two uses of photography in Proust: the first would be the direct references to photography and the camera, while the second, which is much subtler in nature, would concern Proust's allusions to photography that call for a reconsideration of Proustian psychology in photographic terms. Suzanne Guerlac has argued that Proust not only mentions photography in his work but also inflects his understanding and description of human nature with a photographic twist.[50] She goes on to show that Proust, on various occasions in his work, describes the writer's task using words that directly draw on photography such as fixing images, taking impressions, or capturing objects. Proust's notion of involuntary memory, at first dissociated from photography, becomes attached to it in terms of semantics. The limitations of voluntary memory cannot simply be linked to photography because Proust uses terms derived from photographic practice to describe involuntary memory. What he would object to is "the photo-psychological model of memory and perception that is conventionally taken as guarantee of objectivity."[51] The sharp distinction between voluntary and involuntary memory, based on the powers of the photographic image or lack thereof, no longer holds in this light.

Critical strategies such as Bal's and Guerlac's are in tune with the other revisionist accounts of Proust examined in the preceding section, for they seek to demonstrate how a neglected or rejected notion, or medium in this case, finds its way back into Proust's writing unbeknownst to him, so to speak. Therefore, though Proust's perspective could be seen as iconoclastic, we should be wary of too rapidly concluding that he was against technologically reproduced images. Indeed, what Proust's direct references and allusions to photography indicate is that he was against real, material photographs; he had nothing against the photographic process, that is, the type of mental process that would combine the work of the imagination and the impact of the real via

photographic effects. Irene Albers echoes such a viewpoint when she suggests that we must differentiate between the photographic *process* and the photographic *image* in Proust.[52] Whereas the former actually informs the notion of involuntary memory, the latter is seen as a more ambiguous artefact that is associated with a counter model of memory or mortification itself. In fact, emphasizing the photographic process would imply reconsidering the emphasis on involuntary memory as a case of photography rather than the opposite. In the final analysis, photography cannot be equated with an instrumental or unambiguous appropriation in the case of Proust.

"Du côté de chez Marker": Reprocessing Photographs

Marker's approach to digital adaptation relies on a very simple insight: seizing upon particular notions in the *Recherche* in order to give the image the powers of a Proustian madeleine that will tap into involuntary memories. In the case of *Immemory*, the powers of the object image are closely associated with geography and photography. As far as the latter is concerned, doing away with the stillness of photography will be necessary to evoke movement in relational patterns between zones. In *Immemory*, it is not so much identifying Marker's diverse sources that matters as "establishing relations between elements in the form of intertextual montages,"[53] and, to be more accurate, in multilinear relational media assemblages. It is indeed a *"geo-graphy"* that is offered in *Immemory*, that is, the "writing of the earth" as an unchartered territory characterized by memorable spaces of encounter. The photographs and photomontages qua object images found in Marker's heterotopia function as transhistorical and transgeographical *lieux de mémoire* to be interacted with.

Marker's object images qua madeleine offer a fascinating take on digital adaptation. Departing from Proust by emphasizing space and the potential force of the photographic image, Marker makes a brilliant move in rejecting the opposition between the photographic image and the photographic process. In *Immemory*, the object image is deemed worthy of Proust's involuntary memory, and the photographic process as an event taking place between image and beholder is foregrounded in the associations between images themselves and between certain zones that the interactor is invited to explore. Marker thus eliminates the opposition between photographs and the photographic process in replacing traditional montage by the interactive hypermedia assemblage

of digitized photographs that is more in tune with his understanding of memory and his choice of the proper medium for offering photographic memories.

It is little known that Marker stated that he had "no desire for film anymore; after this [that is, *Level Five*], I will work *only* with the computer."[54] *Immemory* is the first complete project that reflects this wish to go beyond film. Made with Roger Wagner's HyperStudio software, *Immemory* provides the user with an interface that is easily navigable. The home page welcomes the interactor by offering eight zones to choose from; it is up to the interactor to decide where the journey inside Marker's memory will begin.[55] Clicking on one of the eight zones will allow access to the zone's contents. Once inside a given zone, the rectangular space in which one finds various reading materials, photographs, a few QuickTime movies, or photomontages usually features directional hotspots that allow the interactor to return to the home page or the home page in a given zone by clicking on the red arrow at the top or bottom of the screen. Certain zones overlap with others (e.g., the Memory zone with the Cinema and Travel zones), thereby tapping into the relational qualities of CD-ROM to make data available just a click away. A most contingent aspect of *Immemory* features Guillaume-en-Egypte, a cartoon cat, which pops up throughout to ask questions of the interactor or to suggest alternative paths. Noteworthy is that the sound and moving-image components of *Immemory* are limited due to CD-ROM's limited memory space. This apparently detrimental characteristic in fact allows Marker to depend on a plethora of still images to explore another form of photobook and, instead of offering an extensive number of QuickTime clips, to rely on *kinema* rather than cinema, thereby privileging the notion of *movement* rather than the cinematic apparatus itself. As we will see, the emphasis on *kinema* will translate into the problem of creating movement between zones in the form of transitions, juxtapositions, and superpositions.

Clicking on the Memory zone, which functions as the nervous centre of *Immemory*, one notices the foundational status of both Proust's *Recherche* and Hitchcock's *Vertigo* in Marker's work. Indeed, the Memory zone's first page asks an apparently very simple question: "What is a Madeleine?" Remembering Marker's desire to claim for the image the powers of a Proustian madeleine, which, in *Swann's Way*, calls back involuntary memories, the interactor knows that this is no innocent question. Marker's subtractive adaptation of Proust rests on the key idea that an object image will be able to generate long-forgotten memories in

an interactive type of involuntary memory. The interactor's next task is to decide between clicking on Proust's face or Hitchcock's. Upon clicking on Proust's face, the interactor will eventually come to a textual reminder: madeleines are "all those objects, all those instants that can serve as triggers for the strange mechanisms of memory." Marker's CD-ROM is populated by diverse digitized artefacts associated with his journeys as traveller, photographer, and filmmaker, most of which are photographic in nature.

As is the case with Proust's *Recherche*, the importance of photography in *Immemory* – its omnipresence really – cannot be overstated. Most of the zones include a great number of digitized photographs or photomontages, and the task of the interactor is to establish connections between the zones and their respective photographs. Moreover, one of the most difficult tasks is to understand how a photograph in Marker's heterotopia is not just a photograph in a digital photobook. On the contrary, because certain photographs can trigger other object images or lead into other zones, they function differently. The photographic image in *Immemory* can thus be related to Marker's idiosyncratic understanding of the role of the image as both a visual artefact and a process that complement one another in creating the ideal medium for memory and the photographic event that sutures image and beholder in various hypermedia assemblages. It is the notion of photographic process itself that merits closer attention in the case of digitally enhanced heterotopic designs because it is implicitly coupled with the notions of automation, code, and interactivity that radically challenge what a photograph is or could be, as we shall see in the next section.

Inquiring into Marker's problems as an artist will translate into further qualifying the notion of space itself. Indeed, how does the artist tackle the problems of rendering movement in space via travelling between zones, juxtaposing and superimposing photographic images, and, recalling Poulet, "spatializing time"? In the case of the Photography zone, Marker takes up Poulet's notion of "juxtaposing superpositions." Functioning as the first step towards understanding Marker's subtractive adaptation of Proust beyond the emphasis on time regained and involuntary memory, the emphasis on juxtaposing superpositions demonstrates that photographic images in *Immemory* tend to obey a certain presentational pattern according to which past and present come to coexist in overlapping formations.

In the Photography zone, the interactor has to decide where Marker's memories will be leading her. This zone offers five countries (Korea,

Japan, China, Cuba, and Russia) to choose from, and two seemingly stranger spaces of exploration ("Erewhelse" and "Fairies") that cannot but pique the interactor's curiosity. In the case of the Korea section, one finds digitized reproductions of Marker's books *Coréennes* and *Le Dépays*, which were published in 1959 and 1982 respectively. The CD-ROM offers Marker the chance to republish in hypermedia format out-of-print publications, and the interactor unfamiliar with Marker's photographic work the opportunity to explore his photographic memories. Of particular interest is the 1997 "Coda" Marker includes in *Immemory*, thus pointing to the resources of digital media to update one's work.[56]

While using various cinematic transitions such as the wipe to transition between images and pages, one of Marker's most effective design strategies is to make visual and textual information coexist for a brief moment in animated assemblages that are composed with juxtaposition and superposition in the form of "juxtaposed superpositions." For example, in the Korea section of the Photography zone, the interactor contemplates a beautiful portrait of an unknown woman. Moving the cursor across the surface of the image, the interactor unwittingly triggers an animated textual formation that unfolds from right to left on the right-hand side of the screen. This textual supplement informs the reader that the photographed woman is named Sweetness and allows Marker to give other autobiographical information. Clicking on the red arrow will wipe the photographic slate clean, so to speak, and another page will unfold after the wipe. This type of media assemblage, as well as the type of transition used, is the most common in *Immemory*. Marker uses a variety of wipes that change direction (from top to bottom, from right to left, from the outer edges to the centre of the image, etc.), as well as other cinematic techniques such as dissolves and fisheye effects, to transition between one image and the next.

Various zones in *Immemory* feature reflections on memory and history that exemplify Marker's use of diverse techniques to suggest movement via juxtaposing superpositions. In the Cuba section of the Photography zone, the interactor is welcomed with the indication "1934, Cuban childhood." In this section Marker reveals an important insight into his understanding of memory and, therefore, photographic memory: "I do not hesitate to take liberties with my own memory, having no historical accounts to render to anyone. On the contrary, everything concerning Uncle Anton is as absolutely truthful as possible, given the numerous holes that riddle his biography. This figure who so fascinated me during

my childhood, and to whom I surely owe something of my passion for images, remains largely unknown to me." Uncle Anton Krasna plays the role of Marker's alter ego in *Immemory*; in the "Une Glace Magnifique" section a photograph of him is shown in an animated juxtaposed superposition that, again, combines textual and visual information in an unfolding pattern. First, a pale photograph of Anton is shown and then a virtual filter is applied to the image, which results in a more vivid photograph of the man. Then a question suddenly appears ("Who was Uncle Anton?"), which is followed by three possible answers that are commented on by Marker. Expanding on Uncle Anton's ghostly presence, in the Travel zone an amazingly well-constructed juxtaposed superposition features a series of photographs supposedly taken by Anton forty-four years ago that are combined with more recent images of the same monuments – the old photographs appearing and disappearing after the interactor has clicked on the red arrow. These are followed by photographs of volcanologist Haroun Tazieff in Iceland, the Arctic Circle, and of cities such as Paris, Stockholm, Tehran, Lisbon, and Berlin; the photographs follow one another in the same compositional strategy joining text and image and relying on the wipe to animate the transitions.

Using such design strategies, Marker's subtractive adaptation of Proust builds on the tension between the photographic image and the photographic process in the *Recherche* by adding movement to the still image via a number of cinematic transitions in interactive hypermedia assemblages. These downplay the stillness of the photographic image by emphasizing how it can open up the processual and relational qualities of the still image in the context of programmed events triggered by the interactor. Relying the way it does on the actions of the interactor, Marker's work points to a number of issues pertaining to how the digitally enhanced photographic image should be understood beyond the concerns of digital photography theory.[57]

Supplementing Photography: The Digitally Enhanced *Punctum*

An insightful way of understanding how Marker's digitized photographs on CD-ROM differ from printed digital photographs is to turn to photography's contingent nature. In his musings on *Immemory*, Patrick ffrench makes a useful distinction that should be borne in mind in the case of Marker's adaptation: "The Travel zone, or the Photography

zone, are of a different order from the Memory zone; iterative rather than narrative, more open to the contingency of the photograph, of its advenience or adventure to cite Barthes, than the images of the Memory zone."[58] Elaborating on this critic's insight, legitimate questions to ask are: What happens to photography's contingency when a photograph is digitized and integrated into a digital environment in which the actions of an interactor can alter the visual design? Can photography theory benefit from a reconsideration of the ontology of the photographic image and its interactive, that is, contingent design in *Immemory*? Ultimately, how can the use of digitized photographs on CD-ROM help us understand photography differently? Marker's interest in juxtaposing superpositions opens the door to a novel approach to digital photography because it offers a different take on both photographic contingency and the *punctum*.

In his reflections on photography in *Camera Lucida*, Roland Barthes establishes the now well-known distinction between what he calls the *studium* and the *punctum*. The former refers to the sociocultural, historical, or political characteristics of a given photograph, and reflects the photographer's intentions from a personal and technical point of view. The *studium* thus points to intentionality as a case of visibility. As part of a theory of reception, the *studium* evokes the quasi-universal appreciation of a photograph in terms of cultural knowledge. As opposed to the *studium*, the *punctum* is a personal, affective response to a particular detail in the photograph. It ruptures the detached contemplation or the vague cultural interest associated with the *studium* to address something more evasive: "The *punctum* therefore escapes from what counts as the art of the photographer, but also from what we could call the art of the photographic technique or of the object – the capturing of the present moment, the precision of technical processes, the exhibition of rarities – precisely because *punctum* is the name with which Barthes seeks to designate what cannot be seen in advance."[59] Indeed, according to Barthes, the *punctum* is a personal and quasi-autonomous characteristic that comes out of the picture, so to speak, grabbing his attention for a reason that cannot be explained easily. The *punctum* is "a 'detail,' *i.e.*, a partial object"[60] that causes the beholder to commit to the photograph in an unexpected way because of its affective impact, be it enjoyable or painful. The *punctum* thus gets a hold of the viewer in such a way that she has to confront her own desire to see; it is a perturbing agent that challenges detached appreciation.

While most critics have focused on the *punctum* as part of Barthes's theory of reception in the context of photography's affective impact, it is equally useful to ask *how* photographs affect us. How do they do it in other words? Such a question shifts the focus from the affect of photography to the construction of photographic affect. A first answer is given in Barthes's description of the *punctum* as possessing, "more or less potentially [*virtuellement*], a power [*force*] of expansion. This power is often metonymic."[61] The virtual force of the *punctum* to animate may take several forms. On the *punctum*'s power to animate metonymically, Jacques Derrida adds: "As soon as it [the *punctum*] allows itself to be drawn into a network of substitutions, it can invade everything, objects as well as affects … I said that the *punctum* allows itself to be drawn into metonymy. Actually, it induces it, and this is its *force*, or rather than its force (since it exercises no actual constraint and exists completely in reserve), its *dynamis*, in other words, its power, potentiality, virtuality and even its dissimulation, its latency."[62] Following up on Derrida's account, the *punctum* can be described as an animated detail or object triggering affect in a revised theory of reception that takes into account *how* the *punctum* manages to affect. Then a necessary question to ask is: how can the *punctum* demonstrate what we could call its "metonymic force or power of expansion"? In the case of Marker's digitized photographs, it is via Poulet's "juxtaposing superposition," which, as the reader will recall, describes Proust's way of organizing pictorial information in space and is taken up in *Immemory* by way of the animated hypermedia assemblages characterizing Marker's object images.

According to Barthes, the difference between inanimate photographs and those that come to life, that is, those that are "animated," would be due to certain photographs functioning as quasi-cinematic agents taking over the still image to animate it or to put it in motion in affective patterns. As Barthes describes the situation: "suddenly a specific photograph reaches me; it animates me, and I animate it. So that is how I must name the attraction which makes it exist: an *animation*."[63] Therein lies the difference between the *studium* and the *punctum* as well, which is to say the difference between photography and cinema. Of course, given that cinema relies on twenty-four frames per second passing in the projector to create the illusion of movement or animation, one has to consider the animated image of cinema as resulting from the work of a relational apparatus combining the stillness of the frame and the movement endowed by the projector. The relational aspect is crucial, for it implies a different understanding of the *studium-punctum* couple

that does not conceive of it in dichotomous terms. The animated assemblage of still images would characterize the effects of the *punctum* in this theory of reception. As Geoffrey Batchen points out: "What matters here is not the difference between *studium* and *punctum* but the political economy of their relationship."[64] The fact that Barthes articulates the *punctum* in terms of the supplement – for Barthes does call the *punctum* a "*supplément*," which is lost in the English translation[65] – points to the relational aspect of the term rather than its exclusionary tendencies, and, in fact, it facilitates a certain composition or common articulation between the *punctum* and the *studium* that is often forgotten. As Derrida remarks, the *studium* and the *punctum* "compose together, the one *with* the other, and we will later recognize in this a *metonymic* operation; the 'subtle beyond' of the *punctum*, the uncoded beyond, composes with the 'always coded' of the *studium*. It belongs to it without belonging to it and is unlocatable within it; it is never inscribed in the homogeneous objectivity of the framed space but instead inhabits or, rather, haunts it."[66] It is these particular relational and compositional aspects that merit closer attention in *Immemory*'s emphasis on photography and the simulation of movement between images and zones.

What happens to the "uncoded" *punctum* when it is generated in a multilinear environment such as that of CD-ROM? Can an artist code what she thinks will function as a *punctum*? Can it be automated to respond in a certain way according to particular actions from the interactor, and what are the consequences for the ontology of the photographic image? According to one critic: "the supplementary force [of the *punctum*] I am talking about, though its effects are everywhere to be felt, is not a generalizable phenomenon. It inheres in the particular and the contingent; it cannot be programmed or predicted."[67] It will be necessary to go beyond such views to discuss Marker's desire to challenge analogue photography's *punctum*, because Barthes does open the door to the impact of digital technologies and environments on both photography and the *punctum* when he attaches it to the indeterminate power of the supplement. Neither is it farfetched to claim that Barthes himself describes the *punctum* in a way that aligns it with automation, coding, and the contingency of interactive demands. On the one hand, Barthes notes that photography is "pure contingency and can be nothing else."[68] On the other hand, the manner in which this contingent photographic artefact can be said to expand beyond the confines of the frame should give us pause, for it points to the photograph as the site of transformation and automation in a way that merits closer attention in

the context of programming. The crux of the matter lies in the idea that for Barthes the *punctum* is what one might call a paradoxical supplement that appropriately describes the coded event between a computer program and an interactor. As he writes in a way that cannot but evoke computer scripts and programmed interaction: "it is what I add to the photograph and *what is nonetheless already there*."[69]

On numerous occasions in *Immemory*, the interactor uses the cursor to cross the surface of the object image in search of something special, that is, a particular detail, object or artefact whose potential for revealing something unexpected generates excitement. This particular object or detail would tend to come in conflict with the Barthesian definition of the *punctum*, in the sense that in *Immemory* the interactor has to search for the digital *punctum*, whereas in *Camera Lucida* the *punctum* is something that practically vies for the beholder's attention in some quasi-autonomous fashion. In other words, there is a reversal at play in the case of the digital *punctum* insofar as it demands something from the interactor in the context of its nature as a programmed object. In fact, this view calls back to mind an insightful comment on Barthes's *punctum* that aligns it with protocomputation: "The real point of the *punctum* is thus that it turns the photograph from a representation – something made by someone to produce a certain effect – into an object – something that may well produce any number of effects, or none at all, depending on the beholder."[70] Such a take on the *punctum* would resituate it by centering on both its digital objecthood and openness to manipulation rather than its affective charge. It should be underscored that this description of the digital *punctum* actually corresponds to Barthes's own description of the *punctum* when he claims that one adds something to the photograph that is paradoxically already in it. The logic of the supplement infects the *punctum* to the point that its essence is destroyed by its relational qualities and enmeshment in programmed contingency. It is precisely the point of automating the *punctum*: programming the contingent aspect by opening it up to the actions of the interactor who can transform the images in a way that was not possible before. However, the nature of these assemblages and how they function merit further qualification, which is what this chapter has tried to provide via a complex web of reflections on space, photography, and interactive media.

It becomes apparent that the *punctum* has to be reconsidered and can in fact be detoured in order to generate a different understanding of photographic artefacts in interactive environments. As a supplement,

the *punctum* already is a protointeractive entity demanding a response that is paradoxically already contained in it by way of its very nature. In the case of *Immemory* and its photographic memories, the interactor activates the *punctum* by clicking on what may be an image or by contemplating the photographic event itself: the changing nature of the environment in which photographs are displayed. The interactive *punctum*, referring to both the photograph and the photographic process itself in the case of *Immemory*, becomes a coded entity in a very different sense from that discussed by Barthes. As a pregnant detail, the *punctum* in a digital heterotopia such as Marker's is literally instrumentalized and thus becomes a coded function that points to the potential action of the interactor. It is what the viewer adds to the picture by her actions, yet it is what is already embedded in the code that permits the interactor to decide between options.

One can thus talk about the *programmed force* or *power* of the *punctum* in *Immemory*. The photograph keeps its contingent nature, but it makes a paradoxical move that automates its contingent aspects by tapping into the future actions of the interactor to be transformed. Therefore, it is not a matter of contingency disappearing in the case of interactive environments such as CD-ROM. As Mary Ann Doane points out: "I don't believe that the fascination with contingency characteristic of modernity is lost in the emergence of the digital. Perhaps, in digital media, contingency is relocated in the concept of interactivity – where the click of the mouse or the touch of a key can lead the user to unexpected virtual places, where navigation always seems to be subject to certain vagaries of chance and to the suddenness of the unforeseen encounter."[71] The *punctum* would thus become a paradoxical entity open to the demands of the interactor only within the confines of its programmed reactions. The hazard and chance associated with the contingency of photography becomes automated, and the detail or part object linked to photography both loses and reinforces its contingent aspect in the case of Marker's digitized photographs. Echoing Deleuze's take on Proust, Barthes notes that "The photograph does not call up the past (nothing Proustian in a photograph)."[72] One could argue that, in the case of Marker's adaptation of Proust and his digitized photographs, it calls up neither the past nor the future but simply the possible, the contingent. In the heterotopic world of CD-ROM, the *punctum* is an even more paradoxical supplement than was the case in analogue photography. The use of photographs in the computer environment thus challenges Barthes's notion of the *punctum* and his understanding of its contingent

aspect once the photograph has been digitized and programmed to respond to certain actions.

Adding a new chapter to the ontology of the photographic image after Walter Benjamin, Sigfried Kracauer, André Bazin, Susan Sontag, Roland Barthes, Henri Van Lier, and Vilém Flusser, *Immemory* even contributes a theorization of the photograph that goes beyond the debates over objectivity and authenticity, the collapse of the distinction between original and copy, and the fate of photographic realism and truth in digital photography. In ROM artworks such as Marker's *Immemory*, George Legrady's *An Anecdoted Archive from the Cold War* (1994), and Norman Klein's *Bleeding Through: Layers of Los Angeles, 1920–1986* (2003), the digitized photograph commands a theorization emphasizing programmed simulation rather than fake representation, and the notion of digital contingency will be key for making sense of this type of object image. Being different from other types of digital images and photographs, the digitized image in an interactive media environment demands both an intervention and a reconsideration of what is at stake in, say, the digital still photographs of Thomas Ruff, Loretta Lux, or Miao Xiaochun. For instance, Marker's images would challenge Lev Manovich's dichotomy between the analogue photograph and the digital, synthetic image when he writes that "In other words, if a traditional photograph always points to the past event, a synthetic photograph points to the future event."[73] One could argue that the digitized photograph in an interactive environment like that of CD-ROM is suspended between both contingent pasts and possible futures precisely because it relies on the *contingent actions* of an interactor to make it fully exist.

The contingent nature of such digitized photographs points to an unwritten chapter in the history of digital photography beyond what is at stake in the fake digital photograph and the downfall of indexicality. It is one of the reasons why Uriel Orlow notes how the notion of identification is to be rethought in the case of *Immemory*: "Marker's claim for, and use of the photographic image-madeleine, proposes a radically different conception of pictorial temporality where the image does not so much provide access to the past but contains the possibility for entering into a subjective relationship with it; a possibility that relies on recognition rather than representation."[74] No longer just a matter of identifying with the image, the digitized photographs in Marker's heterotopia demand a form of recognition that is predicated on interacting with programmed contingent events.

In his reflections on digital photography, Fred Ritchin coins the word "hyperphotography" to describe the type of photograph that will be responsive to programmed contingent events such as the ones found in *Immemory*. Such a photograph "will be forever linked with others as a component in the interactive, networked interplay of a larger metamedia. This new paradigm, which has yet to fully emerge, can be called 'hyperphotography.'"[75] In the case of Marker's hyperphotographs, they open onto unseen worlds and serve as pathways to memories that cannot but point to how Proustian involuntary memory is programmed in such a digital heterotopia. While some may deplore the loss of "real" involuntary memories, others, such as Ritchin, note how coded hyperphotographs offer different artistic experiences: "Much of digital photography will not be, as it is now, reactive but will try to anticipate and deal with potential issues rather than waiting for them to happen and recording their existence."[76] Addressing the notion of temporality and contingency, the hyperphotograph makes unpredictable associations that, recalling Proust, are at the heart of involuntary memory and *Immemory*. Pointing to the future of the photograph rather than its current state, Marker's subtractive adaptation opens the door to an overly due reconsideration of digital photography in line with what it could be instead of what it is in the present.

This chapter has shown how important it is to qualify Marker's creative space in terms of juxtaposing superpositions, photographic memories, and the digital *punctum*. As mentioned in the case of Poulet's rehabilitation of space in the *Recherche*, juxtaposing superpositions are as crucial to understand Proust's writing style as they are to conceive of Marker's way of presenting photographs in object images. Noteworthy in the case of *Immemory* is that it simulates movement and transformation in order to put the *punctum* in motion, so to speak. If Marker's CD-ROM makes movement between zones one of its main emphases, then one must attend to the way in which *Immemory* tries to go beyond its selection of photographs, film stills, and photomontages by employing cinematic techniques such as close-ups, wipes, fisheye effects, and various forms of superpositions that, once again, make it stand apart from the album of photographs or the traditional photobook in its configuration of object images.

In the end, it becomes apparent that it is not enough to rely on analogies between Proust and digital technologies to reconsider the *Recherche*, one critic noting, for instance, that "*À la recherche du temps perdu* can be seen as a huge database of memories."[77] Relying on analogy a great deal rather than on actual hypertextual, multimedia, or interactive artefacts,

such propositions fail to show how Proust can be adapted in the digital age beyond hyperbolic or anachronistic claims. Marker, as a maker of object images, evinces hyperbolic reconsiderations when he suggests focusing on geography rather than time in his adaptation of Proust, the primordial role of space in the form of the architectural spaces of CD-ROM, and, ultimately, the playful nature of CD-ROM to expand on the *Recherche*. This playful element can be associated with the fact that *Immemory* is not so much the cartography of Marker's memory as a reflection on the very possibility of cartography in the sense that the interactor is "inserted in a virtual framework of connections whose map ... is impossible to draw, nor conceive of in a totalizing, unified, and homogenous manner. In any case, it concerns developing a provisional, unstable, fragmentary, and discontinuous cartography, multicentered [*pluricéntrica*]."[78] Marker's work thus functions as a playful hypermedia experience in digital cognitive mapping.

An "Immense Memory"

Of all the literary works on which the subtractive adaptations examined in this book are based – Jean-Jacques Rousseau's *Confessions*, Villiers de L'Isle-Adam's *Tomorrow's Eve*, Raymond Roussel's *Locus Solus*, Nicole Brossard's *Mauve Desert*, and Marcel Proust's *In Search of Lost Time* – the latter is the only one that has been the object of serious attempts to adapt it to the big screen. With the exception of James Joyce's *Finnegans Wake*, Proust's work could be said to be the most "unfilmable" literary work ever. It is therefore deeply intriguing that a great number of screenwriters and filmmakers have sought to translate Proust's world into moving images. One need only think of the unsuccessful attempts of Luchino Visconti or Harold Pinter, who had to abandon their quixotic dream of adapting the *Recherche* due to lack of funding in the 1970s.[79] The 1980s saw German New Wave director Volker Schlöndorff attempt to adapt the first volume, *Un Amour de Swann* (1984), to less than critical acclaim. Fifteen years later, Raúl Ruiz's adaptation of the last volume, *Le Temps retrouvé*, met a mitigated critical response in 1999. The following year, filmmaker Chantal Akerman made *La Captive* (based on *The Prisoner*); it is the only film adaptation of Proust that has been generally well received.[80]

Based on these attempts, it is quite understandable that screenwriters and filmmakers have come to the conclusion that it is impossible to condense over two thousand pages into a ninety-minute film adaptation.

They have thus decided to focus on one particular volume in order to translate the essence of Proust's masterpiece. Adaptations of varying success such as those of Schlöndorff or Ruiz confirm what one critic has noted in his survey of film adaptations of Proust: "it would be wiser to tackle only one part or one theme" rather than the entire *Recherche* or even a given novel among the seven to choose from. Ifri adds: "screenwriters and directors clearly have a better chance of success if they elect to make films inspired by Proust or with a Proustian flavor."[81] It is such a strategy that Marker uses in *Immemory*, and the four subtractive adaptations examined in this study all favour a different approach to adaptation to relaunch the practice and challenge the hegemony of film adaptation.

What the object images analysed in the preceding chapters have shown is that adapting a literary work to a multilinear environment such as CD-ROM involved a considerable reflection on adaptation as a creative practice. One could argue that the failed attempts to adapt Proust stemmed from the failure to reflect on the act of adapting itself, and they implicitly underlined the way in which adaptation to film, and, one should add, to interactive media, could not rely on the old bag of tricks to offer a compelling experience. If it was not possible in the case of Proust and film, how could it be possible in the case of Proust and the ROM environment? I concur with Martine Beugnet and Marion Schmid when they claim that "the films that could be described as particularly 'Proustian' are not necessarily adaptations of his work, strictly speaking, but films that espouse and elaborate upon his radically new aesthetic and thought in their very fabric."[82] This approach is exactly what Marker and the other adapters examined in this book have used in their digital heterotopias in a way that cannot but raise larger questions pertaining to the future of cinema and film adaptation.

In the end, few would question that there is an undeniable desire to go beyond the cinematic apparatus in Marker's work since the 1990s and especially in *Immemory*. Marker concludes the Cinema zone on a very telling note: "From *Wings* to *Star Wars*, I will have seen many things fly over the world's screens. Perhaps cinema has given all it can give, perhaps it must leave room for something else … The death of cinema would be only that, an immense memory. It is an honorable destiny." In the case of *Immemory*, cinema's temporal unfolding and "immense memory" are revisited in such a way as to question the very raison d'être of this temporal art form. There is no doubt that Marker's subtractive adaptation of Proust is just that: a farewell to cinema as the memory of the twentieth century and its spectral evolution in object images.

Conclusion

This study has retraced the emergence of CD-ROM as a creative medium adopted by several media artists interested in its potential during the period of its ascendency in the 1990s. What CD-ROM provided artists such as Jean-Louis Boissier, Zoe Beloff, Adriene Jenik, and Chris Marker was an unprecedented multimedia platform to experiment with new ways of adapting literary works. With the help of four artistic CD-ROMs, I have shown that a sustained look at a digital artefact such as CD-ROM can generate unforeseen insights into the history of media arts and provide the first chapter in the unwritten history of digital adaptation. Continuously denigrated since the rise of the DVD and the Internet, CD-ROM, once given a closer look, can be seen as more than just another discarded digital commodity. Indeed, CD-ROM's resources as a creative medium having been brought to light, one is in a better position to appreciate its crucial position within media history, especially its unique function as an artistic medium in the 1990s. The core chapters thus serve as one case study of a brief – roughly, a decade – but highly fascinating fin-de-millennium encounter between a new interactive medium and well-known literary works that had not received much attention.

In the closing pages of this book, I wish to derive the fundamental implications stemming from the study of subtractive adaptation and the conceptual approach developed in the preceding chapters. I will focus on the implications of studying digital artefacts and what type of approach could be considered in future studies. The study of CD-ROM does raise significant questions for future interpretations of interactive media and digital adaptation, especially regarding the tenets of new media historiography.

As shown in this study, an unwritten chapter in the history of digital media and adaptation practices could focus on the undeniable merits of several art CD-ROMs that borrowed from literary interfaces. As a fascinating case of intermediality in the late twentieth century, the crucial role of novels as matrices for CD-ROM adaptations was an indication of the still pertinent yet unexpected place Rousseau, Villiers, Roussel, Brossard, and Proust could occupy in the heyday of the digital multimedia revolution. Fostering interdisciplinary research the way they did, these CD-ROMs asked that we consider the "lives of the novel"[1] beyond print and film cultures. It is a story of interdependence that has been told in these pages, as writers relied on media artists posthumously, and as media artists drew inspiration and energy from fictional characters and settings to help define their artistic agenda and gain cultural capital in the face of a new medium that provided inspiration, energy, and a certain democratization of the creative process in the context of a new digital media framework that could be easily appropriated. This story makes for a refreshing new chapter in the history of adaptation practices.

Taking a retrospective look at the achievements of Boissier, Beloff, Jenik, and Marker and their artistic medium of choice, one cannot but be intrigued by CD-ROM's peculiar place within media history. Here the notion of "regime of historicity" can help to understand CD-ROM's historical position. A concept borrowed from the work of French historian François Hartog, "regime of historicity" [*régime d'historicité*] refers to the way in which a given historical or artistic period, or even a work of art, establishes its own unique rapport to time.[2] While particular historical periods or artistic trends can be said to have been forward looking and have emphasized the future (e.g., early twentieth-century modernist movements such as Futurism), others can be described as having focused on the past to rejuvenate the present, a good example being the Renaissance writers' interest in revisiting the Latin classics.

Applying Hartog's insight to digital media objects, what could be said to have characterized CD-ROM's regime of historicity is its dual emphasis on both the past and the future in the form of the "frictions and productive juxtapositions" Marsha Kinder and Tara McPherson have discussed.[3] While clearly a medium whose passé nature was already foreseeable with the rise of the DVD and the Internet in the 1990s, CD-ROM, as an artistic medium having produced the first sustained practice of digital adaptation, simultaneously pointed to the future of adaptation if we single out two of its distinctive achievements that are still

with us today: its pioneering subtractive adaptation practice and object images. Suspended between these two historical moments, that is, its impending demise as the promising multimedia platform that would relegate it to the past and its future as the first chapter in the unwritten history of subtractive adaptation practices, CD-ROM's relationship to time was both retrospective and prospective in nature. This ambiguous relationship to time, which is to say CD-ROM's regime of historicity, made it a unique entity in recent media history. It thus behooves us to reread media history against the grain by attending to ephemeral media such as CD-ROM to reconstruct their regime of historicity and to give them their proper place within media history and adaptation studies.

Furthermore, a concept such as Hartog's "regime of historicity" can help to assess the *belated force* of a media entity such as CD-ROM. The implications of Hartog's concept can explain why it is difficult to agree with Vivian Sobchack's retrospective look at her 1999 article on Quick-Time in which the software and its pioneering role are still subordinated to technological obsolescence. Writing more than ten years after the publication of the article, Sobchack notes: "In the piece, if ironically, I regard both the form and the constraints of these little Quick-Time artifacts as *already relegated to the past* insofar as the present was then fixed on achieving the computer memory and speed to allow for 'streaming.' I was prescient insofar as few (if any) of the works made in this mode remain."[4] Contrary to Sobchack's account, which emphasizes QuickTime movies' predictable obsolescence, I would argue that obsolescence need not be the first item on the agenda; understanding a medium's regime of historicity and potential belated forcefulness should. As this study of CD-ROM and digital adaptation has shown, it is not the technologically determined aspects of new media that count, but the unsuspected role certain media play in the hands of artists who serve as intercessors in media history, allowing the literary achievements of novelists to survive in the world of CD-ROM art in this case.

In hindsight, it is the issue of time as relates to the "new" in "new media" that seems to pose a problem in the accounts that adopt a technologically deterministic view of media history. Indeed, where exactly did a new medium such as CD-ROM belong with regard to newness? To answer this question, it is useful to turn to Wendy Chun's provoking description of new media, which justifies the recourse to "regime of historicity" and, in fact, supports the view that CD-ROM's regime of historicity oscillated between the past and the future. Chun writes: "New media, like the computer technology on which they rely, race

simultaneously toward the future and the past, toward what we might call the bleeding edge of obsolescence."[5] Complicating the notions of newness, obsolescence, and speed that have characterized descriptions of digital media, Chun urges us to consider a far more suggestive aspect to new media: the "nonsimultaneity of the new,"[6] which is precisely what CD-ROM's regime of historicity pointed to considering its simultaneous emphasis on the past and the future.

In the context of so much talk about obsolescence and the impending passé nature of all digital artefacts, it is no wonder that the notion of "memory," as shorthand for "regime of historicity," has surfaced in digital media studies to explain the ambiguous workings of specific media entities. Chun herself claims that the "major characteristic of digital media is memory."[7] Time and memory do constitute potential allies for the researcher interested in the belatedness and "nonsimultaneity" of new media. Chun gives the example of computer memory to show that new media have a problem coinciding with themselves in the present: "The age of a computer memory device rarely corresponds with the age of the memory it holds; the device and its content do not fade together."[8] Then, attending to the ontology of what Chun calls the "enduring ephemeral" seems to be a crucial item for digital media studies, media archaeology, and game studies, as shown in the work of James Newman,[9] if these fields wish to resist the siren song of the obsolescence paradigm so much prized by digital capitalism or the revival of dead media for dead media's sake. Turning to the various regimes of history embedded in the devices and platforms that populate our lives for a few years is a good starting point, and this is what Chun refers to when she makes a plea for the analysis of "the ways in which ephemerality is made to endure."[10]

Bearing in mind Chun's insights, one is in a better position to justify the study of recent digital media entities such as CD-ROM. What this conclusion has sought to demonstrate, however, is that the study of an almost forgotten medium such as CD-ROM does not have to be about the past exclusively. While many media archaeological efforts can be said to struggle with demonstrating that their revisionist pleas do concern more than the past as a repository of forgotten media, this study of CD-ROM and digital adaptation, given its emphasis on the creative work of media artists and their wish to explore literary materials in a novel form of adaptation practice called subtractive adaptation, suggests that the medium will have a role to play as precursor in future studies of digital adaptations. That is to say, while the medium

itself, CD-ROM, was indeed ephemeral, the key artistic practice stemming from its use, subtractive adaptation, has endured in various other interactive media, the most commercially successful one being digital games. As interactors become more and more familiar with adaptations to digital games, smartphones, and tablets, CD-ROM artists' pioneering role in being the first to challenge the film adaptation paradigm will emerge. CD-ROM's exploration of the future of adaptation beyond film adaptation will position the ROM medium as the missing link between film adaptations and adaptations to other interactive media platforms.

Finally, the object images studied in this book lay the groundwork for future studies of programmed images by media artists and game designers. Facing the thought-provoking works in the world of gaming and other ludic environments, it is not farfetched to claim that the notions of space and play have become central in adaptation practices given both the complexity of heterotopic designs and the world-making abilities of designers and programmers that entail an increasing degree of interactor engagement in ever larger spatial configurations. In the context of subtractive adaptations featuring larger worlds to explore, the *playable* image, as a case of the object image, trumps the filmic image in the realm of adaptation. It will be up to us to decide if we want to play with the object images in subtractive adaptations and confront their enduring presence in digital media. The pioneering CD-ROMs of Jean-Louis Boissier, Zoe Beloff, Adriene Jenik, and Chris Marker will have shown us the way.

Notes

Introduction

1 George Bluestone, *Novels into Film* (Baltimore: Johns Hopkins Press, 1957).

2 I would further qualify Simone Murray's and Kamilla Elliot's claims that Linda Hutcheon's *A Theory of Adaptation* vastly expands adaptation studies into digital media. The second edition of Hutcheon's *A Theory of Adaptation* does contain a new epilogue by Siobhan O'Flynn, which addresses the fate of adaptation in transmedia worlds. However timely and refreshing, enumerating adaptations to digital games or the tablet is not sufficient; one needs to develop a theoretical and conceptual model for demonstrating the achievements (or lack thereof) of particular digital adaptations. In other words, one cannot limit the analysis to the existence of digital adaptations, for this does not explain their significance, be it in aesthetic, social, or cultural terms. See Simone Murray, *The Adaptation Industry: The Cultural Economy of Contemporary Literary Adaptation* (New York: Routledge, 2012), 3; Kamilla Elliott, "Theorizing Adaptations/ Adapting Theories," in *Adaptation Studies: New Challenges, New Directions*, ed. Jørgen Bruhn, Anne Gjelsvik, and Eirik Frisvold Hanssen (London: Bloomsbury, 2013), 25; and Linda Hutcheon with Siobhan O'Flynn, "Epilogue," in *A Theory of Adaptation*, 2nd ed. (New York: Routledge, 2012), 179–206.

3 I have devoted numerous publications to adaptations in media arts and digital games. See Bruno Lessard, "Intermédialité et interperformativité: à propos du site Web *Last Entry: Bombay, 1 July … A Travel Log Through Time, Space, and Identity* de Andrea Zapp," *Intermédialités* 1 (2003): 139–53;

"Interface, corporéité et intermédialité. *Sonata* de Grahame Weinbren," *Parachute* 113 (2004): 60–9; "The Environment, the Body, and the Digital Fallen Angel in Simon Biggs's *Pandaemonium*," in *Milton in Popular Culture*, ed. Greg Colon Semanza and Laura Knoppers (New York: Palgrave Macmillan, 2006), 213–23; "Hypermedia *Macbeth*: Cognition and Performance," in *Macbeth: New Critical Essays*, ed. Nick Moschovakis (New York: Routledge, 2008), 318–34; "Archiving the Gaze: Relation-Images, Adaptation, and Digital Mnemotechnologies," in *Save as … Digital Memories*, ed. Joanne Garde-Hansen, Anna Reading, and Andrew Hoskins (New York: Palgrave Macmillan, 2009), 115–28; and "The Game's Two Bodies, or the Fate of *Figura* in *Dante's Inferno*," in *Digital Gaming Re-imagines the Middle Ages*, ed. Daniel T. Kline (New York: Routledge, 2013), 133–47.

4 A publication such as Colin MacCabe, Kathleen Murray, and Rick Warner, eds., *True to the Spirit: Film Adaptation and the Question of Fidelity* (Oxford: Oxford University Press, 2011) exemplifies a subtle plea for the return to fidelity criticism.

5 Kamilla Elliott, "Rethinking Formal-Cultural and Textual-Contextual Divides in Adaptation Studies," *Literature/Film Quarterly* 42, no. 4 (2014): 588.

6 N. Katherine Hayles, *How We Think: Digital Media and Contemporary Technogenesis* (Chicago: University of Chicago Press, 2012), 7.

7 Digital game adaptation seems on its way to becoming the object of more sustained attention. See Jamie Russell, *Generation Xbox: How Video Games Invaded Hollywood* (Lewes: Yellow Ant, 2012); Alexis Blanchet, *Des Pixels à Hollywood. Cinéma et jeu vidéo, une histoire économique et culturelle* (Châtillon: Pix'n Love, 2010); and Trevor Elkington, "Too Many Cooks: Media Convergence and Self-Defeating Adaptations," in *The Video Game Theory Reader 2*, ed. Bernard Perron and Mark J.P. Wolf (New York: Routledge, 2009), 213–35.

8 N. Katherine Hayles, *Electronic Literature: New Horizons for the Literary* (Notre Dame, IN: University of Notre Dame Press, 2008), 24.

9 N. Katherine Hayles, "Print Is Flat, Code Is Deep: The Importance of Media-Specific Analysis," in *Transmedia Frictions: The Digital, the Arts, and the Humanities*, ed. Marsha Kinder and Tara McPherson (Berkeley: University of California Press, 2014), 21. This book chapter is a revised version of the 2004 article cited in the following note.

10 N. Katherine Hayles, "Print Is Flat, Code Is Deep," *Poetics Today* 25, no. 1 (2004): 72, emphasis in original.

11 Hayles, *Electronic Literature*, 30.
12 See Jessica Pressman, Mark C. Marino, and Jeremy Douglass, *Reading Project: A Collaborative Analysis of William Poundstone's* Project for Tachistoscope {Bottomless Pit} (Iowa City: University of Iowa Press, 2015).
13 Jessica Pressman, *Digital Modernism: Making It New in New Media* (Oxford: Oxford University Press, 2014), 2.
14 Michael Ryan Moore, "Adaptation and New Media," *Adaptation* 3, no. 2 (2010): 191.
15 Robert Stam, "Introduction," in *Literature and Film: A Guide to the Theory and Practice of Adaptation*, ed. Robert Stam and Alessandra Raengo (Oxford: Blackwell, 2005), 11.
16 Thomas Leitch, *Film Adaptation and Its Discontents* (Baltimore: Johns Hopkins University Press, 2007), 265.
17 Ibid., 258.
18 Costas Constandinides, *From Film Adaptation to Post-Celluloid Adaptation* (London: Continuum, 2010), 149.
19 See Russell J.A. Kilbourn and Patrick Faubert, "Introduction: Film Adaptation in the Post-Cinematic Era," *Journal of Adaptation in Film and Performance* 7, no. 2 (2014): 156.
20 See Thomas Lamarre, "Full Limited Animation," in *Ga-Netchu! The Manga Anime Syndrome* (Frankfurt am Main: Deutsches Filmmuseum, 2008), 106–19, and Thomas Lamarre, *The Anime Machine: A Media Theory of Animation* (Minneapolis: University of Minnesota Press, 2009), 184–206.
21 Gilles Deleuze, *Cinema 1: The Movement-Image*, trans. Hugh Tomlinson and Barbara Habberjam (Minneapolis: University of Minnesota Press, 1986), and Gilles Deleuze, *Cinema 2: The Time-Image*, trans. Hugh Tomlinson and Robert Galeta (Minneapolis: University of Minnesota Press, 1989).
22 Antony Fiant, *Pour un cinéma contemporain soustractif* (Paris: Presses Universitaires de Vincennes, 2014), 10.
23 Ibid., 30.
24 The following developments on the Deleuzian electronic image draw on Bruno Lessard, "Missed Encounters: Film Theory and Expanded Cinema," *Refractory: A Journal of Entertainment Media* 14 (2008), http://refractory.unimelb.edu.au/2008/12/26/missed-encounters-film-theory-and-expanded-cinema---bruno-lessard/.
25 Deleuze, *Cinema 2*, 267.

26 Ibid., 270.
27 The problem of space in Deleuze's thought has been addressed, but its status in Deleuze studies remains marginal compared to that of other notions such as time, actuality, and virtuality. See Ian Buchanan and Gregg Lambert, eds., *Deleuze and Space* (Edinburgh: Edinburgh University Press, 2005).
28 Deleuze, *Cinema 2*, 265.
29 I derive these six elements from Noah Wardrip-Fruin, *Expressive Processing: Digital Fictions, Computer Games, and Software Studies* (Cambridge: MIT Press, 2009), 13.

1. Back to the Future

1 Publications adopting a similar critical and historiographical viewpoint range from new media studies published more than ten years ago when the field was in its infancy to more recent work in media archaeology and game studies. See Lori Emerson, *Reading Writing Interfaces: From the Digital to the Bookbound* (Minneapolis: University of Minnesota Press, 2014); Lisa Gitelman, *Paper Knowledge: Toward a Media History of Documents* (Durham: Duke University Press, 2014); Wolfgang Ernst, *Digital Memory and the Archive*, ed. Jussi Parikka (Minneapolis: University of Minnesota Press, 2013); Wendy Hui Kyong Chun, *Programmed Visions: Software and Memory* (Cambridge: MIT Press, 2011); Erkki Huhtamo and Jussi Parikka, eds., *Media Archaeology: Approaches, Applications, and Implications* (Berkeley: University of California Press, 2011); Alice Bell, *The Possible Worlds of Hypertext Literature* (New York: Palgrave Macmillan, 2010); Noah Wardrip-Fruin, *Expressive Processing: Digital Fictions, Computer Games, and Software Studies* (Cambridge: MIT Press, 2009); Terry Harpold, *Ex-foliations: Reading Machines and the Upgrade Path* (Minneapolis: University of Minnesota Press, 2009); Matthew Kirschenbaum, *Mechanisms: New Media and the Forensic Imagination* (Cambridge: MIT Press, 2007); Charles Acland, ed., *Residual Media* (Minneapolis: University of Minnesota Press, 2007); Lisa Gitelman, *Always Already New: Media, History, and the Data of Culture* (Cambridge: MIT Press, 2006); Wendy Hui Kyong Chun and Thomas Keenan, eds., *New Media, Old Media: A History and Theory Reader* (New York: Routledge, 2005); and Geoffrey B. Pingree and Lisa Gitelman, eds., *New Media, 1740–1915* (Cambridge: MIT Press, 2003). In game studies, a similar concern for historicity can be found. See Nathan Altice, *I Am Error: The*

Nintendo Family Computer / Entertainment System Platform (Cambridge: MIT Press, 2015); Mark J.P. Wolf, ed., *Before the Crash: Early Video Game History* (Detroit: Wayne State University Press, 2012); Jimmy Maher, *The Future Was Here: The Commodore Amiga* (Cambridge: MIT Press, 2012); Nick Montfort and Ian Bogost, *Racing the Beam: The Atari Video Computer System* (Cambridge: MIT Press, 2009); and Mary Flanagan, *Critical Play: Radical Game Design* (Cambridge: MIT Press, 2009).

2 Lev Manovich, *Software Culture* (Milan: Olivares, 2010), 82–8.

3 Geoffrey Rockwell and Andrew Mactavish, "Multimedia," in *A Companion to Digital Humanities*, ed. Susan Schreibman, Ray Siemens, and John Unsworth (Malden: Blackwell, 2004), 109, emphasis mine.

4 Michel Foucault, *The Archaeology of Knowledge and the Discourse on Language*, trans. A. M. Sheridan Smith (London: Tavistock, 1972).

5 Gitelman, *Always Already New*, 6.

6 Gitelman, *Paper Knowledge*, 19.

7 For example, Rockwell and Mactavish establish the following typology: "[W]e could classify multimedia works in terms of their perceived use, from entertainment to education. We could look at the means of distribution and the context of consumption of such works, from free websites that require high-speed Internet connection, to expensive CD-ROM games that require the latest video cards to be playable. We could classify multimedia by the media combined, from remediated works that take a musical work and add synchronized textual commentary, to virtual spaces that are navigated." Rockwell and Mactavish, "Multimedia," 112.

8 Rockwell and Mactavish, "Multimedia," 117. A book such as Christiane Heibach's *Multimediale Aufführungskunst. Medienästhetische Studien zur Entstehung einer neuen Kunstform* (Berlin: Wilhelm Fink, 2009) testifies to the emergence of multimedia studies. However, Rockwell and Mactavish are correct: multimedia, and CD-ROMs in particular, have not received extended critical treatment aside from passing glances. One needs to return to studies published more than fifteen years ago to read substantial reflections on multimedia. For example, see Richard Wise, *Multimedia: A Critical Introduction* (New York: Routledge, 2000).

9 Randall Packer and Ken Jordan, "Overture," in *Multimedia: From Wagner to Virtual Reality*, ed. Randall Packer and Ken Jordan (New York: W&W. Norton, 2001), xxxviii.

10 Gillian Newson and Eric Brown, "CD-ROM: What Went Wrong?" *New Media* (August 1998): 33.

11 Bassett touches on the "open-ended processes of convergence" (148) of two-way interactions in real time that are now ubiquitous on the Internet and social media, which have rendered the one-way interaction of media such as CD-ROM quite passé for many and that might explain "the still-birth of the interactive CD-ROM industry at the hands of the web" (150). See Caroline Bassett, "Is This not a Screen? Notes on the Mobile Phone and Cinema," in *Transmedia Frictions: The Digital, the Arts, and the Humanities*, ed. Marsha Kinder and Tara McPherson (Berkeley: University of California Press, 2014), 147–58.

12 Harpold, *Ex-foliations*, 178, emphasis in original.

13 On CDs, CD-ROMs, and DVDs, see Georges Zénatti, *CD-Rom et vidéo sur CD*, 2nd ed. (Paris: Hermès, 1996), and Anne Friedberg, "CD and DVD," in *The New Media Book*, ed. Dan Harries (London: BFI, 2002), 30–9.

14 As Nick Montfort and Ian Bogost remind us, it is indeed possible to rewrite certain ROMs, but only with considerable efforts. As they point out: "There are ROM technologies that are not truly read-only. Programmable read-only memory (PROM) can be burned in the field rather than in the factory, for instance, and Flash ROM, commonly used in today's consumer electronics, including cameras and routers, can be rewritten – although not rapidly." Montfort and Bogost, *Racing the Beam*, 20–1. For the great majority of users, however, CD-ROM remained a closed medium, and I will treat it as such in this study.

15 The preceding distinction between CD-ROM and DVD-ROM is meant to show the great gap between the two ROM discs in terms of storage capacity. The DVD-ROM titles listed on the following pages are meant to give a fuller picture of the state of ROM art during this time period. The reasons why I have chosen not to examine both CD-ROMs and DVD-ROMs are threefold. First, the great majority of adaptations *explicitly* based on literary works were made using the CD-ROM platform. Second, CD-ROM's impact on the imagination of users cannot be compared to DVD-ROM's. Indeed, CD-ROM was an unprecedented digital multimedia entity when it hit the market, whereas DVD-ROM was more a technological upgrade than a new medium the way CD-ROM was. Third, bearing in mind the distinction between CD-ROM and DVD-ROM, the latter would deserve its own study to do justice to its own history, lines of experimentation, and medium specificity.

16 Tristan Donovan, *Replay: The History of Video Games* (Lewes: Yellow Ant, 2010), 242.

17 Tony Feldman, *Introduction to Digital Media* (New York: Routledge, 1997), 42.

18 Ibid., 46.

19 Ibid., 58.

20 For more information on these statistics, see Feldman, *Introduction to Digital Media*, 58–61. For figures pertaining specifically to France, see Patrick Pognant and Claire Scholl, *Les CD-Rom culturels* (Paris: Hermès, 1996), 20, and Corinne Welger-Barboza, *Le Patrimoine à l'ère du document numérique. Du musée virtuel au musée médiathèque* (Paris: L'Harmattan, 2001), 49–90.

21 Steve Lambert and Suzanne Ropiequet, "Preface," in *CD ROM: The New Papyrus*, ed. Steve Lambert and Suzanne Ropiequet (Redmond, WA: Microsoft Press, 1986), n.p.

22 Simon Biggs, "Multimedia, CD-ROM, and the Net," in *Clicking In: Hot Links to a Digital Culture*, ed. Lynn Hershman (Seattle: Bay Press, 1996), 321.

23 For a list of artistic CD-ROMs, see those presented at "Contact Zones: The Art of CD-ROM," http://contactzones.cit.cornell.edu. Another useful source is http://www.agencetopo.qc.ca/wp/catalogue/.

24 Timothy Murray provides a cogent summary of the issues related to the adaptation of installations to ROM spaces in "The Digital Stain of Technology," in *The Complete artintact komplett*, vols.1–5, 1994–1999, DVD-ROM, ed. Jeffrey Shaw (Karlsruhe: ZKM / Hatje Cantz, 2002), 33–43.

25 Erkki Huhtamo, "Digitalian Treasures, or Glimpses of Art on the CD-ROM Frontier," in *Clicking In: Hot Links to a Digital Culture*, ed. Lynn Hershman (Seattle: Bay Press, 1996), 310.

26 Sean Cubitt, *Digital Aesthetics* (London: SAGE, 1998), 86.

27 Pognant and Scholl, *Les CD-Rom culturels*, 13.

28 Ibid., 61.

29 Ibid., 104.

30 For a retrospective account of the Voyager Co's activities and an interview with its CEO, Bob Stein, see Sean Silverthorne, "Paperless Writer (The Voyager Co's CD ROM Publishing Adventures)," *PC Week* 12, no. 28 (July 1995): A5.

31 For a complete overview of the CD-ROMs and DVD-ROMs associated with the Labyrinth Project, see https://dornsife.usc.edu/labyrinth/laby.html.

32 On ANARCHIVE, see Bruno Lessard, "Between Creation and Preservation: The ANARCHIVE Project," *Convergence: The International Journal of Research into New Media Technologies* 15, no. 3 (2009): 315–31. A description of the ANARCHIVE projects can be found at http://www.anarchive.net/indexeng.htm.

33 Drahos's subtractive adaptations have never been closely examined, that is, to my knowledge. For more information, see http://www.tom-drahos.com.

34 See N. Katherine Hayles, *My Mother Was a Computer: Digital Subjects and Literary Texts* (Chicago: University of Chicago Press, 2005); Nick Montfort, *Twisty Little Passages: An Approach to Interactive Fiction* (Cambridge: MIT Press, 2005); Matthew Kirschenbaum, *Mechanisms: New Media and the Forensic Imagination* (Cambridge: MIT Press, 2007); N. Katherine Hayles, *Electronic Literature*; and Noah Wardrip-Fruin, *Expressive Processing: Digital Fictions, Computer Games, and Software Studies* (Cambridge: MIT Press, 2009).

35 On *Myst*, see Mark J.P. Wolf, Myst *and* Riven: *The World of the D'ni* (Ann Arbor: University of Michigan Press, 2011).

36 In the following chapters, the focus on one artist's CD-ROM is not meant to support the myth of the sole creator or to promote an elitist aesthetic practice. Nor do I claim that a recognizable signature style or voice is attached to any of the media artists to be discussed. The various digital productions of the four media artists show how difficult it would be to attach a monolithic style to any one of them, or to discuss their "body of work" as showing consistency and coherence over decades, as was the case with the filmmakers championed by the *Cahiers du cinéma* critics.

37 For a review of the CD-ROM exhibition curated by Mike Leggett, see Natalie Daniel, "Multimedia Art: Constraining or Liberating?," *Convergence: The International Journal of Research into New Media Technologies* 3, no. 1 (1997): 102–10. Moreover, Mike Leggett is the author of a thesis on CD-ROM art. See Mike Leggett, "Burning the Interface: Artists' Interactive Multimedia 1992–1998" (MFA thesis, University of New South Wales, 2000). Another unpublished study of CD-ROM art is Pierre Morelli, "Multimédia et création: contribution des artistes au développement d'une écriture multimedia" (PhD diss., Université de Metz, 2000).

38 See the exhibition catalogue: Timothy Murray, ed., *Zonas de contacto: el arte en CD-ROM* (Mexico City: CONACULTA / Centro de la imagen, 1999).

39 See the exhibition catalogue: Alison Trope and Holly Willis, eds., *Interactive Frictions Exhibition* (Los Angeles: Labyrinth Research Initiative, Annenberg Center for Communication, 1999).

40 See the exhibition catalogue: Jeffrey Shaw and Peter Weibel, eds., *Future Cinema: The Cinematic Imaginary after Film* (Cambridge: MIT Press, 2003).

41 Douglas Kahn, "What Now the Promise?," in *Burning the Interface: International Artists' CD-ROM*, ed. Mike Leggett (Sydney: Museum of Contemporary Art, 1996), 21.

42 Ibid.

43 Ibid., 27.

44 Ibid., 29, emphasis in original.

45 Ibid., 30.

46 Greg Smith, "Introduction: A Few Words about Interactivity," in *On a Silver Platter: CD-ROMs and the Promises of a New Technology,* ed. Greg Smith (New York: New York University Press, 1999), 2, emphases in original.

47 Ibid., 3.

48 Timothy Murray, "Curatorial Preface," https://contactzones.cit.cornell.edu/why.html.

49 Ibid.

50 Timothy Murray, *Digital Baroque: New Media Art and Cinematic Folds* (Minneapolis: University of Minnesota Press, 2008), 225.

51 Michael Nitsche, *Video Game Spaces: Image, Play, and Structure in 3D Worlds* (Cambridge: MIT Press, 2008), 44.

2. In the Realm of Digital Heterotopias

1 Michel Foucault, "Different Spaces," in *Aesthetics, Method, and Epistemology: The Essential Works of Foucault*, ed. James Faubion (New York: The New Press, 1998), 2:176. The best introduction to Foucault's lecture on heterotopias and its legacy is found in Daniel Defert, "'Hétérotopie': tribulations d'un concept entre Venise, Berlin et Los Angeles," in Michel Foucault, *Le Corps utopique, les hétérotopies* (Paris: Lignes, 2009), 37–61.

2 Foucault, "Different Spaces," 177.

3 Ibid., 178.

4 Ibid., 179.

5 Ibid., 180.

6 Ibid., 181.

7 Ibid., 182

8 Ibid.

9 Ibid.

10 Ibid.

11 Ibid., 183.

12 Ibid., 184.

13 See Tong Qiang, *Kongjian zhexue* (Beijing: Beijing daxue chubanshe, 2011), 80–6.

14 Michel Foucault, *The Order of Things* (New York: Routledge, 2007), xix.

15 James Faubion, "Heterotopia: An Ecology," in *Heterotopia and the City: Public Space in a Postcivil Society*, ed. Michiel Dehaene and Lieven de Cauter (New York: Routledge, 2008), 33.

16 This is not to say that Macromedia had no competitors. Indeed, HyperCard, Apple Media Tool, Authorware Professional, Image Q, Toolbox, Architext, and Automenu all vied for the biggest market share in interactive multimedia authoring software.

17 This summary of Macromedia Director history draws on "An Unofficial Brief History of Director," http://lingoworkshop.com/articles/history.

18 Marc Canter, "The New Workstation: CD ROM Authoring Systems," in *Multimedia: From Wagner to Virtual Reality*, ed. Randall Packer and Ken Jordan (New York: W.W. Norton, 2001), 199.

19 Ibid., 200.

20 Ibid., 206.

21 Ibid., 207.

22 Ibid.

23 Ibid., 200.

24 David Goldberg, "EnterFrame: Cage, Deleuze and Macromedia Director," *Afterimage* 30, no. 1 (2002): 8.

25 Ibid.

26 Ibid.

27 Ibid., 9, emphasis in original.

28 Ibid., emphasis in original.

29 Ibid.

30 Adrian Miles shares Goldberg's theoretical orientation and argues for a cinematic paradigm that would remedy the literary bias in hypertext criticism, thereby bypassing the fact that the cinematic has become as hegemonic as the literary was and, in turn, is equally too much indebted to the "narrative imperative" to generate new conceptual tools to make sense of digital productions. See Adrian Miles, "Cinematic Paradigms for Hypertext," *Continuum: Journal of Media & Cultural Studies* 13, no. 2 (1999): 217–25.

31 Tony Feldman, *Introduction to Digital Media* (New York: Routledge, 1997), 24.

32 Ibid.

33 For a complete history of the artist's book, see Gaëlle Pelachaud, *Livres animés. Du papier au numérique* (Paris: L'Harmattan, 2010).

34 Johanna Drucker, *The Century of Artists' Books* (New York: Granery Books, 2004), 364.

35 Ibid., 359.

36 Ibid., 1.

37 Ibid., 14.

38 Jacques Derrida, *Paper Machine*, trans. Rachel Bowlby (Stanford: Stanford University Press, 2005), 16.

39 N. Katherine Hayles, *Electronic Literature*, 13.

40 Ibid., 24.

41 Peter Stoicheff and Andrew Taylor, "Introduction: Architectures, Ideologies, and Materials of the Page," in *The Future of the Page*, ed. Peter Stoicheff and Andrew Taylor (Toronto: University of Toronto Press, 2004), 8.

42 Joseph Tabbi, "The Processual Page: Materiality and Consciousness in Print and Hypertext," in *The Future of the Page*, ed. Peter Stoicheff and Andrew Taylor (Toronto: University of Toronto Press, 2004), 215.

43 Richard Ferncase, *QuickTime for Filmmakers* (Burlington, MA: Focal Press, 2004), xiv.

44 Matthew Peterson and Michael Schaff, *Interactive QuickTime* (San Francisco: Morgan Kaufman, 2003), 6.

45 Susan Kitchens, *The QuickTime VR Book* (Berkeley: Peachpit Press, 1998), 9.

46 Vivian Sobchack, "Nostalgia for a Digital Object: Regrets on the Quickening of QuickTime," in *Memory Bytes: History, Technology, and Digital Media*, ed. Lauren Rabinovitz and Abraham Geil (Durham: Duke University Press, 2004), 306.

47 Ibid.

48 Ibid., 320.

49 As Sobchack points out, memory boxes "don't only attempt to fix personal memories through repetition, but they also quote and repeat previous artifacts of cultural memory – especially privileging those that speak mnemonically to technologies of reproduction and preservation." Sobchack, "Nostalgia for a Digital Object," 321.

50 Ibid., 307.

51 Ibid., 319.

52 I borrow the expression "imagined nostalgia" from Dai Jinhua, "Imagined Nostalgia," in *Postmodernism & China*, ed. Arif Dirlik and Xudong Zhang (Durham: Duke University Press, 2000), 205–21.

53 Lev Manovich, *The Language of New Media* (Cambridge: MIT Press, 2001), 225.

54 Marsha Kinder, "Designing a Database Cinema," in *Future Cinema: The Cinematic Imagery after Film*, ed. Jeffrey Shaw and Peter Weibel (Karlsruhe / Cambridge, MA: ZKM / MIT Press, 2003), 348.

55 Ibid., 349.
56 N. Katherine Hayles, *How We Think*, 176.
57 Ibid., 181.
58 Manovich, *The Language of New Media*, 228.

3. A Sensuous Gaze

1 Boissier's CD-ROM is designed for both PC and Macintosh computers
 running the Classic (OS 9) environment. I used an iBook G4 to run
 Boissier's work. This chapter expands on a previous study of Boissier's
 CD-ROM. See Bruno Lessard, "Archiving the Gaze: Relation-Images,
 Adaptation, and Digital Mnemotechnologies," in *Save As … Digital
 Memories*, ed. Joanne Garde-Hansen, Andrew Hoskins, and Anna Reading
 (New York: Palgrave Macmillan, 2009), 115–28.
2 Jean-Louis Boissier, "Rousseau, moments interactifs," in *L'Autre de l'oeuvre*,
 ed. Yoshikazu Nakaji (Paris: Presses Universitaires de Vincennes, 2007), 178.
3 On shifters, see Roman Jakobson, "Shifters, Verbal Categories, and the
 Russian Verb," in *Selected Writings* (The Hague: Mouton, 1971), 2: 131–47.
4 Interestingly, Margaret Flinn notes that Boissier's use of shifters forces
 the interactor to reconsider the predominant place of narrative in both
 interactive media arts and adaptation: "Instead, the shifters provide the
 dominant sense of interrelationship from one image to the next, and in
 this sense, *Moments* can be used to push the boundaries of any discussion
 of adaptation that remains overly reliant upon narrative as a defining
 characteristic." Margaret C. Flinn, "Jean-Louis's *Moments* of Jean-
 Jacques," *Studies in French Cinema* 10, no. 2 (2010): 150.
5 On Descartes's dualism, Martin Jay notes: "Cartesian perspectivalism has,
 in fact, been the target of a widespread philosophical critique, which has
 denounced its privileging of an ahistorical, disinterested, disembodied
 subject entirely outside the world it claims to know only from afar."
 Martin Jay, "Scopic Regimes of Modernity," in *Vision and Visuality*, ed. Hal
 Foster (New York: The New York Press, 1988), 10.
6 On Rousseau and the "Sensationalists," see Martin Jay, *Downcast Eyes:
 The Denigration of Vision in Twentieth-Century French Thought* (Berkeley:
 University of California Press, 1993), 83–93.
7 John O'Neal, *Seeing and Observing: Rousseau's Rhetoric of Perception*
 (Saratoga, CA: Anma Libri, 1985), 139.
8 Ibid.
9 Jean-Jacques Rousseau, "Sujets d'estampes," in *Œuvres complètes* II, ed.
 Bernard Gagnebin and Marcel Raymond (Paris: Gallimard, 1959), 761.

10 Ibid.

11 Ibid., 765.

12 Philip Robinson, *Jean-Jacques Rousseau's Doctrine of the Arts* (New York: Peter Lang, 1984), 201.

13 Catherine Ramond, "Autour des sujets d'estampes de *La Nouvelle Héloïse*: estampes dramatiques et tableaux romanesques," *Annales Jean-Jacques Rousseau* 45 (2003): 512.

14 Rousseau, as quoted in Robinson, *Jean-Jacques Rousseau's Doctrine of the Arts*, 205.

15 Robinson, *Jean-Jacques Rousseau's Doctrine of the Arts*, 206.

16 Ramond, "Autour des sujets d'estampes de *La Nouvelle Héloïse*," 513.

17 Jean-Louis Boissier, *La Relation comme forme. L'interactivité en art*, 2nd ed. (Dijon: Les Presses du réel, 2008), 50.

18 Raymond Bellour, "Picture-Book," in *Porous Boundaries: Texts and Images in Twentieth-Century French Culture*, ed. Jérôme Game (New York: Peter Lang, 2007), 92.

19 See Paul St George, ed., *Sequences: Contemporary Chronophotography and Experimental Digital Art* (London: Wallflower Press, 2009).

20 Mary Ann Doane has written at some length about Marey's experiments in chronophotography, and she has emphasized the desire to store time in his practice and in actuality shorts. Acknowledging that this dream had a philosophical as well as a technological basis, she adds that the concern for the "permanence of the real" was also Marey's dream: "From the start, indexicality was the major stake of Marey's representational practices. It was crucial that the body whose movement was being measured be the direct surface for the tracing." Mary Ann Doane, *The Emergence of Cinematic Time: Modernity, Contingency, the Archive* (Cambridge: Harvard University Press, 2002), 47. Departing from the hand-made reproductions of human beings and objects painters had given the Western tradition, Marey sought to offer an objective reflection of reality and movement untainted by the human hand. It is to this genealogy of the photographic storage and representation of time that Boissier's interactive chronophotography belongs.

21 Boissier, *La Relation comme forme*, 239.

22 Jean-Louis Boissier, "The Relation-Image," in *Future Cinema: The Cinematic Imagery after Film*, ed. Jeffrey Shaw and Peter Weibel (Karlsruhe / Cambridge: ZKM / MIT Press, 2003), 398.

23 Ibid., 399.

24 Ibid., 403.

25 Boissier, *La Relation comme forme*, 249.

26 Boissier, "The Relation-Image," 404.

27 Ibid.

28 Boissier, *La Relation comme forme*, 276.

29 Boissier envisages his artistic practice, in the passage from the "interaction-image" to the "relation-image," as a corollary of Deleuze's two central types of filmic images. His "relation-image" is a third type of image that would follow the French philosopher's "movement-image" and "time-image." See Gilles Deleuze, *Cinema 1: The Movement-Image*, trans. Hugh Tomlinson and Barbara Habberjam (Minneapolis: University of Minnesota Press, 1986), and Gilles Deleuze, *Cinema 2: The Time-Image*, trans. Hugh Tomlinson and Robert Galeta (Minneapolis: University of Minnesota Press, 1989).

30 Boissier elaborates on the notion of "relational perspective" in "Expérimentation des dispositifs d'une perspective relationelle," in *In actu. De l'expérimental dans l'art*, ed. Élie During et al. (Dijon: Presses du réel, 2009), 269–84.

31 Boissier, *La Relation comme forme*, 264.

32 Boissier, "The Relation-Image," 398.

33 Ibid., 402, emphasis in original.

34 Ibid.

35 Boissier, *La Relation comme forme*, 254, emphasis in original.

36 Boissier, "The Relation-Image," 406.

37 Ibid.

38 Bellour, "Picture-Book," 91.

39 For two pioneering publications that have challenged psychoanalytic film theory in terms of rehabilitating the senses, embodiment, and haptics, see Vivian Sobchack, *The Address of the Eye: A Phenomenology of Film Experience* (Princeton: Princeton University Press, 1991), and Laura Marks, *The Skin of the Film: Intercultural Cinema, Embodiment, and the Senses* (Durham: Duke University Press, 2000).

40 On "Molyneux's question," see Michael J. Morgan, *Molyneux's Question: Vision, Touch, and the Philosophy of Perception* (Cambridge: Cambridge University Press, 1977).

41 Martin Rueff, "Apprendre à voir: l'optique dans la théorie de l'homme," in *Rousseau et les sciences*, ed. Bernadette Bensaude-Vincent and Bruno Bernardi (Paris: L'Harmattan, 2003), 201.

42 Ibid., 208.

43 Jean-Jacques Rousseau, "Moral Letters," in *Rousseau on Philosophy, Morality, and Religion*, ed. and trans. Christopher Kelly (Hanover: University Press of New England, 2007), 81–2.

44 Ibid., 82.

45 Ibid.

46 Jean-Jacques Rousseau, *Emile*, trans. Barbara Foxley (New York: Everyman's Library, 1974), 104.

47 Ibid., 107.

48 Ibid.

49 Robinson, *Jean-Jacques Rousseau's Doctrine of the Arts*, 208.

50 Jean-Jacques Rousseau, *The Confessions*, trans. J.M. Cohen (New York, Penguin, 1953), 78.

51 Jacques Lacan, *The Seminar of Jacques Lacan, Book XI: The Four Fundamental Concepts of Psychoanalysis*, trans. Alan Sheridan (New York: W.W. Norton, 1981), 74.

52 Lacan, *The Four Fundamental Concepts of Psychoanalysis*, 83.

53 Joan Copjec, *Read My Desire: Lacan against the Historicists* (Cambridge: MIT Press, 1994), 34. On the same topic, Slavoj Žižek is worth quoting at length: "The gaze marks the point in the object (in the picture) from which the subject viewing it is already *gazed at*, i.e., it is the object that is gazing at me. Far from assuring the self-presence of the subject and his vision, the gaze functions thus as a stain, a spot in the picture disturbing its transparent visibility and introducing an irreducible split in my relation to the picture." Slavoj Žižek, *Looking Awry: An Introduction to Jacques Lacan through Popular Culture* (Cambridge: MIT Press, 1992), 125.

54 Rousseau, *The Confessions*, 79.

55 Copjec, *Read My Desire*, 35.

56 Boissier, *La Relation comme forme*, 211.

57 Ibid., 266.

58 Huguette Krief, "'Le pinceau d'un Le Brun' ou l'art pictural du second *Discours* de Rousseau," *Annales Jean-Jacques Rousseau* 45 (2003): 336, emphases in original.

59 Ellie Ragland elaborates on the *objet a*: "Object *a*, as a fundamentally lost Ur-object, resides at the center of the fantasies from which each person constructs desire around substitute objects that can never fill up a real void in being." Elie Ragland, "The Relation between the Voice and the Gaze," in *Reading Seminar XI: Lacan's Four Fundamental Concepts of Psychoanalysis*, ed. Richard Feldstein, Bruce Fink, and Maire Jaanus (Albany: State University of New York Press, 1995), 189.

60 Bellour, "Picture-Book," 89.

61 Boissier, *La Relation comme forme*, 287.

62 Copjec, *Read My Desire*, 16.

63 Lacan, *The Four Fundamental Concepts of Psychoanalysis*, 107.

64 See Jean Starobinski, *L'œil vivant: Corneille, Racine, Rousseau, Stendhal* (Paris: Gallimard, 1999).

65 Rousseau, *The Confessions*, 25.

66 Barthes reflects on this peculiar filmic convention: "I am not far from considering this ban as the cinema's distinctive feature. This art *severs* the gaze: one of us gazes at the other, does only that: it is my right and my duty to gaze; the other never gazes; he gazes at everything, except me. If a single gaze from the screen came to rest on me, the whole film would be lost." Roland Barthes, "Right in the Eyes," in *The Responsibility of Forms*, trans. Richard Howard (New York: Hill and Wang, 1985), 242, emphasis in original.

67 Rousseau, *The Confessions*, 88.

68 Ibid.

69 Ibid., 87.

70 Ibid.

71 Ibid.

72 Daniel Bougnoux, "Faire visage, comme on dit faire surface," *Cahiers de médiologie* 15 (2002): 10.

73 An interesting development in Boissier's reflections on the relation-image has been to associate it with the notion of play. Indeed, the artist has used the word "playable" [*jouable*] to describe relation-images in a way that aligns such visual formations with digital games and installations that are more playful in nature. See Jean-Louis Boissier, "Jouable," in *Jouable: art, jeu et interactivité* (Geneva / Paris: Haute école d'arts appliqués HES / École nationale supérieure des arts décoratifs / Ciren, Université Paris 8, 2004), 15–20.

4. A Cinema of One's Own

1 On these installations, see Zoe Beloff, ed., *Dreamland: The Coney Island Amateur Psychoanalytic Society and Their Circle 1926–1972* (New York: Christine Burgin Gallery, 2009); Zoe Beloff, ed., *The Somnambulists: A Compendium of Sources* (New York: Christine Burgin Gallery, 2008); and Zoe Beloff, "Two Women Visionaries," in *Technologies of Intuition*, ed. Jennifer Fisher (Toronto: YYZ Books, 2007), 69–83.

2 Both CD-ROMs, which originally ran only on Macintosh computers using the Classic (OS 9) environment, were reprogrammed in Flash in 2009, and they are now available on the artist's website at http://www.zoebeloff. com/pages/interactive.html. My analysis of *Beyond* is based on the original CD-ROM version run on an iBook G4.

3 The expressions "attraction and narration" and "showing and telling" refer to Tom Gunning's seminal essay, "The Cinema of Attractions: Early Film, Its Spectator and the Avant-Garde," in *Early Cinema: Space – Frame – Narrative*, ed. Thomas Elsaesser (London: BFI, 1990), 56–62, and André Gaudreault, *From Plato to Lumière: Narration and Monstration in Literature and Cinema*, trans. Timothy Barnard (Toronto: University of Toronto Press, 2009).

4 The manner in which Beloff revives the panorama deserves elaboration. The interface links QuickTime panoramas and QuickTime movies, and the interactor is able to roam free in this environment: "Very simply, QuickTime VR panoramas are virtual 360° spaces that one can explore by dragging the mouse around the space. They are constructed by 'stitching' together in the computer 12 still photographs taken in rotation. The viewer can zoom in and out and, by clicking on 'hotspots,' access the short movies. *Beyond* contains 20 panoramas and 80 QuickTime movies." Zoe Beloff, "An Ersatz of Life: The Dream Life of Technology," in *New Screen Media: Cinema / Art / Narrative*, ed. Martin Rieser and Andrea Zapp (London: British Film Institute, 2002), 289.

5 It is the differences between film narration and interactive media that Beloff wishes to highlight in her work: "With narrative film you're taken on a car ride; you can't go any other way; you can't wander; you can't go back; you can't get lost." Karen Beckman, "Impossible Spaces and Philosophical Toys: An Interview with Zoe Beloff," *Grey Room* 22 (2005): 71.

6 Beloff has stated her indebtedness to Benjamin's philosophy of history, and she has elaborated on his philosophy in a way that relates to her own creative agenda: "Benjamin wished, through examining the past, to make the mechanisms of our own delusions, or own dream state, clear to us. He aimed to do this, not through examining the big events of history, but through examining its scraps and remains." Beloff, "An Ersatz of Life," 289. Rehearsing nineteenth-century phantasmagorias via digital tools, Beloff fashions a concept of history that echoes Benjamin's. She adds: "I was not interested in being literal or illustrative, but instead in letting the past breathe through small discarded objects. For example in *Beyond* the 'dead' are represented by fragments of home movies from the 1920s to 1940 found at flea markets, as well as early film footage from the Library of Congress Paper Print collection" (290).

7 Jeffrey Skoller, *Shadows, Specters, Shards: Making History in Avant-Garde Film* (Minneapolis: University of Minnesota Press, 2005), 191.

8 As Noël Burch reminds us using words that have inspired Beloff, Edison's desire "to have it all," that is, to reproduce sound and image,

was the desire "to extend the conquest of nature by triumphing over death through an ersatz of Life itself." Noël Burch, *Life to Those Shadows* (Berkeley: University of California Press, 1990), 7.

9 This brief plot summary cannot do justice to the literary Edison's metaphysical project. In fact, not only Villiers's Edison's but also the "real" Edison's endeavour was to capture the voice of the living in order for it to be heard in the future. Edison's project was only one of many fin-de-siècle journeys to produce, reproduce, and to artificially create life by technological tricks. Spirit photography, magic lantern shows, Méliès's trick films, and other cultural productions participated in a vast phantasmagoria meant to rehearse and overcome the deepest fear of all, death. The only problem, or so it seems, is that overcoming death was linked to the manipulation of the female body and its transformation into philosophical toys, talking dolls, or androids.

10 Villiers de l'Isle-Adam, *Tomorrow's Eve*, trans. Robert Martin Adams (Urbana: University of Illinois Press, 2001), 117.

11 Marie Lathers, *The Aesthetics of Artifice: Villiers's* L'Eve Future (Chapel Hill: University of North Carolina Department of Romance Languages, 1996), 103.

12 Felicia Miller Frank, *The Mechanical Song: Women, Voice, and the Artificial in Nineteenth-Century French Narrative* (Stanford: Stanford University Press, 1995), 143.

13 See Raymond Bellour, "Ideal Hadaly," *Camera Obscura* 15 (1986): 111–33, and Annette Michelson, "On the Eve of the Future: The Reasonable Facsimile and the Philosophical Toy," *October* 29 (1984): 3–20.

14 Alain Boillat, "On the Singular Status of the Human Voice: *Tomorrow's Eve* and the Cultural Series of Talking Machines," in *Cinema Beyond Film: Media Epistemology in the Modern Era*, ed. François Albera and Maria Tortajada (Amsterdam: Amsterdam University Press, 2010), 235.

15 See Michel Leiris, *Raymond Roussel & Co.* (Saint-Clément-la-Rivière: Fata Morgana, 1998); Michel Foucault, *Raymond Roussel* (Paris: Gallimard, 1963); Alain Robbe-Grillet, "Enigmes et transparence chez Raymond Roussel," in *Pour un nouveau roman* (Paris: Editions de Minuit, 1961), 70–6; and Pierre Janet, *De l'angoisse à l'extase: études sur les croyances et les sentiments* (Paris: Société Pierre Janet, 1975), 115–19.

16 Raymond Roussel, *Comment j'ai écrit certains de mes livres* (Paris: Gallimard, 1995).

17 Douglas Kahn, "Death in Light of the Phonograph: Raymond Roussel's *Locus Solus*," in *Wireless Imagination: Sound, Radio, and the Avant-Garde*, ed. Douglas Kahn and Gregory Whitehead (Cambridge: MIT Press, 1992), 72.

18 Jonathan Sterne, *The Audible Past: Cultural Origins of Sound Reproduction* (Durham: Duke University Press, 2003), 290.

19 Raymond Roussel, *Locus Solus*, trans. Rupert Copeland Cuningham (Berkeley: University of California Press, 1970), 6.

20 Beloff, "An Ersatz of Life," 292.

21 Roussel, *Locus Solus*, 58.

22 Ibid., 118.

23 Ibid.

24 Ibid.

25 Ibid., 119.

26 Ibid., 186.

27 Ibid., 192.

28 Kahn, "Death in Light of the Phonograph," 81.

29 Robbe-Grillet, "Enigmes et transparence chez Raymond Roussel," 74.

30 Beloff, "An Ersatz of Life," 289.

31 The best visual source on Charcot and hysteria is Georges Didi-Huberman, *Invention of Hysteria: Charcot and the Photographic Iconography of the Salpêtrière*, trans. Alisa Hartz (Cambridge: MIT Press, 2003). Beloff has written on Charcot, photography, and the Salpêtrière in Zoe Beloff, "Mental Images: The Dramatization of Psychological Disturbance," in *Still Moving: Between Cinema and Photography*, ed. Karen Beckman and Jean Ma (Durham: Duke University Press, 2008), 226–52.

32 Tom Gunning, "Phantom Images and Modern Manifestations: Spirit Photography, Magic Theater, Trick Films, and Photography's Uncanny," in *Fugitive Images: From Photography to Video*, ed. Patrice Petro (Bloomington: Indiana University Press, 1995), 47.

33 See A. Freiherrn von Schrenck-Notzing, *Materialisationsphänomene. Ein Beitrag zur Erforschung der mediumistichen Teleplastie* (Munich: Ernst Reinhardt, 1923).

34 Beloff has described the use of her voice: "In *Beyond*, I found myself speaking in what I call my 1930s BBC radio drama voice, the voice of a medium." Beckman, "Impossible Spaces and Philosophical Toys," 78.

35 Here is the dialogue between the two characters:

> GOLAUD: N'ayez pas peur. Vous n'avez rien à craindre. Pourquoi pleurez-vous petite fille?
> MÉLISANDE: Ne me touchez pas, ne me touchez pas!
> GOLAUD: N'ayez pas peur. Je ne vous ferai pas … Oh, vous êtes belle!
> MÉLISANDE: Ne me touchez pas. Ne me touchez pas.

GOLAUD: Je ne vous touche pas, je resterai ici, contre l'arbre …
Quelqu'un vous a-t-il fait du mal?
MÉLISANDE: Oh, oui, oui, oui.
GOLAUD: Qui est-ce qui vous a fait du mal?
MÉLISANDE: Tous! Tous!
GOLAUD: Quel mal vous a-t-on fait?
MÉLISANDE: Je ne peux pas le dire, je ne peux pas le dire.
GOLAUD: Voyons, ne pleurez pas petite.

I quote the dialogue as reprinted in the booklet of Debussy's *Pelléas et Mélisande*. Sony Classical SM3K 47265. Pierre Boulez conducts this recording of the opera.

36 Hal Foster, "An Archival Impulse," *October* 110 (2004): 21.
37 Nicolas Bourriaud, *Postproduction* (New York: Sternberg, 2005).
38 Beckman, "Impossible Spaces and Philosophical Toys," 83.
39 See Janet Beizer, *Ventriloquized Bodies: Narratives of Hysteria in Nineteenth Century France* (Ithaca: Cornell University Press, 1994).
40 For international perspectives on the film lecturer, see Germain Lacasse, Vincent Bouchard, and Gwenn Scheppler, eds., *Pratiques orales du cinéma* (Paris: L'Harmattan, 2011).
41 Beloff unwittingly refers to André Gaudreault's phrase when she states her artistic credo: "Yet when you make a work, you want *to show and not tell*. An artwork should not describe, but conjure up." Beckman, "Impossible Spaces and Philosophical Toys," 82, emphasis mine.
42 Tom Gunning, "Cinema of Attractions," in *Encyclopedia of Early Cinema*, ed. Richard Abel (London: Routledge, 2005), 125.
43 Ibid., 126.
44 Tom Gunning, *D.W. Griffith and the Origins of American Narrative Film: The Early Years at Biograph* (Urbana: University of Illinois Press, 1991), 91.
45 Burch, *Life to Those Shadows*, 154.
46 Jacques Lacan, *Le Séminaire livre III. Les psychoses* (Paris: Editions du Seuil, 1981), 303–4, emphasis mine.
47 Slavoj Žižek, *The Sublime Object of Ideology* (London: Verso, 1989), 87.
48 As Žižek mentions, the quilting point "is rather the word which, *as a word*, on the level of the signifier itself, unifies a given field, constitutes its identity." Žižek, *The Sublime Object of Ideology*, 95, emphasis in original.
49 André Gaudreault, *Cinema delle origini o della "cinematografia-attrazione"* (Milan: Il Castoro, 2004), 124.
50 Gunning, *D.W. Griffith and the Origins of American Narrative Film*, 92.
51 Beckman, "Impossible Spaces and Philosophical Toys," 75.

52 Germain Lacasse, *Le bonimenteur de vues animées. Le cinéma "muet" entre tradition et modernité* (Québec / Paris: Nota Bene / Méridiens Klincksieck, 2000), 132.

53 Heather Hendershot, "Of Ghosts and Machines: An Interview with Zoe Beloff," *Cinema Journal* 45, no. 3 (2006): 133.

54 Germain Lacasse, "The Lecturer and the Attraction," in *The Cinema of Attractions Reloaded*, ed. Wanda Strauven (Amsterdam: Amsterdam University Press, 2006), 185–6.

55 Thomas Lamarre, "The First Time as Farce: Digital Animation and the Repetition of Cinema," in *Cinema Anime: Critical Engagements with Japanese Animation*, ed. Steven T. Brown (New York: Palgrave Macmillan, 2006), 163.

56 Skoller, *Shadows, Specters, Shards*, 187.

57 Raúl Ruiz, *Poética del cine* (Santiago: Editorial Sudamericana, 2000).

58 Beloff has described her work as "spectral cinema." See Zoe Beloff, "Towards a Spectral Cinema," in *Book of Imaginary Media: Excavating the Dream of the Ultimate Communication Medium*, ed. Eric Kluitenberg (Rotterdam: NAi Publishers, 2006), 215–39.

5. Spaces of Desire

1 Jenik's CD-ROM runs only on Macintosh computers using the Classic (OS 9) environment. I used an iBook G4 to run the work.

2 The reader will find descriptions of Jenik's projects at http://www.adrienejenik.net/.

3 On these experiments, see Adriene Jenik, "Desktop Theater: Keyboard Catharsis and the Masking of Roundheads," *The Drama Review* 45, no. 3 (2001): 95–112, and Adriene Jenik, "*Santaman's Harvest* Yields Questions, or Does a Performance Happen if It Exists in a Virtual Forest?," in *Second Person: Role-Playing and Story in Games and Playable Media*, ed. Pat Harrigan and Noah Wardrip-Fruin (Cambridge, MIT Press, 2007), 289–96. Sue-Ellen Case discusses Jenik's online projects in "Dracula's Daughters: In-Corporating Avatars in Cyberspace," in *Feminist and Queer Performance: Critical Strategies* (New York: Palgrave Macmillan, 2009), 170–87.

4 On this project, see Adriene Jenik and Sarah Lewison, "Moving in Place: The Question of Distributed Social Cinema," in *Third Person: Authoring and Exploring Vast Narratives*, ed. Pat Harrigan and Noah Wardrip-Fruin (Cambridge, MIT Press, 2009), 179–91.

5 The themes and issues outlined above do not seem to have interested the critics who have written on Jenik's CD-ROM. Indeed, it is noteworthy

that Jenik's *Mauve Desert* has not been linked to an explicit theory and practice of interactive media adaptation or to feminist translation theory. See Denis Bachand, "Du roman au cédérom. *Le désert mauve* de Nicole Brossard," in *Cinéma et littérature au Québec: rencontres médiatiques*, ed. Michel Larouche (Montréal: XYZ, 2003), 43–53; Beverley Curran, "Re-reading the Desert in Hypertranslation," in *Western Futures: Perspectives on the Humanities at the Millennium*, ed. Stephen Tchudi, Susanne Bentley, and Brad Lucas (Reno, NV: Nevada Humanities Committee, 2000), 245–59; and Sue-Ellen Case, "Eve's Apple, or Women's Narrative Bytes," *Modern Fiction Studies* 43, no. 3 (1997): 631–50.

6 Brossard discusses the origins of her interest in translation in Nicole Brossard, *Fluid Arguments*, ed. Susan Rudy, trans. Ann-Marie Wheeler (Toronto: Mercury Press, 2005), 141–2.

7 Nicole Brossard, *Mauve Desert*, trans. Susanne de Lotbinière-Harwood (Toronto: Coach House Press, 1990), 11.

8 Ibid.

9 Nicole Brossard, *The Aerial Letter*, trans. Marlene Wildeman (Toronto: Women's Press, 1988), 112.

10 Ibid., 75, emphasis in original.

11 Brossard, *Mauve Desert*, 32.

12 Ibid., 24, emphases in original.

13 See Jacques Lacan's distinction between the eye [*oeil*] and the gaze [*regard*] in *The Seminar of Jacques Lacan, Book XI: The Four Fundamental Concepts of Psychoanalysis*, trans. Alan Sheridan (New York: W.W. Norton, 1981), 67–119. In this now famous seminar, Lacan makes an enlightening remark on the object and the gaze in terms that relate to painting and the effects of the "*lumière*" that Mélanie describes: "That which is light looks at me, and by means of that light in the depths of my eye, something is painted … something that is an impression, the shimmering of a surface that is not, in advance, situated for me in its distance" (96).

14 Brossard, *Mauve Desert*, 33.

15 Ibid.

16 See Judith Butler, *Gender Trouble: Feminism and the Subversion of Identity*, 2nd ed. (New York: Routledge, 1999), and *Bodies that Matter: On the Discursive Limits of "Sex"* (New York: Routledge, 1993). Butler expands and revises the theoretical positions elaborated in the aforementioned books in *The Psychic Life of Power: Theories in Subjection* (Stanford: Stanford University Press, 1997), and *Undoing Gender* (New York: Routledge, 2004).

17 Alice Parker, *Liminal Visions of Nicole Brossard* (New York: Peter Lang, 1998), 51.

18 Moya Lloyd, "Performativity, Parody, Politics," *Theory, Culture & Society* 16, no. 2 (1999): 210.

19 Brossard, *Mauve Desert*, 40.

20 Ibid., 196.

21 Ibid., 112.

22 Ibid.

23 Ibid., 124.

24 Ibid., 125.

25 Ibid.

26 Ibid.

27 Ibid., 46.

28 Ibid., 144, emphases in original.

29 Sue-Ellen Case, *The Domain-Matrix: Performing Lesbian at the End of Print Culture* (Bloomington: Indiana University Press, 1996), 121.

30 Ibid., 123.

31 Susan Holbrook, "Delirium and Desire in Nicole Brossard's *Le Désert Mauve / Mauve Desert*," *differences: A Journal of Feminist Cultural Studies* 12, no. 2 (2001): 79.

32 For example, see these seminal writings in translation studies: Walter Benjamin, "The Task of the Translator," in *Illuminations*, trans. Harry Zohn (New York: Schoken Books, 1985), 69–82; Roman Jakobson, "On Linguistic Aspects of Translation," in *Selected Writings* (The Hague: Mouton, 1971), 2: 260–6; George Steiner, *After Babel: Aspects of Language and Translation* (Oxford: Oxford University Press, 1975); and Jacques Derrida, "Des tours de Babel," in *Difference in Translation*, ed. Joseph F. Graham (Ithaca: Cornell University Press, 1985), 165–207. Feminist translation theorists have taken issue with the male-oriented views of translation exposed in such writings.

33 Susanne de Lotbinière-Harwood, "Geographies of Why," in *Culture in Transit: Translating the Literature of Quebec*, ed. Sherry Simon (Montréal: Véhicule Press, 1995), 60.

34 Ibid., 61.

35 Ibid., 63.

36 Two exceptions would be Norie Neumark, Ross Gibson, and Theo van Leeuwen, eds., *VOICE: Vocal Aesthetics in Digital Arts and Media* (Cambridge: MIT Press, 2010), and Frances Dyson, *Sounding New Media: Immersion and Embodiment in the Arts and Culture* (Berkeley: University of California Press, 2009).

37 Brossard, *Mauve Desert*, 157.

38 Susanne de Lotbinière-Harwood, *Re-belle et infidèle: la traduction comme*

pratique de réécriture au féminin / The Body Bilingual: Translation as a Re-Writing in the Feminine (Montréal / Toronto: Éditions du Remue-ménage / Women's Press, 1991), 43.

39 Franco Moretti, *Atlante del romanzo europeano, 1800-1900* (Turin: Einaudi, 1997), and Giuliana Bruno, *Atlas of Emotion: Journeys in Art, Architecture, and Film* (New York: Verso, 2002).

40 Moretti, *Atlante del romanzo europeano*, 7.

41 Ibid., 202.

42 Bruno, *Atlas of Emotion*, 20.

43 Bruno's account of space and film is indebted to the understanding of cinema as movement and translation. In the first of his cinema books, Gilles Deleuze mentions how cinema developed from a sense of spatial translation: "One might conceive of a series of means of translation (train, car, aeroplane…) and, in parallel, a series of means of expression (diagram, photo, cinema). The camera would then appear as an exchanger or, rather, as a generalised equivalent of the movements of translation." Gilles Deleuze, *Cinema 1: The Movement-Image*, trans. Hugh Tomlinson and Barbara Habberjam (Minneapolis: University of Minnesota Press, 1986), 4–5. Deleuze emphasizes how spatial movement and its expression are at the heart of the "movement-image," and he stresses this feature of early cinema when he points out that "Movement is a translation in space" (8).

44 Bruno, *Atlas of Emotion*, 186.

45 Ibid., 83.

46 The reference to Kerouac's *On the Road* and Scott's *Thelma and Louise* is even more appropriate given that Jenik herself has called *Mauve Desert* a "CD-Rom road movie." Jenik, "Desktop Theater," 96.

47 Jenik's correspondence with Brossard highlights the sense of space and distance that separates California and the American desert from Montréal. The interactor can read such confidences as Jenik is seen moving from California to upstate New York and back. The conception and the evolution of the CD-ROM are discussed in letters, faxes, and emails included in the digital work. An interesting feature of this correspondence is the series of missed encounters between Jenik and Brossard. Indeed, they failed to meet on several occasions at the beginning of the creation process, as the content of the correspondence reveals.

48 Sidonie Smith gives an overview of this form of "writing" in *Moving Lives: Twentieth-Century Women's Travel Writing* (Minneapolis: University of Minnesota Press, 2001), 203–8.

49 Ibid., 22.

50 Ibid., 23.

51 Ibid., 207.

52 See Susan Holbrook, "Mauve Arrows and the Erotics of Translation," *Essays on Canadian Writing* 61 (1997): 232, and Barbara Godard, "Translating (with) the Speculum," *TTR: terminologie, traduction, rédaction* 4, no. 2 (1991): 90.

53 Carol Maier, "Translation as Performance: Three Notes," *Translation Review* 15 (1984): 5.

54 De Lotbinière-Harwood, *Re-belle et infidèle*, 48.

55 Beverley Curran, "Obsessed by Her Reading: An Interview with Adriene Jenik about Her CD-ROM Translation of Nicole Brossard's *Le désert mauve*," *Links & Letters* 5 (1998): 105.

56 On *hypomnemata*, see Michel Foucault, "Self Writing," in *Ethics: Subjectivity and Truth*, ed. Paul Rabinow (New York: The New Press, 1997), 207–22. For a critical reassessment of Foucault's thoughts on *hypomnemata* in light of contemporary technology, see Bernard Stiegler, *Taking Care of Youth and the Generations,* trans. Stephen Baker (Stanford: Stanford University Press, 2010).

57 Sidonie Smith, "Performativity, Autobiographical Practice, Resistance," in *Women, Autobiography, Theory: A Reader*, ed. Sidonie Smith and Julia Watson (Madison: University of Wisconsin Press, 1998), 111.

58 Jan Campbell and Janet Harbord, "Playing it Again: Citation, Reiteration or Circularity?," *Theory, Culture & Society* 16, no. 2 (1999): 229.

59 Miléna Santoro, "Feminist Translation: Writing and Transmission among Women in Nicole Brossard's *Le Désert mauve* and Madeleine Gagnon's *Lueur*," in *Women by Women: The Treatment of Female Characters by Women Writers of Fiction in Quebec since 1980*, ed. Roseanna Lewis Dufault (Madison, NJ: Fairleigh Dickinson University Press, 1997), 152.

60 Nicole Côté's Deleuzian reading of space and nomadism in Brossard's novel supports this critical take on Jenik's work. See Nicole Côté, "*Désert mauve*, un *bildungsroman* queer?," in *The Child in French and Francophone Literature*, ed. Buford Norman and Daniela Di Cecco (Amsterdam: Rodopi, 2004), 135–48. Barbara Godard has also discussed feminist translation in terms of geography and re-territorialization in "Deleuze and Translation," *Parallax* 14 (2000): 56–81.

61 Julia Watson and Sidonie Smith, "Introduction: Mapping Women's Self-Representation at Visual / Textual Interfaces," in *Interfaces: Women, Autobiography, Image, Performance*, ed. Julia Watson and Sidonie Smith (Ann Arbor: University of Michigan Press, 2002), 8.

62 Ibid., 9.

63 Ibid., 12.

64 Sidonie Smith, *Subjectivity, Identity, and the Body: Women's Autobiographical Practices in the Twentieth Century* (Bloomington: Indiana University Press, 1993), 23.

65 Ibid., 21.

66 Smith, "Performativity, Autobiographical Practice, Resistance," 131.

67 Case, "Eve's Apple, or Women's Narrative Bytes," 647.

6. In Search of Lost Space

1 The CD-ROM was originally published in French in 1998, and an English edition came out in 2002. Both versions were for Macintosh computers running the Classic (OS 9) environment. An updated English version for the Macintosh OS X came out in 2008, featuring additional "X-Plugs." This analysis of *Immemory* is based on both the 1998 version run on an iBook G4 and the 2008-updated version run on a MacBook Pro.

2 On *Silent Movie*, see Chris Marker, "The Rest Is Silent," *Trafic* 46 (2003): 57–62.

3 Viva Paci examines this installation in "'Life is very long,' avant et après *The Hollow Men*," in *Chris Marker et l'imprimerie du regard*, ed. André Habib and Viva Paci (Paris: L'Harmattan, 2008), 275–91. Paci provides the most complete analysis of Marker's "digital period," including *Silent Movie*, *Level Five*, and *Immemory*, in *Il Cinema di Chris Marker: Come un vivaio ai pescatori di passato dell'avvenire* (Bologna: Hybris, 2005), 143–73.

4 Marker renamed his work *Immemory One* before its first exhibition, thereby indicating that the CD-ROM would be the first in a series of at least two projects. I will refer to Marker's CD-ROM as *Immemory* rather than *Immemory One* in this chapter.

5 Raymond Bellour, "The Book, Back and Forth," in *Qu'est-ce qu'une madeleine? A propos du CD-ROM* Immemory *de Chris Marker*, ed. Laurent Roth and Raymond Bellour (Paris: Yves Gevaert / Centre Georges Pompidou, 1997), 116.

6 Irene Albers, "Prousts photographisches Gedächtnis," *Zeitschrift für französische Sprache und Literatur* 111 (2001): 20.

7 Marker explores the importance of Hitchcock's film in "A free replay (notes sur *Vertigo*)," *Positif* 400 (1994): 79–84. Noteworthy is that several sections of this article are reproduced in the Cinema zone of *Immemory*.

8 Chris Marker, *Immemory* (Paris: Centre Georges Pompidou, 1999), liner notes, n.p.

9 Félix Guattari, *The Machinic Unconscious: Essays in Schizoanalysis*, trans. Taylor Adkins (Los Angeles: Semiotext(e), 2011), 231.

10 Samuel Douhaire and Annick Rivoire, "Marker Direct: An Interview with Chris Marker," *Film Comment* 39, no. 3 (2003), http://www.filmcomment.com/article/marker-direct-an-interview-with-chris-marker. Catherine Lupton adds to Marker's reflections on CD-ROM: "In the introductory text to Immemory, Marker contends that the virtual architectures of cyberspace, which permit non-linear, multi-directional navigation at the user's own chosen speed, are far closer to the aleatory, non-linear drift of actual human memory than the capabilities of older media. The CD-ROM format has allowed Marker to realize a mapping of the geography of his own memory more effectively than a film like Sans Soleil, which can be seen as a prototype of this long-cherished project, but one that remained limited by the linearity and fixed temporal rate of film." Catherine Lupton, "Chris Marker: In Memory of New Technology," http://chrismarker.org/chris-marker-2/catherine-lupton-in-memory-of-new-technology/.

11 Georges Poulet, *Proustian Space*, trans. Elliott Coleman (Baltimore: Johns Hopkins University Press, 1977), 4. For a rare study that builds on Poulet's work on space in Proust, see Nathan Guss, *Proust Outdoors* (Lewisburg, PA: Bucknell University Press, 2009).

12 Poulet, *Proustian Space*, 16. Poulet's efforts to rehabilitate space actually call back to mind Walter Benjamin's insight to the effect that "The eternity which Proust opens to view is convoluted time, not boundless time. His true interest is in the passage of time in its most real – that is, space-bound – form." Walter Benjamin, "The Image of Proust," in *Illuminations*, trans. Harry Zohn (New York: Schocken, 1985), 211.

13 Poulet, *Proustian Space*, 39.

14 Ibid, 66.

15 Ibid., 91.

16 Ibid.

17 Ibid., 93.

18 Ibid., 94, emphasis in original.

19 Ibid., 95.

20 Ibid., 101.

21 Ibid., 105, emphasis in original.

22 Ibid., 106.

23 Gilles Deleuze, *Proust and Signs*, trans. Richard Howard (Minneapolis: University of Minnesota Press, 2000), 4.

24 Ibid.

25 Ibid., 26.

26 Ibid., 95.

27 Guattari, *The Machinic Unconscious*, 279.

28 Ibid., 313.

29 Ibid., 319.

30 Ibid., 320.

31 Birgit Kämper touches on this issue when she claims that *Immemory* is "the search to translate for the first time the metaphorical structure of the image as madeleine in a creative principle of remembering." Birgit Kämper, "Das Bild als Madeleine. 'Sans soleil' und 'Immemory,'" in *Chris Marker: Filmessayist*, ed. Birgit Kämper and Thomas Tode (Munich: Institut Français de Munich / CICM, 1997), 159.

32 Catherine Lupton, *Chris Marker: Memories of the Future* (London: Reaktion Books, 2004), 205.

33 Ibid., 212.

34 On Proust's rejection of naturalism in the context of photography, see Antonio Ansón, "Proust, la fotografía y el cine," *Moenia: Revista lucense de lingüística & literatura* 2 (1996): 271–4.

35 Brassaï, *Proust in the Power of Photography*, trans. Richard Howard (Chicago: University of Chicago Press, 2001), 97.

36 On these media in Proust's work, see Roger Shattuck, *Proust's Binoculars* (New York: Random House, 1963), and Wolfram Nitsch, "Vom Panorama zum Stereoskop. Medium und Metapher bei Proust," in *Marcel Proust und die Künste*, ed. Wolfram Nitsch and Rainer Zaiser (Frankfurt: Insel Verlag, 2004), 240–62. On Proust and the cinematograph in particular, a growing body of criticism includes Jacques Bourgeois, "Le Cinéma à la recherche du temps perdu," *Revue du cinéma* 3 (1946): 18–37; Paul Goodman, "The Proustian Camera Eye," in *American Film Criticism: From The Beginnings to Citizen Kane*, ed. Stanley Kauffmann (Westport, CT: Greenwood Press, 1972), 311–14; Yves Baudelle, "Proust et le cinéma," in *Roman et cinéma*, ed. Paul Renard (Lille: Roman 20/50, 1996), 45–70; and Danielle Dahan, "De l'image cinématographique à l'écriture cinématographique," in *Proust und die Medien*, ed. Volker Roloff (Munich: Fink, 2005), 61–80.

37 Volker Roloff, "Proust und die Medien. Zur intermedialen Ästhetik Prousts," in *Proust und die Medien*, ed. Volker Roloff (Munich: Fink, 2005), 11.

38 Eduardo Cadava, *Words of Light: Theses on the Photography of History* (Princeton: Princeton University Press, 1997), 76.

39 Benjamin, "The Image of Proust," 214.

40 Marcel Proust, *Time Regained*, in *In Search of Lost Time*, trans. C.K. Scott Moncrieff and Terence Kilmartin (New York: Vintage, 1996), 3: 897–8.

41 Marcel Proust, *Cities of the Plain*, in *In Search of Lost Time*, trans. C.K. Scott Moncrieff and Terence Kilmartin (New York: Vintage, 1996), 2: 807.

42 Susan Sontag, *On Photography* (New York: Picador, 1977), 164.

43 Marcel Proust, *Within a Budding Grove*, in *In Search of Lost Time*, trans. C.K. Scott Moncrieff and Terence Kilmartin (New York: Vintage, 1996), 1: 821.

44 Marcel Proust, *The Fugitive*, in *In Search of Lost Time*, trans. C.K. Scott Moncrieff and Terence Kilmartin (New York: Vintage, 1996), 3: 585.

45 Marcel Proust, *The Captive*, in *In Search of Lost Time*, trans. C.K. Scott Moncrieff and Terence Kilmartin (New York: Vintage, 1996), 3: 145–6.

46 Mieke Bal, *The Mottled Screen: Reading Proust Visually*, trans. Anna-Louise Milne (Stanford: Stanford University Press, 1997), 183.

47 Ibid., 201.

48 Proust, *Within a Budding Grove*, 932.

49 Proust, *Time Regained*, 931.

50 Suzanne Guerlac, "Visual Dust: On Time, Memory, and Photography in Proust," *Contemporary French and Francophone Studies* 13, no. 4 (2009): 397–404.

51 Ibid., 402.

52 Albers, "Prousts photographisches Gedächtnis," 26.

53 Vincent Bonin, "Les archives de Chris Marker, les archives des autres," in *Chris Marker et l'imprimerie du regard*, ed. André Habib and Viva Paci (Paris: L'Harmattan, 2008), 180–1.

54 Chris Marker, in a 1995 letter to Birgit Kämper reproduced in Birgit Kämper and Thomas Tode, eds., *Chris Marker – Filmessayist* (Munich: Institut Français de Munich / CICM, 1997), 330, emphasis in original.

55 The term "zone" is already found in Marker's *Sans Soleil* (1982) and, most importantly, derives from Andrei Tarkovsky's film *Stalker* (1979), in which the Zone is the place of repressed desires, hopes, and unfulfilled dreams.

56 In the Coda, Marker comments on Korean politics forty years after his visit there, and he reflects on the reasons that led him to visit Korea, China, and Cuba in the 1950s.

57 On such concerns, see W.J.T. Mitchell's path-breaking study of digital photography, *The Reconfigured Eye: Visual Truth in the Post-Photographical Era* (Cambridge: MIT Press, 1992).

58 Patrick ffrench, "The Immanent Ethnography of Chris Marker, Reader of Proust," *Film Studies* 6 (2005): 93.

59 Eduardo Cadava and Paola Cortés-Rocca, "Notes on Love and Photography," in *Photography Degree Zero: Reflections on Roland Barthes's Camera Lucida*, ed. Geoffrey Batchen (Cambridge: MIT Press, 2009), 113.

60 Roland Barthes, *Camera Lucida*, trans. Richard Howard (New York: Hill and Wang, 2010), 43.

61 Ibid., 45.
62 Jacques Derrida, "The Deaths of Roland Barthes," in *The Work of Mourning*, ed. and trans. Pascale-Anne Brault and Michael Naas (Chicago: University of Chicago Press, 2001), 57.
63 Barthes, *Camera Lucida*, 20, emphasis in original.
64 Geoffrey Batchen, "*Camera Lucida*: Another Little History of Photography," in *Photography Degree Zero: Reflections on Roland Barthes's* Camera Lucida, ed. Geoffrey Batchen (Cambridge: MIT Press, 2009), 268.
65 Roland Barthes, *La chambre claire. Note sur la photographie* (Paris: Gallimard / Seuil, 1980), 89.
66 Derrida, "The Deaths of Roland Barthes," 41, emphasis in original.
67 Derek Attridge, "Roland Barthes's Obtuse, Sharp Meaning and the Responsibilities of Commentary," in *Writing the Image after Roland Barthes*, ed. Jean-Michel Rabaté (Philadelphia: University of Pennsylvania Press, 1997), 85.
68 Barthes, *Camera Lucida*, 28.
69 Ibid., 55, emphasis in original.
70 Walter Benn Michaels, "Photographs and Fossils," in *Photography Theory*, ed. James Elkins (New York: Routledge, 2007), 440.
71 Mary Ann Doane, "Imaging Contingency: An Interview with Mary Ann Doane," *Parallax* 13, no. 4 (2007): 20.
72 Barthes, *Camera Lucida*, 82. Barthes's lifelong interest in Proust can be attested to in the planned seminar on Proust and photography he intended to give before his tragic death in 1980, which can be found in Roland Barthes, *The Preparation of the Novel: Lecture Course and Seminars at the Collège de France (1978-1979 and 1979-1980)*, trans. Kate Briggs (New York: Columbia University Press, 2011). On this seminar, see Kathrin Yacavone, *Benjamin, Barthes, and the Singularity of Photography* (New York: Continuum, 2012), 187–216.
73 Lev Manovich, "The Paradoxes of Digital Photography," in *Photography after Photography*, ed. Hubertus von Amelunxen, Stefan Iglhaut, and Florian Rötzer (Amsterdam: G+B Arts, 1996), 64.
74 Uriel Orlow, "Chris Marker: The Archival Power of the Image," in *Lost in the Archives*, ed. Rebecca Comay (Toronto: Alphabet City, 2002), 441.
75 Fred Ritchin, *After Photography* (New York: W.W. Norton & Co., 2008), 141.
76 Ibid., 143.
77 J. Hillis Miller, "The Ethics of Hypertext," *Diacritics* 25, no. 3 (1995): 37.
78 Marcelo *Expósito*, "Retornar de la historia. *Immemory* de Chris Marker," *Kalias* 9, no. 17–18 (1997): 162.
79 See the screenplays for both projects: Suso Cecchi d'Amico and Luchino Visconti, *Alla ricerca del tempo perduto: sceneggiatura dall'opera di Marcel*

Proust (Milan: Mondadori, 1986), and Harold Pinter, *The Proust Screenplay* (New York: Grove Press, 2000).

80 For studies of Proust and film, see Martine Beugnet and Marion Schmid, *Proust at the Movies* (Burlington, VT: Ashgate, 2005), and Peter Kravanja, *Proust à l'écran* (Brussels: La Lettre volée, 2003).

81 Pascal Ifri, "One Novel, Five Adaptations: Proust on Film," *Contemporary French and Francophone Studies* 9, no. 1 (2005): 26.

82 Beugnet and Schmid, *Proust at the Movies*, 49.

Conclusion

1 See Thomas G. Pavel, *The Lives of the Novel: A History* (Princeton: Princeton University Press, 2013).

2 See François Hartog, *Régimes d'historicité: présentisme et expériences du temps* (Paris: Seuil, 2003).

3 Marsha Kinder and Tara McPherson, "Preface: Origins, Agents, and Alternative Archaeologies," in *Transmedia Frictions: The Digital, the Arts, and the Humanities*, ed. Marsha Kinder and Tara McPherson (Berkeley: University of California Press, 2014), xiv.

4 Vivian Sobchack, "Afterword: Media Archaeology and Re-presencing the Past," in *Media Archaeology: Approaches, Applications, and Implications*, ed. Erkki Huhtamo and Jussi Parikka (Berkeley: University of California Press, 2011), 332, emphasis in original.

5 Wendy Hui Kyong Chun, "The Enduring Ephemeral, or the Future Is a Memory," in *Media Archaeology: Approaches, Applications, and Implications*, ed. Erkki Huhtamo and Jussi Parikka (Berkeley: University of California Press, 2011), 184.

6 Ibid.

7 Ibid., 188.

8 Ibid., 193.

9 See James Newman, *Best Before: Videogames, Supersession and Obsolescence* (New York: Routledge, 2012).

10 Chun, "Enduring Ephemeral," 200.

Bibliography

Acland, Charles, ed. *Residual Media*. Minneapolis: University of Minnesota Press, 2007.

Albers, Irene. "Prousts photographisches Gedächtnis." *Zeitschrift für französische Sprache und Literatur* 111, no. 1 (2001): 19–56.

Altice, Nathan. *I Am Error: The Nintendo Family Computer / Entertainment System Platform*. Cambridge: MIT Press, 2015.

Ansón, Antonio. "Proust, la fotografía y el cine." *Moenia: Revista lucense de lingüística & literatura* 2 (1996): 267–83.

Attridge, Derek. "Roland Barthes's Obtuse, Sharp Meaning and the Responsibilities of Commentary." In *Writing the Image after Roland Barthes*, edited by Jean-Michel Rabaté, 77–89. Philadelphia: University of Pennsylvania Press, 1997.

Bachand, Denis. "Du roman au cédérom. *Le désert mauve* de Nicole Brossard." In *Cinéma et littérature au Québec: rencontres médiatiques*, edited by Michel Larouche, 43–53. Montréal: XYZ, 2003.

Bal, Mieke. *The Mottled Screen: Reading Proust Visually*. Translated by Anna-Louise Milne. Stanford: Stanford University Press, 1997.

Barthes, Roland. *La chambre claire. Note sur la photographie*. Paris: Gallimard / Seuil, 1980.

– "Right in the Eyes." In *The Responsibility of Forms*. Translated by Richard Howard, 237–242. New York: Hill and Wang, 1985.

– *Camera Lucida*. Translated by Richard Howard. New York: Hill and Wang, 2010.

– *The Preparation of the Novel: Lecture Course and Seminars at the Collège de France (1978–1979 and 1979–1980)*. Translated by Kate Briggs. New York: Columbia University Press, 2011.

Bassett, Caroline. "Is This not a Screen? Notes on the Mobile Phone and Cinema." In *Transmedia Frictions: The Digital, the Arts, and the Humanities*, edited by Marsha Kinder and Tara McPherson, 147–58. Berkeley: University of California Press, 2014.

Batchen, Geoffrey. "*Camera Lucida*: Another Little History of Photography." In *Photography Degree Zero: Reflections on Roland Barthes's* Camera Lucida, edited by Geoffrey Batchen, 259–73. Cambridge: MIT Press, 2009.

Baudelle, Yves. "Proust et le cinéma." In *Roman et cinéma*, edited by Paul Renard, 45–70. Lille: Roman 20/50, 1996.

Beckman, Karen. "Impossible Spaces and Philosophical Toys: An Interview with Zoe Beloff." *Grey Room* 22 (2005): 68–85.

Beizer, Janet. *Ventriloquized Bodies: Narratives of Hysteria in Nineteenth-Century France.* Ithaca: Cornell University Press. 1994.

Bell, Alice. *The Possible Worlds of Hypertext Literature.* New York: Palgrave Macmillan, 2010.

Bellour, Raymond. "Ideal Hadaly." *Camera Obscura* 15 (1986): 111–33.

– "The Book, Back and Forth." In *Qu'est-ce qu'une Madeleine? A propos du CD-ROM* Immemory *de Chris Marker*, edited by Laurent Roth and Raymond Bellour, 109–49. Paris: Yves Gevaert / Centre Georges Pompidou, 1997.

– "Picture-Book." In *Porous Boundaries: Texts and Images in Twentieth-Century French Culture*, edited by Jérôme Game, 83–100. New York: Peter Lang, 2007.

Beloff, Zoe. *Beyond.* New York, privately printed, 1997. CD-ROM.

– "An Ersatz of Life: The Dream Life of Technology." In *New Screen Media: Cinema / Art / Narrative*, edited by Martin Rieser and Andrea Zapp, 287–96. London: British Film Institute, 2002.

– "Towards a Spectral Cinema." In *Book of Imaginary Media: Excavating the Dream of the Ultimate Communication Medium*, edited by Eric Kluitenberg, 215–39. Rotterdam: NAi Publishers, 2006.

– "Two Women Visionaries." In *Technologies of Intuition*, edited by Jennifer Fisher, 69–83. Toronto: YYZ Books, 2007.

–, ed. *The Somnambulists: A Compendium of Sources.* New York: Christine Burgin Gallery, 2008.

– "Mental Images: The Dramatization of Psychological Disturbance." In *Still Moving: Between Cinema and Photography*, edited by Karen Beckman and Jean Ma, 226–52. Durham: Duke University Press, 2008.

–, ed. *Dreamland: The Coney Island Amateur Psychoanalytic Society and Their Circle 1926–1972.* New York: Christine Burgin Gallery, 2009.

Benjamin, Walter. "The Image of Proust." In *Illuminations.* Translated by Harry Zohn, 201–15. New York: Schoken Books, 1985.

– "The Task of the Translator." In *Illuminations*. Translated by Harry Zohn, 69–82. New York: Schoken Books, 1985.

Benn Michaels, Walter. "Photographs and Fossils." In *Photography Theory*, edited by James Elkins, 431–50. New York: Routledge, 2007.

Beugnet, Martine, and Marion Schmid. *Proust at the Movies*. Burlington, VT: Ashgate, 2004.

Biggs, Simon. "Multimedia, CD-ROM, and the Net." In *Clicking In: Hot Links to a Digital Culture*, edited by Lynn Hershman, 318–24. Seattle: Bay Press, 1996.

Blanchet, Alexis. *Des Pixels à Hollywood. Cinéma et jeu vidéo, une histoire économique et culturelle*. Châtillon: Pix'n Love, 2010.

Bluestone, George. *Novels into Film*. Baltimore: Johns Hopkins Press, 1957.

Boillat, Alain. "On the Singular Status of the Human Voice. *Tomorrow's Eve* and the Cultural Series of Talking Machines." In *Cinema Beyond Film: Media Epistemology in the Modern Era*, edited by François Albera and Maria Tortajada, 233–51. Amsterdam: Amsterdam University Press, 2010.

Boissier, Jean-Louis. *Moments de Jean-Jacques Rousseau*. Paris / Saint-Gervais Genève: Gallimard / Centre pour l'image contemporaine, 2000. CD-ROM.

– "The Relation-Image." In *Future Cinema: The Cinematic Imagery after Film*, edited by Jeffrey Shaw and Peter Weibel, 398–407. Karlsruhe / Cambridge, MA: ZKM / MIT Press, 2003.

– "Jouable." In *Jouable: art, jeu et interactivité*,15–20. Geneva / Paris: Haute école d'arts appliqués HES / École nationale supérieure des arts décoratifs / Ciren, Université Paris 8, 2004.

– "Rousseau, moments interactifs." In *L'Autre de l'œuvre*, edited by Yoshikazu Nakaji, 177–188. Paris: Presses Universitaires de Vincennes, 2007.

– *La Relation comme forme. L'interactivité en art*. 2nd Edition. Dijon: Les Presses du réel, 2008.

– "Expérimentation des dispositifs d'une perspective relationelle." In *In actu. De l'expérimental dans l'art*, edited by Élie During, Laurent Jeanpierre, Christophe Kihm, and Dork Zabunyan, 269–84. Dijon: Presses du réel, 2009.

Bonin, Vincent. "Les archives de Chris Marker, les archives des autres." In *Chris Marker et l'imprimerie du regard*, edited by André Habib and Viva Paci, 179–96. Paris: L'Harmattan, 2008.

Bougnoux, Daniel. "Faire visage, comme on dit faire surface." *Cahiers de médiologie* 15 (2002): 9–15.

Bourgeois, Jacques. "Le Cinéma à la recherche du temps perdu." *Revue du cinéma* 3 (1946): 18–37.

Bourriaud, Nicolas. *Postproduction*. New York: Sternberg, 2005.

Brassaï. *Proust in the Power of Photography*. Translated by Richard Howard. Chicago: University of Chicago Press, 2001.

Brossard, Nicole. *The Aerial Letter.* Translated by Marlene Wildeman. Toronto: Women's Press, 1988.

– *Mauve Desert.* Translated by Susanne de Lotbinière-Harwood. Toronto: Coach House Press, 1990.

– *Fluid Arguments.* Edited by Susan Rudy. Translated by Ann-Marie Wheeler. Toronto: Mercury Press, 2005.

Bruno, Giuliana. *Atlas of Emotion: Journeys in Art, Architecture, and Film.* New York: Verso, 2002.

Buchanan, Ian, and Gregg Lambert, eds. *Deleuze and Space.* Edinburgh: Edinburgh University Press, 2005.

Burch, Noël. *Life to Those Shadows.* Berkeley: University of California Press, 1990.

Butler, Judith. *Bodies that Matter: On the Discursive Limits of "Sex."* New York: Routledge, 1993.

– *The Psychic Life of Power: Theories in Subjection.* Stanford: Stanford University Press, 1997.

– *Gender Trouble: Feminism and the Subversion of Identity.* 2nd ed. New York: Routledge, 1999.

– *Undoing Gender.* New York: Routledge, 2004.

Cadava, Eduardo. *Words of Light: Theses on the Photography of History.* Princeton: Princeton University Press, 1997.

–, and Paola Cortés-Rocca. "Notes on Love and Photography." In *Photography Degree Zero: Reflections on Roland Barthes's* Camera Lucida, edited by Geoffrey Batchen, 105–39. Cambridge: MIT Press, 2009.

Campbell, Jan, and Janet Harbord. "Playing it Again: Citation, Reiteration or Circularity?" *Theory, Culture & Society* 16, no. 2 (1999): 229–39.

Canter, Marc. "The New Workstation: CD ROM Authoring Systems." In *Multimedia: From Wagner to Virtual Reality*, edited by Randall Packer and Ken Jordan, 198–207. New York: W&W. Norton, 2001.

Case, Sue-Ellen. *The Domain-Matrix: Performing Lesbian at the End of Print Culture.* Bloomington: Indiana University Press, 1996.

– "Eve's Apple, or Women's Narrative Bytes." *Modern Fiction Studies* 43, no. 3 (1997): 631–50.

– "Dracula's Daughters: In-Corporating Avatars in Cyberspace." In *Feminist and Queer Performance: Critical Strategies*, 170–87. New York: Palgrave Macmillan, 2009.

Cecchi d'Amico, Suso, and Luchino Visconti. *Alla ricerca del tempo perduto: sceneggiatura dall'opera di Marcel Proust.* Milan: Mondadori, 1986.

Chun, Wendy Hui Kyong. "The Enduring Ephemeral, or the Future Is a Memory." In *Media Archaeology: Approaches, Applications, and Implications*,

edited by Erkki Huhtamo and Jussi Parikka, 184–203. Berkeley: University of California Press, 2011.

– *Programmed Visions: Software and Memory*. Cambridge: MIT Press, 2011.

–, and Thomas Keenan, eds. *New Media, Old Media: A History and Theory Reader*. New York: Routledge, 2005.

Constandinides, Costas. *From Film Adaptation to Post-Celluloid Adaptation*. London: Continuum, 2010.

Copjec, Joan. *Read My Desire: Lacan against the Historicists*. Cambridge: MIT Press, 1994.

Côté, Nicole. "*Désert mauve*, un *bildungsroman* queer?" In *The Child in French and Francophone Literature*, edited by Buford Norman and Daniela Di Cecco, 135–48. Amsterdam: Rodopi, 2004.

Cubitt, Sean. *Digital Aesthetics*. London: SAGE, 1998.

Curran, Beverley. "Obsessed by Her Reading: An Interview with Adriene Jenik about Her CD-ROM Translation of Nicole Brossard's *Le désert mauve*." *Links & Letters* 5 (1998): 97–109.

– "Re-Reading the Desert in Hypertranslation." In *Western Futures: Perspectives on the Humanities at the Millennium*, edited by Stephen Tchudi, Susanne Bentley, and Brad Lucas, 245–59. Reno, NV: Nevada Humanities Committee, 2000.

Dahan, Danielle. "De l'image cinématographique à l'écriture cinématographique." In *Proust und die Medien*, edited by Volker Roloff, 61–80. Munich: Fink, 2005.

Dai, Jinhua. "Imagined Nostalgia." In *Postmodernism & China*, edited by Arif Dirlik and Xudong Zhang, 205–21. Durham: Duke University Press, 2000.

Daniel, Natalie. "Multimedia Art. Constraining or Liberating?" *Convergence: The International Journal of Research into New Media Technologies* 3, no. 1 (1997): 102–10.

Defert, Daniel. "'Hétérotopie': tribulations d'un concept entre Venise, Berlin et Los Angeles." In Michel Foucault, *Le Corps utopique, les hétérotopies*, 37–61. Paris: Lignes, 2009.

Deleuze, Gilles. *Cinema 1: The Movement-Image*. Translated by Hugh Tomlinson and Barbara Habberjam. Minneapolis: University of Minnesota Press, 1986.

– *Cinema 2: The Time-Image*. Translated by Hugh Tomlinson and Robert Galeta. Minneapolis: University of Minnesota Press, 1989.

– *Proust and Signs*. Translated by Richard Howard. Minneapolis: University of Minnesota Press, 2000.

Derrida, Jacques. "Des tours de Babel." In *Difference in Translation*, edited by Joseph F. Graham, 165–207. Ithaca: Cornell University Press, 1985.

- "The Deaths of Roland Barthes." In *The Work of Mourning*, edited and translated by Pascale-Anne Brault and Michael Naas, 31–67. Chicago: University of Chicago Press, 2001.
- *Paper Machine*. Translated by Rachel Bowlby. Stanford: Stanford University Press, 2005.

Didi-Huberman, Georges. *Invention of Hysteria: Charcot and the Photographic Iconography of the Salpêtrière*. Translated by Alisa Hartz. Cambridge: MIT Press, 2003.

Doane, Mary Ann. *The Emergence of Cinematic Time: Modernity, Contingency, the Archive*. Cambridge, MA: Harvard University Press, 2002.
- "Imaging Contingency: An Interview with Mary Ann Doane." *Parallax* 13, no. 4 (2007): 16–25.

Donovan, Tristan. *Replay: The History of Video Games*. Lewes: Yellow Ant, 2010.

Douhaire, Samuel and Annick Rivoire. "Marker Direct: An Interview with Chris Marker." *Film Comment* 39, no. 3 (2003). http://www.filmcomment. com/article/marker-direct-an-interview-with-chris-marker.

Drucker, Johanna. *The Century of Artists' Books*. New York: Granery Books, 2004.

Dyson, Frances. *Sounding New Media: Immersion and Embodiment in the Arts and Culture*. Berkeley: University of California Press, 2009.

Elkington, Trevor. "Too Many Cooks: Media Convergence and Self-Defeating Adaptations." In *The Video Game Theory Reader* 2, edited by Bernard Perron and Mark J.P. Wolf, 213–35. New York: Routledge, 2009.

Elliott, Kamilla. "Theorizing Adaptations/Adapting Theories." In *Adaptation Studies: New Challenges, New Directions*, edited by Jørgen Bruhn, Anne Gjelsvik, and Eirik Frisvold Hanssen, 19–45. London: Bloomsbury, 2013.
- "Rethinking Formal-Cultural and Textual-Contextual Divides in Adaptation Studies." *Literature/Film Quarterly* 42, no. 4 (2014): 576–93.

Ernst, Wolfgang. *Digital Memory and the Archive*. Edited by Jussi Parikka. Minneapolis: University of Minnesota Press, 2013.

Expósito, Marcelo. "Retornar de la historia. *Immemory* de Chris Marker." *Kalias* 9, no. 17–18 (1997): 159–65.

Faubion, James. "Heterotopia: An Ecology." In *Heterotopia and the City: Public Space in a Postcivil Society*, edited by Michiel Dehaene and Lieven de Cauter, 31–9. New York: Routledge, 2008.

Feldman, Tony. *Introduction to Digital Media*. New York: Routledge, 1997.

Ferncase, Richard. *QuickTime for Filmmakers*. Burlington, MA: Focal Press, 2004.

ffrench, Patrick. "The Immanent Ethnography of Chris Marker, Reader of Proust." *Film Studies* 6 (2005): 87–96.

Fiant, Antony. *Pour un cinéma contemporain soustractif*. Paris: Presses Universitaires de Vincennes, 2014.

Flanagan, Mary. *Critical Play: Radical Game Design*. Cambridge: MIT Press, 2009.

Flinn, Margaret C. "Jean-Louis's *Moments* of Jean-Jacques." *Studies in French Cinema* 10, no. 2 (2010): 141–54.

Foster, Hal. "An Archival Impulse." *October* 110 (2004): 3–22.

Foucault, Michel. *Raymond Roussel*. Paris: Gallimard, 1963.

– "Self Writing." In *Ethics: Subjectivity and Truth*, edited by Paul Rabinow, 207–22. New York: The New Press, 1997.

– "Different Spaces." In *Aesthetics, Method, and Epistemology. The Essential Works of Foucault, Vol. 2*, edited by James Faubion, 175–85. New York: The New Press, 1998.

– *The Order of Things*. New York: Routledge, 2007.

Friedberg, Anne. "CD and DVD." In *The New Media Book*, edited by Dan Harries, 30–9. London: BFI, 2002.

Gaudreault, André. *Cinema delle origini o della "cinematografia-attrazione."* Milan: Il Castoro, 2004.

– *From Plato to Lumière: Narration and Monstration in Literature and Cinema*. Translated by Timothy Barnard. Toronto: University of Toronto Press, 2009.

Gitelman, Lisa. *Always Already New: Media, History, and the Data of Culture*. Cambridge: MIT Press, 2006.

– *Paper Knowledge: Toward a Media History of Documents*. Durham: Duke University Press, 2014.

Godard, Barbara. "Translating (with) the Speculum." *TTR: terminologie, traduction, rédaction* 4, no. 2 (1991): 85–121.

– "Deleuze and Translation." *Parallax* 14 (2000): 56–81.

Goldberg, David. "EnterFrame: Cage, Deleuze and Macromedia Director." *Afterimage* 30, no. 1 (2002): 8–9.

Goodman, Paul. "The Proustian Camera Eye." In *American Film Criticism: From The Beginnings to* Citizen Kane, edited by Stanley Kauffmann, 311–14. Westport: Greenwood Press, 1972.

Guattari, Félix. *The Machinic Unconscious: Essays in Schizoanalysis*. Translated by Taylor Adkins. Los Angeles: Semiotext(e), 2011.

Guerlac, Suzanne. "Visual Dust: On Time, Memory, and Photography in Proust." *Contemporary French and Francophone Studies* 13, no. 4 (2009): 397–404.

Gunning, Tom. "The Cinema of Attractions: Early Film, Its Spectator and the Avant-Garde." In *Early Cinema: Space – Frame – Narrative*, edited by Thomas Elsaesser, 56–62. London: BFI, 1990.

– *D.W. Griffith and the Origins of American Narrative Film: The Early Years at Biograph.* Urbana: University of Illinois Press, 1991.
– "Phantom Images and Modern Manifestations: Spirit Photography, Magic Theater, Trick Films, and Photography's Uncanny." In *Fugitive Images: From Photography to Video*, edited by Patrice Petro, 42–71. Bloomington: Indiana University Press, 1995.
– "Cinema of Attractions." In *Encyclopedia of Early Cinema*, edited by Richard Abel, 124–6. London: Routledge, 2005.
Guss, Nathan. *Proust Outdoors.* Lewisburg, PA: Bucknell University Press, 2009.
Harpold, Terry. *Ex-foliations: Reading Machines and the Upgrade Path.* Minneapolis: University of Minnesota Press, 2009.
Hartog, François. *Régimes d'historicité: présentisme et expériences du temps.* Paris: Seuil, 2003.
Hayles, N. Katherine. "Print Is Flat, Code Is Deep: The Importance of Media-Specific Analysis." *Poetics Today* 25, no. 1 (2004): 67–90.
– *My Mother Was a Computer: Digital Subjects and Literary Texts.* Chicago: University of Chicago Press, 2005.
– *Electronic Literature: New Horizons for the Literary.* Notre Dame, IN: University of Notre Dame Press, 2008.
– *How We Think: Digital Media and Contemporary Technogenesis.* Chicago: University of Chicago Press, 2012.
– "Print Is Flat, Code Is Deep: The Importance of Media-Specific Analysis." In *Transmedia Frictions: The Digital, the Arts, and the Humanities*, edited by Marsha Kinder and Tara McPherson, 20–33. Berkeley: University of California Press, 2014.
Heibach, Christiane. *Multimediale Aufführungskunst. Medienästhetische Studien zur Entstehung einer neuen Kunstform.* Berlin: Wilhelm Fink, 2009.
Hendershot, Heather. "Of Ghosts and Machines: An Interview with Zoe Beloff." *Cinema Journal* 45, no. 3 (2006): 130–40.
Holbrook, Susan. "Mauve Arrows and the Erotics of Translation." *Essays on Canadian Writing* 61 (1997): 232–41.
– "Delirium and Desire in Nicole Brossard's *Le Désert Mauve/Mauve Desert.*" *differences: A Journal of Feminist Cultural Studies* 12, no. 2 (2001): 70–83.
Huhtamo, Erkki. "Digitalian Treasures, or Glimpses of Art on the CD-ROM Frontier." In *Clicking In: Hot Links to a Digital Culture*, edited by Lynn Hershman, 306–17. Seattle: Bay Press, 1996.
–, and Jussi Parikka, eds. *Media Archaeology: Approaches, Applications, and Implications.* Berkeley: University of California Press, 2011.
Hutcheon, Linda, with Siobhan O'Flynn. *A Theory of Adaptation.* 2nd ed. New York: Routledge, 2012.

Ifri, Pascal. "One Novel, Five Adaptations: Proust on Film." *Contemporary French and Francophone Studies* 9, no. 1 (2005): 15–29.

Jakobson, Roman. "On Linguistic Aspects of Translation." In *Selected Writings II: Word and Language*, 260–6. The Hague: Mouton, 1971.

– "Shifters, Verbal Categories, and the Russian Verb." In *Selected Writings II: Word and Language*, 131–47. The Hague: Mouton, 1971.

Janet, Pierre. *De l'angoisse à l'extase: études sur les croyances et les sentiments.* Paris: Société Pierre Janet, 1975.

Jay, Martin. "Scopic Regimes of Modernity." In *Vision and Visuality,* edited by Hal Foster, 3–23. New York: The New York Press, 1988.

– *Downcast Eyes: The Denigration of Vision in Twentieth-Century French Thought.* Berkeley: University of California Press, 1993.

Jenik, Adriene. *Mauve Desert: A CD-ROM Translation.* Los Angeles: Shifting Horizons Production, 1997. CD-ROM.

– "Desktop Theater: Keyboard Catharsis and the Masking of Roundheads." *The Drama Review* 45, no. 3 (2001): 95–112.

– "*Santaman's Harvest* Yields Questions, or Does a Performance Happen if It Exists in a Virtual Forest?" In *Second Person: Role-Playing and Story in Games and Playable Media*, edited by Pat Harrigan and Noah Wardrip-Fruin, 289–96. Cambridge, MIT Press, 2007.

–, and Sarah Lewison. "Moving in Place: The Question of Distributed Social Cinema." In *Third Person: Authoring and Exploring Vast Narratives*, edited by Pat Harrigan and Noah Wardrip-Fruin, 179–91. Cambridge, MIT Press, 2009.

Kahn, Douglas. "Death in Light of the Phonograph: Raymond Roussel's *Locus Solus.*" In *Wireless Imagination: Sound, Radio, and the Avant-Garde,* edited by Douglas Kahn and Gregory Whitehead, 69–103. Cambridge, MA: MIT Press, 1992.

– "What Now the Promise?" In *Burning the Interface: International Artists' CD-ROM*, edited by Mike Leggett, 21–30. Sydney: Museum of Contemporary Art, 1996.

Kämper, Birgit. "Das Bild als Madeleine. 'Sans soleil" und "Immemory."' In *Chris Marker: Filmessayist*, edited by Birgit Kämper and Thomas Tode, 143–59. Munich: Institut Français de Munich / CICM, 1997.

Kilbourn, Russell J.A., and Patrick Faubert. "Introduction: Film Adaptation in the Post-Cinematic Era." *Journal of Adaptation in Film and Performance* 7, no. 2 (2014): 155–8.

Kinder, Marsha. "Designing a Database Cinema." In *Future Cinema: The Cinematic Imagery after Film*, edited by Jeffrey Shaw and Peter Weibel, 346–53. Karlsruhe / Cambridge, MA: ZKM / MIT Press, 2003.

–, and Tara McPherson. "Preface: Origins, Agents, and Alternative
 Archaeologies." In *Transmedia Frictions: The Digital, the Arts, and the
 Humanities*, edited by Marsha Kinder and Tara McPherson, xiii–xvii.
 Berkeley: University of California Press, 2014.

Kirschenbaum, Matthew. *Mechanisms: New Media and the Forensic Imagination*.
 Cambridge: MIT Press, 2007.

Kitchens, Susan. *The QuickTime VR Book*. Berkeley: Peachpit Press, 1998.

Kravanja, Peter. *Proust à l'écran*. Brussels: La Lettre volée, 2003.

Krief, Huguette. "'Le pinceau d'un Le Brun' ou l'art pictural du second
 Discours de Rousseau." *Annales Jean-Jacques Rousseau* 45 (2003): 335–56.

Lacan, Jacques. *Le Séminaire livre III. Les psychoses*. Paris: Éditions du Seuil,
 1981.

– *The Seminar of Jacques Lacan, Book XI: The Four Fundamental Concepts of
 Psychoanalysis*. Translated by Alan Sheridan. New York: W.W. Norton, 1981.

Lacasse, Germain. *Le Bonimenteur de vues animées. Le cinéma "muet" entre
 tradition et modernité*. Québec: Nota Bene, 2000.

– "The Lecturer and the Attraction." In *The Cinema of Attractions Reloaded*,
 edited by Wanda Strauven, 181–91. Amsterdam: Amsterdam University
 Press, 2006.

–, Vincent Bouchard, and Gwenn Scheppler, eds. *Pratiques orales du cinéma*.
 Paris: L'Harmattan, 2011.

Lamarre, Thomas. "The First Time as Farce: Digital Animation and the
 Repetition of Cinema." In *Cinema Anime: Critical Engagements with Japanese
 Animation*, edited by Steven T. Brown, 161–88. New York: Palgrave
 Macmillan, 2006.

– "Full Limited Animation." In *Ga-Netchu! The Manga Anime Syndrome*,
 106–19. Frankfurt am Main: Deutsches Filmmuseum, 2008.

– *The Anime Machine: A Media Theory of Animation*. Minneapolis: University of
 Minnesota Press, 2009.

Lambert, Steve, and Suzanne Ropiequet. "Preface." In *CD ROM: The New
 Papyrus*, edited by Steve Lambert and Suzanne Ropiequet, n.p. Redmond,
 WA: Microsoft Press, 1986.

Lathers, Marie. *The Aesthetics of Artifice: Villiers's L'Eve Future*. Chapel Hill:
 University of North Carolina Department of Romance Languages, 1996.

Leggett, Mike. "Burning the Interface: Artists' Interactive Multimedia 1992–
 1998." MFA thesis, University of New South Wales, 2000.

Leiris, Michel. *Raymond Roussel & Co.* Saint-Clément-la-Rivière: Fata Morgana,
 1998.

Leitch, Thomas. *Film Adaptation and Its Discontents*. Baltimore: Johns Hopkins
 University Press, 2007.

Lessard, Bruno. "Intermédialité et interperformativité: à propos du site Web *Last Entry: Bombay, 1 July … A Travel Log Through Time, Space, and Identity* de Andrea Zapp." *Intermédialités* 1 (2003): 139–53.

– "Interface, corporéité et intermédialité. *Sonata* de Grahame Weinbren." *Parachute* 113 (2004): 60–9.

– "The Environment, the Body, and the Digital Fallen Angel in Simon Biggs's *Pandaemonium*." In *Milton in Popular Culture*, edited by Greg Colon Semanza and Laura Knoppers, 213–23. New York: Palgrave Macmillan, 2006.

– "Hypermedia *Macbeth*: Cognition and Performance." In *Macbeth: New Critical Essays*, edited by Nick Moschovakis, 318–34. New York: Routledge, 2008.

– "Missed Encounters: Film Theory and Expanded Cinema." *Refractory: A Journal of Entertainment Media* 14 (2008). http://refractory.unimelb.edu. au/2008/12/26/missed-encounters-film-theory-and-expanded-cinema-%E2%80%93-bruno-lessard/

– "Between Creation and Preservation: The ANARCHIVE Project." *Convergence: The International Journal of Research into New Media Technologies* 15, no. 3 (2009): 315–31.

– "Archiving the Gaze: Relation-Images, Adaptation, and Digital Mnemotechnologies." In *Save as … Digital Memories*, edited by Joanne Garde-Hansen, Anna Reading, and Andrew Hoskins, 115–28. New York: Palgrave Macmillan, 2009.

– "The Game's Two Bodies, or the Fate of *Figura* in *Dante's Inferno*." In *Digital Gaming Re-imagines the Middle Ages*, edited by Daniel T. Kline, 133–47. New York: Routledge, 2013.

Lloyd, Moya. "Performativity, Parody, Politics." *Theory, Culture & Society* 16, no. 2 (1999): 195–213.

Lotbinière-Harwood, Susanne de. *Re-belle et infidèle: la traduction comme pratique de réécriture au féminin / The Body Bilingual: Translation as a Re-Writing in the Feminine*. Montréal / Toronto: Éditions du Remue-ménage / Women's Press, 1991.

– "Geographies of Why." In *Culture in Transit: Translating the Literature of Quebec*, edited by Sherry Simon, 55–68. Montréal: Véhicule Press, 1995.

Lupton, Catherine. *Chris Marker: Memories of the Future*. London: Reaktion Books, 2004.

– "Chris Marker: In Memory of New Technology." http://www.chrismarker. org/catherine-lupton-in-memory-of-new-technology.

MacCabe, Colin, Kathleen Murray, and Rick Warner, eds. *True to the Spirit: Film Adaptation and the Question of Fidelity*. Oxford: Oxford University Press, 2011.

Maier, Carol. "Translation as Performance: Three Notes." *Translation Review* 15 (1984): 5–8.

Mamber, Stephen. "Films Beget Digital Media." In *Transmedia Frictions: The Digital, the Arts, and the Humanities*, edited by Marsha Kinder and Tara McPherson, 115–25. Berkeley: University of California Press, 2014.

Manovich, Lev. "The Paradoxes of Digital Photography." In *Photography after Photography*, edited by Hubertus von Amelunxen, Stefan Iglhaut, and Florian Rötzer, 57–65. Amsterdam: G+B Arts, 1996.

– *The Language of New Media*. Cambridge: MIT Press, 2001.

– *Software Culture*. Milan: Olivares, 2010.

Marker, Chris. "A free replay (notes sur *Vertigo*)." *Positif* 400 (1994): 79–84.

– *Immemory*. Paris: Centre Georges Pompidou, 1999. CD-ROM.

– "The Rest Is Silent." *Trafic* 46 (2003): 57–62.

Marks, Laura. *The Skin of the Film: Intercultural Cinema, Embodiment, and the Senses*. Durham: Duke University Press, 2000.

Michelson, Annette. "On the Eve of the Future: The Reasonable Facsimile and the Philosophical Toy." *October* 29 (1984): 3–20.

Miles, Adrian. "Cinematic Paradigms for Hypertext." *Continuum: Journal of Media & Cultural Studies* 13, no. 2 (1999): 217–25.

Miller Frank, Felicia. *The Mechanical Song: Women, Voice, and the Artificial in Nineteenth-Century French Narrative*. Stanford: Stanford University Press, 1995.

Miller, J. Hillis. "The Ethics of Hypertext." *Diacritics* 25, no. 3 (1995): 27–39.

Mitchell, W.J.T. *The Reconfigured Eye: Visual Truth in the Post-Photographical Era*. Cambridge: MIT Press, 1992.

Montfort, Nick. *Twisty Little Passages: An Approach to Interactive Fiction*. Cambridge: MIT Press, 2005.

–, and Ian Bogost. *Racing the Beam: The Atari Video Computer System*. Cambridge: MIT Press, 2009.

Moore, Michael Ryan. "Adaptation and New Media." *Adaptation* 3, no. 2 (2010): 179–92.

Morelli, Pierre. "Multimédia et création: contribution des artistes au développement d'une écriture multimedia." PhD diss., Université de Metz, 2000.

Moretti, Franco. *Atlante del romanzo europeano, 1800–1900*. Turin: Einaudi, 1997.

Morgan, Michael J. *Molyneux's Question: Vision, Touch, and the Philosophy of Perception*. Cambridge: Cambridge University Press, 1977.

Murray, Simone. *The Adaptation Industry: The Cultural Economy of Contemporary Literary Adaptation*. New York: Routledge, 2012.

Murray, Timothy. "Curatorial Preface." https://contactzones.cit.cornell.edu/
why.html.

–, ed. *Zonas de contacto: el arte en CD-ROM*. Mexico City: CONACULTA /
Centro de la imagen, 1999.

– "The Digital Stain of Technology." In *The Complete Artintact komplett*.
Vols.1–5, 1994–1999, ed. Jeffrey Shaw, 33–42. Karlsruhe: ZKM / Hatje Cantz,
2002. DVD-ROM.

– *Digital Baroque: New Media Art and Cinematic Folds*. Minneapolis: University
of Minnesota Press, 2008.

Neumark, Norie, Ross Gibson, and Theo van Leeuwen, eds. *VOICE: Vocal
Aesthetics in Digital Arts and Media*. Cambridge: MIT Press, 2010.

Newman, James. *Best Before: Videogames, Supersession and Obsolescence*. New
York: Routledge, 2012.

Newson, Gillian, and Eric Brown. "CD-ROM: What Went Wrong?" *New Media*
(August 1998): 32–8.

Nitsch, Wolfram. "Vom Panorama zum Stereoskop. Medium und Metapher
bei Proust." In *Marcel Proust und die Künste*, edited by Wolfram Nitsch and
Rainer Zaiser, 240–62. Frankfurt: Insel Verlag, 2004.

Nitsche, Michael. *Video Game Spaces: Image, Play, and Structure in 3D Worlds*.
Cambridge: MIT Press, 2008.

O'Neal, John C. *Seeing and Observing: Rousseau's Rhetoric of Perception*.
Saratoga, CA: Anma Libri, 1985.

Orlow, Uriel. "Chris Marker: The Archival Power of the Image." In *Lost in the
Archives*, edited by Rebecca Comay, 437–51. Toronto: Alphabet City, 2002.

Paci, Viva. *Il cinema di Chris Marker: come un vivaio ai pescatori di passato
dell'avvenire*. Bologna: Hybris, 2005.

– "'Life is very long,' avant et après *The Hollow Men*." In *Chris Marker et
l'imprimerie du regard*, edited by André Habib and Viva Paci, 275–91. Paris:
L'Harmattan, 2008.

Packer, Randall, and Ken Jordan. "Overture." In *Multimedia: From Wagner to
Virtual Reality*, edited by Randall Packer and Ken Jordan, xv–xxxviii. New
York: W&W. Norton, 2001.

Parker, Alice. *Liminal Visions of Nicole Brossard*. New York: Peter Lang, 1998.

Pavel, Thomas G. *The Lives of the Novel: A History*. Princeton: Princeton
University Press, 2013.

Pelachaud, Gaëlle. *Livres animés. Du papier au numérique*. Paris: L'Harmattan,
2010.

Peterson, Matthew, and Michael Schaff. *Interactive QuickTime*. San Francisco:
Morgan Kaufman, 2003.

Pilgree, Geoffrey B., and Lisa Gitelman, eds. *New Media, 1740–1915.* Cambridge: MIT Press, 2003.

Pinter, Harold. *The Proust Screenplay.* New York: Grove Press, 2000.

Pognant, Patrick, and Claire Scholl. *Les CD-Rom culturels.* Paris: Hermès, 1996.

Poulet, Georges. *Proustian Space.* Translated by Elliott Coleman. Baltimore: Johns Hopkins University Press, 1977.

Pressman, Jessica. *Digital Modernism: Making It New in New Media.* Oxford: Oxford University Press, 2014.

–, Mark C. Marino, and Jeremy Douglass. *Reading Project: A Collaborative Analysis of William Poundstone's* Project for Tachistoscope {Bottomless Pit}. Iowa City: University of Iowa Press, 2015.

Proust, Marcel. *In Search of Lost Time.* Translated by C.K. Scott Moncrieff and Terence Kilmartin. Vols. 1–3. New York: Vintage, 1996.

Ragland, Ellie. "The Relation between the Voice and the Gaze." In *Reading Seminar XI: Lacan's Four Fundamental Concepts of Psychoanalysis*, edited by Richard Feldstein, Bruce Fink, and Maire Jaanus, 187–203. Albany: State University of New York Press, 1995.

Ramond, Catherine. "Autour des sujets d'estampes de *La Nouvelle Héloïse*: estampes dramatiques et tableaux romanesques." *Annales Jean-Jacques Rousseau* 45 (2003): 511–27.

Ritchin, Fred. *After Photography.* New York: W.W. Norton & Co., 2008.

Robbe-Grillet, Alain. "Énigmes et transparence chez Raymond Roussel." In *Pour un nouveau roman*, 70–6. Paris: Éditions de Minuit, 1961.

Robinson, Philip. *Jean-Jacques Rousseau's Doctrine of the Arts.* New York: Peter Lang, 1984.

Rockwell, Geoffrey, and Andrew Mactavish. "Multimedia." In *A Companion to Digital Humanities*, edited by Susan Schreibman, Ray Siemens, and John Unsworth, 108–20. Malden: Blackwell, 2004.

Roloff, Volker. "Proust und die Medien. Zur intermedialen Ästhetik Prousts." In *Proust und die Medien*, edited by Volker Roloff, 11–19. Munich: Fink, 2005.

Rousseau, Jean-Jacques. *The Confessions.* Translated by J.M. Cohen. New York: Penguin, 1953.

– "Sujets d'estampes." In *Œuvres complètes* II, edited by Bernard Gagnebin and Marcel Raymond, 761–71. Paris: Gallimard, 1959.

– *Emile.* Translated by Barbara Foxley. New York: Everyman's Library, 1974.

– "Moral Letters." In *Rousseau on Philosophy, Morality, and Religion*, edited and translated by Christopher Kelly, 73–101. Hanover: University Press of New England, 2007.

Roussel, Raymond. *Locus Solus.* Translated by Rupert Copeland Cuningham. Berkeley: University of California Press, 1970.

– *Comment j'ai écrit certains de mes livres*. Paris: Gallimard, 1995.

Rueff, Martin. "Apprendre à voir: l'optique dans la théorie de l'homme." In *Rousseau et les sciences*, edited by Bernadette Bensaude-Vincent and Bruno Bernardi, 193–214. Paris: L'Harmattan, 2003.

Ruiz, Raúl. *Poética del cine*. Santiago: Editorial Sudamericana, 2000.

Russell, Jamie. *Generation Xbox: How Video Games Invaded Hollywood*. Lewes: Yellow Ant, 2012.

Santoro, Miléna. "Feminist Translation: Writing and Transmission among Women in Nicole Brossard's *Le Désert mauve* and Madeleine Gagnon's *Lueur*." In *Women by Women: The Treatment of Female Characters by Women Writers of Fiction in Quebec since 1980*, edited by Roseanna Lewis Dufault, 147–67. Madison, NJ: Fairleigh Dickinson University Press, 1997.

Schrenck-Notzing, A. Freiherrn von. *Materialisationsphänomene. Ein Beitrag zur Erforschung der mediumistichen Teleplastie*. Munich: Ernst Reinhardt, 1923.

Shattuck, Roger. *Proust's Binoculars*. New York: Random House, 1963.

Shaw, Jeffrey, and Peter Weibel, eds. *Future Cinema: The Cinematic Imaginary after Film*. Karlsruhe / Cambridge: ZKM / MIT Press, 2003.

Silverthorne, Sean. "Paperless Writer (The Voyager Co's CD ROM Publishing Adventures)." *PC Week* 12, no. 28 (July 1995): A5.

Skoller, Jeffrey. *Shadows, Specters, Shards: Making History in Avant-Garde Film*. Minneapolis: University of Minnesota Press, 2005.

Smith, Greg M. "Introduction: A Few Words about Interactivity." In *On a Silver Platter: CD-ROMs and the Promises of a New Technology*, edited by Greg Smith, 1–34. New York: New York University Press, 1999.

Smith, Sidonie. *Subjectivity, Identity, and the Body: Women's Autobiographical Practices in the Twentieth Century*. Bloomington: Indiana University Press, 1993.

– "Performativity, Autobiographical Practice, Resistance." In *Women, Autobiography, Theory: A Reader*, edited by Sidonie Smith and Julia Watson, 108–15. Madison: University of Wisconsin Press, 1998.

– *Moving Lives: Twentieth-Century Women's Travel Writing*. Minneapolis: University of Minnesota Press, 2001.

Sobchack, Vivian. *The Address of the Eye: A Phenomenology of Film Experience*. Princeton: Princeton University Press, 1991.

– "Nostalgia for a Digital Object: Regrets on the Quickening of QuickTime." In *Memory Bytes: History, Technology, and Digital Media*, edited by Lauren Rabinovitz and Abraham Geil, 305–29. Durham: Duke University Press, 2004.

– "Afterword: Media Archaeology and Re-presencing the Past." In *Media Archaeology: Approaches, Applications, and Implications*, edited by Erkki

Huhtamo and Jussi Parikka, 323–33. Berkeley: University of California Press, 2011.

Sontag, Susan. *On Photography*. New York: Picador, 1977.

St George, Paul, ed. *Sequences: Contemporary Chronophotography and Experimental Digital Art*. London: Wallflower Press, 2009.

Stam, Robert. "Introduction." In *Literature and Film: A Guide to the Theory and Practice of Adaptation*, edited by Robert Stam and Alessandra Raengo, 1–52. Oxford: Blackwell, 2005.

Starobinski, Jean. *L'œil vivant: Corneille, Racine, Rousseau, Stendhal*. Paris: Gallimard, 1999.

Steiner, George. *After Babel: Aspects of Language and Translation*. Oxford: Oxford University Press, 1975.

Sterne, Jonathan. *The Audible Past: Cultural Origins of Sound Reproduction*. Durham: Duke University Press, 2003.

Stiegler, Bernard. *Taking Care of Youth and the Generations.* Translated by Stephen Baker. Stanford: Stanford University Press, 2010.

Stoicheff, Peter, and Andrew Taylor. "Introduction: Architectures, Ideologies, and Materials of the Page." In *The Future of the Page*, edited by Peter Stoicheff and Andrew Taylor, 3–26. Toronto: University of Toronto Press, 2004.

Tabbi, Joseph. "The Processual Page: Materiality and Consciousness in Print and Hypertext." In *The Future of the Page*, edited by Peter Stoicheff and Andrew Taylor, 201–30. Toronto: University of Toronto Press, 2004.

Tong, Qiang. *Kongjian zhexue*. Beijing: Beijing daxue chubanshe, 2011.

Trope, Alison, and Holly Willis, eds. *Interactive Frictions Exhibition*. Los Angeles: Labyrinth Research Initiative, Annenberg Center for Communication, 1999.

Villiers de l'Isle-Adam. *Tomorrow's Eve*. Translated by Robert Martin Adams. Urbana: University of Illinois Press, 2001.

Wardrip-Fruin, Noah. *Expressive Processing: Digital Fictions, Computer Games, and Software Studies*. Cambridge: MIT Press, 2009.

Watson, Julia, and Sidonie Smith. "Introduction: Mapping Women's Self-Representation at Visual/Textual Interfaces." In *Interfaces: Women, Autobiography, Image, Performance*, edited by Julia Watson and Sidonie Smith, 1–46. Ann Arbor: University of Michigan Press, 2002.

Welger-Barboza, Corinne. *Le Patrimoine à l'ère du document numérique. Du musée virtuel au musée médiathèque*. Paris: L'Harmattan, 2001.

Wise, Richard. *Multimedia: A Critical Introduction*. New York: Routledge, 2000.

Wolf, Mark J.P. Myst *and* Riven: *The World of the D'ni*. Ann Arbor: University of Michigan Press, 2011.

–, ed. *Before the Crash: Early Video Game History*. Detroit: Wayne State University Press, 2012.

Yacavone, Kathrin. *Benjamin, Barthes, and the Singularity of Photography*. New York: Continuum, 2012.

Zénatti, Georges. *CD-ROM et vidéo sur CD*. 2nd ed. Paris: Hermès, 1996.

Žižek, Slavoj. *The Sublime Object of Ideology*. London: Verso, 1989.

– *Looking Awry: An Introduction to Jacques Lacan through Popular Culture*. Cambridge: MIT Press, 1992.

Index

Willis, Holly, 33
Woolery, Reginald, 30
Woolf, Virgina, 31

Yang, Lian, 31
Yitzhak, Shmuel ben, 31

Zapp, Andrea, 31
Zielinski, Siegfried, 20
Žižek, Slavoj, 108
ZKM (Zentrum für Kunstmedien),
 29, 33
Zola, Emile, 148